Professional Patternmaking for Designers

Women's Wear
Men's Casual Wear

JACK HANDFORD

FAIRCHILD PUBLICATIONS, INC.
NEW YORK

Dedication

This book is dedicated to all of my students, past and present, including those hundreds of students who have been helped by my first book on the art of patternmaking; to the memory of my former teachers; and to my good friends in the garment industry who have stimulated and prompted me to discover new methods to present an endlessly fascinating subject.

Jack Handford, Ed. D.
Los Angeles

Table of Contents

Introduction

The aspiring designer studies many things - drawing, textiles, patternmaking, costume history, color, draping, sewing. All of these are essential to designing a garment that will combine flattery, fit and fashion appeal. The art of patternmaking gives the designer a vocabulary to express the current season's ideas.

Many well known designers insist on making their own first patterns in order to be sure that the translation from sketch to the finished garment is under their control. Sometimes it is not practical for the designer to make the first pattern. However, it is important that the designer knows and understands how the pattern was made in case there are corrections needed. In other words, even if the designer does not make all the patterns, it is essential that patternmaking be emphasized in the designer's training.

Customers do not buy sketches or ideas - they buy garments. In order to produce garments commercially, a carefully made pattern is needed for each component of the finished product. The completed garment must not only fit the customer, the pattern pieces must fit together. Each piece of every pattern must be carefully checked against the piece to which it will be sewn: The bodice front must fit to the bodice back; the collar must fit the neckline; the sleeve must fit the armscye; etc. When the garment is completed it should be checked on the form for the correct placement of the seams, darts, roll of the collar and general proportions. It should then be tested on a live model for freedom of movement: Raising the arms, walking, sitting, etc. Only when the garment has passed all these tests can the pattern be considered finished and ready to cut for mass production.

The success of this or any system of patternmaking will depend upon the accuracy with which the measurements are taken and how carefully those measurements are transferred to the paper pattern. Since the patterns are constructed from basic blocks, the patterns will be consistent in fit - good or bad. After the blocks have been drafted they should be traced on to sheeting weight muslin, carefully stitched with a large stitch to simplify any needed adjustments and tried on the form or person for whom the pattern was made. If any discrepancy in fit is discovered in the try-on, let out or take in the muslin, pinning and marking it as accurately as possible. Any alterations in the muslin should be immediately transferred to the paper pattern, and the measurement rechecked and corrected to conform to the muslin and the corrected block.

As a beginner, do not be put off by the fact that it is necessary to learn to make the blocks called for in this text. If the construction of the blocks is thoroughly understood, future patterns and fittings will be much easier. Do not slight those patterns that appear "old fashioned": Fashions have a habit of coming back. The principles that are essential to good patternmaking remain the same.

The system of making basic blocks that is presented here will work on any set of measurements for any body size - junior petite through larger women's sizes. The Size 10 used for the examples is a commercially accepted size for popular priced garments. More expensive houses may use these identical measurements but label the garment Size 8. In the chapter on Men's Casual Wear, the sample size is for a 40" (101.6 cm) chest and a 32" (81.3 cm) waist.

The patterns in this book are on a scale of 0.5 centimeters equals one inch. The few exceptions, that had to be further reduced to fit the page, are on a scale of 0.5 centimeters equals two inches.

When the term "on the fold" is used in this book, it means that the pattern is constructed on the fold of the paper so that when the pattern is cut out it will open

into a full pattern. This is necessary because the fabrics used in factories are rolled on tubes without a crease or fold down the center. Never mark a pattern "Cut on fold" or "Place on fold". That is strictly for home sewing and very unprofessional.

The basic blocks illustrated are primarily for firmly woven fabrics. If knitted or stretch fabrics are being used, a different set of blocks for those fabrics is needed. However, unless only one type of knit or stretch fabric is being worked with repeatedly, it would not be worthwhile to make a complete set of blocks as the stretch factor in knits and elasticized fabrics varies so greatly that it is impossible to make a basic block that will be right for any and all of them and still maintain a consistent fit. It is suggested that the basic blocks for a knitted fabric be draped on the form in the fabric that is to be used. "Body landmarks" (neckline, bustline, waistline, hipline, armscye, etc.) should be chalked on the draping. The chalk marks would then be transferred from the fabric to the paper with a tracing wheel. Once the block for a knit is made the procedure for making patterns for woven fabrics may be followed.

Since designers are expected to provide their own patternmaking tools on the job, it is best to get them as a student and learn to handle and care for them properly. Good equipment will make the beginner more proficient and more confident, and will outlast the tools available to the home sewer. In addition to sharp pencils, the designer-patternmaker should have (1) a good tape measure marked in inches and/or centimeters for taking measurements from the body or dress form; (2) an "L-Square" (sometimes called a tailor's square - Fairgate makes a good one in aluminum) or a right angle triangle for squaring lines; (3) a "straight-edge", a yard or a meter long for drawing long straight lines - Fairgate also makes this in light weight aluminum; (4) a shorter ruler marked in inches with sixteenth inch divisions or centimeters with milimeter divisions (C-Thru Ruler Co. makes some that combine inches and centimeters); (5) a needle pointed tracing wheel for transferring lines from one pattern to another or from muslin to paper; (6) a sixteenth inch notcher for marking seam allowances and guide notches; (7) a small awl for making punches; (8) A really good pair of shears for cutting patterns. French curves and curved rulers of various types are handy and the individual worker will find many small gadgets that may prove useful...push pins or small weights for holding the paper or fabric in place, staplers to assist in cutting folded patterns accurately, buttonhole markers, etc. The main thing is to learn how to handle the tools needed and not clutter the work area with unnecessary items.

There is much knowledge to be gained from closely examining actual garments made by leaders in various price categories. How was the fullness achieved? What seam allowances, including hems, were used? Examine the way the zippers were sewn and how the waistbands, cuffs, pockets and trims were applied. Be open to new methods - the old ways are not necessarily the best.

Always keep in mind that designing is experimenting. Much of designing-patternmaking can be defined as simply taking a basic shape and varying designs within a given silhouette by cutting the blocks apart in new ways and putting them back together with different methods of sewing, trimming or fabric/color changes. Although the human body remains relatively consistent in dimensions, the concept of fit and the re-shaping of the body to current tastes changes with the cycles of fashion. Once the basic rules of patternmaking are mastered and thoroughly understood, try bending (if not breaking) a few of the rules to come up with your own innovative ideas. Not all of them will work but now and then one will - and when it does it is well worth the effort!

METRIC CONVERSION TABLES

Inches To Centimeters

1 Inch, U. S. Standard = 2.540005 Centimeters

The centimeter equivalent to the inch measurement as given in the text is to the nearest tenth.

When using the metric system of measurement exclusively it is a general practice to measure to the nearest half centimeter for major measurements.

Inches	Fractions									Inches
	0	1/16	1/8	1/4	3/8	1/2	5/8	3/4	7/8	
0	0.0	0.2	0.3	0.6	1.0	1.3	1.6	1.9	2.2	0
1	2.5	2.7	2.9	3.2	3.5	3.8	4.1	4.4	4.8	1
2	5.1	5.2	5.4	5.7	6.0	6.4	6.7	7.0	7.3	2
3	7.6	7.8	7.9	8.3	8.6	8.9	9.2	9.5	9.8	3
4	10.2	10.3	10.5	10.8	11.1	11.4	11.7	12.1	12.4	4
5	12.7	12.9	13.0	13.3	13.7	14.0	14.3	14.6	14.9	5
6	15.2	15.4	15.6	15.9	16.2	16.5	16.8	17.1	17.5	6
7	17.8	17.9	18.1	18.4	18.7	19.1	19.4	19.7	20.0	7
8	20.3	20.5	20.6	21.0	21.3	21.6	21.9	22.2	22.5	8
9	22.9	23.0	23.2	23.5	23.8	24.1	24.4	24.8	25.1	9
10	25.4	25.6	25.7	26.0	26.4	26.7	27.0	27.3	27.6	10
11	27.9	28.1	28.3	28.6	28.9	29.2	29.5	29.8	30.2	11
12	30.5	30.6	30.8	31.1	31.4	31.8	32.1	32.4	32.7	12
13	33.0	33.2	33.3	33.7	34.0	34.3	34.6	34.9	35.2	13
14	35.6	35.7	35.9	36.2	36.5	36.8	37.1	37.5	37.8	14
15	38.1	38.3	38.4	38.7	39.1	39.4	39.7	40.0	40.3	15
16	40.6	40.8	41.0	41.3	41.6	41.9	42.2	42.5	42.9	16
17	43.2	43.3	43.5	43.8	44.1	44.4	44.8	45.1	45.4	17
18	45.7	45.9	46.0	46.4	46.7	47.0	47.3	47.6	47.9	18
19	48.3	48.4	48.6	48.9	49.2	49.5	49.8	50.2	50.5	19
20	50.8	51.0	51.1	51.4	51.7	52.1	52.4	52.7	53.0	20
21	53.3	53.5	53.7	54.0	54.3	54.6	54.9	55.2	55.6	21
22	55.9	56.0	56.2	56.5	56.8	57.2	57.5	57.8	58.1	22
23	58.4	58.6	58.7	59.1	59.4	59.7	60.0	60.3	60.6	23
24	61.0	61.1	61.3	61.6	61.9	62.2	62.5	62.9	63.2	24

Inches	Fractions									Inches
	0	1/16	1/8	1/4	3/8	1/2	5/8	3/4	7/8	
25	63.5	63.7	63.8	64.1	64.5	64.8	65.1	65.4	65.7	25
26	66.0	66.2	66.4	66.7	67.0	67.3	67.6	67.9	68.3	26
27	68.6	68.7	69.0	69.2	69.5	69.9	70.2	70.5	70.8	27
28	71.1	71.3	71.4	71.8	72.1	72.4	72.7	73.0	73.3	28
29	73.7	73.8	74.0	74.3	74.6	74.9	75.2	75.6	75.9	29
30	76.2	76.4	76.5	76.8	77.2	77.5	77.8	78.1	78.4	30
31	78.7	78.9	79.1	79.4	79.7	80.0	80.3	80.6	81.0	31
32	81.3	81.4	81.6	81.9	82.2	82.6	82.9	83.2	83.5	32
33	83.8	84.0	84.1	84.5	84.8	85.1	85.4	85.7	86.0	33
34	86.4	86.5	86.7	87.0	87.3	87.6	87.9	88.3	88.6	34
35	88.9	89.1	89.2	89.5	89.9	90.2	90.5	90.8	91.1	35
36	91.4	91.6	91.8	92.1	92.4	92.7	93.0	93.3	93.7	36
37	94.0	94.1	94.3	94.6	94.9	95.3	95.6	95.9	96.2	37
38	96.5	96.7	96.8	97.2	97.5	97.8	98.1	98.4	98.7	38
39	99.1	99.2	99.4	99.7	100.0	100.3	100.6	101.0	101.3	39
40	101.6	101.8	101.9	102.2	102.6	102.9	103.2	103.5	103.8	40
41	104.1	104.3	104.5	104.8	105.1	105.4	105.7	106.0	106.4	41
42	106.7	106.8	107.0	107.3	107.6	108.0	108.3	108.6	108.9	42
43	109.2	109.4	109.5	109.9	110.2	110.5	110.8	111.1	111.4	43
44	111.8	111.9	112.1	112.4	112.7	113.0	113.3	113.7	114.0	44
45	114.3	114.5	114.6	114.9	115.2	115.6	115.9	116.2	116.5	45
46	116.8	117.0	117.2	117.5	117.8	118.1	118.4	118.7	119.1	46
47	119.4	119.5	119.7	120.0	120.3	120.7	121.0	121.3	121.6	47
48	121.9	122.1	122.2	122.6	122.9	123.2	123.5	123.8	124.1	48
49	124.5	124.6	124.8	125.1	125.4	125.7	126.1	126.4	126.7	49
50	127.0	127.2	127.3	127.6	128.0	128.3	128.6	128.9	129.2	50
51	129.5	129.7	129.9	130.2	130.5	130.8	131.1	131.5	131.8	51
52	132.1	132.2	132.4	132.7	133.0	133.4	133.7	134.0	134.3	52
53	134.6	134.8	134.9	135.3	135.6	135.9	136.2	136.5	136.9	53
54	137.2	137.3	137.5	137.8	138.1	138.4	138.8	139.1	139.4	54
55	139.7	139.9	140.0	140.3	140.7	141.0	141.3	141.6	141.9	55
60	152.4	152.6	152.7	153.0	153.4	153.7	154.0	154.3	154.6	60

Chapter 1

How To Measure For

The Basic Blocks

Notes

The fit of the garment to be made from the basic blocks will depend a great deal on the accuracy with which the measurements are taken. All measurements should be double checked. Commercial dress forms for the trade are fairly consistent on both sides but it would be well to check the two sides of the figure, using the larger of the two measurements if there is a difference. In measuring a person, both sides of the body should be measured and if there is more than a quarter of an inch (0.6 cm) difference it will be necessary to make separate patterns for the right and left sides.

Measurements should be taken in the order given as that is how they will be used to construct the basic blocks.

BODICE FRONT AND BACK

1. Full Front Length

 A. On the dress form the measurement is taken from the joining of the neck and shoulder seams down to the lower edge of the tape at the waistline. The measuring tape should be kept parallel to the center front. See *Figure 1*.

 B. On the human figure it will be necessary to mark certain points on the body, preferably with washable ink. After placing a tape loosely around the base of the neck to simulate a basic neckline, marks should be made on each side of the neck in line with the mastoid process (the small hollow close under the back of the lower part of the ear). A narrow ribbon tied or pinned comfortably around the waistline will serve to indicate the waist. The body is then measured as shown in *Figure 2*.

 2. Center Front Length

 A. Pin a ribbon from bust point to bust point on the form. Place the tape 1/4" (0.6 cm) below the neckline seam and measure the center front length over the ribbon at the bust to the lower edge of the waistline tape on the form. See *Figure 1*.

 B. Pin a ribbon from bust point to bust point on the figure. Be sure to let the tape fall over the ribbon from the middle of the hollow at the base of the throat (the top edges of the clavicle bones) to the ribbon at the waist. See *Figure 2*.

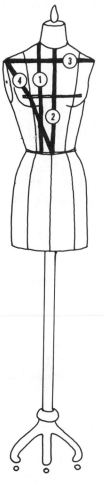

Figure 1

Figure 2

1

3. Shoulder Width - Front

 A. On the dress form the measurement is taken from the intersection of the armscye and shoulder seams across the front of the base of the neck. See *Figure 1.*

 B. The ends of the shoulder bones (the acromion process) should be marked with a dot. Take care to line up the marks on the shoulders with the previous marks made on the neck so that the shoulder seams will appear straight and not falling either to the back or front. The measurement is taken from shoulder edge to shoulder edge across the front. See *Figure 2.*

4. Shoulder Slope - Front

 A. On the dress form the measurement is taken from the center front of the waistline to the end of the shoulder at the armscye seam, over the fullest part of the bust. See *Figure 1.*

 B. The center of the waistline is generally in line with the navel. The measurement is taken from the center front of the waistline to the end of the shoulder, the mark made for No. 3 above. Be sure to measure the right and left sides as a "low shoulder" is a common figure fault and will determine whether it will be necessary to make separate blocks for the right and left sides. See *Figure 2.*

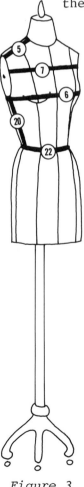

Figure 3

 5. Shoulder Length - Front

 A. This is the distance from the intersection of the neckline with the shoulder to the intersection of the armscye with the shoulder seam. The measurement will determine the length of the shoulder seam. See *Figure 3.*

 B. On the human figure, the end of the tape is placed at the mark on the side of the neck to the mark at the end of the shoulder. Be sure to measure both the right and left sides. See *Figure 4.*

 6. Body Width

 A. Measure around the body at the fullest part of the bust, being careful to keep the tape parallel with the floor. See *Figure 3.*

 B. The measurement is taken around the body at the fullest part of the bust, being careful not to flatten the breasts. The tape must be kept parallel with the floor. See *Figure 4.*

 7. Chest Width

 A. On the dress form, the chest measurement is taken from armscye edge (where the sleeve seam would join the bodice) to armscye edge, at about the level of the screws in the center of the armscye plate. See *Figure 3.*

B. About midway between the base of the throat and the
 fullest part of the bust, measure across the chest
 from the outer edge of where the pectoral muscles
 form a slight indentation as they join the arm on
 the right to the same point on the left.
 See *Figure 4*.

8. Bust Point From Shoulder

 A. From where the neck and shoulder seams join, measure
 down to the center of the fullest part of the bust.
 Be careful not to get this measurement too short as
 it determines the height of the bust dart.
 See *Figure 5*.

 B. Measure from the mark at the side of the neck to the
 lower edge of the nipple. Be sure to measure both
 right and left sides. See *Figure 6*.

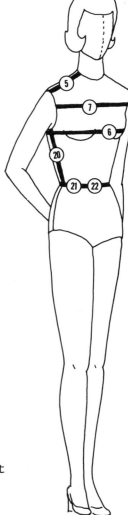

Figure 4

9. Bust Point To Bust Point

 A. Measure from the centers of the
 fullest part of the bust. See
 Figure 5.

 B. Measure the distance between the
 nipples. See *Figure 6*.

10. Center Front Waist To Dart

 A. Most forms have a seam from the waist
 over the middle of the bust to the
 center of the shoulder. If in view-
 ing the figure from the front you
 feel that this is a good proportional
 division, use the distance from the
 center front waist to that seam. See
 Figure 5.

 B. Since there are no seams on the human body it often
 becomes necessary to depend on certain standard calcu-
 lations and the eye. If the waistline is exceptionally
 flat but broad, or extremely rounded, the following
 table will need to be adjusted accordingly.

Total Waist Measurement	*Center Front to Dart*
22" to 23" (55.8 to 58.4 cm)	*2 1/2" (5.7 cm)*
24" to 25" (60.9 to 63.5 cm)	*2 3/4" (6.9 cm)*
26" to 27" (66.0 to 68.5 cm)	*3" (7.6 cm)*
28" to 29" (71.1 to 73.6 cm)	*3 1/4" (8.2 cm)*
30" to 31" (76.2 to 78.7 cm)	*3 1/2" (8.9 cm)*
32" to 33" (81.3 to 83.8 cm)	*3 3/4" (9.5 cm)*

Figure 5

3

11. Difference Between Center Back Length (Number 12) and Full
Back Length (Number 13)

This measurement is not taken directly on the form or the
body but must be mathematically calculated.

12. Center Back Length

A. On the dress form measure from the intersection of the
back neck and the center back down to the lower edge
of the waistline tape. See *Figure 7*.

B. On the body the center back length is measured from the
top of the seventh cervicale (the bony protuberance at
the nape of the neck) to the waistline. See *Figure 8*.

13. Full Back Length

A. Corresponds with Number 1 - Full Front Length: From
the joining of the neck and shoulder seams down to the
lower edge of the waistline tape. The tape should be
kept parallel with the center back. See *Figure 7*.

B. On the human figure the measurement is from
the mark at the side of the neck down to
the waistline. Be sure to measure both
sides of the body. See *Figure 8*.

14. Shoulder Width - Back

A. The measurement is taken from the inter-
section of the armscye and shoulder
seams across the back of the form. See
Figure 7.

B. The measurement is taken on the body from the marks on
the shoulder edges across the back at the base of the
neck. See *Figure 8*.

15. Shoulder Slope - Back

A. The back shoulder slope measurement is taken from the
center of the back waistline to the end of the shoulder
at the armscye seam. See *Figure 7*.

B. The measurement is taken from the center back waistline
to the mark at the edge of the shoulder. Be sure to
measure the right and left sides. See *Figure 8*.

16. Back Neck

A. The back neck is measured along the seamline from
shoulder seam to shoulder seam. See *Figure 7*.

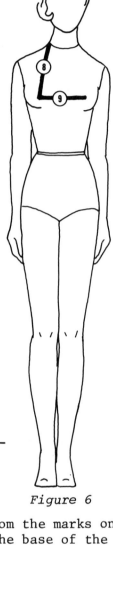

Figure 6

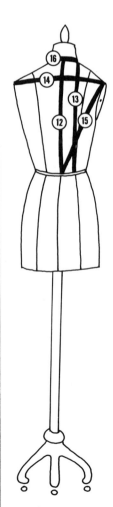

Figure 7

4

B. On the body this measurement is taken from the right
 side to the left side between the two marks on the sides
 of the neck, across the back at the base of the neck.
 See *Figure 8*.

17. Shoulder Length - Back

This measurement need not be taken again as it will be the
same as Number 5 (Shoulder Length - Front).

18. Blade Width

A. Corresponds with Chest Width (Number 7). It is taken
 from armscye edge to armscye edge at about the level of
 the screws in the center of the armscye plate. See
 Figure 9.

B. The measurement is taken across the back over the full-
 ness of the shoulder blades (scapula). It should be
 taken fairly loose as this will determine the amount of
 freedom of movement in the garment across the back.
 See *Figure 10*.

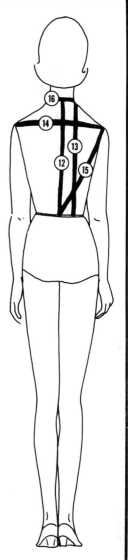

Figure 8

19. Center Back Waist To Dart

This measurement will be the same as the
one used for Center Front Waist to Dart
(Number 10).

20. Side Seam Length

A. On the dress form this measurement is
 taken about 1" (2.5 cm) below the
 edge of the armscye plate to the lower
 edge of the waistline tape at the side
 seam. See *Figure 3*.

B. With the arm and shoulder in a normal relaxed position,
 place the end of the tape as high as possible in the
 armpit and measure to the lower edge of the waistline
 tape. From this measurement deduct about 1 1/2"
 (3.8 cm) for the side seam length. See *Figure 4*.

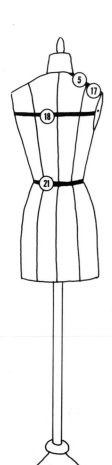

Figure 9

5

21. Back Waist

 A. On the dress form the measurement is taken from side seam to side seam across the back waistline. See *Figure 9.*

 B. Measure snugly around the waist with two fingers tucked under the tape. See *Figure 4.*

22. Front Waist

 A. On the dress form the measurement is taken from side seam to side seam across the front of the waistline. Be sure that the entire waist measurement is checked and that the Back Waist (Number 21) and the Front Waist (Number 22) add up to the proper total for the waistline. See *Figure 3.*

 B. Recheck the total waist measurement taken for Back Waist (Number 21). See *Figure 4.*

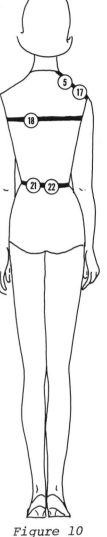

Figure 10

SKIRT FRONT AND BACK

1. Center Front Length

 A. Measurements for Number 1, Number 3 and Number 5 are taken from the waistline to the floor. The length from the floor at which the skirt is to be worn can then be subtracted from the total lengths.

 B. It is easier to take this measurement by holding the tape so that the edge barely touches the floor and then read the measurement at the waistline. See *Figure 12.*

2. Front Hip

 A. On the standard dress form this measurement is taken 7" (17.8 cm) below the waistline tape, from side seam to side seam across the front. See *Figure 11.*

 B. Since the body does not have side seams it is necessary to take the full hip measurement around the fullest part of the hip. Depending on the height of the person, this will be about 7" to 8" (17.8 cm to 20.3 cm) down from the waistline. See *Figure 12.*

3. Side Seam Length

Figure 11

 Refer to Center Front Length, Number 1. See *Figures 11 - 12*

4. Back Hip

 A. On the form the measurement is taken 7" (17.8 cm) below
 the waistline from side seam to side seam across the
 back. See *Figure 13*.

 B. The back hip measurement was included in Front Hip (Num-
 ber 2) as explained above.

5. Center Back Length

 Refer to SKIRT Center Front Length (Number 1). See *Figure
 13* and *Figure 14*.

6. Abdominal Extension

 A. The measurement is taken from side seam to side seam
 across the front, about halfway between the waist and
 the hip. See *Figure 11*.

 B. This measurement cannot be taken directly from the body
 but must be calculated. "Abdominal extension" simply
 means *how much does the stomach stick out*. If it is
 more or less than normal, adjustments will be
 necessary while the pattern is being made.

Figure 12

7. Center Front Waist To Dart

 Use the same measurement as used for Center Front Waist To
 Dart (Number 10) under BODICE. The darts on the skirt and
 bodice must be the same distance from the
 center front and center back at the waist.

8. Front Waist

 Refer to BODICE Front Waist (Number 22).

9. Center Back Waist To Dart

 See Center Front Waist To Dart (Number 7)
 above. The same measurement will be used
 in the back as is used in the front.

10. Back Waist

 Refer to BODICE Back Waist (Number 21).

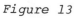

Figure 13

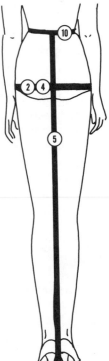

Figure 14

7

SLEEVE

Since the dress forms do not have arms attached, patterns for sleeves are generally drafted from standard measurements. Sleeve measurements for the individual are taken as follows.

1. Shoulder To Wrist

 The measurement is taken from the edge of the shoulder, where the sleeve would normally attach to the bodice, down to the wrist over a slightly bent elbow. See *Figure 15*.

2. Underarm Length

 Measure from the armpit at the lower edge of the armscye to the wrist with the arm held straight. See *Figure 16*.

3. Shoulder to Elbow

 The measurement is taken on the outer side of the arm from the end of the shoulder to the point of the elbow when the arm is bent. See *Figure 17*.

Figure 15

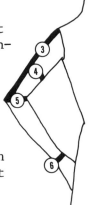

Figure 16

4. Upper Arm Width

 Measure around the upper arm over the fullest part of the biceps muscle. Ease is added later. See *Figure 17*.

5. Elbow Width

 Unless the arms are out of proportion it is generally more satisfactory to use Upper Arm Width (Number 4) *without the ease*. If necessary to take the elbow measurement it should be taken with the elbow slightly bent as in *Figure 17*.

6. Wrist Circumference

 For a tight sleeve that requires an opening to get the hand through, the measurement is taken as in *Figure 17* and 1" (2.5 cm) is added for ease.

 For a semi-snug sleeve, measure the hand with the thumb folded under and the hand held as it would be when putting on a tight sleeve. See *Figure 18*.

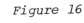

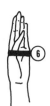

Figure 17

Figure 18

PANTS

Many of the measurements for pants are the same or similar to those taken for the skirt. Although bifurcated forms are available to the garment industry they are not always entirely satisfactory. They cannot perform the movements of walking, bending or sitting that a human body can. For these reasons it is always mandatory to try pants on a live model.

1. Center Front Length

 Measurements Number 1, Number 3 and Number 4 should be taken from the waist-line to the floor. The length from the floor at which the pants are to be worn can then be subtracted from the total length. In a flat shoe the outer ankle bone is about 2" (5.0 cm) from the floor. See *Figure 12*.

2. Front Hip

 Measure the full hip circumference about 7" (17.8 cm) down from the waist. See *Figure 12*.

3. Side Seam Length

 Refer to Center Front Length (Number 1) above. See *Figure 12*.

4. Center Back Length

 Refer to Center Front Length (Number 1) above. See *Figure 14*.

5. Abdominal Extension

 This measurement will be calculated while the pattern is being drafted. If it is more or less than normal, some adjustment will be necessary. Refer to SKIRT Abdominal Extension (Number 6).

 6. Waist Front And Back

 The total waist circumference should be taken fairly snug. It is generally 1/2" (1.3 cm) smaller than the dress waist measurement since a dress is supported from the shoulders.

 7. Crotch Depth

 The person being measured should be seated on a flat hard surface, such as a table. The measurement is taken from the seating surface to the waistline at the side seam. See *Figure 19*.

 Figure 19

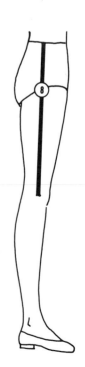

8. Knee Depth

 This measurement is taken at the side from the waist to the center of the knee. If there is difficulty in locating the middle of the knee, have the person being measured bend the leg back at the knee. The crease in the back of the knee will be the center. See *Figure 20*.

9. Bottom Width

 This measurement varies according to changing fashions. For the basic block it should be about 14" (35.6 cm).

 Figure 20

Notes

Chapter 2

Drafting The Bodice

Notes

MEASUREMENT CHART

BODICE FRONT AND BACK

Measurement	Size 10 Inches	Centimeters	Personal
1. Full Front Length.....................	18	45.7	_____
2. Center Front Length..................	15 1/4	38.8	_____
3. Front Shoulder Width - *Total*.........	14 3/4	37.5	_____
Divided by 2.....................	7 3/8	18.7	_____
4. Front Shoulder Slope - *Right*.........	17 3/4	45.0	_____
Front Shoulder Slope - *Left*..........	17 3/4	45.0	_____
5. Shoulder Length......................	5 1/2	14.0	_____
6. Body Width *Depth of Body Width is Center Front Length (Number 2) divided by 3....*	5 1/12	12.9	_____
Body Width - *Total*...................	36	91.4	_____
Including 1 1/2" (3.8 cm) ease....	37 1/2	95.2	_____
Half of Body Width - Total, including ease....................	18 3/4	47.6	_____
Front Body Width *One fourth of Body Width - Total, including ease, plus 1/2" (1.3 cm)*	9 7/8	25.1	_____
Back Body Width *One fourth of Body Width - Total, including ease, minus 1/2" (1.3 cm)*	8 7/8	22.5	_____
7. Chest Width - *Total*.................	13 1/2	34.3	_____
Divided by 2.....................	6 3/4	17.2	_____
8. Bust Point From Shoulder - *Right*......	10 1/2	26.7	_____
Bust Point From Shoulder - *Left*.......	10 1/2	26.7	_____

Measurement	Size 10		Personal
	Inches	Centimeters	
9. Bust Point To Bust Point - *Total*......	7 3/4	19.7	_____
Divided by 2....................	3 7/8	9.8	_____
10. Center Front Waist To Dart...........	3	7.6	_____
11. Middle of Center Back Length - *Difference between Number 12 and Number 13*...	3/4	1.9	_____
12. Center Back Length...................	16 3/4	42.5	_____
Divided by 2....................	8 3/8	21.2	_____
13. Full Back Length.................... 17 1/2 *Normally from 1/2" (1.3 cm) to 1 1/4" (3.2 cm) more than Number 12*	17 1/2	44.4	_____
14. Back Shoulder Width - *Total*..........	15 1/4	38.8	_____
Divided by 2 plus 3/8" (1.0 cm) for ease........................	8	20.4	_____
15. Back Shoulder Slope - *Right*..........	16 7/8	42.8	_____
Back Shoulder Slope - *Left*...........	16 7/8	42.8	_____
16. Back Neck - *Total*...................	6	15.2	_____
Divided by 2....................	3	7.6	_____
17. Back Shoulder Length.................	5 1/2	14.0	_____
18. Back Blade Width - *Total*.............	14	35.6	_____
Divided by 2....................	7	17.8	_____
19. Center Back Waist To Dart............	3	7.6	_____
20. Side Seam Length.....................	8	20.3	_____
21. Waist - *Total*.......................	26 1/2	67.3	_____
Back Waist *(Half)* - *Waist* - *Total* *divided by 4 minus 3/8" (1.0 cm)*..	6 1/4	15.9	_____
22. Front Waist *(Half)* *Waist* - *Total divided by 4 plus 3/8" (1.0 cm)*..............	7	17.8	_____

Although the measurements used for this draft are size 10, the procedure is the same for any size. The draft follows the same order as the taking of the measurements and corresponds to the numbers on the MEASUREMENT CHART.

The pattern produced is for the right size of the body.

Experienced patternmakers may evolve some short cuts but in the beginning it will be easier to follow the directions step by step.

1. Full Front Length - 18" (45.7 cm)

 Draw a vertical line of the proper length near the right hand edge of the paper. Square the line at the top and at the bottom as shown in *Figure 1*.

2. Center Front Length - 15 1/4" (38.8 cm)

 Measuring up from the bottom of the squared line on Number 1- Full Front Length, mark the distance from the center front waistline to the center front neck. Square the line to indicate the neck. See *Figure 1*.

3. Front Shoulder Width - 7 3/8" (18.7 cm)

 Extend the squared line at the top of the draft for the Front Shoulder Width. Square a vertical line down (parallel with Number 1 - Full Front Length) from the end of the Front Shoulder Width for a length of about 5" (12.7 cm). See *Figure 2*.

4. Front Shoulder Slope - 17 3/4" (45.0 cm)

 Placing the end of the ruler at the lower edge of line Number 1 - Full Front Length, angle the ruler so it is intersected at the correct length by the line squared down from Number 3 - Front Shoulder Width. See *Figure 2*.

Figure 1

5. Shoulder Length - 5 1/2" (14.0 cm)

 From the point where the Number 4 - Shoulder Slope intersects the line squared down from the Number 3 - Front Shoulder Width, draw the Shoulder Length to wherever it falls on Number 3 - Front Shoulder Width.

 Square a line down from the Shoulder Length to meet the line squared at Number 2 - Center Front Length. This area will be rounded out later to form the front neckline. See *Figure 2*.

Figure 2

6. Body Width - *Including ease* - 37 1/2" (95.2 cm)

Divide Number 2 - Center Front Length by 3 to find the horizontal line of
the Body Width.

$$15 \ 1/4" \div 3 = 5 \ 1/12"$$
$$(38.8 \ cm \div 3 = 12.9 \ cm)$$

Measure down from the neckline to locate the Body Width, squaring the line
from the Center Front. Divide the Body Width including ease by 2 to deter-
mine the length of this line.

$$37 \ 1/2" \div 2 = 18 \ 3/4"$$
$$(91.4 \ cm \div 2 = 47.6 \ cm)$$

At the left end of the Body Width, square a line up and down for the Center
Back of the bodice.

The Front Body Width is determined by dividing the total Body Width includ-
ing ease by 4 and adding 1/2" (1.3 cm) to the measurement. This is marked
on the Body Width line, measuring from the Center Front.

$$37 \ 1/2" \div 4 = 9 \ 3/8" + 1/2" = 9 \ 7/8" - Front$$
$$(95.2 \ cm \div 4 = 23.8 \ cm + 1.3 \ cm = 25.1 \ cm - Front)$$

$$37 \ 1/2" \div 4 = 9 \ 3/8" - 1/2" = 8 \ 7/8" - Back$$
$$(95.2 \ cm \div 4 = 23.8 \ cm - 1.3 \ cm = 22.5 \ cm - Back)$$

See *Figure 3.*

Be sure that all lines are
exactly squared...a slight
discrepancy can throw the
entire pattern off.

When drawing a measured
line, make a small cross-
mark at the end of the
measurement. This makes
it easier to see the ex-
act end of a line and will
aid in rechecking a pattern.

Remember that all future
patterns will be made from
the basic blocks. The ac-
curacy of the blocks will
affect any patterns made
from it.

Keep your pencil sharp and
measure carefully.

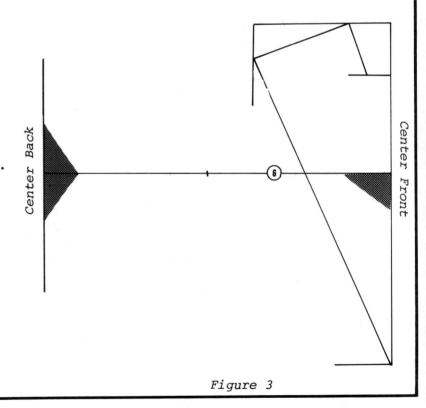

Figure 3

7. Chest Width - 6 3/4" (17.2 cm)

 Square a line halfway between the neck and Number 6 - Body Width for the
 Chest Width. The end of the Chest Width should be squared down to the
 Body Width. See *Figure 4*.

8. Bust Point From Shoulder - 10 1/2" (26.7 cm)

 On Number 1 - Full Front Length, measure down from the top to find the
 bust line. The bust line will be squared from the Center Front.
 See *Figure 4*.

9. Bust Point to Bust Point - 3 7/8" (9.8 cm)

 Extend the squared line from Center Front drawn in step Number 8 - Bust
 Point From Shoulder. See *Figure 4*.

10. Center Front Waist To Dart - 3" (7.6 cm)

 On the lower squared line of Number 1 - Full Front Length, measuring
 from the Center Front, mark the front edge of the dart.

 Connect the front edge of the dart to Number 9 - Bust Point.
 See *Figure 4*.

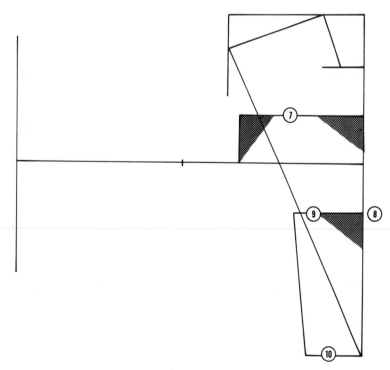

Figure 4

11. Middle Of Center Back Length - 3/4" (1.9 cm)

The difference between Number 12 - Center Back Length and Number 13 - Full Back Length is measured up from the Body Width on the Center Back. Make a crossmark on the Center Back. See *Figure 5*

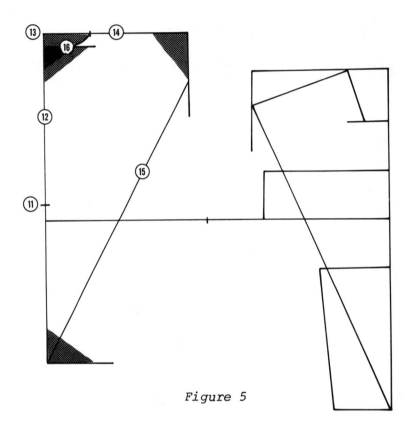

Figure 5

12. Center Back Length - 16 3/4" (42.5 cm)

From the crossmark at Middle of Center Back Length - Number 11, measure down half of the Center Back Length - 8 3/8" (21.2 cm) - and square a line about 5" (12.7 cm) long to indicate the back waistline. From the Center Back waistline, measure up the Center Back Length and square a short line to mark the Center Back neckline. See *Figure 5*.

13. Full Back Length - 17 1/2" (44.4 cm)

On the Center Back line, measure up from the waistline and square a short line at the top. See *Figure 5*.

14. Back Shoulder Width - *Including 3/8" (1.0 cm) ease* - 8" (20.4 cm)

 Extend the squared line at the top of Full Back Length - Number 13. At the end of the Shoulder Width, square down for about 5" (12.7 cm). See *Figure 5*.

15. Back Shoulder Slope - 16 7/8" (42.8 cm)

 Place one end of the ruler at the Center Back waistline. Angle the ruler so that it is intersected at the correct length by the line squared down from Back Shoulder Width - Number 14. See *Figure 5*.

16. Back Neck - 3" (7.6 cm)

 On the squared line at the top of Full Back Length - Number 13, mark a point about 1/4" (0.6 cm) less than the Back Neck from the Center Back. From the squared line at the top of Center Back Length - Number 12, draw a curved line for the Back Neck connecting it to the point made previously. See *Figure 5*.

17. Back Shoulder Length - 5 1/2" (14.0 cm)

 Draw a line connecting the end of Back Shoulder Slope - Number 15 to the shoulder edge of Back Neck - Number 16. If the difference between that line and the desired measurement is 1/4" (0.6 cm) or less, the difference can be eased into the front shoulder.

 If the difference is greater than 1/4" (0.6 cm) it will be necessary to make a dart in the back shoulder. The dart should be centered on the Back Shoulder Length and would be the width of the difference between the Front Shoulder Length - Number 5 and the back shoulder line just drawn.

 The dart should be about 3" (7.6 cm) long. The center of the dart is in line with the Center Back waist. Measure the two legs of the dart. If one is longer than the other, extend the *shorter* side so that the two legs are equal. Connect the end of the extended dart leg to the shoulder. See *Figure 6*.

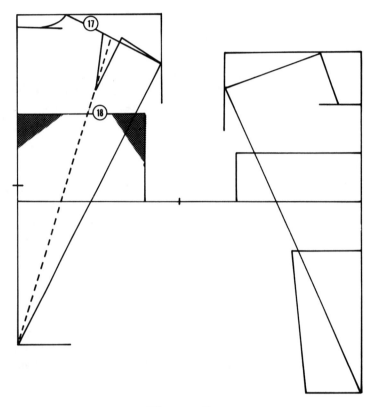

Figure 6

18. Back Blade Width - 7" (17.8 cm)

The Back Blade Width is squared from the Center Back halfway between the
Body Width and the Center Back neckline. It is then squared down to the
Body Width. See *Figure 6*.

19. Center Back Waist To Dart - 3" (7.6 cm)

From the Center Back waistline measure out on the squared line to the
beginning of the dart. The normal dart for the back is 1 1/2 " (3.8 cm)
wide. Square up from the waistline through the center of the dart to
the Body Width to locate the end of the dart. Complete the dart by draw-
ing in the two legs of the dart from the waistline to the Body Width.
See *Figure 7*.

20. Side Seam Length – 8" (20.3 cm)

From the crossmark at the Front Body Width, draw a light arc line the length of the Side Seam by pivoting the ruler. See *Figure 7*.

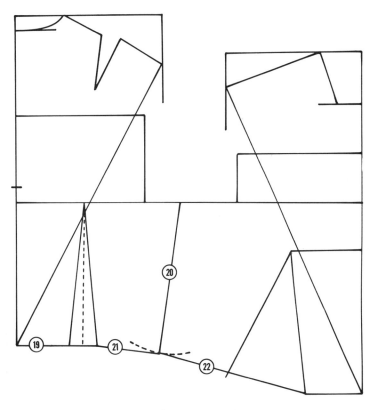

Figure 7

21. Back Waist – 6 1/4" (15.9 cm)

Subtract Center Back Waist To Dart – Number 19 from the Back Waist. The remainder will be the measurement from the outer edge of the dart to the side seam, indicated by the arc line.

6 1/4" – 3" = 3 1/4" (15.9 cm – 7.6 cm = 8.3 cm)

After the back waistline is completed, connect the Side Seam of the Back Waist to the Front Body Width. See *Figure 7*.

22. Front Waist – 7" (17.8 cm)

From the Front Waist measurement, subtract Center Front Waist To Dart – Number 10. The remainder will be the distance from the end of the Side Seam at the waistline to the edge of the dart. This will be measured

on a line drawn from the Side Seam at the waistline to the front leg
of the dart.

$$7" - 3" = 4" \qquad (17.8 \text{ cm} - 7.6 \text{ cm} = 10.2 \text{ cm})$$

Complete the front dart, making the second leg of the dart the same
length as the first leg of the dart. See *Figure 7*.

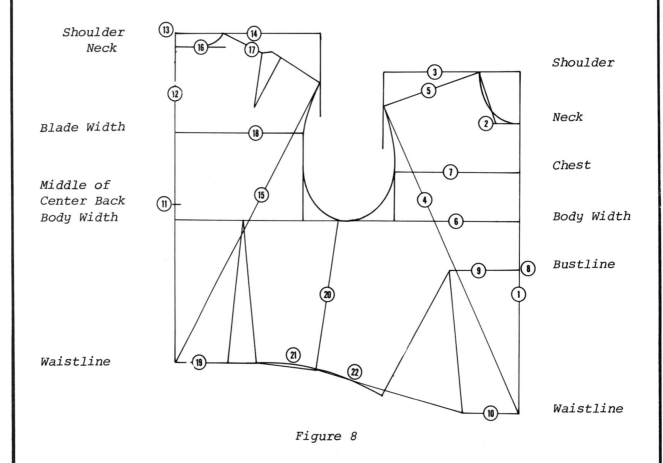

Figure 8

The front and back waistlines should be slightly curved between the
second (outer) legs of the front and back darts. This can be done
by folding the darts and drawing a curved line from the back dart,
through the lower edge of the Side Seam to the front dart.

Draw in the curves for the front neck and the armscye. See *Figure 8*.

Figure 9

The completed Front and Back Bodice is shown in *Figure 9*. After cutting out the patterns, notch the front armscye on the Chest Width – Number 7. Measure the distance from the shoulder point at the armscye to the notch. Measure the same distance down on the back armscye from the shoulder point plus 1/2" (1.3 cm) and make the first notch. The second notch is about 1/4" (0.6 cm) below the first notch.

These patterns should be traced on to tagboard or heavy paper as they will be the blocks from which future patterns will be made. Measure the outer edges of the patterns and make a note of the measurement on the patterns. This can save a great deal of time later.

Notes

Chapter 3

Drafting The Skirt

Notes

SKIRT FRONT AND BACK

Measurement	Size 10 Inches	Centimeters	Personal
1. Center Front Length - *To the floor*.....	40	101.6	_____
Street Length - Floor length minus 17 1/2" (44.4 cm)...........	22 1/2	57.2	_____
2. Front Hip			
Hip circumference - Total.........	37	94.0	_____
Including 1 1/2" (3.8 cm) ease	38 1/2	97.8	_____
Hip circumference - Total, including ease, divided by 2.................	19 1/4	48.9	_____
Front Hip			
Hip circumference - Total, including ease divided by 4 plus 1/4"(0.6 cm)	9 7/8	25.0	_____
3. Side Seam Length - *To the floor*........	40 1/8	101.9	_____
Street Length - Floor length minus 17 1/2" (44.4 cm)...........	22 5/8	57.5	_____
4. Back Hip			
Hip circumference - Total, including ease divided by 4 minus 1/4"(0.6 cm)	9 3/8	23.8	_____
5. Center Back Length - *To the floor*......	39 7/8	101.3	_____
Street Length - Floor length minus 17 1/2" (44.4 cm)...........	22 3/8	56.9	_____
6. Abdominal Extension....................	18	45.7	_____
Including 1" (2.5 cm) ease........	19	48.2	_____
Divided by 2.....................	9 1/2	24.1	_____
(Normally 3/8" (1.0 cm) less than #2 - Front hip)			
7. Center Front Waist To Dart.............	3	7.6	_____
8. Front Waist *(see BODICE Number 22)*.....	7	17.8	_____
9. Center Back Waist To Dart.............	3	7.6	_____
10. Back Waist *(see BODICE Number 21)*......	6 1/4	15.9	_____

The slim straight skirt is basically a tube which fits around the hips. The hip circumference is reduced to the waistline circumference with darts, tucks, pleats or shirring.

1. Center Front Length - 22 1/2" (57.2 cm)

 Draw a vertical line near the right hand edge of the paper, squaring it at the bottom *only*. See *Figure 1*.

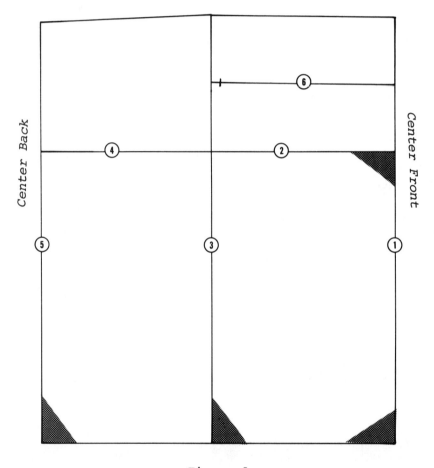

Figure 1

2. Front Hip - 9 7/8" (25.0 cm)

 Measure down from the top of the Center Front Length the distance from waistline to hipline. For the Size 10, use 7" (17.8 cm). At the hipline, square a line from the Center Front Length for half the distance of the total hip circumference, including ease. Extend the horizontal line which was squared from the bottom of the Center Front Length the same distance as the hipline.

Mark the Front Hip Measurement on the hipline and on the hemline.

37" + 1 1/2" = 38 1/2")
(94.0 cm + 3.8 cm = 97.8 cm))...*Total hip including ease*

38 1/2" ÷ 2 = 19 1/4")
(97.8 cm ÷ 2 = 48.9 cm))........*Center Front to Center Back*

19 1/4" ÷ 2 = 9 5/8" + 1/4" = 9 7/8")
(48.9 cm ÷ 2 = 24.4 cm + 0.6 cm = 25.0 cm))····*Front Hip*

See Figure 1

3. Side Seam Length - 22 5/8" (57.5 cm)

The Side Seam Length is squared with the hemline through the hipline at the Front Hip mark. See *Figure 1*.

4. Back Hip - 9 3/8" (23.8 cm)

Check the measurement of the hipline from Side Seam to Center Back at both the hipline and the hemline. See *Figure 1*.

37" + 1 1/2" = 38 1/2")
(94.0 cm + 3.8 cm = 97.8 cm))...*Total hip including ease*

38 1/2" ÷ 2 = 19 1/4")
(97.8 cm ÷ 2 = 48.9 cm))........*Center Front to Center Back*

19 1/4" ÷ 2 = 9 5/8" - 1/4" = 9 3/8")
(48.9 cm ÷ 2 = 24.4 cm - 0.6 cm = 23.8 cm))·····*Back Hip*

5. Center Back Length - 22 3/8" (56.9 cm)

This measurement is squared with the hemline through the hipline. At the top of the pattern, which will be the waistline, connect the Center Front Length to the Side Seam Length. Connect the Side Seam Length to the Center Back Length. See *Figure 1*.

6. Abdominal Extension - 9 1/2" (24.1 cm)

From the waistline at the top of the Center Front Length, measure down half the distance between the waistline and the hipline, 3 1/2" (8.9 cm) and make a crossmark on the Center Front Length. From the waistline at the top of the Side Seam Length, measure down the same length, 3 1/2" (8.9 cm), and make a crossmark. Connect the two points so that the Abdominal Extension line runs parallel to the waistline. The length of the Abdominal Extension is measured from the Center Front. See *Figure 1*.

7. Center Front Waist To Dart - 3" (7.6 cm)

 This is measured on the waistline from the Center Front and must match
 the same measurement on the front bodice. See *Figure 2*.

Figure 2

8. Front Waist - 7" (17.8 cm)

 A. *Arbitrary dart*

 Working from the Center Front waistline, measure 1" (2.5 cm) past the
 distance from Center Front Waist To Dart - Number 7. 1" (2.5 cm)
 will be the width of the dart. Find the center of the dart on the
 waistline and, keeping the center of the dart parallel with the Cen-
 ter Front, draw down to the Abdominal Extension - Number 6. Complete
 the legs of the dart as shown in *Figure 2*.

 Subtract the measurement of Center Front Waist To Dart - Number 7
 from the Front Waist. The remainder will be the measurement from
 the outer edge (second leg) of the dart to the Side Seam at the waist.

 Draw a curved line from the hipline at the Side Seam, through the
 crossmark on the Abdominal Extension line, to the waistline. See
 Figure 2.

 B. *Calculated dart*

 Draw a straight line from the hipline at the Side Seam through the
 crossmark made on the Abdominal Extension line to the waistline.
 Measure the waistline as it is now drawn and subtract from it the
 desired measurement for the *finished* waistline. The difference is
 divided into four parts.

 Two parts are used for the width of the dart. Be sure to keep the
 center of the dart parallel with the Center Front. The other two
 parts are removed from the side of the waistline down to the cross-
 mark made on the Abdominal Extension line.

 Draw a curved line from the hipline at the Side Seam through the
 Abdominal Extension to the waistline. See *Figure 3*.

9. Center Back Waist To Dart - 3" (7.6 cm)

 This is measured on the waistline from the Center Back and must match the
 back bodice. See *Figure 2 or Figure 3*.

Figure 3

10. Back Waist - 6 1/4" (15.9 cm)

 A. *Arbitrary dart*

 Working from the Center Back waistline, measure 1 1/2" (3.8 cm) past
 the distance from Center Back Waist To Dart - Number 9. 1 1/2" (3.8 cm)
 will be the width of the dart. Find the center of the dart on the
 waistline and, keeping the center of the dart parallel with the Center
 Back, draw the dart down to the hipline. Complete the legs of the
 dart as shown in *Figure 2*.

 Subtract the measurement of Center Back Waist To Dart - Number 9 from
 the Back Waist. The difference will be the measurement from the out-
 er edge (second leg) of the dart to the Side Seam at the waistline.

 Draw a curved line from the hipline at the Side Seam to the waistline.
 See *Figure 2*.

 B. *Calculated dart*

 Measure the waistline as it is now drawn from the Center Back to the
 Side Seam. Subtract from it the measurement desired for the *finished*
 back waistline. The difference is divided into three parts.

 Two parts are used for the width of the dart. Be sure to keep the
 center of the dart parallel with the Center Back. The other part
 is removed from the side of the waistline, in a curved line, down
 to the hipline at the Side Seam. See *Figure 3*.

31

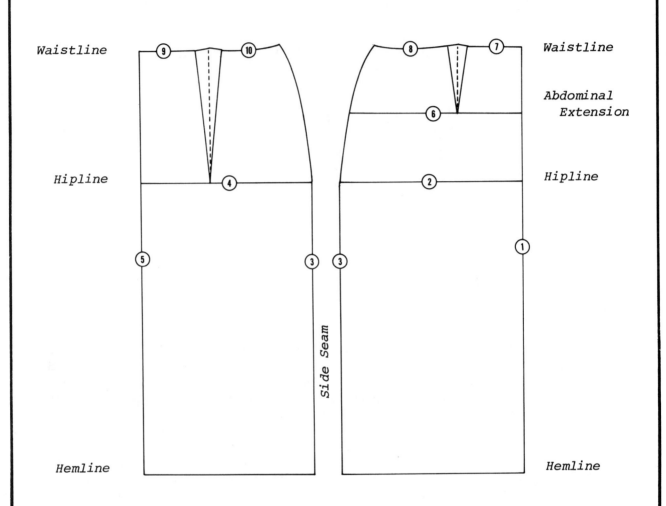

Waistline

Hipline

Side Seam

Hemline

Waistline

*Abdominal
Extension*

Hipline

Hemline

Figure 4

Before cutting out the skirt patterns, check the completed bodice patterns against them at the waistline. Cut out the front skirt first, leaving an extra inch (2.5 cm) at the top of the waistline. Fold out the front dart and smooth the waistline into a slight curve.

Cut out the back skirt leaving an extra inch at the top of the waistline. Check the Side Seam length of the front skirt against the Side Seam of the back skirt, working from the hipline up. Any adjustment is made on the back skirt at the waistline. Fold out the back dart and smooth the waistline. Trim off the excess on the front and back waistlines.

Notes

Chapter 4

Drafting The Sleeve

Notes

MEASUREMENT CHART

SLEEVE

Measurement	Size 10 Inches	Centimeters	Personal
1. Shoulder To Wrist.....................	23 1/4	59.0	_____
2. Underarm Length......................	17 3/4	45.0	_____
(Normally 5 1/2" (14.0 cm) less than Shoulder To Wrist - Number 1)			
3. Shoulder To Elbow....................	13 1/2	34.2	_____
4. Upper Arm (Bicep)....................	10 1/2	26.7	_____
Including 2" (5.0 cm) ease........	12 1/2	31.7	_____
Divided by 2.................	6 1/4	15.8	_____
Divided by 4.................	3 1/8	7.9	_____
Divided by 8.................	1 9/16	3.9	_____
Divided by 16...............	25/32	1.9	_____
5. Elbow Width..........................	10 1/2	26.7	_____
Divided by 2.....................	5 1/4	13.3	_____
Divided by 4.....................	2 5/8	6.6	_____
6. Wrist Circumference..................	6	15.2	_____
A. Wrist Circumference *including* 1" (2.5 cm) ease.................	7	17.8	_____
Divided by 4.................	1 3/4	4.4	_____
B. Over Hand Measurement.............	7 3/4	19.7	_____
Divided by 4.................	1 15/16	4.9	_____

1. Shoulder To Wrist - 23 1/4" (59.0 cm)

 About 10" (25.4 cm) from the right hand edge of the paper, draw a vertical line for the Shoulder To Wrist length. Square the line at the top and bottom for about 5" (12.7 cm). The top represents the highest point of the sleeve cap and the bottom line will be the wristline.
 See *Figure 1*.

2. Underarm Length - 17 3/4" (45.0 cm)

 From the squared line at the bottom of Shoulder To Wrist - Number 1, measure up and mark the Underarm Length. From the original vertical line, square a line about 7" (17.8 cm) long on each side.
 See *Figure 1*.

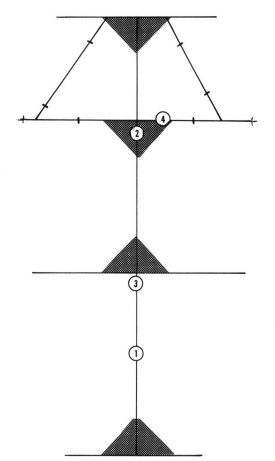

3. Shoulder To Elbow - 13 1/2" (34.2 cm)

 From the squared line at the top of Shoulder To Wrist - Number 1, measure down and mark the Elbow. Square a line about 6" (15.2 cm) long on each side of the vertical line.
 See *Figure 1*.

Figure 1

4. Upper Arm (Bicep) - *Including 2" (5.0 cm) ease - 12 1/2" (31.7 cm)*

On the squared Underarm Length - Number 2, divide the Upper Arm including ease by 2. Mark half on each side of the vertical line, marking on the squared line. Each half is now divided into half again.

The quarter of the Upper Arm on the right side of the vertical line, *the front part of the sleeve,* is again divided into half. The same measurement, one eighth of the Upper Arm, is marked on each side of the top of the cap.

The quarter of the Upper Arm measurement at the left side of the vertical line, *the back part of the sleeve,* is divided into fourths.

The lines for the cap of the sleeve are connected. Crossmarks should be made on the diagonal lines the same distance up and down as the diagonal lines are from the squared lines. The sleeve cap is curved from the guide lines. The back part of the cap should be drawn about 1/4" (0.6 cm) outside of the guide line. See *Figure 2.*

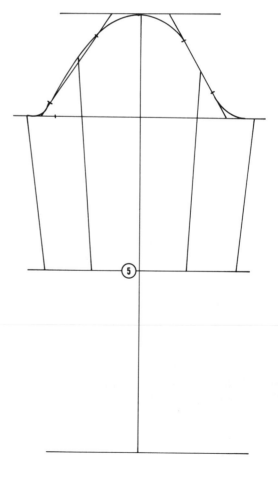

5. Elbow Width - 10 1/2" (26.7 cm)

Mark half of the Elbow Width on each side of the horizontal line squared at Shoulder To Elbow - Number 3.

Divide the total Elbow Width into quarters and connect to the quarter divisions on the Upper Arm line.

See *Figure 2.*

Figure 2

39

6. Wrist Circumference - 7" (17.8 cm)

Placing the corner of the tailor's square so that it touches at the bottom of the Shoulder To Wrist line and extends through the middle of the back half of the sleeve, draw from the elbow to the wrist and around the corner of the square for one fourth of the Wrist Circumference.

On the new wristline just drawn, extend it to the left toward the back of the sleeve, for one quarter of the Wrist Circumference. Connect the back edge of the elbow to the back edge of the new wristline. Connect the middle of the elbow to the quarter of the Wrist Circumference that extends to the right of the original vertical line. This becomes the center of the wristline and the new middle of the sleeve from the elbow to the wrist.

On the right end of the new wrist center, extend a line for one quarter of the Wrist Circumference, keeping the line parallel to the squared line from Shoulder To Wrist - Number 1. Connect the end of the wristline just drawn to the middle of the front half of the elbow.

For the last quarter of the wrist, angle the line down to the original squared line and connect it to the front edge of the elbow. Check the front edge of the sleeve from the Under Arm Length - Number 2 to the elbow to the wristline to be sure that it measures exactly the same length as the Under Arm Length - Number 2. Any necessary adjustments in length are made at the wrist.

Draw a slightly curved line from the back edge of the sleeve to the front edge at the wristline.

On the front edge of the sleeve, measure up from the wrist to the elbow. Mark the same distance on the back edge of the sleeve, measuring from the wrist up. When that point is connected to the middle of the back half at the elbow the dart will be formed. Check the lower leg of the dart against the upper leg, lengthening if necessary so that both legs are the same.

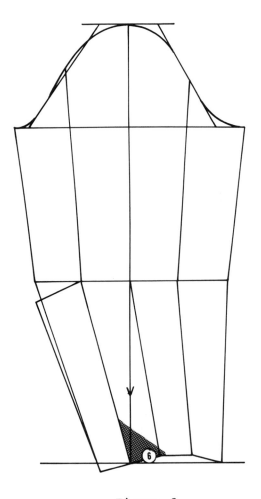

Figure 3

40

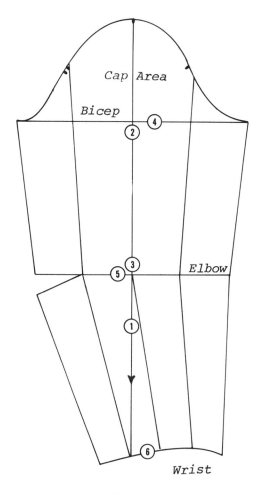

Figure 4

Indicate the grainline of the sleeve by putting an arrow on the original vertical line, Shoulder To Wrist - Number 1.

The sleeve cap must be checked against the armscye of the bodice into which the sleeve will be sewn. Approximately 1 1/2" (3.8 cm) ease is allowed in the cap of the sleeve: 1/2" (1.3 cm) on each side of the center to the notch and 1/4" (0.6 cm) between the notch and the underarm.

If any adjustment is necessary, recheck the curves on the cap of the sleeve. A slight modification of the curves can often solve the problem. If adjustment is still needed, make it at the underarm of the sleeve, correcting the line down to the elbow.

Chapter 5

Drafting The Torso

Notes

The basic Torso block is made from the Bodice and Skirt blocks already constructed.

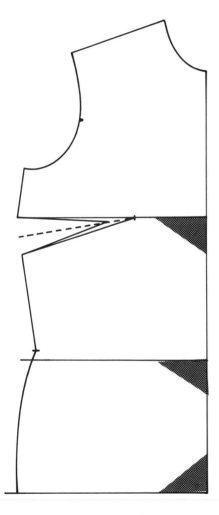

Figure 1

1. Trace the Front Bodice from Center Front waistline around the neck, shoulder and armscye to the bust-line. Be sure to include the notch at the front armscye.

 Extend the Center Front line down 7" (17.8 cm) below the waistline for the hipline. From Center Front square the bustline, waistline and hipline. See *Figure 1*.

2. Pivot the Front Bodice at the bust point until the Side Seam at the waistline is 1/4" (0.6 cm) above the line squared for the waistline from Center Front.

 Trace the Front Bodice from the original bustline to the waistline at the side seam. This will form the outer edges of the side bust dart. See *Figure 1*.

3. Make a side bust dart 1 1/2" (3.8 cm) to the left away from the original bust point. See *Figure 1*.

4. The front hipline will be the same width as the front bustline from the Center Front. Draw a curved line from the hipline to 1/4" (0.6 cm) above the squared waistline. See *Figure 1*

5. The Torso block is 1" (2.5 cm) larger at the waistline than the Bodice block, or 1/4" (0.6 cm) larger on the quarter pattern. Add 1/4" (0.6 cm) to the Front Bodice waistline measurement. Subtract this amount from the length that the waistline measures as shown in *Figure 1* and divide the difference into darts.

If the amount is less than 2" (5.0 cm) use only one dart. If the amount is 2" (5.0 cm) or more make two darts. The dart closest to Center Front will be the larger if there is any difference in the size of the two darts.

> *First dart,* the one closest to Center Front, will be from the bustline to the hipline. The front edge of the dart will be the same distance from the Center Front waistline as it is on the Front Bodice block. Keep the center of the dart parallel with the Center Front.

> *Second dart* will be halfway between the first dart and the side seam at the waistline. Keep center of second dart parallel with Center Front.

> Make second dart 3/4" (1.9 cm) below the lower leg of the side bust dart and 1" (2.5 cm) above the hipline. See *Figure 2*.

6. Cut out Front Torso block, leaving an extra 1" (2.5 cm) at the side bust dart area.

Fold out the side bust dart and correct the side seam by drawing a straight line from the lower edge of the armscye - Body Width line - to the waistline. Cut the side seam on the corrected line.

The finished pattern will look like *Figure 2*.

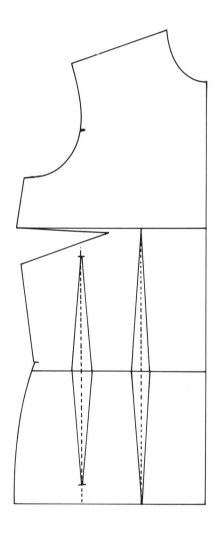

Figure 2

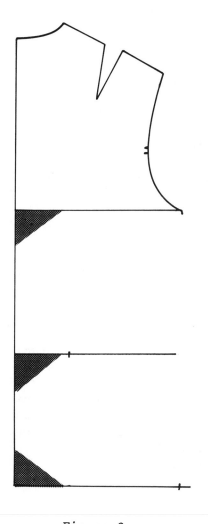

Figure 3

7. Trace Back Bodice from Center Back waist-
line around the neck, shoulder and arm-
scye. Be sure to include the notches in
the armscye.

Extend the Center Back line down 7" (17.8 cm)
below the waistline for the hipline.

From Center Back, square the Body Width line,
waistline and hipline.

See *Figure 3.*

8. The hipline will be the same width as the
Body Width line. Check total hip measure-
ment from Front and Back Torso patterns
against total hip from the Front and Back
Skirt patterns.

*The front hipline on the Skirt block does
not have to be the same length as the front
hipline on the Torso block. The back hip-
line on the Skirt block does not have to be
the same length as the back hipline on the
Torso block.*

*The TOTAL hipline on the Front and Back
Torso blocks must equal the TOTAL hipline
on the Front and Back Skirt blocks. Adjust
Front and Back Torso blocks the same amount
at the side seam if any adjustment is neces-
sary.*

9. *First dart,* the one closest to the Center Back, will be from the Body Width line to the hipline. The edge of the dart at the waistline will be the same distance from the Center Back as it is on the Back Bodice block. Make the dart 1" (2.5 cm) wide. Keep the center of the dart parallel with the Center Back.

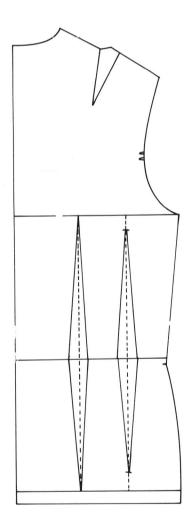

Second art will be halfway between the first dart and the side seam at the waistline. The second dart will be 3/4" (1.9 cm) wide.

To locate the second dart, add 1/4" (0.6 cm) to the Back Waist measurement used on the Back Bodice block. Subtract from that figure the distance from Center Back Waist To Dart. Divide the remainder in half and put the first half from the outer edge of the first dart. Mark the width of the second dart and mark the other half of the remainder, which will be the side seam. Keep the center of the second dart parallel with the Center Back.

Make the second dart 3/4" (1.9 cm) below the Body Width line and 1" (2.5 cm) above the hipline. See *Figure 4.*

10. Match Front Torso block to Back Torso block from armscye to waistline at the side seam, marking the new back waistline. Continue matching from waistline to hipline, tracing the side seam for the Back from the Front. Adjust side seam length if necessary, squaring from Center Back to the corrected side seam length. See *Figure 4.*

Figure 4

Notes

Chapter 6

Drafting The No-Dart

Bodice/Blouse Block

Notes

MEASUREMENT CHART

NO-DART BODICE/BLOUSE BLOCK

Measurement	Size 10 Inches	Centimeters	Personal
1. Center Back Length (12)*................16 3/4		42.5	_____
2. Body Width (6)* - Total.................36		91.4	_____
Including 2" (5.0 cm) ease.........38		96.5	_____
Half of Body Width - Total, including ease.....................19		48.3	_____
One fourth of Body Width - Total, including ease..................... 9 1/2		24.1	_____
3. Side Seam Length (20)*................ 8		20.3	_____
4. Neck Circumference.....................14		35.6	_____
Neck Diameter...................... 4 1/2 (Circumference divided by PI (3 1/7)		11.4	_____
Neck Radius....................... 2 1/4 (Diameter divided by 2)		5.7	_____
5. Chest Width (7)*.....................13 1/2		34.3	_____
Divided by 2 plus 1/2" (1.3 cm)..... 7 1/4		18.4	_____
6. Back Blade Width (18)*.................14		35.6	_____
Divided by 2 plus 1/2" (1.3 cm)..... 7 1/2		19.1	_____
7. Full Back Length (13)*................17 1/2		44.4	_____
8. Back Shoulder Drop.................... 1 1/2		3.8	_____
9. Back Shoulder Length (17)*............. 5 1/2		14.0	_____
10. Front Shoulder Length (5)*............. 5 1/2		14.0	_____

*These numbers refer to the instructions in Chapter 1.

This draft follows the order of the numbers on the MEASUREMENT CHART. It is for woven fabrics and is not fitted as close to the body as the previous blocks.

1. Center Back Length - 16 3/4" (42.5 cm)

 Draw a vertical line for the Center Back Length at the left side of the paper, leaving approximately 2" (5.1 cm) above the line and 8" (20.3 cm) below.

2. Body Width - *Half, including ease* - 19" (48.3 cm)

 Square the Center Back Length, top and bottom, for half the Body Width, including ease. Connect the top and bottom lines for the Center Front. Divide the area between the Center Back and Center Front in half for the Side Seam, making sure that the line is squared from the top and bottom. Label the bottom line *Waistline*. See *Figure 1*.

3. Side Seam Length - 8" (20.3 cm)

 Measure Side Seam Length from the Waistline up and square to Center Back and Center Front.

4. Neck Radius - 2 1/4" (5.7 cm)

 From Center Front, on the top line, mark Neck Radius and the same distance down on Center Front. Square the two measurements, from the top line and from Center Front, to form a square. See *Figure 1*.

5. Chest Width - 7 1/4" (18.4 cm)

 From Center Front on the Waistline, measure the Chest Width and square a line to the top.

6. Back Blade Width - 7 1/2" (19.1 cm)

 From Center Back on the Waistline, measure the Back Blade Width and square a line to the top. See *Figure 1*.

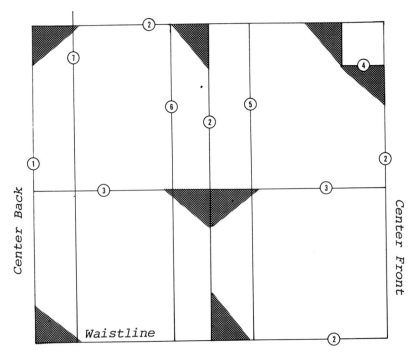

Figure 1

54

7. Full Back Length - 17 1/2" (44.4 cm)

From the Center Back mark the Neck Radius at the top and Waistline. Measuring from the Waistline up, draw a line through the marks at Waistline and top for the Full Back Length. See *Figure 1*.

8. Back Shoulder Drop - 1 1/2" (3.8 cm)

The Back Shoulder Drop is measured down from Center Back Length. Square the line through the Side Seam to the side of the front neck. See *Figure 2*.

9. Back Shoulder Length - 5 1/2" (14.0 cm)

The Back Shoulder Length is drawn from the top of Full Back Length to where it touches on the Shoulder Drop line.

10. Front Shoulder Length - 5 1/2" (14.0 cm)

Draw Front Shoulder Length from the side of the front neck to where the measurement touches on the Shoulder Drop line.

11. At a point half way between the base of the front neck and the Body Width line, square a line from Center Front to the Chest Width.

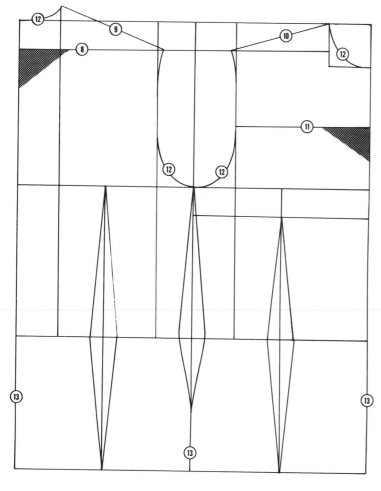

Figure 2

12. Draw in curves for neck and armscye. The front armscye notch will be on the chest line. The double notches on the back armscye are 1/2" (1.3 cm) further from the top corner of the armscye than the front notch.

13. For a Blouse block, extend the Center Back, Side Seam and Center Front line 7" (17.8 cm) down from Waistline to Hip line, connecting the lines at the bottom. See *Figure 2*.

14. If darts or shaping are required, divide back Body Width in half at hip and armscye level. Draw center of back dart from armscye level to hip.

Divide front Body Width in half at hip line and armscye level. Draw center of dart from armscye

to hip, dropping the line 1 1/2" (3.8 cm) below the armscye level for the top of the dart.

Subtract half of desired Waistline measurement from the Center Back to Center Front Waistline on the pattern just drafted. Divide the difference by 8. Use 2 parts for each dart and 2 parts at the Side Seam. The remaining 2 parts will be additional ease. See *Figure 2*.

This block may be used either as a Blouse block or as a Bodice block when a close to the body fit is not critical. It can easily be slashed and spread to achieve extra fullness as in a *blouson* or tent dress styling.

Suits or Coats may be made from this block by altering the patterns as shown on pages 410 and 414.

The completed pattern is shown in *Figure 3*.

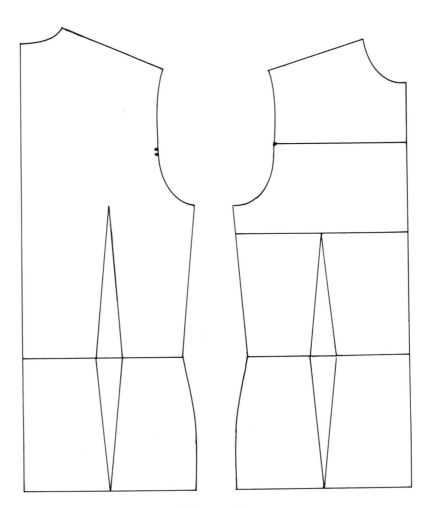

Figure 3

MEASUREMENT CHART

SLEEVE
for
NO-DART BODICE/BLOUSE BLOCK

Measurement	Size 10 Inches	Centimeters	Personal
1. Shoulder To Wrist (1)*..................	23 1/4	59.0	_____
2. Cap Height...........................	5	12.7	_____
Upper Arm (Bicep) (4)*, *including* 2" (5.0 cm) ease......................	12 1/2	31.7	_____
Divided by 2......................	6 1/4	15.8	_____
3. Shoulder To Elbow (3)*.................	13 1/2	34.2	_____
Elbow Width (5)*.....................	10 1/2	26.7	_____
Divided by 2......................	5 1/4	13,3	_____
4. Width of Elbow Dart..................	1 1/2	3.8	_____
5. Wrist Circumference (6-B)*...........	7 3/4	19.7	_____
Divided by 2......................	3 7/8	9.8	_____

*These numbers refer to the instructions for measuring in Chapter 1.

It is necessary to make a separate sleeve to fit into the No-Dart Bodice/Blouse block as the armscye is quite different from the regular Bodice or Torso blocks.

Once the special sleeve has been made and fitted to the No-Dart Bodice block, any style sleeve can be made from it - either separate sleeves such as puffed or shirt sleeve, or sleeves that become part of the bodice, i.e., kimono, rag-lan, etc. Because of the looser fit through the body, No-Dart Bodices gener-ally look better with a sleeve of some kind, if only a cap sleeve, rather than sleeveless.

1. Shoulder To Wrist - 23 1/4" (59.0 cm)

 Fold a piece of paper approximately 26" (66.0 cm) by 18" (45.7 cm) in the
 middle, lengthwise. Leaving some space at the top and bottom of the fold,
 mark the Shoulder To Wrist measurement, squaring a short line at the top
 and bottom. See *Figure 1*.

2. Cap Height - 5" (12.7 cm)
 Upperarm (Bicep) - 6 1/4" (15.8 cm)

 From the top of the line squared in Number 1, measure down for the Cap
 Height. Square a line from the fold for the Upperarm measurement.

3. Shoulder To Elbow - 13 1/2" (34.2 cm)
 Elbow Width - 5 1/4" (13.3 cm)

 From the top measure down for the elbow. From the fold, square a line for
 the Elbow Width. See *Figure 1*.

4. Width of Elbow Dart - 1 1/2" (3.8 cm)

 At the end of the line drawn for the Elbow Width,
 measure down for the Width of Elbow Dart - the broken
 line in *Figure 1*. Crease the line just drawn and
 fold it up to the Elbow Width line.

 Refold the original crease from top to elbow and from
 elbow down, keeping the elbow dart folded. The paper
 will be perfectly flat when properly folded. See
 Figure 2.

5. Wrist Circumference - 3 7/8" (9.8 cm)

 From the top, recheck the Shoulder To Wrist measure-
 ment, Number 1, along the folded edges. At the lower
 edge of the fold from elbow to wrist, square a line
 for the Wrist.

6. Connect Wrist to Elbow and Elbow to Upperarm (Bicep).

7. Draw the curve for the cap of the sleeve, making the
 back slightly fuller by about 1/4" (0.6 cm) than the
 front.

 If the Sleeve block from Chapter 4 has been made, the
 curves for the new sleeve may easily be drawn from the
 old one with slight adjustments. See *Figure 2*.

Figure 1

8. Keeping the paper folded, trace the front curve of the sleeve cap and the underarm seam to the other side of the paper. Be sure that the elbow dart and the fuller part of the sleeve cap are on the back edge of the sleeve when unfolded.

Shorten the elbow dart to one fourth of the total Elbow Width. Curve the wrist line slightly.

The original fold line will be the grain line and should be marked with an arrow.

For the completed sleeve, see *Figure 3*.

Figure 2

Figure 3

The sleeve cap must be checked against the armscye of the bodice. Approximately 1 1/2" (3.8 cm) ease is allowed in the cap of the sleeve: 1/2" (1.3 cm) on each side of the center to the notch and 1/4" (0.6 cm) between the notch and the underarm seam.

If any adjustment is necessary to make the sleeve fit the armscye, recheck the curves on the cap of the sleeve. If adjustment is still needed, make it at the underarm of the sleeve, correcting the line down to the elbow.

Chapter 7

Drafting The Pants

Notes

MEASUREMENT CHART

PANTS

Measurement	Size 10		Personal
	Inches	Centimeters	
1. Center Front Length – *To the floor*.....	40	101.6	_____
Ankle Length – Floor length minus 2" (5.0 cm)..................	38	96.6	_____
2. Hip Circumference – *Total*.............	37	94.0	_____
Including 1" (2.5 cm) ease........	38	96.6	_____
Divided by 2.................	19	48.3	_____
Front Hip *Hip circumference including ease divided by 4 plus 1/4" (0.6 cm)*....	9 3/4	24.7	_____
Back Hip *Hip circumference including ease divided by 4 minus 1/4" (0.6 cm)*...	9 1/4	23.5	_____
3. Side Seam Length – *To the floor*.......	40 1/8	101.9	_____
Ankle Length – Floor length minus 2" (5.0 cm)..................	38 1/8	96.9	_____
4. Center Back Length –*To the floor*.......	39 7/8	101.3	_____
Ankle Length – Floor length minus 2" (5.0 cm)..................	37 7/8	96.3	_____
5. Abdominal Extension....................	18	45.7	_____
Including 1/2" (1.3 cm) ease.......	18 1/2	47.0	_____
Divided by 2.....................	9 1/4	23.5	_____
6. Waist Circumference – *Total*...........	26	66.0	_____
Front Waist *Waist Circumference divided by 4 plus 3/8" (1.0 cm)*............	6 7/8	17.5	_____
Waist Circumference divided by 4 minus 3/8" (1.0 cm)...........	6 1/8	15.5	_____

Notes

Measurement	Size 10		Personal
	Inches	Centimeters	
7. Crotch Depth............................	10 3/4	27.3	_____
Including 1" (2.5 cm) ease.........	11 3/4	29.8	_____
8. Knee Depth.............................	22 1/2	57.2	_____
9. Bottom Width...........................	14	35.6	_____
Divided by 2......................	7	17.8	_____
Divided by 4......................	3 1/2	8.9	_____

1. Center Front Length – 38" (96.6 cm)

 Draw a vertical line approximately 4" (10.0 cm) from the right hand edge of the paper, squaring it at the bottom only. See *Figure 1.*

2. Hipline – *Center Front to Center Back* – 19" (48.3 cm)

 Measure down from the top of the Center Front Length – Number 1 the distance from waist to hip 7" (17.8 cm). Square the hipline from the Center Front for half the total measurement of the hip circumference including ease. Extend the horizontal line which was squared from the bottom of the Center Front Length the same length as the hipline.

 Front Hip – 9 3/4 (24.7 cm) Back Hip – 9 1/4" (23.5 cm)

 From the Center Front, mark the Front Hip measurement on the hipline and on the hemline. See *Figure 1.*

3. Side Seam Length – 38 1/8" (96.9 cm)

 The Side Seam Length is squared with the hemline up through the hipline at the Front Hip crossmark. See *Figure 1.*

4. Center Back Length – 37 7/8" (96.3 cm)

 This measurement is squared with the hemline through the end of the Back Hip.

 At the top of the pattern, connect the Center Front Length – Number 1 to the Side Seam Length – Number 2 and the Side Seam Length to the Center Back Length. This will be the waistline. See *Figure 1.*

5. Abdominal Extension – 9 1/4" (23.5 cm)

 From the waistline at the top of the Center Front Length measure down half the distance between the waistline and the hipline – 3 1/2" (8.9 cm). From the waistline at the top of the Side Seam Length measure down the same length, 3 1/2" (8.9 cm). Connect the two points so that the Abdominal Extension line runs parallel with the waistline.

 The length of the Abdominal Extension is measured from the Center Front. See *Figure 1.*

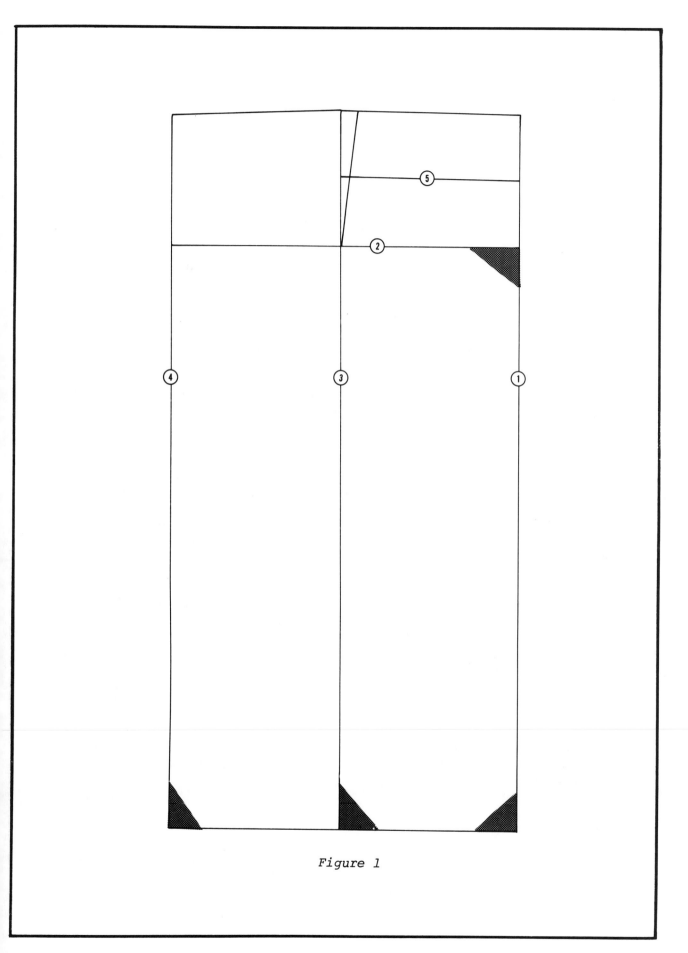

Figure 1

6. Waist Circumference - 26" (66.0 cm)

 Front Waist - 6 7/8" (17.5 cm)

 Draw a straight line from the hipline at the side seam through the Abdominal Extension to the waistline. Measure the waistline as it is now drawn and subtract from it the measurement desired for the *finished* Front Waist. The difference is divided into four parts. One part is used for each of the two darts and two parts are removed from the side seam of the waistline down to the Abdominal Extension line at the side seam.

 The first dart, the one closest to the Center Front, will be 3" (7.6 cm) from the Center Front. Keep the center of the dart parallel with the Center Front.

 The second dart is halfway between the outer edge of the first dart and the side seam at the waistline. The end of the dart is halfway between the end of the first dart and the side seam on the Abdominal Extension line.

 Draw curved line from the hipline at the side seam through the Abdominal Extension to the Front Waist. See *Figure 2*.

 Back Waist - 6 1/8" (15.5 cm)

 Measure the waistline as it is now drawn from the Center Back to the side seam. Subtract from that measurement the length desired for the *finished* Back Waist. The difference is divided into four parts. One part is removed from the Center Back waistline in a straight line down to the hipline. One part is removed from the waistline at the side seam by drawing a slightly curved line down to the hipline. The other two parts will be used for the darts.

 The first dart, the one closest to the Center Back, will be 3" (7.6 cm) from the newly drawn Center Back. The center of the dart is kept parallel with the original Center Back Length.

 The second dart is halfway between the outer edge of the first dart and the side seam at the waistline. The end of the dart is halfway between the end of the first dart and the side seam at the hipline but it is 1" (2.5 cm) shorter than the first dart.

 Extend the new Center Back up through the waistline so that the Center Back Waist To Dart will be squared with the new Center Back. See *Figure 2*.

7. Crotch Depth - 11 3/4" (29.8 cm)

 From the waistline at the Side Seam Length measure down the distance of the Crotch Depth and square a line across the front and back of the pattern. The Front Hip - Number 2 is divided into four parts. The front crotch line

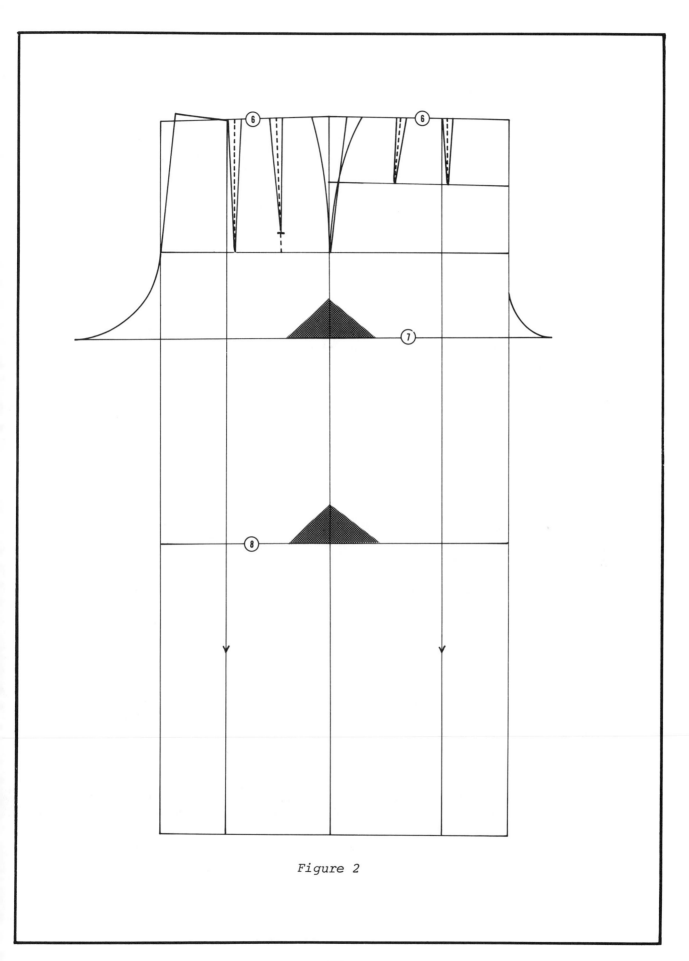

Figure 2

is extended past the Center Front Length for the same distance as one fourth of the Front Hip. Make the curve for the front crotch by measuring up on the Center Front Length the same distance the front crotch is extended. See *Figure 2*.

After extending the front crotch, measure from the side seam to the end of the front crotch. Divide this measurement in half, marking it on the crotch line. Measure the distance from this crossmark to the Center Front Length and mark the same distance on the hemline from the Center Front. The grain line, marked with an arrow, is drawn through these two marks for the length of the pattern.

For the back crotch, divide the Back Hip - Number 2 in half. The back crotch line is extended for a distance equal to half of the Back Hip measurement. Make the curve for the back crotch by measuring up on the new Center Back the same distance the back crotch was extended. See *Figure 2*.

The back grain, marked with an arrow, is drawn from the hemline to the waistline at the same distance from the original Center Back Length as the front grain line is from the Center Front Length. See *Figure 2*.

8. Knee Depth - 22 1/2" (57.2 cm)

From the waistline at the Side Seam Length measure down the distance for the Knee Depth and square a line across the front and back of the pattern. See *Figure 2*.

9. Bottom Width - 14" (35.6 cm)

Divide the Bottom Width into quarters. Put one part on each side of the front grain line at the hemline. Put on part on each side of the back grain line at the hemline.

Make a crossmark halfway between the hipline and the Crotch Depth on the side seam. Draw the outseam of the pants by connecting this crossmark to the Bottom Width measurement nearest to the side seam on the front and back hemline.

At the front crotch line measure in 1/2" (1.3 cm) from the point of the crotch. Connect the front Bottom Width to this mark. Check both sides of the front at the Knee Depth, adjusting to the shorter line if any adjustment is necessary. Draw a slight curve from the front inseam to the point of the front crotch.

At the back crotch line measure in 1" (2.5 cm) from the point of the crotch. Measure half of the back knee line between the grain line and the back outseam. Mark that same distance on the inseam of the knee line and connect to the back inseam of the Bottom Width. Connect the crossmark on the back crotch to the back inseam at the knee line. Draw a slight curve from the knee line to the point of the back crotch for the back inseam.

See *Figure 3*.

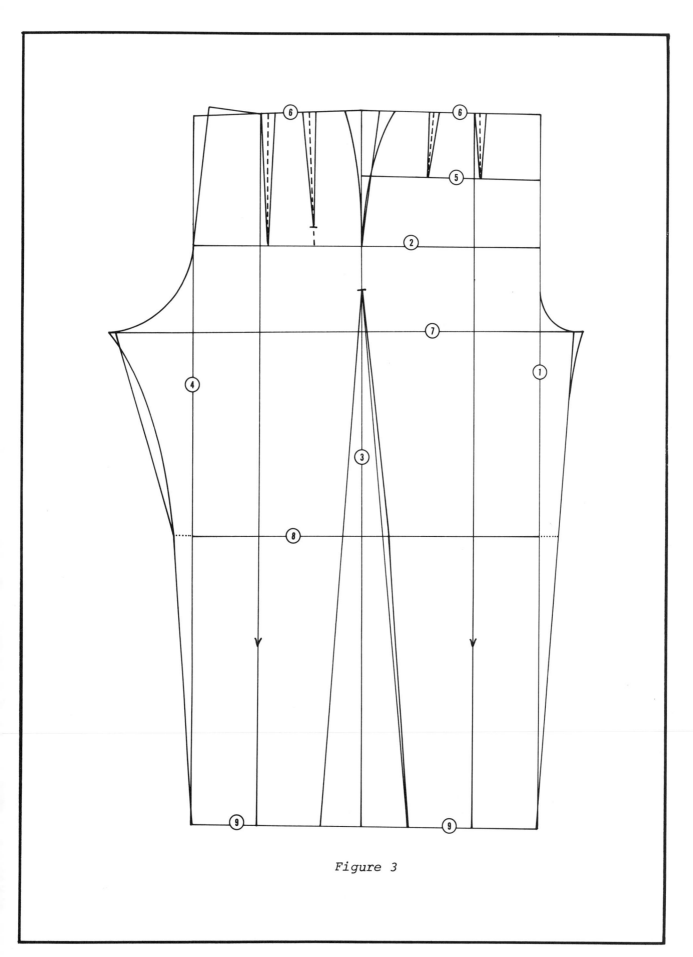

Figure 3

Smooth out the angle at the side seam between the hipline and the crotch, on both the front and back patterns.

Cut out the front pants, leaving an extra 1" (2.5 cm) at the top of the waistline. Fold out the two darts and smooth the waistline into a slight curve. Cut on the corrected waistline.

Cut out the back pants, leaving the extra 1" (2.5 cm) at the top of the waistline.

Check the side seam of the front pants against the side seam of the back pants from the hipline to the waistline. Any adjustment on the side seam length will be made on the back pants pattern at the waistline by either raising or lowering the waistline. Fold out the two darts and smooth the waistline into a slight curve from the first dart to the adjusted side seam. Cut on the corrected waistline.

Check the inseam of the front pants against the inseam of the back pants by working from the knee up. Any adjustment on the inseam will be made on the back pants at the crotch. It is usually necessary to lower the back crotch since the curve for the back inseam is greater than the curve for the front inseam. Blend the back crotch curve to the adjusted length on the back inseam.

The completed patterns are shown in *Figure 4.*

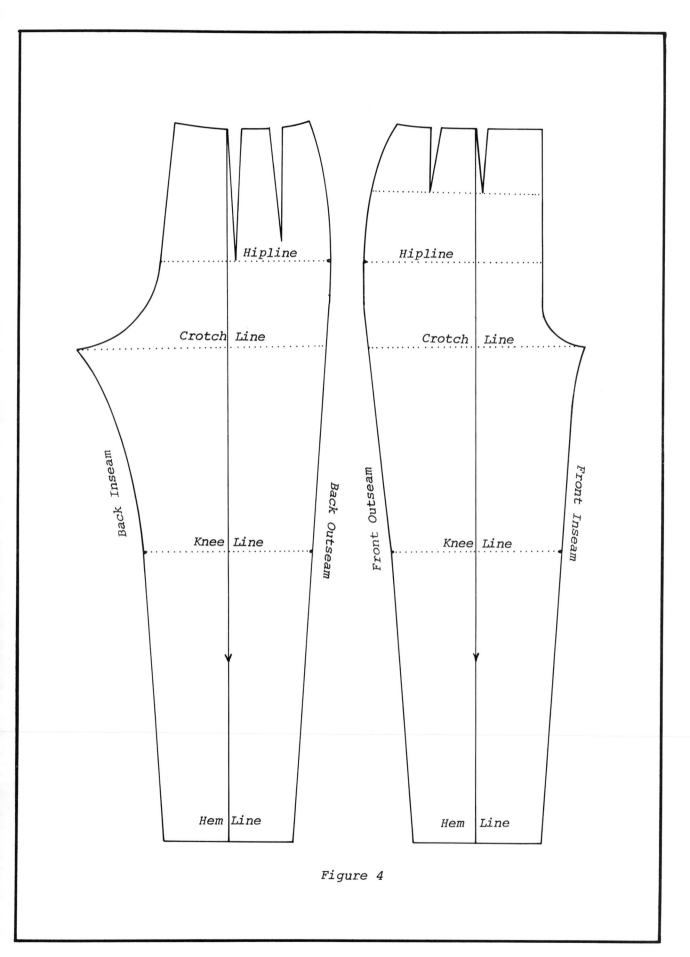

Figure 4

73

Chapter 8

Seam Allowances; Buttons- Buttonholes; Notches And Punches; Facings

Notes

SEAM ALLOWANCES

When deciding how much seam allowance is to be used, several point must be considered:

What are the standards for seam allowances in the factory where the garment will be sewn?

Is the seam an edge? A point of strain? A common alteration point?

Will the usual standards for seam allowances work on the fabric that is to be used for the garment? Should it have 3/8" (1.0 cm) allowance instead of 1/4" (0.6 cm) because of raveling? Is it an elasticized or stretch fabric that makes alterations unnecessary and a smaller seam more practical? Will the seam press better by making it larger or smaller than the normal allowance?

The following seam allowances are those generally used in the industry in medium to better priced garments but may vary slightly from one factory to another:

1/4" (0.6 cm)......Edges wherever a separate facing is used, collars, cuffs, necklines

3/8" (1.0 cm)......All seams in tricot lingerie that are sewn on the *superlock* sewing machine, men's dress or sport shirts

1/2" (1.3 cm)......Points of strain such as shoulders, yokes, waistlines, gores or panels within the body of the garment, sleeves

3/4" (1.9 cm)......Cut-out darts

1" (2.5 cm)......Side seams, zipper openings, center front and center back seams, pocket hems

1 1/2" (3.8 cm)......Folded hems on sleeves or overblouses

2" (5.0 cm)......Hems on street or floor length garments, unless the hem is too circular to accomodate that much turn up in which case it must be reduced accordingly

EXTENSIONS FOR BUTTONS - BUTTONHOLES

When the garment is designed for a button closure the minimum amount of extension necessary can be determined by dividing the width of the button in half and adding 1/4" (0.6 cm).

For a 40 line button, which measures 1" (2.5 cm) across, the extension would be figured as follows:

$$1" \div 2 = 1/2" + 1/4" = 3/4" \text{ extension}$$
$$(2.5 \text{ cm} \div 2 = 1.3 \text{ cm} + 0.6 \text{ cm} = 1.9 \text{ cm extension})$$

The distance from the edge of the button to the edge of the seam at the top is usually the same distance as it is from the edge of the button to the edge of the seam at Center Front or Center Back. See *Figure 1*.

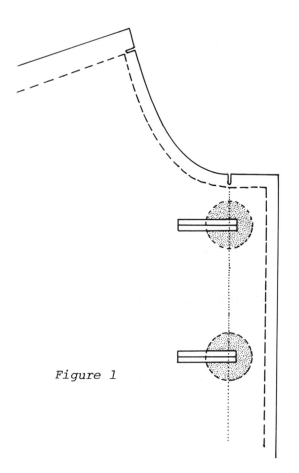

Figure 1

Buttonholes should be 1/4" (0.6 cm) longer than the button is wide if a flat button is used. For a thick or fancy button of irregular shape it will be necessary to make a test buttonhole first to determine the size buttonhole required.

When the garment is buttoned, the centers of the buttons should be exactly centered on the original Center Front or Center Back of the garment. For this reason it is necessary that the buttonholes should start 1/8" (0.3 cm) *outside* the center to allow for the sewing of the button.

See *Figure 1*.

NOTCH AND PUNCH PLACEMENT

Notches serve four primary purposes:

> To indicate seam allowances
>
> To match one piece of pattern to another
>
> To mark the width of darts, tucks, pleats, shirring
>
> To indicate the center front, center back and waistline

When used to indicate seam allowances, the patternmaker must know which seams will be sewn first. Notches should not be made at both edges of a corner but only on the seams that are to be stitched first.

See *Figure 2*.

The exception to this would be notches to indicate the amount to be folded back for the hem.

Seams of 1/4" (0.6 cm) are not usually notched to indicate the seam allowance as it would cause the fabric to unravel. However, notches to match one piece of a pattern to another are used on 1/4" (0.6 cm) seams.

Figure 2

When used to match one piece of a long pattern to another, notches should be placed approximately 15" (38.1 cm) apart - about the distance an operator can comfortably hold the fabric from the needle of the sewing machine.

Single notches are used to indicate the front parts of the garment; the spacing for darts, pleats, tucks, shirring; center front and center back; the waistline; the end of a zipper; seam allowances.

Double notches are used to indicate the back parts of the garment, particularly when there might be confusion between back and front pieces. In no case can double notches be matched to single notches.

Triple notches are sometimes used to indicate the Center Back of a garment.

See *Figure 3* and *Figure 4*.

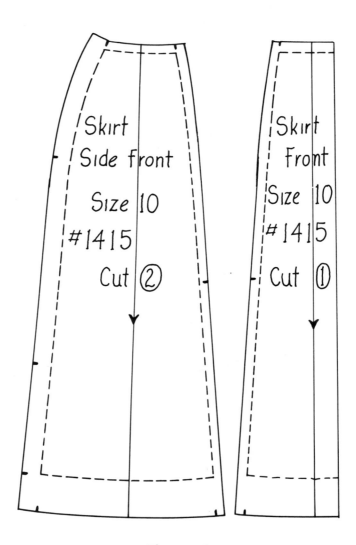

Figure 3

Grain lines should be marked on each pattern piece by drawing a straight line in the proper direction *from one edge of the pattern piece to the other.* This will assist the person making the marker (the cutting layout) in the factory.

A well defined arrow should be drawn on the line to readily indicate the grain.

See *Figure 3* and *Figure 4.*

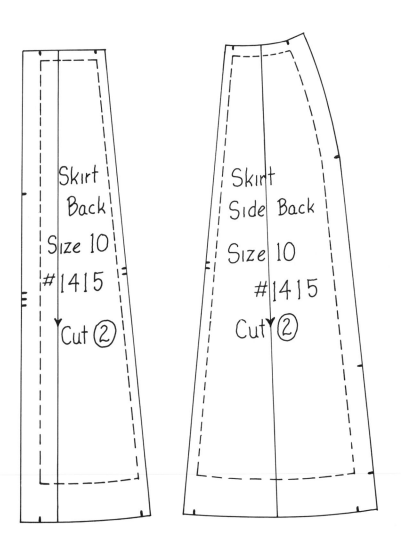

Figure 4

The style number, size, identification and number of pieces to be cut should be plainly indicated on each pattern section.
See *Figure 3, Figure 4* and *Figure 5.*

Notches are used at the seam edges of the pattern to indicate the width and spacing of darts, tucks, pleats, shirring or ease that is to be stitched into a seam.

Notches are also used to show where any trim is to be attached or where special attention is to be paid, such as corners or curved seams.

See *Figure 5, Figure 6* and *Figure 7.*

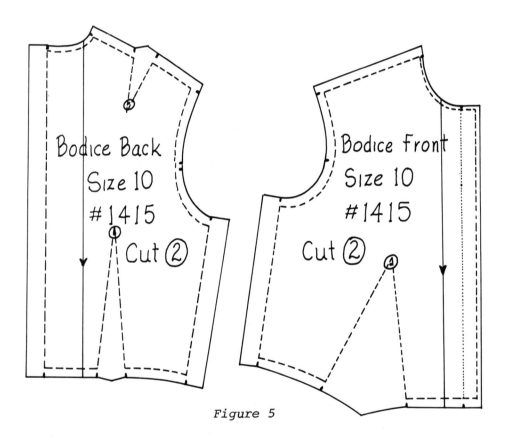

Figure 5

Punch marks are used to indicate the ends of darts. Be sure to circle punch marks so that it will be known that they have been put there for a purpose and are not just holes or flaws in the pattern paper.

Punch marks are also used to show where to apply trim within the body of the garment.

The exact width of the braid, ribbon, applique, etc., should be traced on the pattern. The punches are then made so that when the trim is sewn on the punch marks will be covered. See *Figure 4*.

For asymmetrical designs or when there is any difference between the right and left sides of a garment, pattern pieces should be clearly marked *THIS SIDE UP*.

This is doubly important where the fabric is distinctly different on the wrong side - pile fabrics, satins, prints, etc.

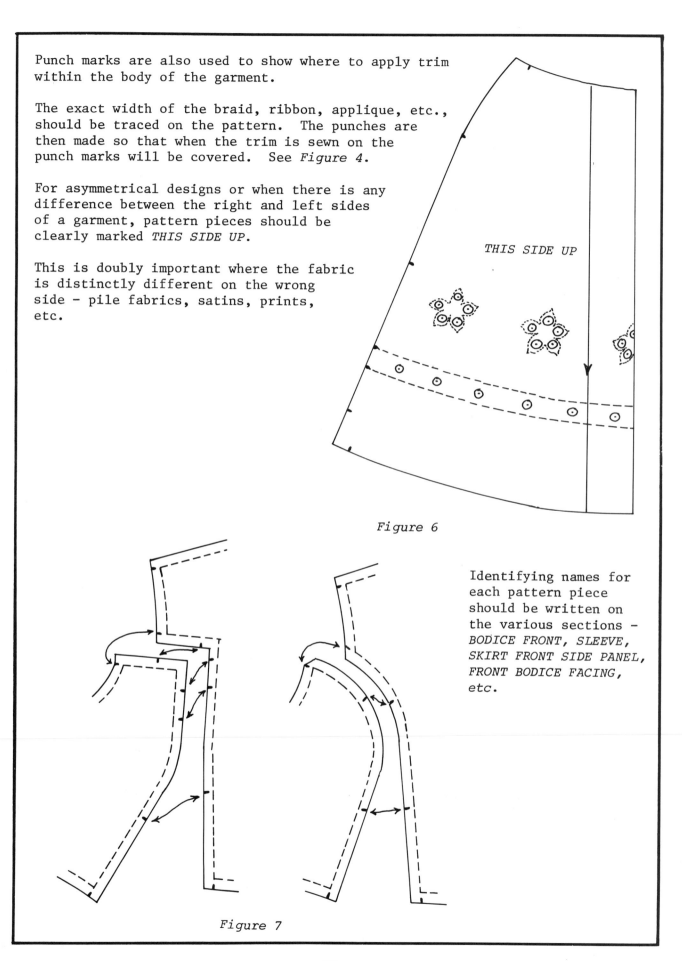

THIS SIDE UP

Figure 6

Identifying names for each pattern piece should be written on the various sections - *BODICE FRONT, SLEEVE, SKIRT FRONT SIDE PANEL, FRONT BODICE FACING,* etc.

Figure 7

Center Front and Center Back should always be indicated with notches.

Waistlines on garments that do not have a seam at the natural waist should be identified by notches.

See *Figure 8.*

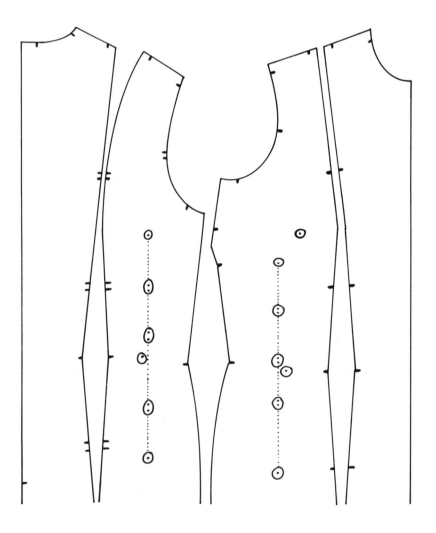

Figure 8

Punches are used to show the end of a dart that begins at a seam edge, *Figure 9;* dart-tucks, *Figure 10;* shaped darts, *Figure 11;* or darts within the body of the garment that are not at a seam edge (sometimes referred to as fish-eye darts), *Figure 12.*

Figure 9

Punches at the end of darts running to a point should be located about 3/8" (1.0 cm) from where the actual stitching line ends so that the hole punched in the cloth will be concealed by the stitching.

See *Figure 9.*

Figure 10

Figure 11

Punches for dart-tucks and shaped darts must be inside the stitching line by about 1/8" (0.3 cm). If the center of the dart or dart-tuck is in a straight line, double punches will indicate the center or fold line of the dart or dart-tuck.

Punch marks to show where the stitching is to be will only be necessary on one side of the fold line.

See *Figure 10, Figure 11* and *Figure 12.*

Figure 12

FACINGS

Facings may be cut in one with the garment and folded back or cut separately and stitched to the garment before folding back.

If the edge to be faced is shaped or curved it will be necessary to make a separate facing. See *Figure 13* and *Figure 14* for a comparison between the facing cut in one with the garment and a separate facing.

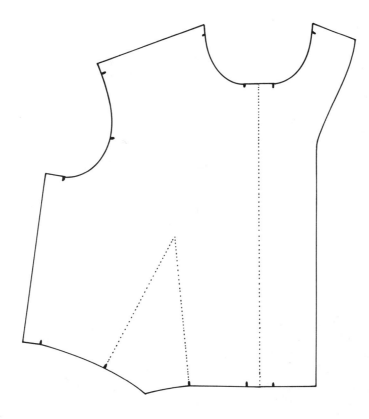

Figure 13

Facings should be made from the finished pattern, after the seam allowances and notches are made, to insure an accurate match.

In the case of a front opening which may be worn either open or closed, the facing should be wide enough to not show when the opening is rolled back. The finished edge of the facing should be about 1" (2.5 cm) wider than the end of the buttonholes. Finished dimensions are the same whether the facing is cut in one with the garment or cut separately.

If the garment is not lined, i.e., the lining stitched to the edge of the facing, 1/4" (0.6 cm) should be allowed at the edge of a facing to be turned under and stitched. If the edge of the facing is to be sewn to a lining, 1/2" (1.3 cm) should be allowed on both pieces as it becomes a point of strain.

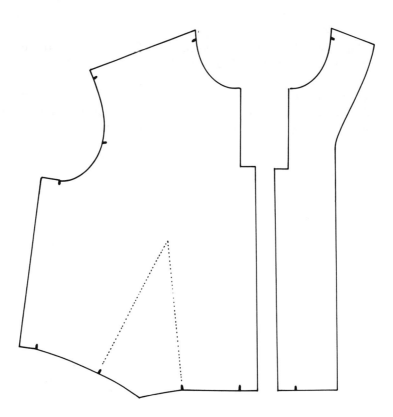

Figure 14

For a garment that buttons down
the Center Front or Center Back,
the finished facing should not
be less than 3" (7.6 cm) wide at
the Center Front or Center Back
and not less than 2" (5.0 cm)
wide at the neck edge of the
shoulder.

See *Figure 15*.

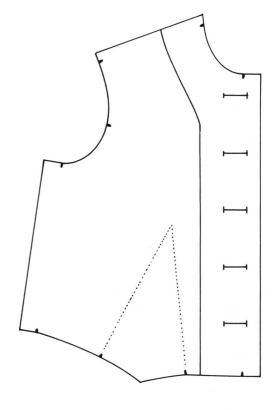

Figure 15

Neck facings should not be less than 2" (5.0 cm) wide at the shoulder and wide enough in the Center Back and Center Front to (1) avoid turning to the right side of the garment when worn, (2) accomodate the label, size ticket, care instructions, fiber content, etc., (3) cover the inside of the garment when the garment is on a hanger. See *Figure 16* and *Figure 17*.

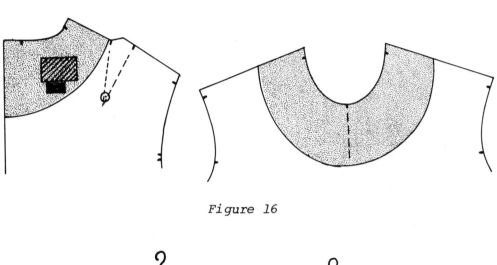

Figure 16

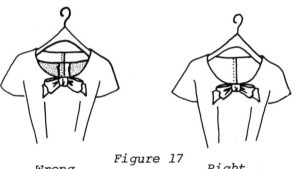

Wrong *Figure 17* *Right*

Most facings, especially curved or shaped facings, should have 1/8" (0.3 cm) removed from the edge that will be joined to the garment so that the facing will roll under easily and not show from the right side.

When a thick or bulky fabric is being used it will be necessary to take off more from the facing edge. See *Figure 18*.

This same principle applies to making an under collar that will lie flat except in the case of a collar the *outer* edge of the under collar is trimmed away instead of the neck edge.

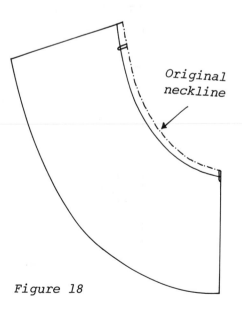

Original neckline

Figure 18

Facings for sleeveless armscyes should be about 2" (5.0 cm) wide finished.

If possible the front and back armscye
facings are cut in one piece.
See *Figure 19*.

When the facing for the neck and
armscye are cut in one, the facing
should finish about 2" (5.0 cm) deep
at the lower armscye and curve up
above the fullness of the breast in
front and the fullness of the shoulder
blades in the back.
See *Figure 20*.

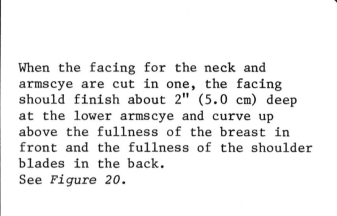

Figure 19

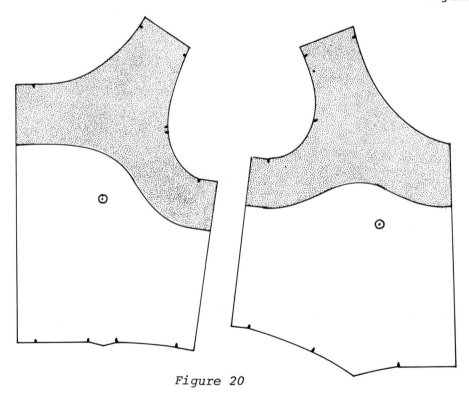

Figure 20

INTERFACINGS

Interfacings should be traced from the finished pattern pieces with seam allowances and notches.

For dresses and sportswear the interfacing reinforces the area of the buttons and buttonholes and gives body to the edges of a garment - collarless necklines, center fronts, collars, cuffs, flaps, waistlines on skirts and pants, etc.

Patterns for interfacings should be slightly narrower at the outer edge than the patterns for facings so that the interfacing is not visible, even from the inside of the garment. See *Figure 21.*

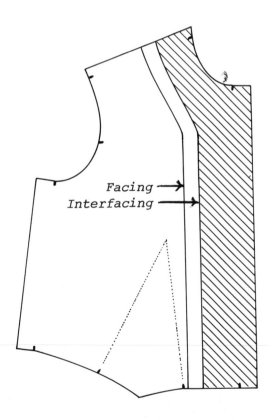

Facing ⟶

Interfacing ⟶

Figure 21

Chapter 9

Bodices

Figure 1

Darts are one means by which a wider or longer length of fabric necessary for one area is reduced to a shorter width or length for a smaller area of the body.

For example, the width needed for the bust may be reduced by a dart to the smaller size of the waistline or shoulder.

A dart is a stitched fold in the fabric, starting at a specified point, conforming to the contours of the body.

See *Figure 1* for an illustration of a dart before it is stitched.

Figure 2 shows the dart after it has been sewn.

Note how the original size of the fabric, as shown by the shaded area, remains the same width at the top but is smaller at the lower edge.

Figure 2

95

Longer lengths or widths may also be shortened by shirring (gathering), tucking, pleating or dart-tucks - a partially sewn dart - but the fit of the garment will not be as close to the body as when a dart is used.

Figure 3 shows shirring.

Figure 4 shows tucks.

Figure 5 shows pleats.

Figure 6 shows a dart-tuck.

Figure 3

Note how the original area is reduced at the lower edge while remaining the same width at the top.

Figure 4

96

Figure 5

Figure 6

The front bodice is considered the most important area of a garment. It is no accident that it is generally the first part of the pattern that is made and the other pieces fitted to it.

The generally accepted placement of darts on the bodice are at the waistline, side seam, armscye, shoulder, neckline and center.

Sometimes the entire dart is moved to a new location. In many cases only a part of the original dart is moved so that the combination of two or more darts will create the desired fit or line.

Before trying any of the dart changes in this chapter, mark the Basic Block of the Bodice Front as shown in *Figure 7*.

The line from the neck originates midway between center front and the shoulder; the line from the shoulder is in the middle of the shoulder; the starting in the armscye is halfway between the side seam and the sleeve notch; the side bust dart is on a line squared through the bust point from the center front; the French dart originates 1 1/2" (3.8 cm) above the waistline.

Figure 7

Darts can be relocated by either (A) slashing the pattern or (B) pivoting the pattern. The principles of changing the darts which follow can be applied to other areas of the garment where darts are involved. Both methods will be shown in the first section but most of the later illustrations will show the slash method. Pivoting should be tried whenever single darts are being relocated as it is faster and more accurate.

While all darts for the Front Bodice radiate from the point of the bust and must be slashed or pivoted from that point, not all darts end at the point of the bust. They do end within the area of the bust as indicated by the dotted line circling the bust area, as shown in *Figure 7*.

The following general rules have been set up for a guide on how far from the original bust point the various darts should end for the best effect:

 Neckline darts.............2" (5.0 cm) from bust point

 Shoulder darts.............2" (5.0 cm) from bust point

 Armscye darts.............1 3/4" (4.4 cm) from bust point

 Side bust darts...........1 1/2" (3.8 cm) from bust point

 French darts.............. 3/4" (1.9 cm) from bust point

 Center front darts........ 1/2" (1.3 cm) from bust point

 Waistline darts...........To the original bust point

The above measurements are based on a size 10, using approximately 2" (5.0 cm) as the radius for the bust area.

Larger or smaller sizes would be adjusted accordingly.

DART RELOCATION OR MANIPULATION

1. French Dart

 Figure 8 shows how the garment will appear when completed.

Figure 8

(A) Slash Method

Prepare the pattern to be slashed by drawing around the front bodice and cutting it out.

Draw in the new dart location, marking the end of the dart 3/4" (1.9 cm) from the original bust point. See *Figure 9-A*.

Cut through the new French Dart line to the bust point. Draw around the section of the pattern shown by the shaded area in *Figure 10-A*.

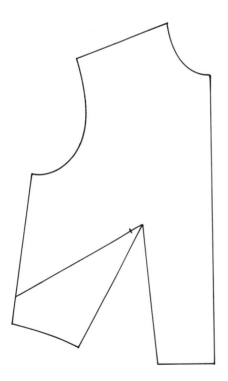

Figure 9-A

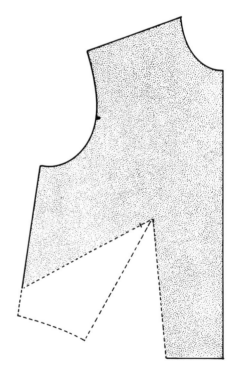

Figure 10-A

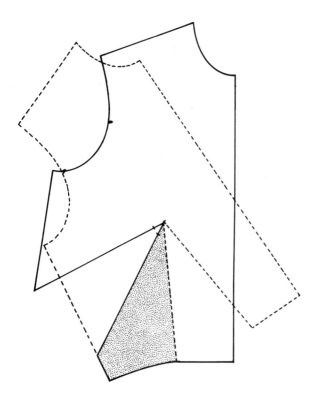

Close the waistline dart by placing the two legs of the original dart together.

Draw around the shaded area as shown in *Figure 11-A*.

This will form a dart running from the lower part of the side seam to the bust point.

Figure 11-A

To locate the new bust point, mark the center of the new dart 3/4" (1.9 cm) from the original bust point.

Draw the new legs of the dart to the side seam as shown in *Figure 12-A*.

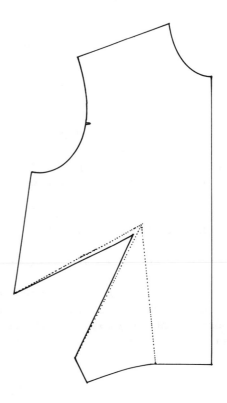

Figure 12-A

(B) Pivoting Method

Figure 9-B shows where the dart is to be relocated on the orginal front bodice.

Figure 9-B

Draw around the shaded area of the original pattern in the direction of the arrows shown in Figure 10-B, beginning at the leg of the dart closest to the Center Front.

Continue around the waistline, center front, neckline, shoulder, armscye (including the notch), the side seam down to where the new dart will be.

With a tracing wheel, trace the new dart from the side seam to the point of the bust. Make a crossmark where the new dart will end.

Figure 10-B

Holding the original pattern at the
bust point with a push pin, pivot
the pattern until the two legs of
the original dart come together.

With the pattern in this position
draw around the edge of the pattern
as shown by the shaded area in *Fig-
ure 11-B*.

Retrace the line for the new dart,
making a crossmark at the end of
the dart.

Figure 11-B

Locate the new bust point 3/4" (1.9 cm)
from the original bust point and draw in
the new legs of the dart as shown in *Fig-
ure 12-B*.

Figure 12-B

2. Side Bust Dart

The completed garment is shown in *Figure 13*.

(A) Slash Method

Figure 14-A shows the pattern after it has been copied from the front bodice, cut out and the new dart location drawn in. The pattern is now ready for slashing.

Cut through the new dart line to the bust point and draw around the part of the pattern as indicated by the shaded area in *Figure 15-A*.

Figure 13

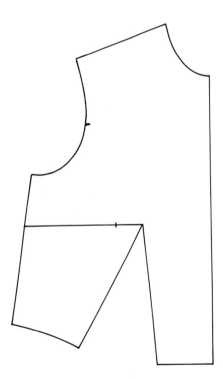

Figure 14-A

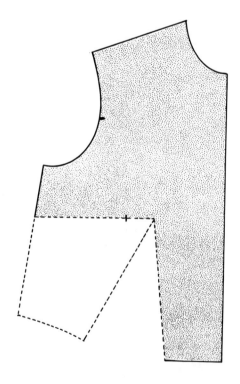

Figure 15-A

Close the waistline dart by
placing the two legs of the
dart together.

Draw around the shaded area
as as shown in *Figure 16-A*.

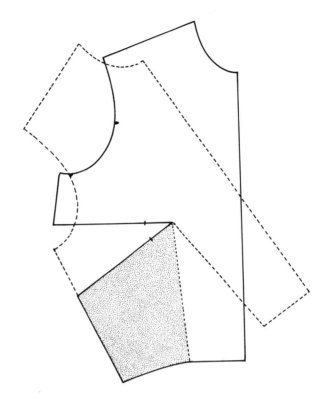

Figure 16-A

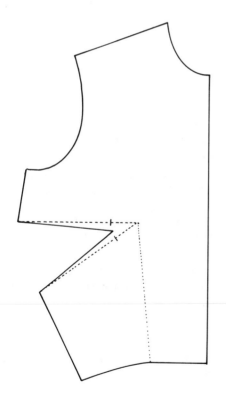

Locate the new bust point 1 1/2" (3.8 cm)
from the original bust point.

Draw in the new legs of the dart to the
side seam as shown in *Figure 17-A*.

Figure 17-A

(B) Pivoting Method

Figure 14-B shows the pattern
prepared for pivoting.

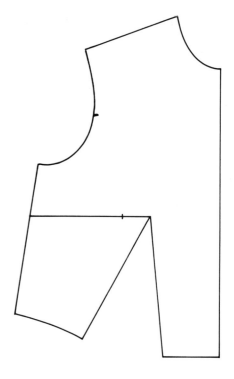

Figure 14-B

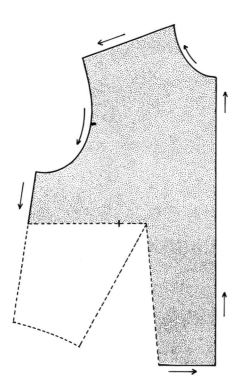

Draw around the shaded area of the origi-
nal pattern as shown in *Figure 15-B,* be-
ginning at the leg of the dart closest
to the center front and continuing on
around the waistline, center front, neck-
line, shoulder, armscye including the
notch, the side seam down to where the
new dart will be at the bustline.

With the tracing wheel, trace the new
dart line, making a crossmark where the
dart will end.

Figure 15-B

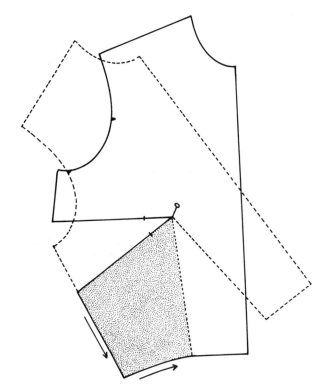

Holding the original pattern at the bust point with a push pin, pivot the pattern until the two legs of the original dart come together.

Keep the pattern in this position and draw around the edge of the pattern as shown by the shaded area in *Figure 16-B*.

Retrace the line for the new dart.

Figure 16-B

Locate the new bust point 1 1/2" (3.8 cm) from the original bust point.

Draw the new legs of the dart as shown in *Figure 17-B*.

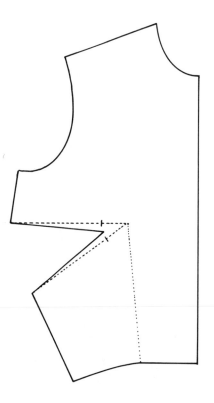

Figure 17-B

3. Armscye Dart

The completed garment is shown in *Figure 18*.

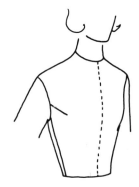

(A) Slash Method

Figure 19-A shows the pattern prepared for slashing.

Cut through the new dart line to the bust point and draw around the pattern as shown by the shaded area in *Figure 20-A*.

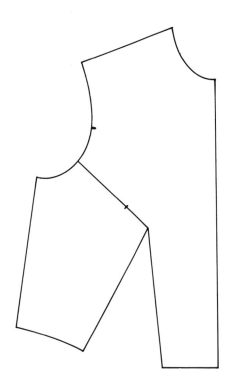

Figure 19-A

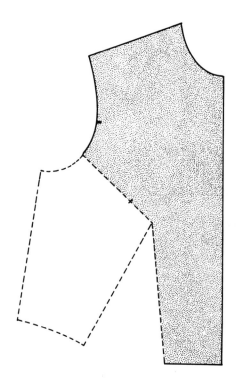

Figure 20-A

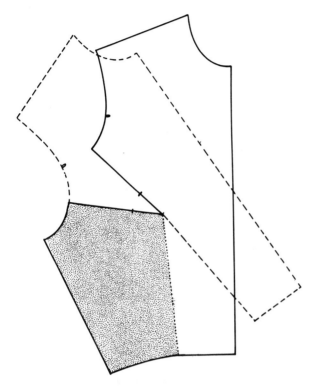

Close the waistline dart and
draw around the shaded area
as shown in *Figure 21-A*.

Figure 21-A

Locate the new bust point 1 3/4"
(4.4 cm) from the original bust
point. Draw the new legs of the
dart to the armscye as shown in
Figure 22-A.

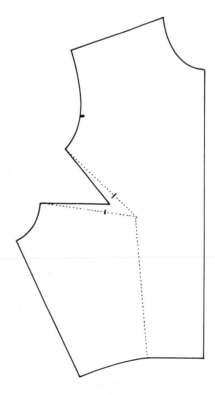

Figure 22-A

(B) Pivoting Method

Figure 19-B shows the location of the new dart.

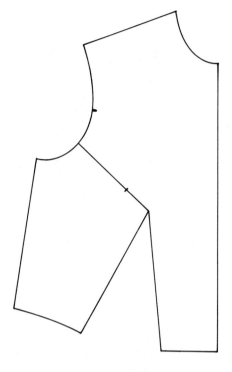

Figure 19-B

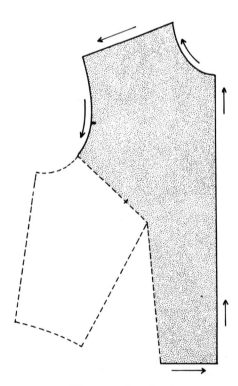

Figure 20-B

Draw around the shaded area of the original pattern as shown in *Figure 20-B*, beginning at the first leg of the original waistline dart and continuing around the pattern to the new dart. Trace the new dart, making a crossmark at the end of the dart.

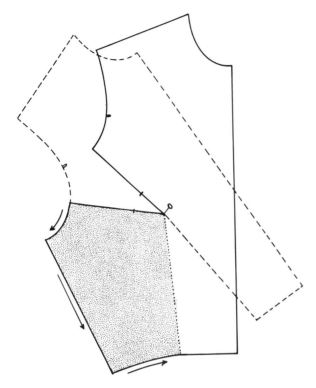

Figure 21-B

Pivot the original pattern at
the bust point until the waist-
line dart is closed.

Draw around the pattern as in-
dicated by the shaded area in
Figure 21-B.

Retrace the line for the new
dart.

Locate the new bust point
1 3/4" (4.4 cm) from the
original bust point.

Draw the new legs of the
dart as shown in *Figure 22-B*.

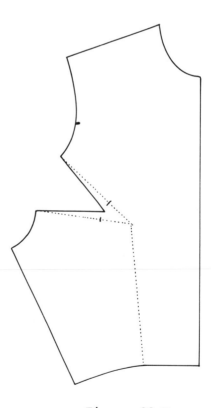

Figure 22-B

4. Shoulder Dart

 Figure 23 shows the completed garment.

Figure 23

(A) Slash Method

 Figure 24-A shows the pattern prepared for slashing.

 Cut through the new dart line to the bust point. Draw around the pattern as shown by the shaded area in *Figure 25-A*.

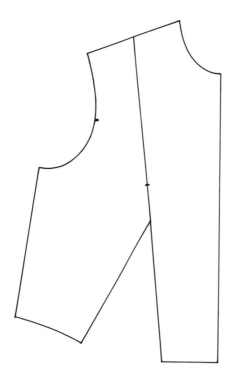

Figure 24-A

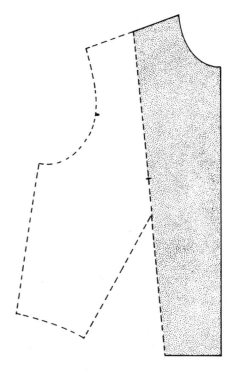

Figure 25-A

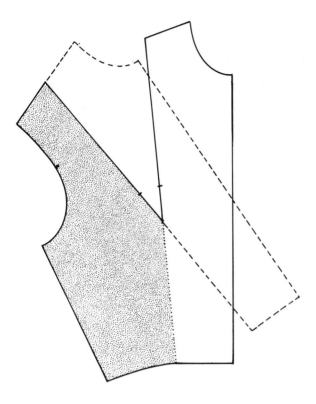

Close the waistline dart and
draw around the pattern as
shown by the shaded area in
Figure 26-A.

Figure 26-A

Locate the new bust point
2" (5.0 cm) from the origi-
nal bust point.

Draw in the new dart as
shown in *Figure 27-A*.

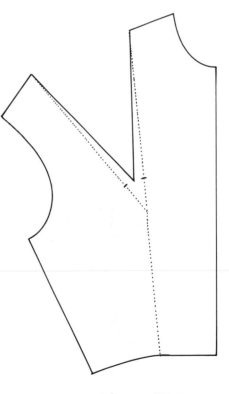

Figure 27-A

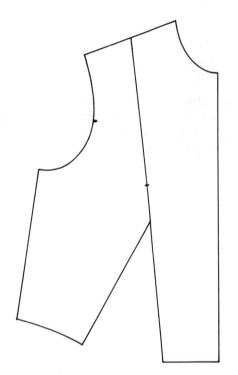

Figure 24-B

(B) Pivoting Method

Figure 24-B shows the location
of the new dart.

Complete the pattern by following
the illustrations in *Figure 25-B,*
Figure 26-B and *Figure 27-B.*

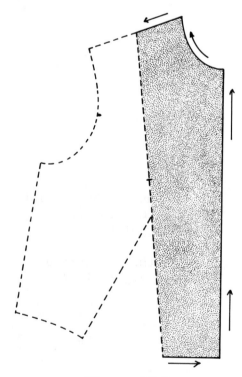

Figure 25-B

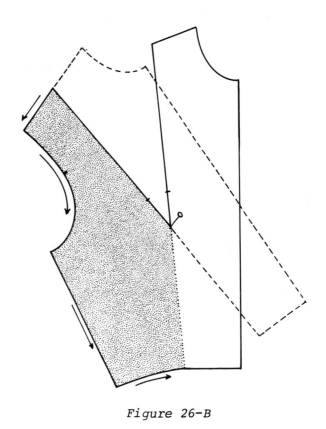

Figure 26-B

The new bust point will be 2"
(5.0 cm) from the original bust
point.

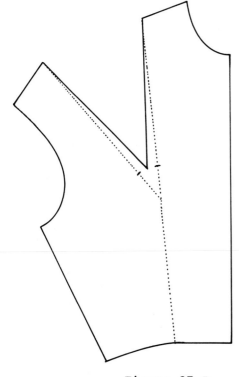

Figure 27-B

115

5. Neckline Dart

Figure 24 shows the completed garment.

(A) Slash Method

Figure 29-A shows the pattern prepared for slashing.

Complete the pattern by following the illustrations in Figure 30-A, Figure 31-A and Figure 32-A

Figure 28

Figure 29-A

Figure 30-A

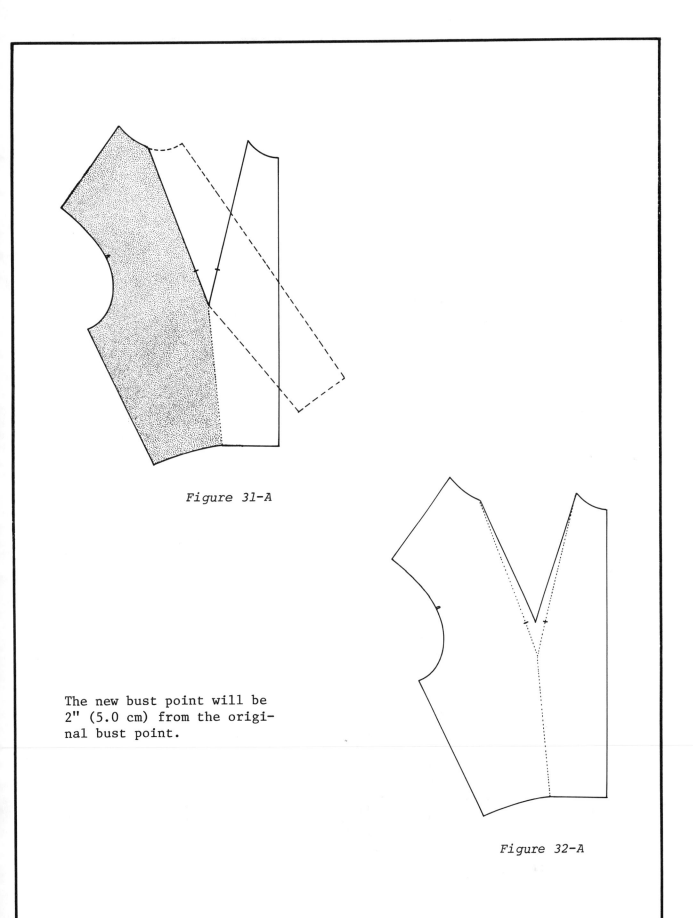

Figure 31-A

The new bust point will be
2" (5.0 cm) from the origi-
nal bust point.

Figure 32-A

(B) Pivoting Method

Figure 29-B shows the new
location of the dart.

Complete the pattern by
following the illustrations
in *Figure 30-B*, *Figure 31-B*
and *Figure 32-B*.

Figure 29-B

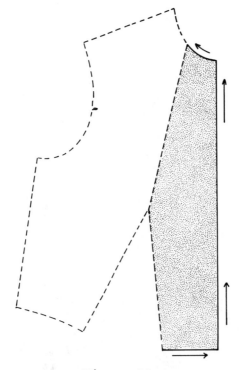

Figure 30-B

118

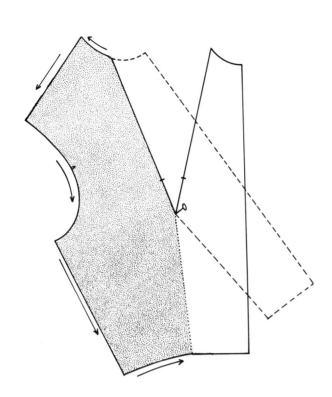

Figure 31-B

The new bust point will be
2" (5.0 cm) from the origi-
nal bust point.

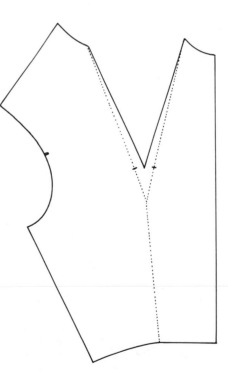

Figure 32-B

119

6. Center Front Waistline Dart

Figure 33 shows the completed garment.

Figure 33

(A) Slash Method

Figure 34-A shows the pattern prepared for slashing.

Complete the pattern by following the illustrations in *Figure 35-A*, *Figure 36-A* and *Figure 37-A*.

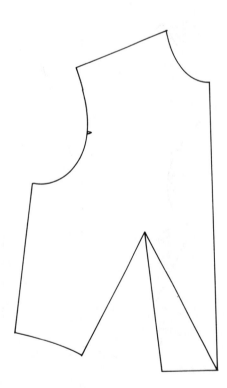

Figure 34-A

Figure 35-A

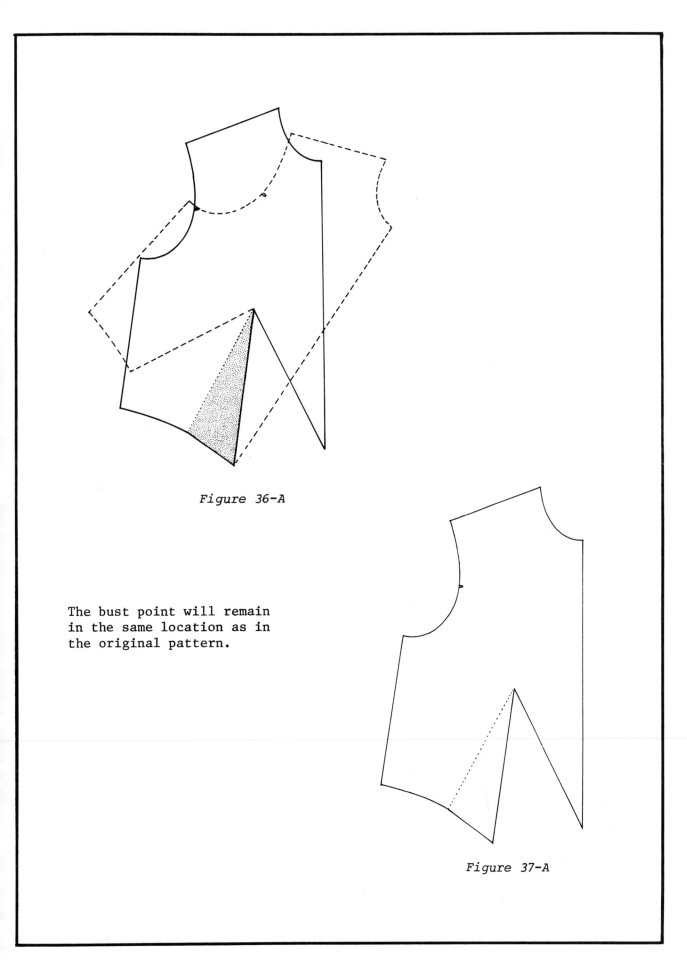

Figure 36-A

The bust point will remain
in the same location as in
the original pattern.

Figure 37-A

121

(B) Pivoting Method

Figure 34-B shows the new location of the dart.

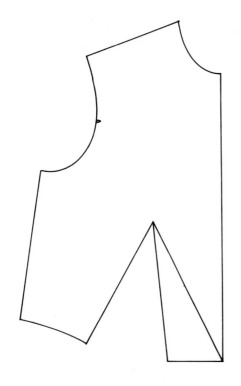

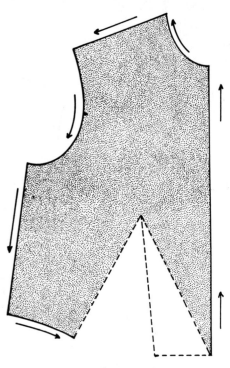

Figure 35-B

Complete the pattern by following the illustrations in *Figure 35-B*, *Figure 36-B* and *Figure 37-B*.

Figure 34-B

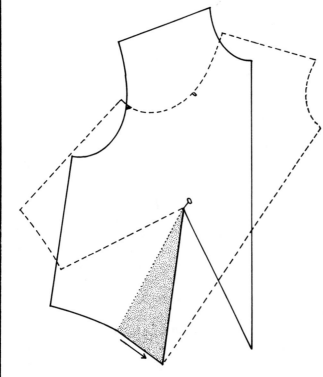

Figure 36-B

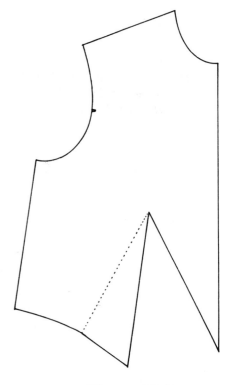

Figure 37-B

122

SHOULDER PADS

Bodice patterns are easily adjusted for shoulder pads. The adjustment may be
made before the pattern is made by altering the blocks, or after the pattern
has been made and before the seam allowance is added.

After the type of pad to be used has been selected, measure the depth of the
pad at the thickest part and determine how much longer the shoulder seam
should be. See *Figure 1*.

If the pad is 1/2" (1.3 cm) thick and the shoulder seam
is to be 1/2" (1.3 cm) longer, the shoulder seam, begin-
ning from about the middle of the shoulder, will be
raised and extended. The new armscye will be blended
into the original armscye slightly below the notches.
The armscye notches will be transferred to the new arm-
scye line.

Figure 1

The directions are the same for the front and back bodice
patterns. See *Figure 2* and *Figure 3*.

It will also be necessary to adjust the sleeve at the cap
to fit the new armscye. For directions on adjusting the
sleeve, see page 277.

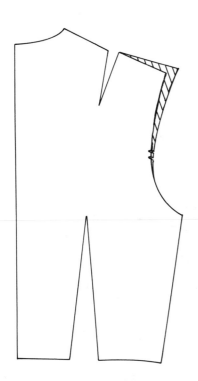

Figure 2

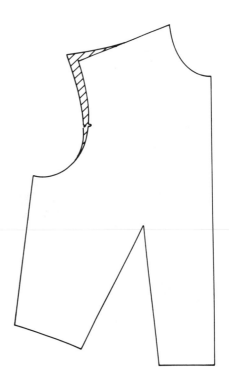

Figure 3

STYLE LINES IN THE BODICE

A. Dividing The Original Dart Into Two Or More Darts

Sometimes this is done for better fit when there is an exceptionally large difference between the but and waist measurements which will result in a very large dart in the front bodice if only the one waistline dart is used.

Most often multiple darts are used for styling purposes. In the following combinations, patterns may be either slashed or pivoted.

Figure 1

1. Waistline Dart and Side Bust Dart

 Figure 1 shows the completed garment.

 Figure 2 shows the location of the additional dart, the upper leg of which is on the original bustline.

 The side bust dart should be opened about 1 1/2" (3.8 cm) when used in combination with another dart.

 The point of the new side bust dart will be 1 1/2" (3.8 cm) from the orginal bust point. For the completed pattern, see *Figure 3*.

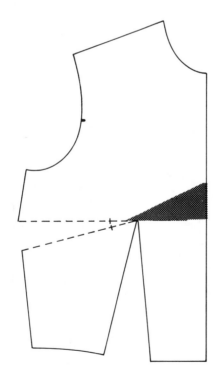

Figure 2

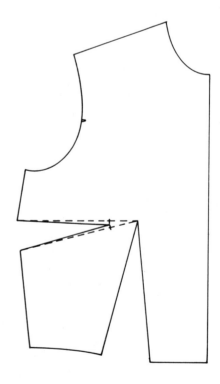

Figure 3

2. Waistline Dart and Shoulder Dart

Figure 4 shows the completed garment.

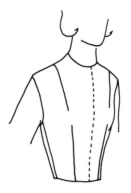

Figure 4

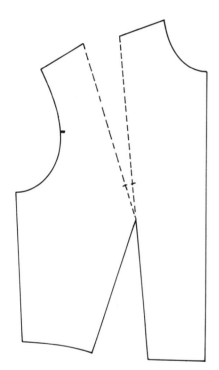

Figure 5

Figure 5 shows the location of the additional dart.

The shoulder dart has been opened 2" (5.0 cm) and the point of the new shoulder dart is 2" (5.0 cm) from the orginal bust point.

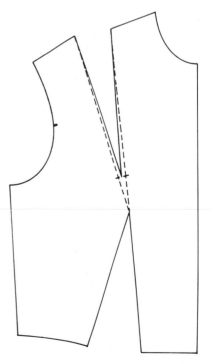

Figure 6 shows the completed pattern.

Figure 6

Figure 7 shows the completed garment.

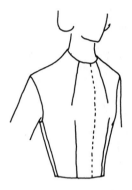

Figure 7

Figure 8 shows the location of the additional dart.

The neckline dart has been opened 2" (5.0 cm) and the point of the new dart is 2" (5.0 cm) from the original bust point.

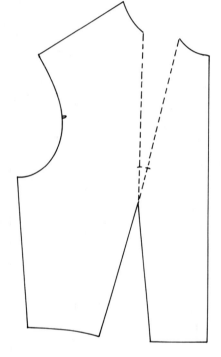

Figure 8

Figure 9 shows the completed pattern.

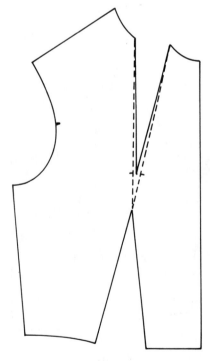

Figure 9

126

4. French Dart and Neckline Dart

Figure 10 shows the completed garment.

Figure 10

Figure 11 shows the location of the two darts.

When possible, darts originating below the bustline - from the waistline or beginning low on the center front or side seam - should be slightly larger than darts beginning above the waist-line.

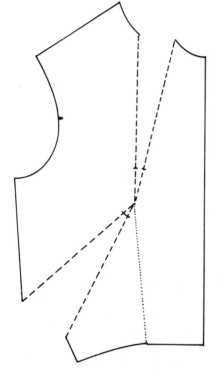

Figure 11

Figure 12 shows the completed pattern.

Figure 12

127

B. Double And Triple Darts

When the new darts will be in an area where there is already a dart it
will be necessary to shift the existing dart out of the way. The origi-
nal dart may be shifted by pivoting. It will be necessary to slash the
pattern to make the double or triple darts.

1. Double Darts from the Waistline

Figure 1 shows the completed garment.

Figure 1

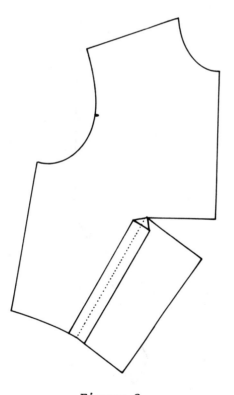

Shift the original dart to the
center front. Draw the new darts
1/2" (1.3 cm) on each side of the
original dart position and to
within 1/2" (1.3 cm) of the bust
point. Connect the ends of the
new darts to the bust point as
shown in *Figure 2.*

Cut on the lines drawn for the new
darts from the waistline to the
bust point, following the angles
at the top of the darts.

Figure 2

Figure 3

Close the center front dart. Place the small cut out piece so that the width of the two darts are of equal distance at the waistline and the tops of the two darts are directly opposite the angles cut in the pattern.

This will cause the center of the cut out piece to overlap slightly at the point shown by the shaded area of *Figure 3*.

Mark the points of the new darts and draw in the legs.

See *Figure 4*.

Figure 4

2. Double French Darts

Figure 5 shows the completed garment.

Shift the original dart to the center front. Draw
a line from the lower part of the side seam to the
bust point. This will be the center of the two new
darts. Draw the new darts 3/4" (1.9 cm) on each
side of this line to within 3/4" (1.9 cm) of the
bust point. Connect the ends of the new darts to
the bust point as shown in *Figure 6*.

Cut on the lines drawn for the new darts from the
side seam to the bust point, following the angles
at the top of the darts.

Figure 5

Close the center front dart. Place the small cut out piece so that the
width of the two arts are of equal distance at the side seam and the tops
of the two arts are directly opposite the angles cut in the pattern. Over-
lap the center slightly as shown in *Figure 3*.

Complete the pattern as shown in *Figure 7*.

Figure 6

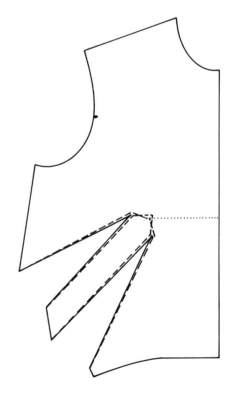

Figure 7

3. Triple Shoulder Darts and Waistline Dart

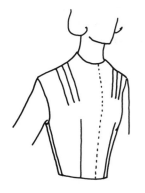

Figure 8 shows the completed garment.

Since the multiple darts will be in the shoulder area it is not necessary to transfer the original dart.

Draw a line from the center of the shoulder to the point of the bust. Draw the other two darts 1" (2.5 cm) on each side of this line to within 2" (5.0 cm) of the bust point. Connect the ends of the outer darts to the bust point as shown in *Figure 9*.

Figure 8

Cut and spread the darts about 1" (2.5 cm) apart at the shoulder and complete the pattern as shown in *Figure 10*.

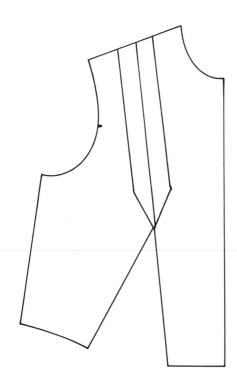

Figure 9

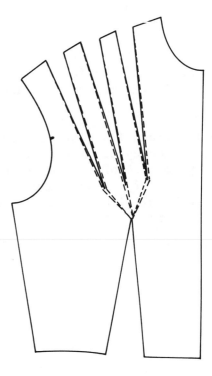

Figure 10

C. Darts Incorporated In Seams

When cutting the patterns apart in the *slash method* it was easy to see that by simply adding seam allowances and identifying notches to the pieces a similar fit could be achieved by seaming rather than darts.

1. Classic Princess

Figure 1 shows the completed garment.

Figure 2 shows where the pattern will be cut. Identifying crossmarks should be made 3" (7.6 cm) above and below the bust point.

After the pieces are separated, the resulting angle at the bustline should be rounded out between the two crossmarks. See *Figure 3*.

Figure 1

The grain line for the center front panel will be at the center front fold.

The grain line for the side panel is made by drawing a line through the middle of the waistline to the middle of the bust area. Extend the grain line to the top of the pattern. See *Figure 3*.

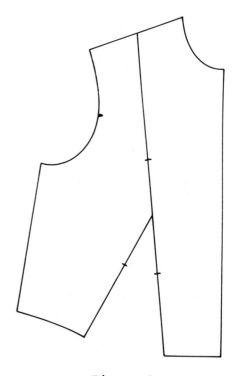

Figure 2

2. Armscye Princess

Figure 4 shows the completed garment.

Figure 4

Figure 5 shows where the pattern will be cut apart. Identifying crossmarks are 3" (7.6 cm) above and below the bust point.

The same rules for the grain line apply to the Classic Princess and the Armscye Princess.

The completed pattern is shown in *Figure 6*.

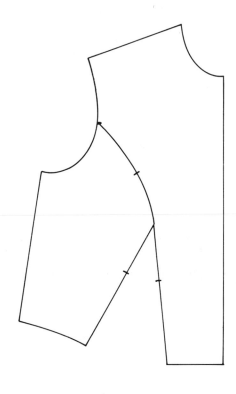

Figure 3

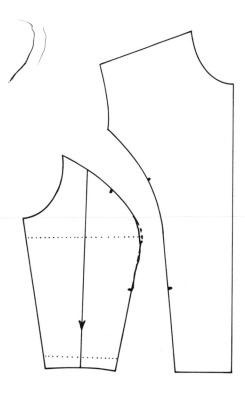

Figure 5 *Figure 6*

133

D. Seams And Darts For Fitting

A combination of seams and darts can be used. One of the advantages, as
may be seen in the following illustrations, is that the curve of the side
panel over the bust is less pronounced when the side bust dart is used.
by lessening the curve the garment is easier to sew.

1. Class Princess with
 Side Bust Dart.

Figure 1 shows the
completed garment

Figure 2 shows
where the pattern
will be cut.

Figure 1

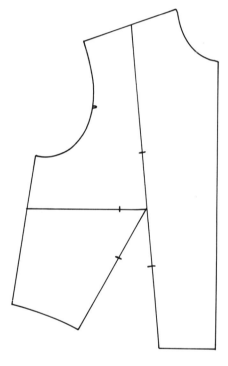

Figure 2

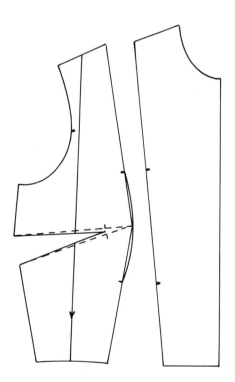

Figure 3 shows the completed pattern.
Note the grain line on the side panel.

Figure 3

2. Armscye Princess with Side Bust Dart

Figure 4 shows the completed garment.

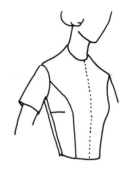

Figure 4

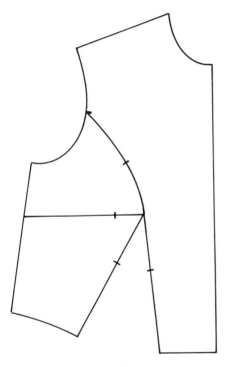

Figure 5

Figure 5 shows where the pattern will be prepared, crossmarked and cut.

Figure 6 shows the completed pattern.

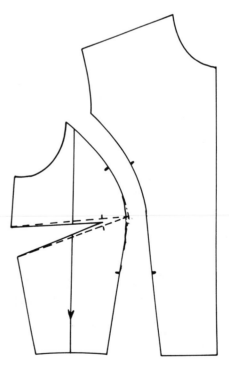

Figure 6

E. Yokes

Another way of incorporating seaming for fitting or styling is with yokes.
Yokes may be accented with shirring, tucking, darting, pleating or with
dart-tucks.

1. Yoke in Front Only

 Figure 1 shows the completed garment with
 dart-tucks below the yoke seam.

 Figure 2 shows where the pattern will be
 cut.

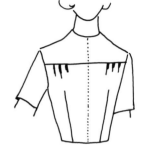

Figure 1

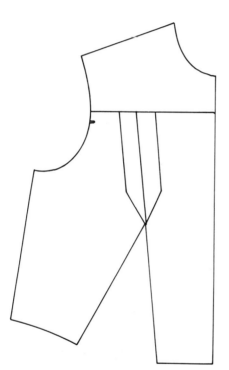

Figure 2

Figure 3 shows the completed
patterns.

Figure 3

136

2. Yoke in Back Only

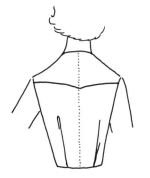

Figure 4

Figure 4 shows the completed garment with pleats at the waistline instead of darts.

Figure 5 shows where the pattern will be cut.

The shoulder dart is eliminated when the line of the yoke goes through the point of the dart. The dart may then be shifted into the seam.

If the shoulder dart is folded before drawing the line for the yoke it will result in a smoother line.

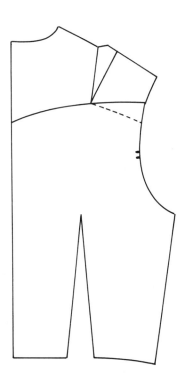

Figure 5

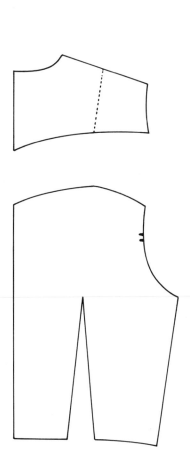

Figure 6

Figure 6 shows the completed patterns.

F. Shirring

Shirring, sometimes called gathering, may take up the original fullness of the dart or additional fullness may be added by slashing and spreading the pattern.

When making patterns for shirring, always work with both the piece that is to be shirred and the one it is to be sewn to - the control piece.

The notches for the finished amount of shirring should be marked on the control piece and the slashed pattern spread so that the amount to be shirred will have a definite *ratio* of fullness to the control size.

The shirring ratio simply means how many times longer is the part to be shirred than the finished shirring or control piece. If the piece to be shirred is twice as long as the control piece, the ratio of shirring would be 2 to 1; if three times as long the ratio would be 3 to 1; if four times the ratio would be 4 to 1.

The correct amount of fabric to be shirred can only be determined by actually shirring a piece of fabric to various ratios before making the pattern.

The ratio of shirring in *Figure 1* is 1 1/2 to 1 - the amount to be shirred is one and one half times the distance between the notches on the control piece.

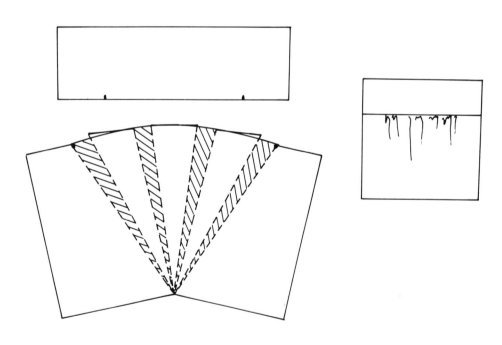

Figure 1

The ratio of shirring in *Figure 2* is 2 to 1 - twice the distance between the notches on the control piece.

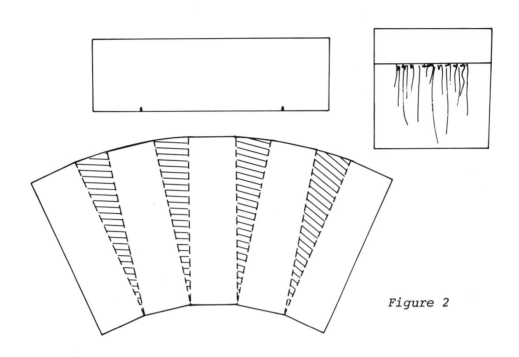

Figure 2

The most generally used ratios of shirring are:

1 1/2 to 1.........*Medium to heavy weight fabrics*
 If the control piece measures 3" (7.6 cm)
 between notches, the piece to be shirred
 will measure 4 1/2" (11.5) between notches.

2 to 1.............*Light, medium and heavy weight fabrics*
 If the control piece measures 3" (7.6 cm)
 between notches, the piece to be shirred
 will measure 6" (15.2 cm) between notches.

3 to 1.............*Light to medium weight fabrics*
 If the control piece measures 3" (7.6 cm)
 between notches, the piece to be shirred
 will measure 9" (22.8 cm) between notches.

4 to 1, or more....*Very light weight fabrics, or where an ex-
 ceptional amount of fullness is desired*
 Measure the control piece between the notches
 and multiply the distance by 4 (or whatever
 ratio is to be used) for the size of the
 piece to be shirred.

If shirring is used on more than one place in a garment, i.e., neck and
sleeve or front yoke and skirt, try to maintain the same ratio of shirring
throughout the garment. Once the machine is set to shirr a particular
fabric a given ratio it will speed up production and thereby lessen the
cost by not having to readjust the machine for each section of the garment.

1. Shirring with Waistline Dart

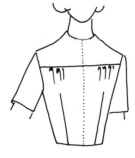

Figure 3

Figure 3 shows the completed garment.

Figure 4 shows where the pattern will be cut.

The yoke, which is the control piece, should be marked before the pattern is cut apart.

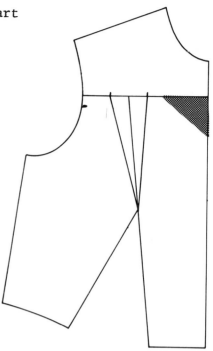

Figure 4

Figure 5 shows the completed patterns with the ratio of shirring at 1 1/2 to 1.

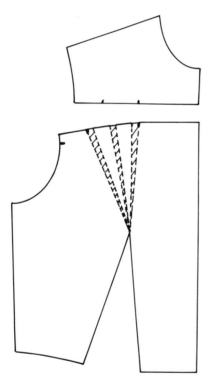

Figure 5

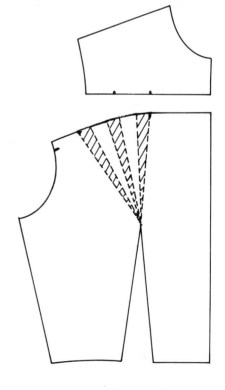

Figure 6

Figure 6 shows the completed patterns with the ratio of shirring at 3 to 1.

Note that the control piece remains the same regardless of the ratio of shirring.

140

2. Shirring for Extra Fullness

Figure 7 shows the completed garment.

Figure 7

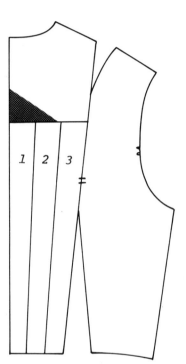

Figure 8

Figure 8 shows where the pattern will be cut. In this example the original distance from the center back to the dart will be the control for the waistline shirring.

The ratio of shirring will be the same at the yoke line and at the waistline - even though the yoke line is longer.

An easy way to do a ratio of 2 to 1 is to number the pieces and draw around each one twice.

Extra length is added to the lower edge of the center back to produce a bloused look as shown in *Figure 7*.

Figure 9 shows the completed patterns.

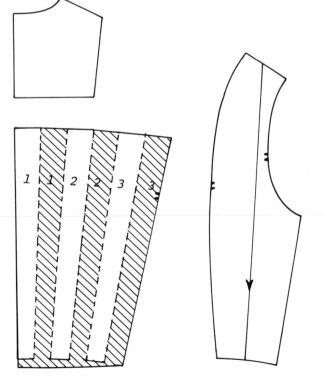

Figure 9

141

G. Midriff Seams

Since the original dart on the front bodice creates a straight line from
waistline to bust point, as shown in *Figure 1,* it is necessary to shape
the front dart so that it will conform to the contours of the body as
shown in *Figure 2.* The back darts remain the same.

The dart may be reshaped by measuring down about 3" (7.6 cm) on each leg
of the dart and making the dart 1/4" (0.6 cm) wider on each side at that
point. It is easier to get both legs of the dart curved the same by fold-
the dart through the center, curving only one leg and then tracing it
through to the other side. The new legs of the dart should be curved as
shown in *Figure 2.*

Figure 1

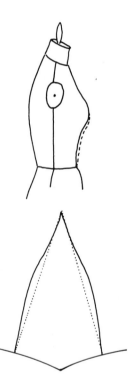

Figure 2

1. Midriff Seam with Shirring

Figure 3 shows the completed garment.

Figure 4 shows where the pattern will be cut after it has been altered at the dart for a snug fit under the bust.

The legs of the dart should be folded together when drawing the line for the midriff seam.

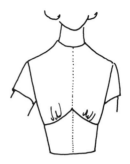

Figure 3

Figure 4

Figure 5 shows the completed patterns.

Figure 5

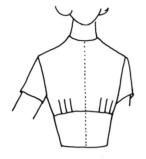

Figure 6

2. Midriff Seam with Triple Darts

Figure 6 shows the completed garment.

Figure 7 shows the pattern preparation.

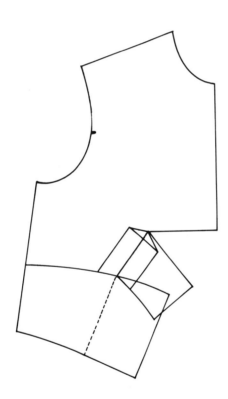

Figure 7

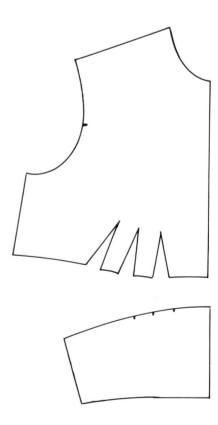

Figure 8 shows the completed patterns.

Figure 8

144

3. Snugg Midriff with Simulated Cummerbund

Figure 9 shows the completed garment.

Figure 10 shows the pattern preparation.

The dotted lines, which indicate where the pattern will be cut, are drawn parallel to the waistline.

When the pieces are spread apart they are kept in a straight line with the side seam and the center front.

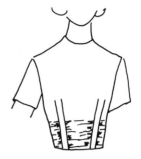

Figure 9

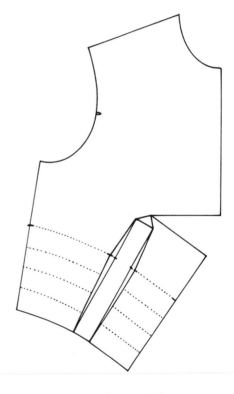

Figure 10

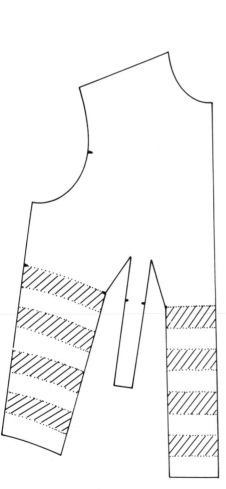

Figure 11

Figure 11 shows the completed patterns.

H. Surplice Lines

Surplice lines are usually a part of a closure which may be fastened at the waistline or buttoned. Surplice lines may be used on the front or the back of the bodice. It is sometimes necessary to make a slight adjustment at the waistline at the side seam due to the change in the grain of fabric.

1. Surplice Front Bodice

Figure 1 shows the completed garment.

Figure 2 shows the pattern preparation.

Figure 3 shows the completed pattern.

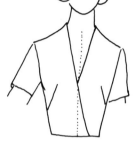

Figure 1

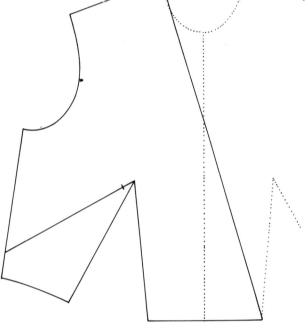

Figure 2

Note the grainline. The facing may be cut-on to the bodice and folded under or cut separately - depending on the width of fabric, type of fabric, whether an interfacing is to be used, etc.

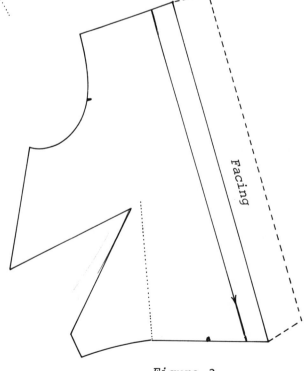

Figure 3

2. Surplice Back Bodice

Figure 4 shows the completed garment.

Figure 4

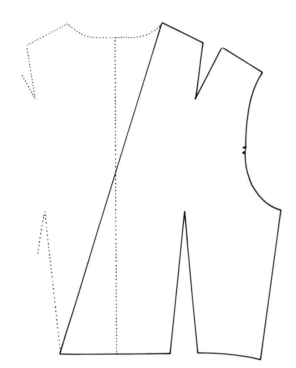

Figure 5

Figure 5 shows the pattern preparation.

Figure 6 shows the completed pattern.

If the fabric design requires a different grain line than shown here, the facing should be cut separately. The facing can then be cut on the straight of the fabric to prevent the surplice line from stretching.

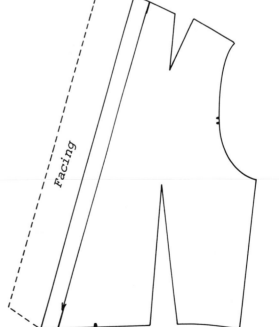

Figure 6

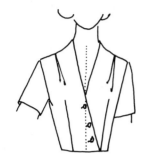

Figure 7

3. Buttoned Surplice

 Figure 7 shows the
 completed garment.

 Figure 8 shows the
 pattern preparation.

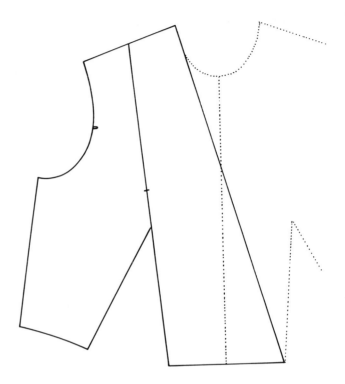

Figure 8

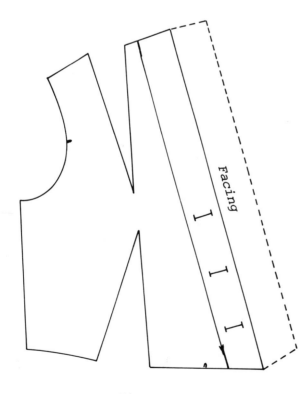

Facing

Figure 9 shows the completed
pattern.

Note the direction of the button-
holes due to the change in the
grain line.

Figure 9

I. Double Breasted Closures

The double breasted closure is usually buttoned. In essence it is simply an enlarged extension with a corresponding increase in the lap-over. Functional buttons and buttonholes are generally used only on the outer edge of the extension and the second row of buttons is for decorative balance.

If both sets of buttons and buttonholes are not functional, it will be necessary to hold the extended edge of the underside of the garment with hidden snaps, hooks or inside buttons.

1. Double Breasted Front Bodice

Figure 1 shows the completed garment.

Figure 2 shows the pattern preparation.

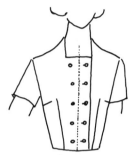

Figure 1

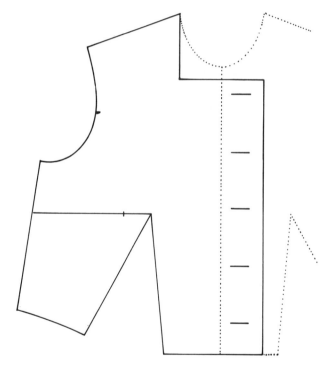

Figure 2

Figure 3 shows the completed pattern.

Only one set of buttonholes need to be marked on the pattern.

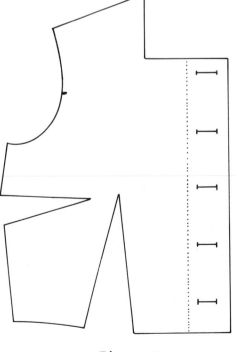

Figure 3

149

2. Double Buttoned Back Bodice

 Figure 4 shows the completed garment.

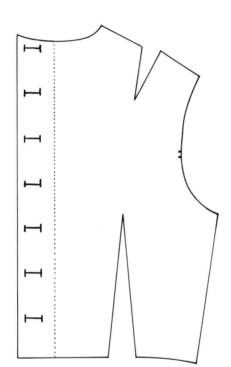

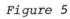

Figure 5

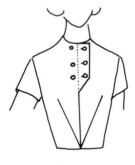

Figure 6

Figure 4

Figure 5 shows the completed pattern with the extension added to the back bodice and the buttonholes marked.

3. Double Buttoned Opening Front Bodice

 Figure 6 shows the completed garment.

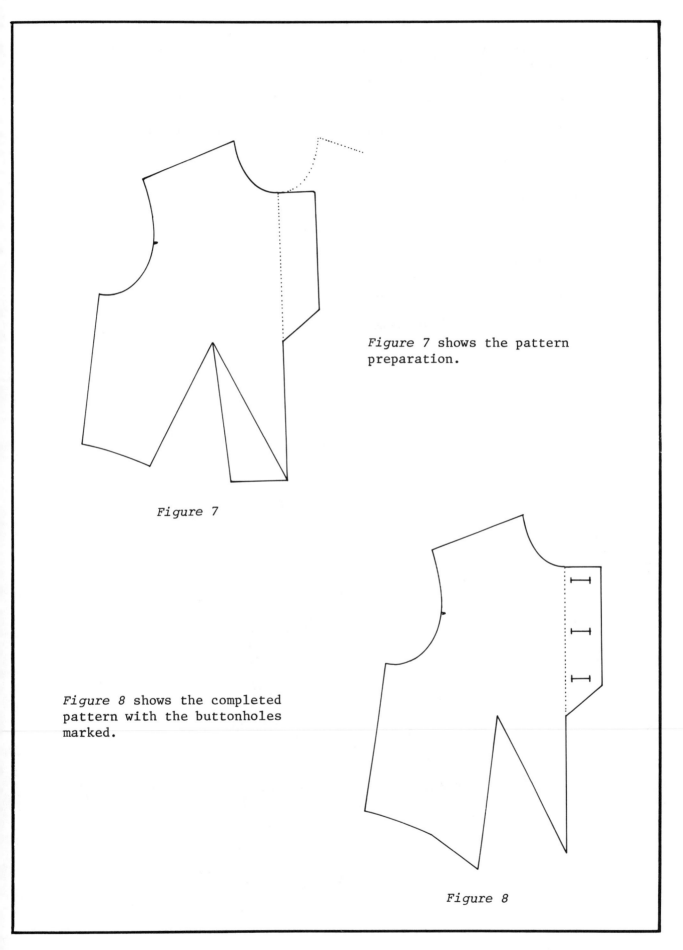

Figure 7 shows the pattern preparation.

Figure 7

Figure 8 shows the completed pattern with the buttonholes marked.

Figure 8

J. Side closures differ from double breasted or double buttoned garments in that the patterns for the left and right sides are not identical. Sometimes the patterns are marked *Left Side* and *Right Side* but most factories mark the patterns *This side up* to distinguish between the two sides.

Side closures use only one row of buttons, hooks or a zipper.

1. Buttoned Side Closure

 Figure 1 shows the completed garment.

 Figure 2 shows the pattern preparation.

 Note that the full front bodice must be used. The shaded area indicates the overlap for the buttons and buttonholes.

 Figure 3 shows the completed patterns.

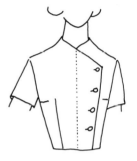

Figure 1

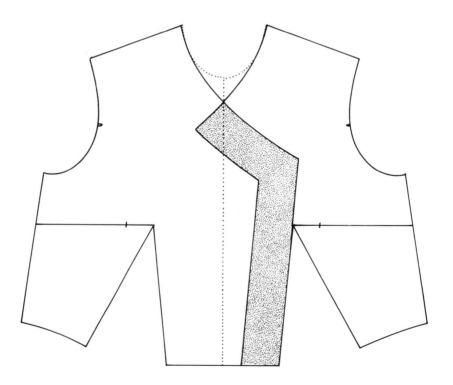

Figure 2

152

The grain lines are determined by drawing parallel lines to the original Center Front of the bodice.

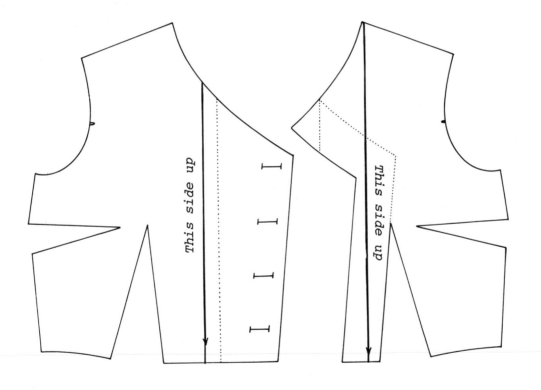

Figure 3

2. Zippered Side Closure

Figure 4, Figure 5, Figure 6 show the completed garment, pattern preparation and completed patterns.

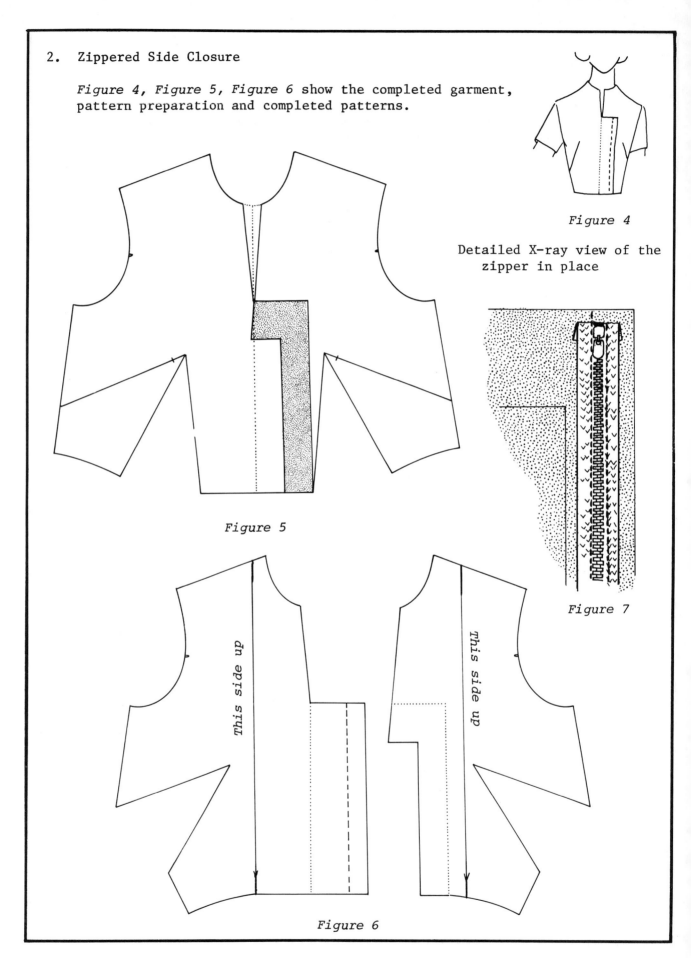

Figure 4

Detailed X-ray view of the zipper in place

Figure 5

Figure 7

This side up

This side up

Figure 6

ELIMINATION OF SIDE SEAMS AND SHOULDER SEAMS

Before commercial patternmaking was developed all clothing was
individually tailored for the wearer. When *ready to wear - pret
a porter* to the French, *off the peg* to the English - became widely
acceptable as fashionable clothing during the 1920's, garment
makers needed a model or *mannequin* on which to fit the mass pro-
duced clothing.

Live models were fine for showing the finished garments but they
were not entirely satisfactory to pin and drape on: They couldn't
stand still long enough and they were expensive. *Papier mache*
bodies, covered with linen, proved a practical substitute.

Manufacturers began using the seams on the dress forms as guides
for putting the seams on garments. The accepted placement of
major seams was dictated by the seaming on the dress forms.

When working with basic blocks it is easy for the designer to
forget that the human body does not have *shoulder seams, waist-
line seams, side seams, etc.,* even though more than 90% of the
manufactured clothes are constructed with these seams. People
have become accustomed to them and look at these seams for points
of alteration.

Occasionally some of these seams may be eliminated - for reasons
of styling, to reduce sewing costs or to reduce yardage. With
new developments in knitted and elasticized fabrics, and with the
recent advances in sizing, alterations problems have decreased.
Thus, unusual seam placement has become more acceptable to the
customer.

When experimenting with new ideas for the elimination of some of
the usual seaming on a garment, a set of minature blocks that can
be easily shifted around will be much easier to work with than
full scale blocks. Once the idea has been worked out with the
small blocks it is a simple matter to translate the idea into the
full scale blocks.

Figure 1

1. Bodice Without Standard Shoulder
 Seams

The original garments from which this
style was adapted were work clothing.
The shoulder area was doubled fabric
or padded to protect the worker's
shoulder area when carrying a large
wooden bar from which were suspended
buckets or containers. This equip-
ment was known as a yoke, hence the
term by which we refer to this part.

Figure 1 shows the completed garment with the seam at the shoulder
brought forward in a yoke.

Figure 2 shows the pattern preparation. The back shoulder dart
will be transferred into a seam in the final pattern. It is easy
to get the correct line by folding the dart before drawing the
back yoke.

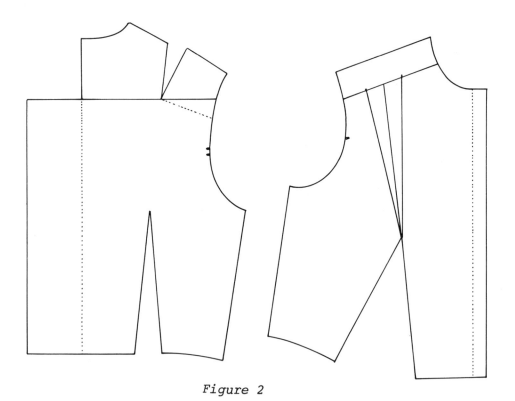

Figure 2

When matching the front and back sections at the shoulder line to elimi-
nate the seam in the yoke, be sure to match the two pieces at the neck
if there is any difference in length of shoulder. The difference can be
easily blended into the shoulder edge where the fitting is not so criti-
cal. Be sure to notch the yoke section at the shoulder edge for match-
ing the notch in the center of the cap of the sleeve.

Figure 3 shows the completed patterns. The patterns for the yoke and
the back bodice are constructed on a fold of paper so that when they
are cut and unfolded they will be complete.

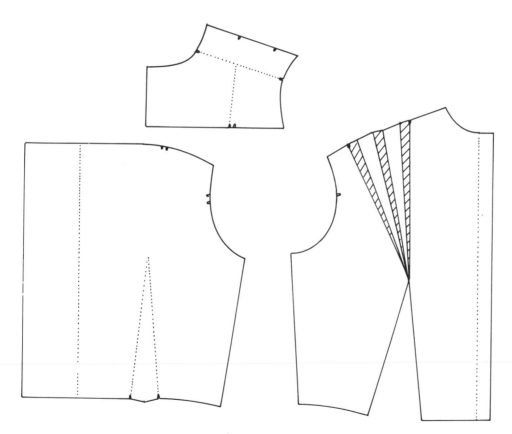

Figure 3

2. Bodice Without Standard
 Side Seams

 Figure 4 shows the completed
 garment.

Figure 4

Figure 5 shows the pattern preparation. Note that the area of
the original waistline dart in the back bodice is transferred
to the new seam and the original dart is closed.

Be sure to make crossmarks as guides for matching pieces before
cutting the patterns apart.

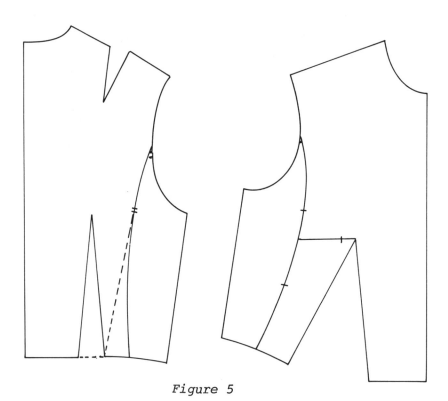

Figure 5

Figure 6 shows the completed patterns.

Grain lines would be at the center front, on the original side seam and at center back unless the fabric design dictated otherwise.

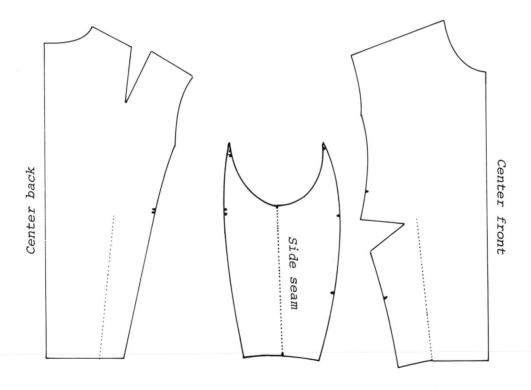

Figure 6

3. Bodice Without Standard
 Shoulder Seams Or Side
 Seams

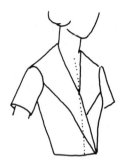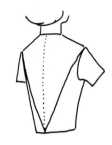

Figure 7 shows the com-
pleted garment. This
would have to be a sur-
plice or wrap-over front
as there would be no
other means of putting
the garment on.

Figure 7

Figure 8 shows the pattern preparation. Note how the shoulder
dart is transferred to a new location.

Be sure to make crossmarks on the style lines before cutting
the pattern apart.

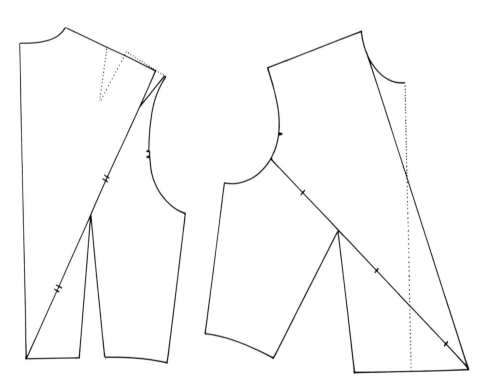

Figure 8

Figure 9 shows the completed patterns.

Unless the design of the fabric required a different treatment, the grain lines would be on the center back and where the original side seams came together.

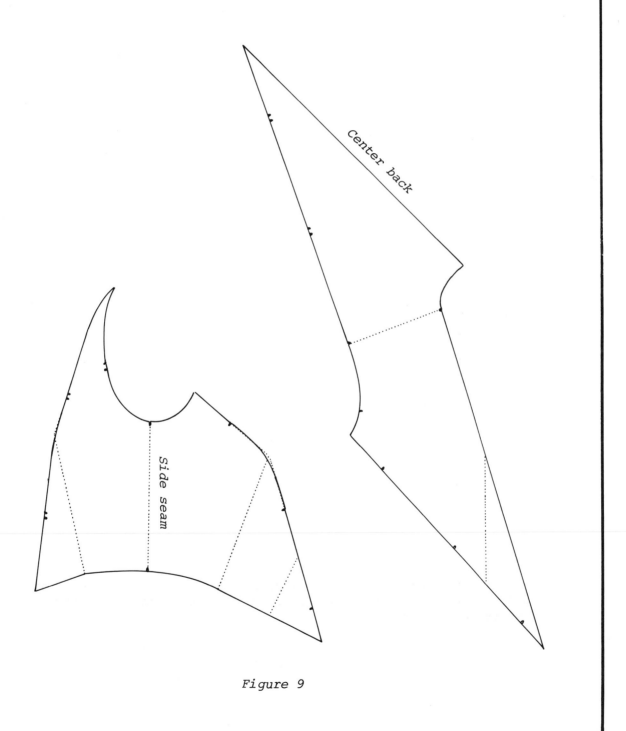

Figure 9

SLEEVELESS BODICES - OPEN NECKLINES

The standard basic bodice is constructed for a sleeve. When a sleeveless bodice is desired, the following changes must be made on the *front* and *back* of the standard basic bodice patterns:

3/8" (1.0 cm) is removed from the side seam at the armscye to nothing at the waistline. If a side bust dart is used, be sure to fold out the dart before making the side seam adjustment.

If the garment is for a size or age range where a brassiere is likely to be worn, the lower armscye is raised 1/4" (0.6 cm) at the side seam. The line is blended back into the curved line of the original armscye.

See *Figure 1* for the above alterations.

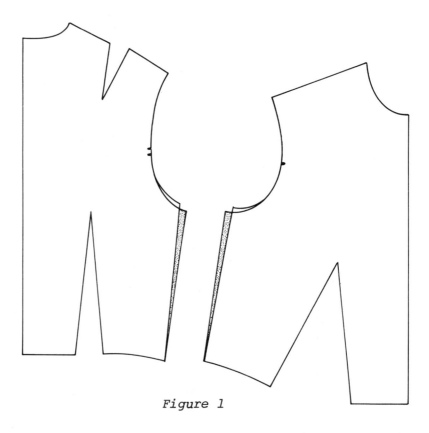

Figure 1

Note that 1/4" (0.6 cm) seam allowance is needed for sewing the facing to a sleeveless armscye - instead of the 1/2" (1.3 cm) seam allowance necessary for setting in a sleeve.

The notches on the armscye remain the same - single notch to indicate the front and double notches for the back.

If a wider neckline, or any other style line, is going to interfere with the back shoulder dart, the shoulder dart should be transferred to the back neck:

Find the middle of the back neck on the basic back bodice and draw a line parallel with the center back and the same length as the original shoulder dart.

Starting at this new mark on the neckline, draw around the remainder of the neckline to the center back. Draw around the center back, waistline, side seam, armscye including the notches, the shoulder seam to the outer edge of the original shoulder dart. Draw in the direction indicated by the arrows in *Figure 2*.

Slide the pattern away from the center back – keeping the center back of the pattern parallel with the center back just drawn – until the shoulder dart is closed at the shoulder seam. Draw from the shoulder dart to the neckline and the edge of the new neckline dart.

Follow the directions of the arrows in *Figure 3*. The center of the new neckline dart will be parallel to the center back.

Smooth out the shoulder line of the new pattern and check it against the shoulder length of the front bodice. The two shoulder lengths should be the same. Any adjustments necessary should be made on the back shoulder of the new pattern before cutting.

Figure 2

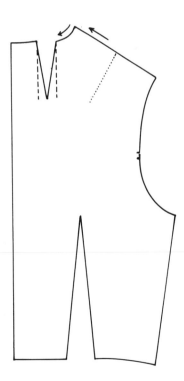

Figure 3

When the neckline is to be widened at the shoulder seam, 1/4" (0.6 cm) should be removed from the neck edge of the seam to nothing at the armscye edge on both the *front* and *back* of the bodice.

This will make the garment fit better into the curve of the shoulder and will help eliminate gapping at the neckline. See *Figure 4*

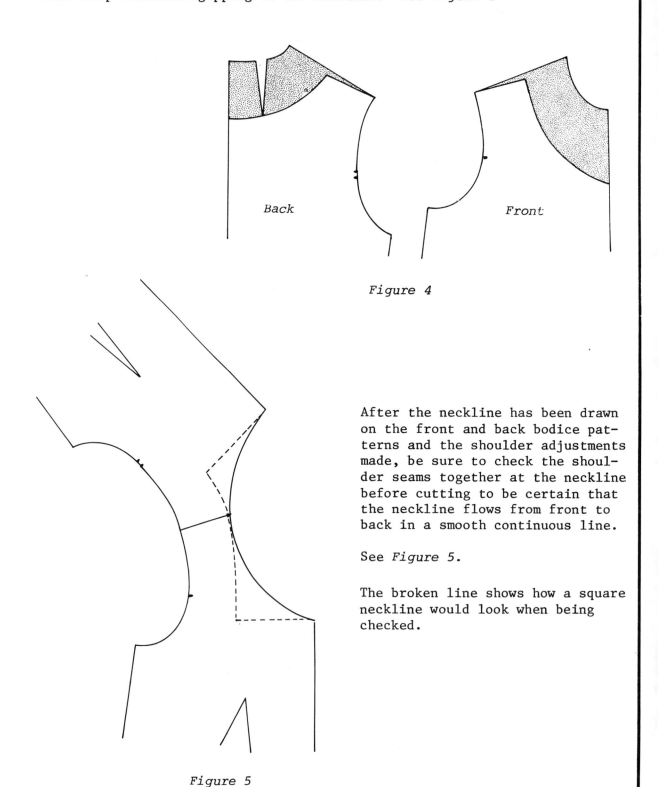

Back

Front

Figure 4

After the neckline has been drawn on the front and back bodice patterns and the shoulder adjustments made, be sure to check the shoulder seams together at the neckline before cutting to be certain that the neckline flows from front to back in a smooth continuous line.

See *Figure 5.*

The broken line shows how a square neckline would look when being checked.

Figure 5

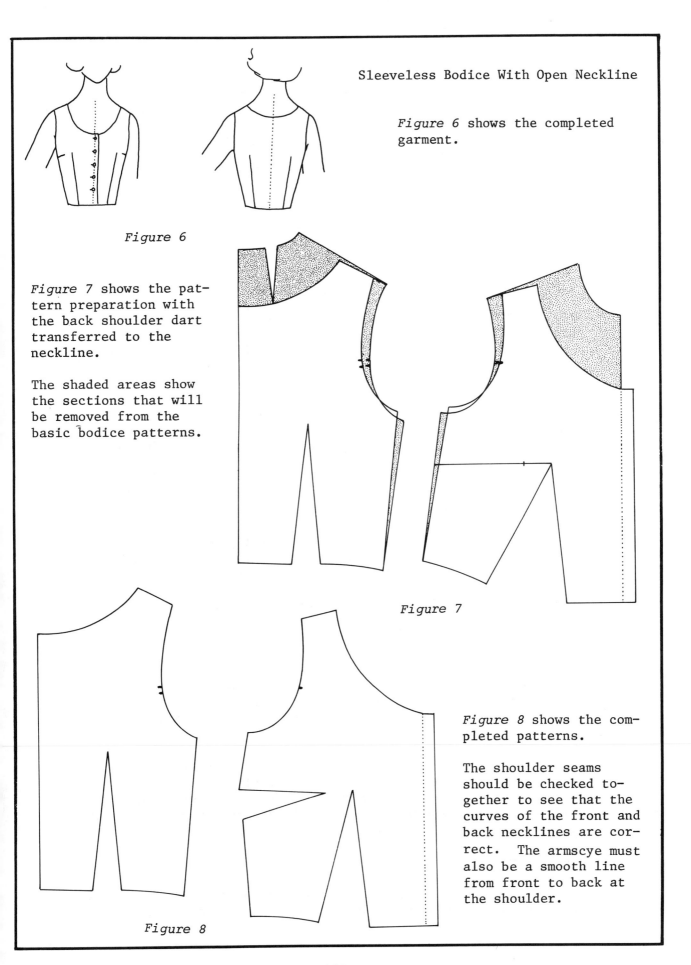

Figure 6 shows the completed garment.

Figure 6

Figure 7 shows the pattern preparation with the back shoulder dart transferred to the neckline.

The shaded areas show the sections that will be removed from the basic bodice patterns.

Figure 7

Figure 8 shows the completed patterns.

The shoulder seams should be checked together to see that the curves of the front and back necklines are correct. The armscye must also be a smooth line from front to back at the shoulder.

Figure 8

STRAPLESS BODICE

Support for the breasts in a strapless bodice must be through the snug fit of the bodice in the midriff section and reinforced with featherboning at the seam lines. Once the lining foundation is properly constructed it may be draped with looser fitting fabric so that it will not resemble a long-line brassiere.

Strapless Bodice Lining Foundation

Figure 1 shows the completed foundation.

Draw around the front and back basic bodice patterns and make the following adjustments:

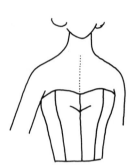

Figure 1

Remove 3/8" (1.0 cm) from the side seams from the armscye to and including the waistline on both the front and back blocks.

From the center back, square a line to 1/2" (1.3 cm) below the top of the back waistline dart. Continue the line in a slight curve to the top of the side seam at the underarm.

On the front bodice draw in the upper edge by curving a line from the side seam at the underarm, over the radius of the bust area, and dipping slightly in the center front.

At the upper edge of the bodice front make a small curved dart to the bust point. The dart should be 1/4" (0.6 cm) wide from each side of the line from the middle of the shoulder to the bust point.

Approximately 1/2" (1.3 cm) below the circle of the bust area, take out 1/2" (1.3 cm) from each side of the waistline dart. Curve the dart up to the bust point and in a straight line down to the waistline.

About 1/2" (1.3 cm) below the bustline at the center front, draw a line from the center front to the point of the bust. This will be opened 1" (2.5 cm) to form the dart in the center front. The point of the new dart will be about 1" (2.5 cm) from the original bust point.

See *Figure 2*.

The shaded areas are the sections to be removed from the basic front and back bodice patterns. Make crossmarks as shown.

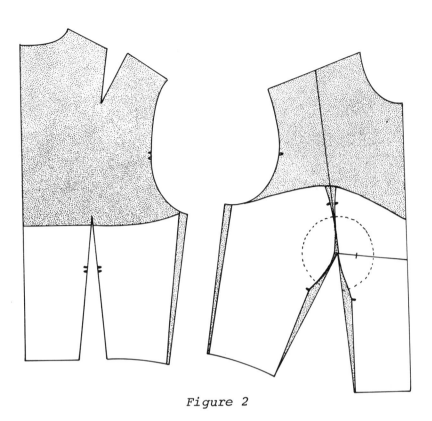

Figure 2

Figure 3 shows the completed patterns. Grain lines for the front and back sections are parallel with the center front and center back. The grain lines of the side sections are drawn through the centers of the panels as on the princess bodice.

Figure 3

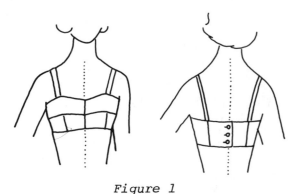

Figure 1

BRA-TOPS

The bra-top outer garment supports the breasts through either the shoulder straps or a built-up shoulder – with or without a sleeve.

Bra-tops may be made with or without pre-moulded bust forms.

Primary attention must be paid to getting the garment to fit snugly under the breasts, generally with the use of some elastic inserts.

1. Bare Midriff Bra-Top

 Figure 1 shows the completed garment.

 Figure 2 shows the pattern preparation. Note that the areas of adjustment are similar to those for the Strapless Bodice, plus the adjustments on the shoulder seams.

Figure 2

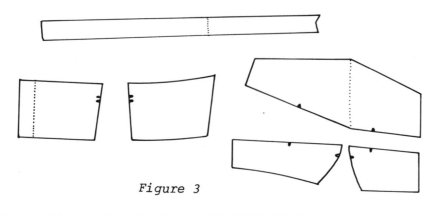

Figure 3

Figure 3 shows the completed patterns.

When adding seam allowances, the end of the shoulder strap at the back should have an extra 1 1/2" (3.8 cm) for adjustment.

168

2. Bare Midriff Bra-Top With Sleeves

Figure 4 shows the completed
garment.

Figure 4

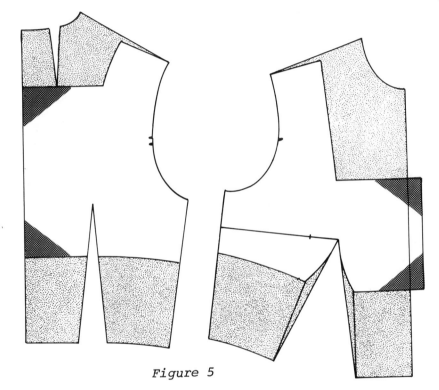

Figure 5 shows the pat-
tern adjustments.

The lower edge of the
garment is parallel to
the waistline. Fold
out the darts to get a
smooth continuous line
at the lower edge.

Figure 5

Figure 6 shows the com-
pleted patterns. The
grain lines would be
parallel with the cen-
ter front and center
back. The center back
pattern is made on the
fold as there is no
center back seam.

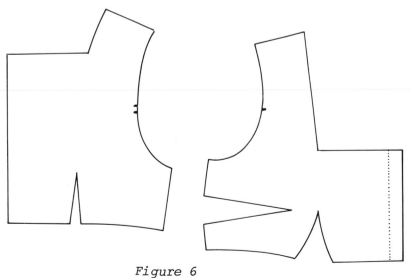

Figure 6

3. Bra-Top With Skirt Attached

Figure 7 shows the upper part of the completed garment.

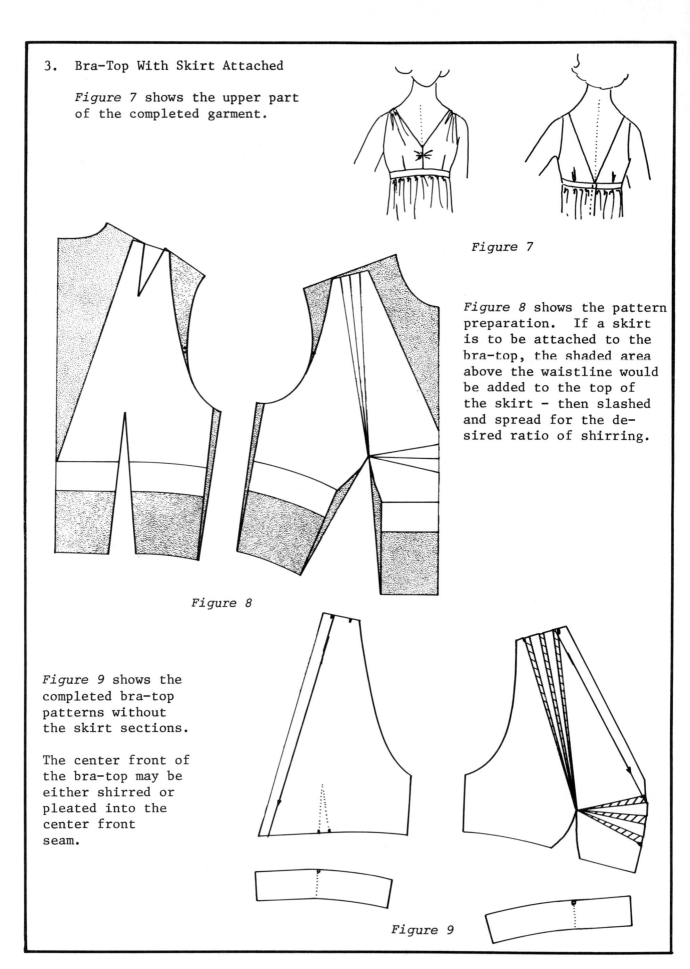

Figure 7

Figure 8 shows the pattern preparation. If a skirt is to be attached to the bra-top, the shaded area above the waistline would be added to the top of the skirt - then slashed and spread for the desired ratio of shirring.

Figure 8

Figure 9 shows the completed bra-top patterns without the skirt sections.

The center front of the bra-top may be either shirred or pleated into the center front seam.

Figure 9

Notes

Chapter 10

Skirts

Notes

Skirt patterns are either constructed as a part of a dress or as a separate garment. The skirt for the basic block is a part of a dress and needs no adjustment when it is to be attached to a bodice.

In addition to the single dart skirt, i.e., one dart in each quarter section of the pattern, a double dart skirt block as shown in *Figure 1* will also prove useful. The double dart skirt generally fits better, particularly when there is a greater than normal difference between the waist and hip measurements.

To make the double dart pattern, draw around the single dart front skirt beginning at the center front waist, down to and including the hemline, up the side seam to the hipline.

Trace in the hipline and the abdominal extension line. Mark the waistline from the center front to the edge of the first dart.

Front *Back*

Figure 1

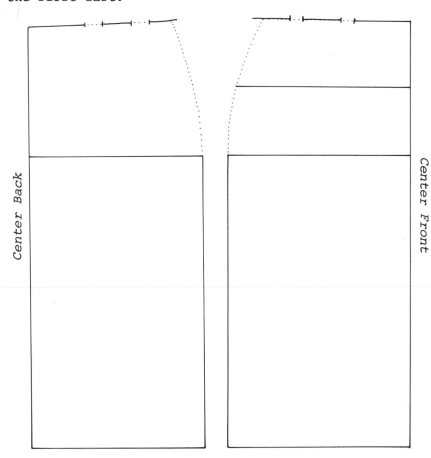

Center Back

Center Front

For the front double dart skirt, the darts will be 3/4" (1.9 cm) wide. The second dart will be exactly halfway between the first dart and the side seam.

The back skirt is done in the same way as the front skirt.

The back darts are each 1" (2.5 cm) wide.

See *Figure 2*.

Figure 2

To complete the darts on the front skirt: The center of the first dart - the one closest to the center front - will be parallel with the center front. The end of the second dart will be located halfway between the point of the first dart and the side seam on the abdominal extension line.

To complete the darts on the back skirt: The center of the first dart - the one closest to the center back - will be parallel with the center back. The second dart is located halfway between the end of the first dart and the side seam at the hipline. The second dart is 1" (2.5 cm) shorter than the first dart. See *Figure 3*.

Complete the front skirt by folding out the darts and curving the waistline very slightly from the first dart to the side seam. Check the front skirt against the back skirt at the side seams, adjusting the back skirt at the waistline of the side seam if any adjustment is necessary. Fold out the back darts and curve the waistline from the first dart to the side seam.

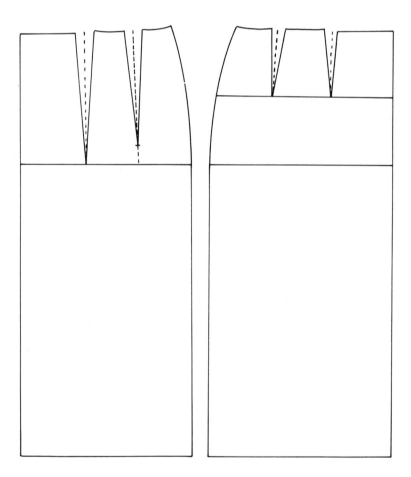

Figure 3

176

SKIRTS ATTACHED TO BODICES

As the bodice patterns are generally made before the skirt patterns are made, the dart and seam placement on the bodice must be kept in mind when working on the skirt.

Front skirts should be checked against front bodices and back skirts against back bodices.

If there is more than one piece in the front or back skirt, the patterns should be checked against the adjoining sections, using single notches to fit front skirts together and double notches for back skirts. Notches at the side seams on both front and back skirts are always single notches as double notches can never be matched to single notches.

1. Flared Skirts

 A. A-Line Flare

 This skirt has a minimum
 amount of flare and may be
 cut with or without center
 seams. The grain line
 should run parallel with
 the center of the skirt
 in both front and back.

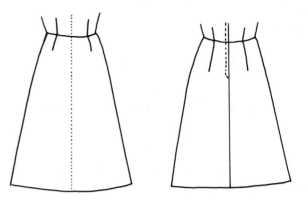

Figure 4

 Figure 4 shows the completed
 skirt.

 Figure 5 shows the pattern preparation. The skirt sections are
 cut on the lines running from the second darts on both the back
 and the front.

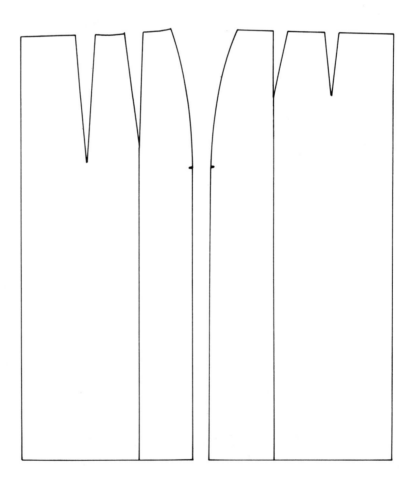

Figure 5

When the second darts in the front and back skirts are closed, as shown by the dotted lines, the lower sections will be spread apart.

Instead of slashing and spreading, these patterns could be made by pivoting. After drawing around the front skirt from the edge of the second dart to the line from the second dart at the hemline, hold the point of the second dart with a push pin and pivot the dart closed. Draw from the mark on the hemline, up the side seam, to the second dart.

The same procedure would be repeated for the back skirt.

Figure 6 shows the completed patterns.

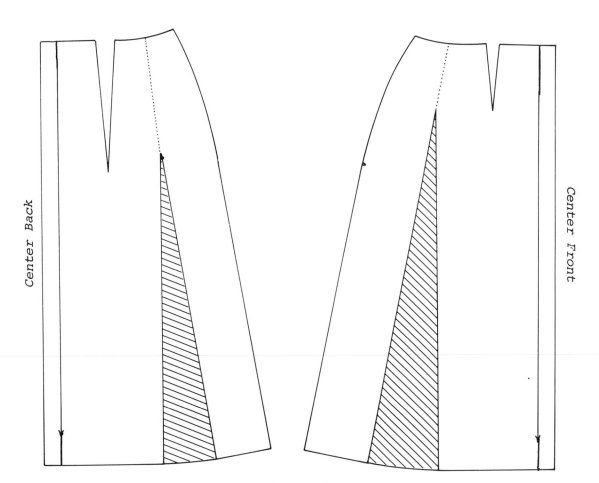

Figure 6

B. Full Flare

The flare is obtained by closing out both darts,
either by pivoting or slashing, and adding width
to the side seams at the hemline.

The placement of the grain line will determine
the effect achieved. In *Figure 7,* with grain
line at the center, the fullness is at the sides.
In *Figure 8,* with the grain parallel to the
side seam, the fullness is in the center. In
Figure 9, with the grain line evenly divided at
the waistline and hemline, the flare is evenly
distributed.

None of the grain lines shown are either right
or wrong – just be sure to use the one that will
give the desired effect. Grain lines must be
consistent for the front and back, i.e., both
straight in the center of the skirt; both straight
at the side seams; both evenly divided.

Figure 10 shows the pattern preparation.

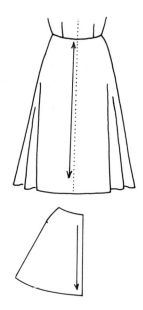

Figure 7

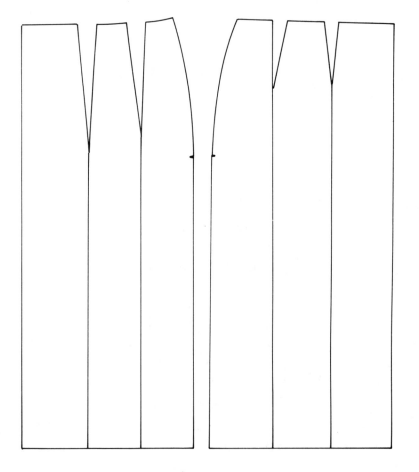

Figure 10

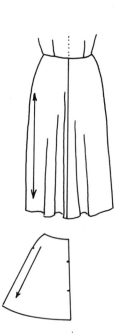

Figure 8

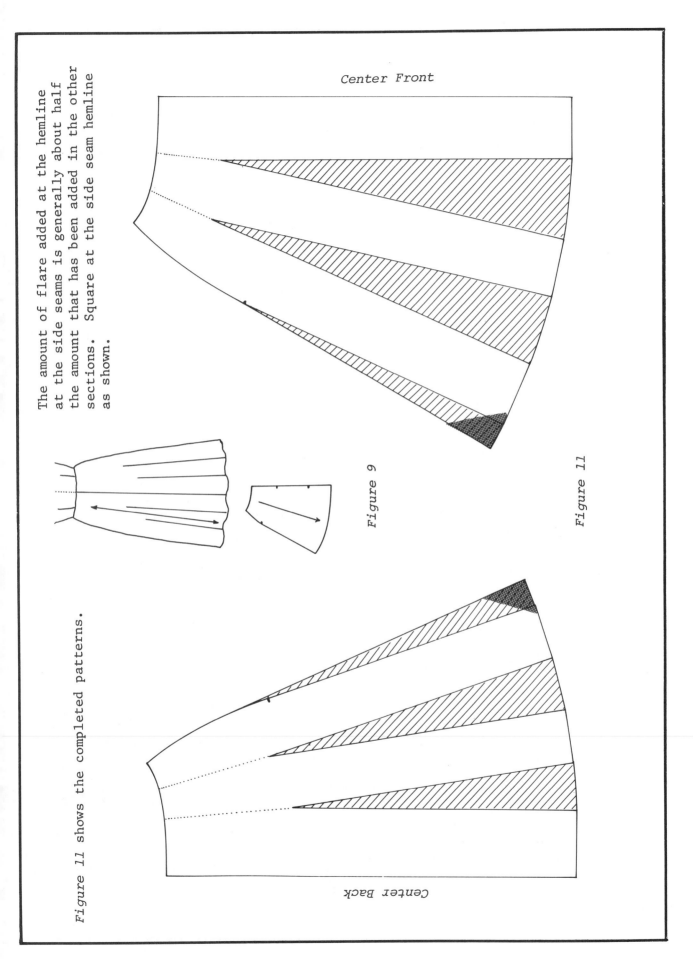

Center Front

The amount of flare added at the hemline at the side seams is generally about half the amount that has been added in the other sections. Square at the side seam hemline as shown.

Figure 9

Figure 11

Figure 11 shows the completed patterns.

Center Back

181

C. Bias Flare

Figure 12 shows the completed skirt.

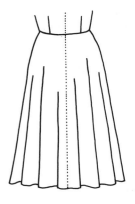

Figure 12

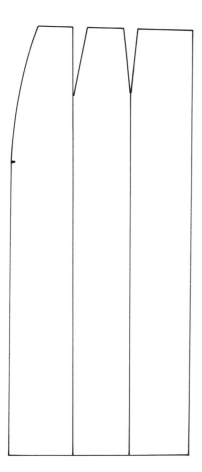

Figure 13 shows the pattern preparation, which is exactly the same as for the Full Flare Skirt.

This pattern can be made by either slashing and spreading or by pivoting.

Figure 13

Because fabric stretches when cut on the bias, part of the curve at the side seam at the hip can be removed for a smoother fit. This same adjustment would be made on the back skirt pattern.

Be sure to let any skirt cut on the bias hang for 24 hours before marking the hem. After the hemline has been marked and the excess fabric trimmed away, lay the fabric removed from the hemline on the original patterns to correct the patterns. By following this procedure, future skirts cut in the same fabric will then hang even at the hemline after 24 hours.

Figure 14 shows the completed front skirt pattern. Construction of the back skirt pattern would follow the same procedure as for the front skirt.

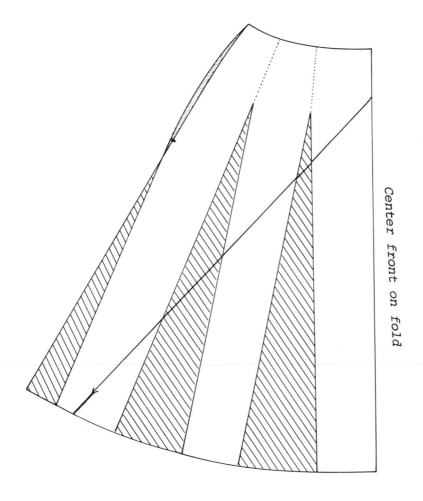

Figure 14

183

2. Gored Skirts

In the following examples, fullness is achieved by cutting the skirt into panels and adding flare to each section. Note the crossmarks and notching on each illustration.

A. Six Gored Skirt

Figure 1 shows the completed skirt.

Figure 2 shows the pattern preparation with identifying crossmarks on the various sections.

The center back panel may be made in one piece by making the pattern on the fold of the paper - or made in two pieces with seam allowance on the center back seam.

Figure 1

Figure 2

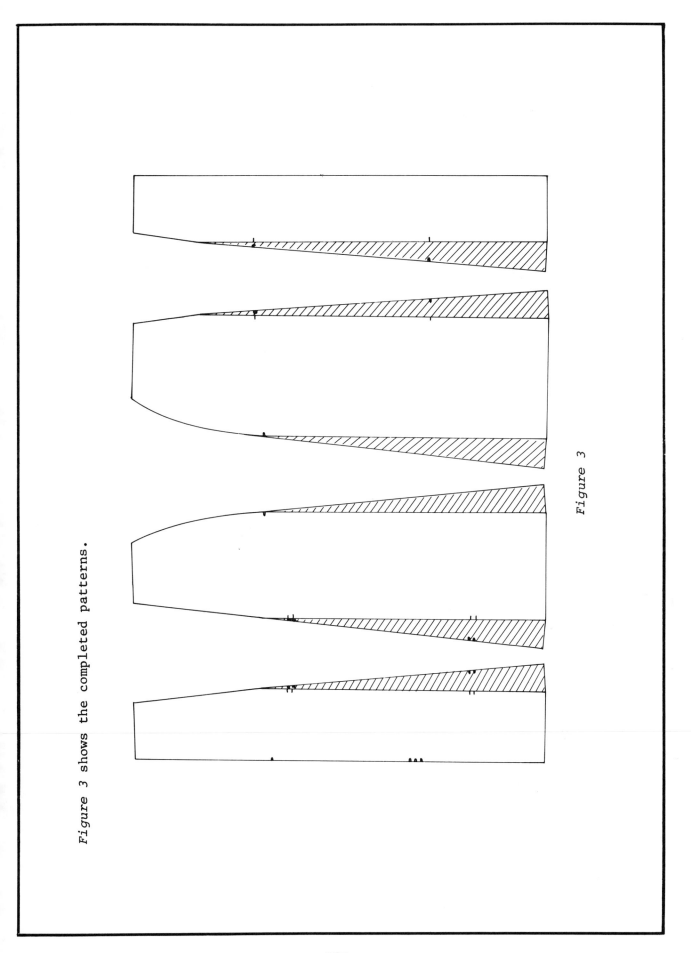

Figure 3 shows the completed patterns.

Figure 3

185

B. Eight Gored Skirt

Figure 4 shows the completed
skirt.

Figure 5 shows the pattern
preparation.

In the six and eight gored
skirts, the single dart or
double dart blocks may be
used.

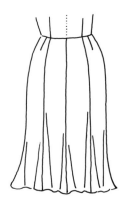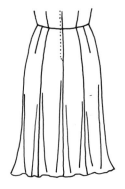

Figure 4

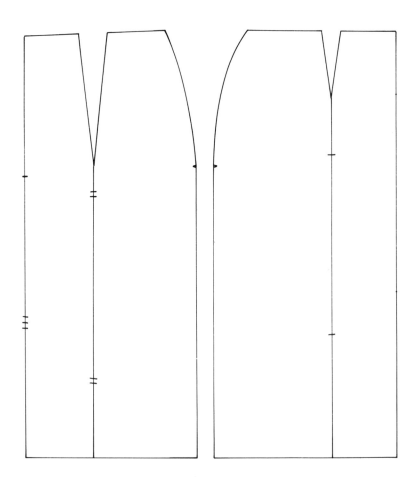

Figure 5

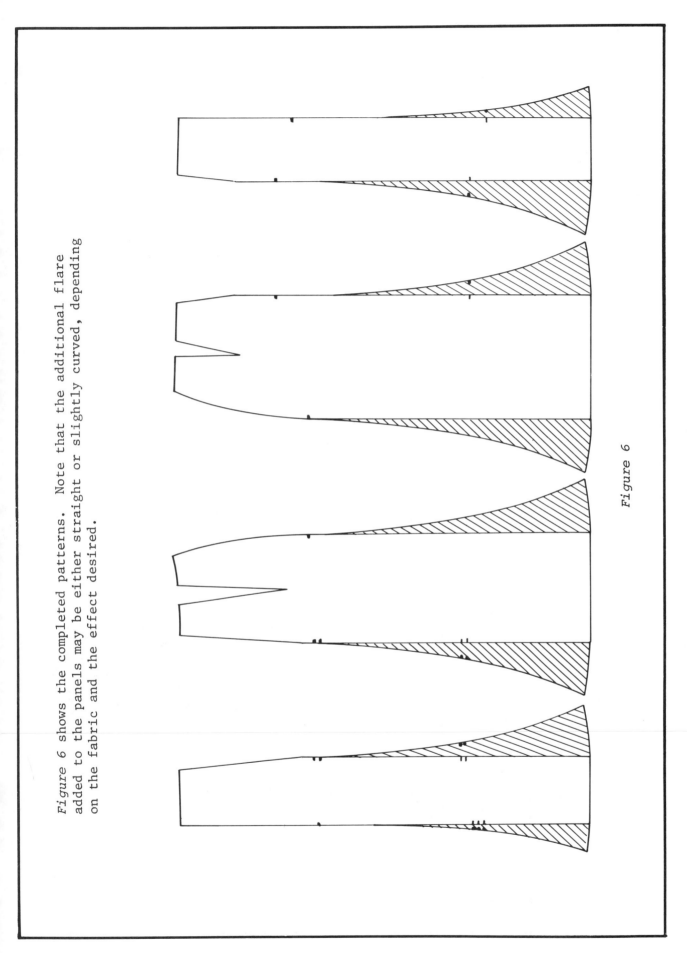

Figure 6 shows the completed patterns. Note that the additional flare added to the panels may be either straight or slightly curved, depending on the fabric and the effect desired.

Figure 6

187

C. Twelve Gored Skirt

Figure 7 shows the completed skirt.

Figure 7

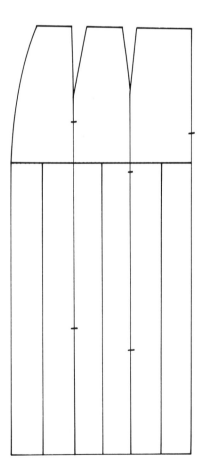

Figure 8 shows the pattern preparation
for the front skirt.

The back skirt is made the same way the
front skirt is made.

A "24 gored skirt" can be made on this
pattern by placing the grain line at
the center of each panel and then sew-
ing a small inside tuck for the length
of each panel. Be sure to allow extra
width on each panel for the width of the
tuck.

Figure 8

Figure 9 shows the completed patterns for the front skirt.

Follow the same procedure to make the back skirt.

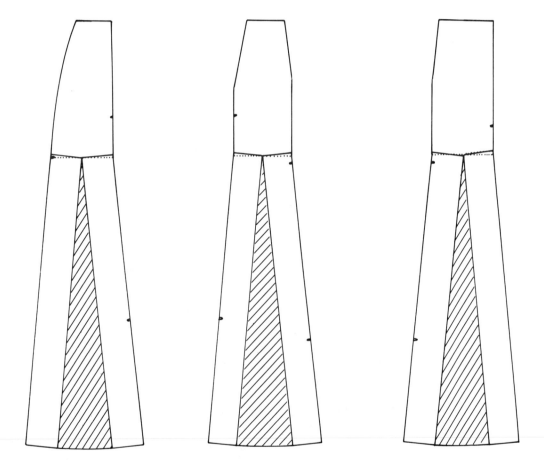

Figure 9

Note that the straight pieces that are spread apart for the flare over-
lap slightly at the hipline. The amount of overlap will depend on the
amount of flare added at the hemline. Smooth out any angle created at
the hipline.

3. Circular Skirts

 Accurate measurements for the waistline of patterns for circular skirts
 may be determined with this simple mathematical formula:

 Circumference (waistline measurement) divided by *PI* (3.1416 or 3 1/7)
 equals *diameter* (distance across the middle of the circle).

 Diameter divided by 2 equals the *radius* (distance from the center of
 the circle to the edge of the circle).

A. Full Circle Skirt

 Figure 1 shows the completed skirt.

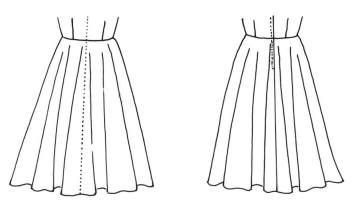

Figure 1

 Since only the measurements from the basic block are used, but
 not the basic block patterns, the pattern for the circular
 skirt is constructed in the following steps:

(1) Separate Skirt Not Attached To Bodice

 Find the radius of the waistline measurement. For a size 10
 this would be 1/2" (1.3 cm) smaller than the waistline for a
 skirt attached to a bodice – 26" (66.0 cm).

 26" ÷ 3 1/7 = 8 1/4" ÷ 2 = 4 1/8" radius
 (66.0 cm ÷ 3.1416 = 21.0 cm ÷ 2 = 10.5 cm radius)

 On a strip of firm paper about 1" (2.5 cm) wide and 30"
 (76.0 cm) long, mark *Pivot point, Waistline* and *Hemline*
 as shown in *Figure 2.*

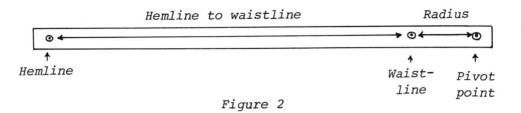

Hemline to waistline Radius

Hemline Waist-line Pivot point

Figure 2

Fold the pattern paper and square a line from the fold, near the top, for the side seam.

Holding the *Pivot point* with a push pin at the intersection of the fold and the squared line, pivot the strip of paper to mark the *Waistline* and *Hemline*. See *Figure 3*.

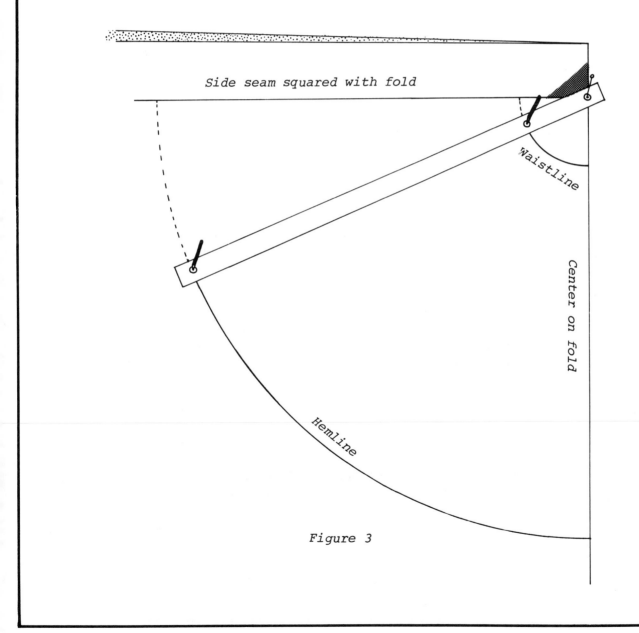

Side seam squared with fold

Waistline

Center on fold

Hemline

Figure 3

1" (2.5 cm) seam allowance is added to the side seam. 1/4"
(0.6 cm) is added to the outer edge of the waistline and 1/2"
(1.3 cm) is added for the hem allowance at the bottom or lower
edge. The skirt should hang for 24 hours before marking the
finished hemline. See *Figure 4*.

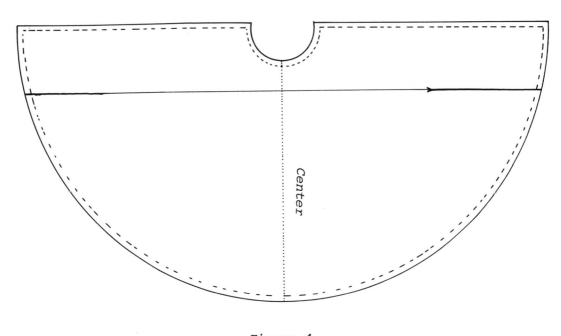

Figure 4

The same pattern is used for the front and back skirt. If the back
skirt is to have a center back seam, trace the front skirt pattern,
using the folded edge as the center back, and add seam allowance.

(2) Skirt Attached To Bodice

The procedure is the same as for a separate skirt except that
in order to make the front skirt fit to the front bodice and
the back skirt to the back bodice, separate patterns must be
made for the front and back.

Double the full front waistline measurement taken from the
front bodice for the *circumference*. Divide by *pi* for the
diameter. Divide the *diameter* by 2 for the *radius*.

Size 10 - Half of Front Waist - 7" (17.8 cm)
 Full Front Waist - 14" (35.6 cm)

14" x 2 = 28" ÷ 3 1/7 = 8 10/11" ÷ 2 = 4 1/2" radius
(35.6 cm x 2 = 71.2 cm ÷ 3.1416 = 22.8 cm ÷ 2 = 11.4 cm radius)

Follow the directions in (1) Separate Skirt Not Attached To Bodice except that 1/2" (1.3 cm) seam allowance will be used at the waistline to sew the skirt to the bodice.

For the back skirt, double the full back waistline measurement for the *circumference*. Divide by *pi* for the *diameter*. Divide the *diameter* by 2 for the *radius*.

Size 10 - Half of Back Waist - 6 1/4" (15.9 cm)
 Full Back Waist - 12 1/2" (31.8 cm)

12 1/2" x 2 = 25" ÷ 3 1/7 = 8" ÷ 2 = 4" radius
(31.8 cm x 2 = 63.6 cm ÷ 3.1416 = 20.2 cm ÷ 2 = 10.1 cm radius)

Complete the back skirt by the same method used for the front skirt.

Figure 5 shows a comparison between the front and back skirt patterns when the patterns are made to fit the bodice patterns at the waistline.

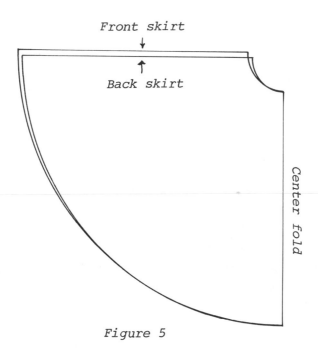

Figure 5

193

B. Half Circle Skirt

Since there are no side seams, only a center back seam, this skirt
is usually made as a separate skirt.

Figure 6 shows the completed skirt.

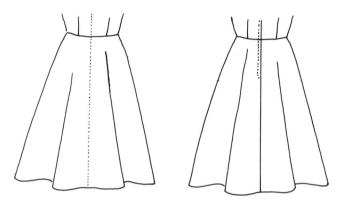

Figure 6

For the half circle skirt, the *diameter* of the *circumference*
of the waistline is used as the distance from the *pivot point*
to the waistline on the strip of paper used to pivot.

 26" ÷ 3 1/7 = 8 1/4" - pivot point to waistline
 (66.0 cm ÷ 3.1416 = 21.0 cm - pivot point to waistline)

Refer to *Figure 3* to make the pattern.

The completed pattern would appear the same as the half of the
full circle, *Figure 4,* except that the waistline is larger and
only one piece is cut.

C. Double Circle Skirt

This style may be used as either a separate skirt or attached to a
bodice. Directions are given for the separate skirt but if differ-
ent front and back patters are required, refer to the directions
under A (2) Skirt Attached To Bodice.

 26" ÷ 3 1/7 = 8 1/4" ÷ 2 = 4 1/8" - Radius for full circle
 4 1/8 ÷ 2 = 2 1/16" - Radius for double circle
 (66.0 cm ÷ 3.1416 = 21.0 cm ÷ 2 = 10.5 cm - Radius for
 full circle)
 10.5 cm ÷ 2 = 5.2 cm - Radius for double circle

Figure 7 shows the completed garment. To make the pattern, refer to *Figure 3*.

Note that it will be necessary to cut 4 of the half circle pieces in order to fit the waistline and to obtain the double circle.

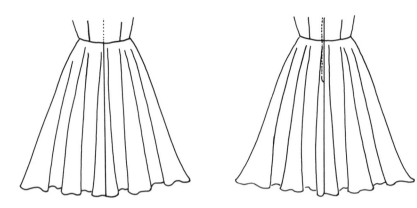

Figure 7

D. Gathered Circle Skirts and Circular Flounces

The following formula may be used to determine how much fabric is needed to shirr to a given measurement so that the gathered skirt will form a full circle:

Circumference of waistline divided by *pi* equals waistline *diameter*.

Waistline *diameter* plus twice the length of the skirt equals the hemline *diameter*.

Hemline *diameter* times *pi* equals the hemline *circumference*, or the length of the straight width of fabric before shirring.

The hemline circumference divided by the waistline circumference will equal the ratio of shirring.

Size 10 waistline for separate skirt - 26" (66.0 cm)

Length of skirt from waistline to hemline - 24" (6.0 cm)

26" ÷ 3 1/7 = 8 1/4" + 2 x 24" = 56 1/4" x 3 1/7 = 177"
(66.0 cm ÷ 3.1416 = 21.0 cm + 2 x 61.0 cm =
 143.0 cm ÷ 3.1416 = 450.0 cm)

A straight length of fabric 24" (61.0 cm) wide and 177" (450.0 cm) long would form a complete circle when shirred to 26" (66.0 cm) The ratio would be 6 3/4 to 1.

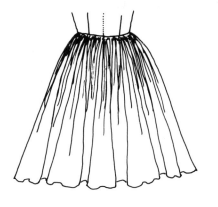

All formulas given for circular skirts would also apply for sleeve, neckline or hemline flounces as long as the finished circumference of the sleeve, neckline or hemline is known.

Figure 8 shows the completed skirt.

Figure 9 shows the gathered circle laid out flat.

Figure 10 shows the completed pattern.

Figure 8

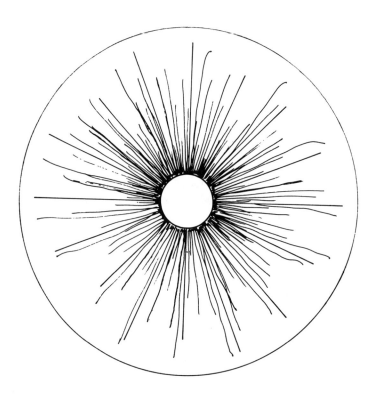

Figure 9

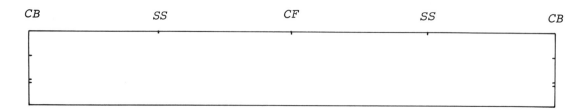

CB SS CF SS CB

Figure 10

4. Dirndl Skirts

Sometimes called *peasant skirts*, this is the simplest form of skirt. The top was hemmed and a drawstring pulled through the casing. The skirt was then gathered to fit the wearer's waistline and held up by the drawstring.

Most manufacturers use three widths of 45" (114.3 cm) fabric or two widths of 54" to 60" (137.1 cm to 152.4 cm) fabric for this type of skirt.

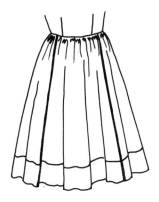

When using 3 widths, one panel is centered in either the front or the back, depending on where the opening is. *Figure 1* shows the completed skirt and the pattern.

When using 2 widths of fabric, one width is generally split from waist to hem and used for the opening if the closure is not at the side seam. *Figure 2* shows the skirt and the pattern.

For inexpensive garments this method is adequate but it does cause the skirt to hang slightly uneven at the hemline.

Figure 1

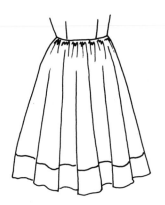

Figure 2

197

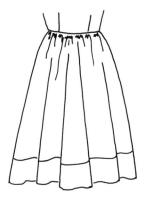

Figure 3

A. Even Hemline Dirndl

Figure 3 shows the completed skirt.

Figure 4 shows the pattern preparation.

When splitting a pattern into a number of small pieces, particularly when the shapes of the pieces are similar, it is best to number each piece to keep them in the proper order.

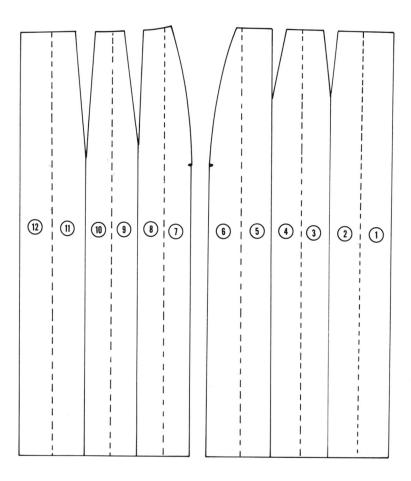

Figure 4

The pieces may be spread to fit the width of the fabric. The hemline will remain straight and even, which makes this particularly suitable for border prints, but there will be a slight curve at the waistline to compensate for the longer length of the side seams. If the skirt is very full and is to be cut on the length of the fabric, it may be pieced where necessary - see *Figure 1* and *Figure 2*.

The completed pattern is shown in *Figure 5*.

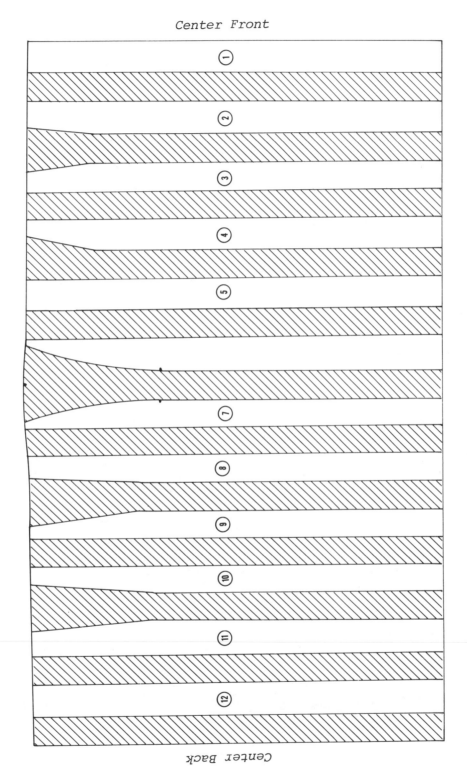

Center Front

Center Back

Figure 5

B. Flared Dirndl

The finished skirt will look similar to *Figure 3* but with less shirring at the waistline.

The pattern preparation is the same as in *Figure 4*.

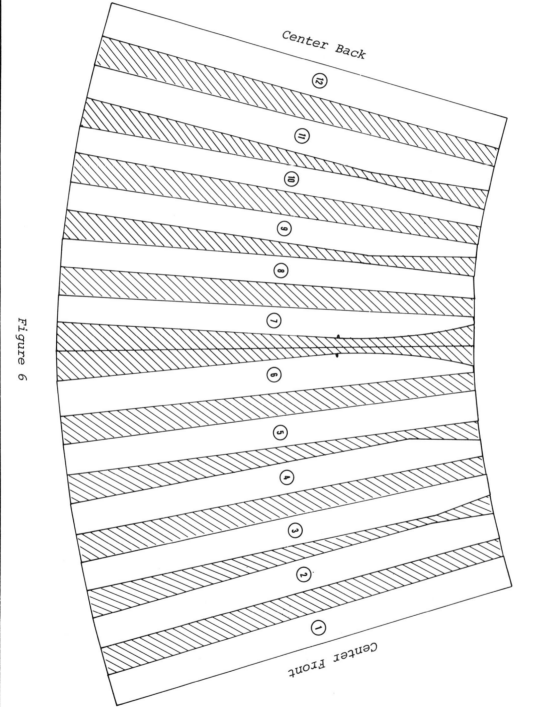

Figure 6

Figure 6 shows the completed pattern. If necessary, due to fabric limitations, the pattern may be split at the side seam line.

C. Slim Dirndl

For a slimmer look through the hips this style is often used, particularly in a soft lightweight fabric that drapes well.

Figure 7 shows the completed garment.

The pattern preparation would be the same as in *Figure 4*.

Figure 8 shows the completed pattern.

Figure 7

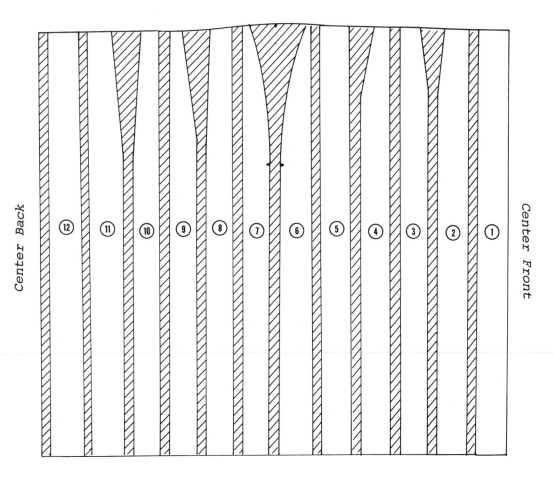

Figure 8

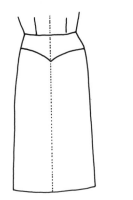
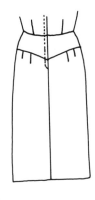

Figure 1

5. Hip Yoked Skirts

Sometimes the hip yoke detail is used only in the front and a plain or gored skirt is used for the back.

The following skirts have the hip yoke in both the front and back.

A. Slim Skirt With Hip Yoke

Figure 1 shows the completed skirt.

Figure 2 shows the pattern preparation.

Be sure to fold out the darts before marking the yoke line.

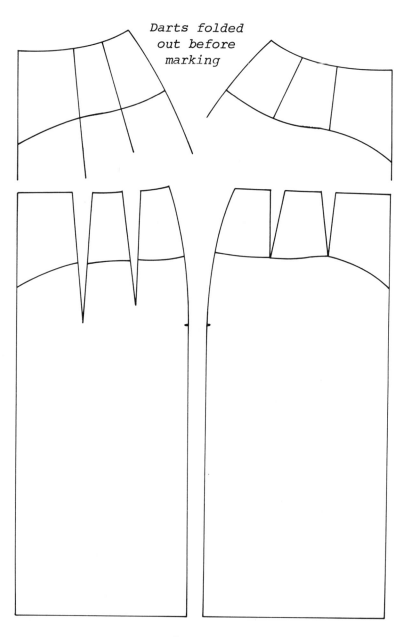

Darts folded out before marking

Figure 2

202

Figure 3 shows the completed pattern.

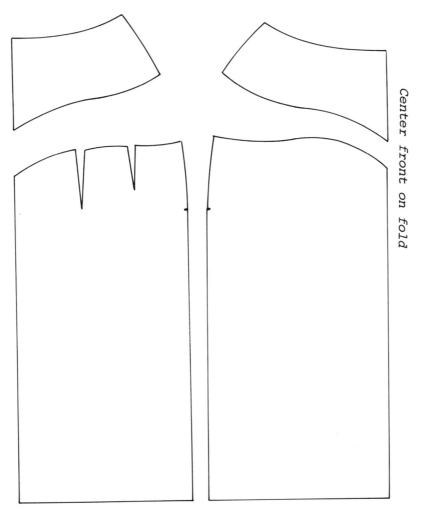

Figure 3

B. Flared Skirt With Hip Yoke

Figure 4 shows the completed skirt.

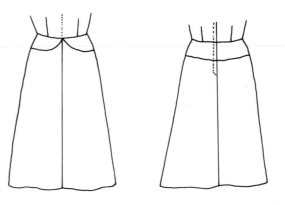

Figure 4

Figure 5 shows the pattern preparation with the darts folded out on the back skirt before the yoke line is drawn.

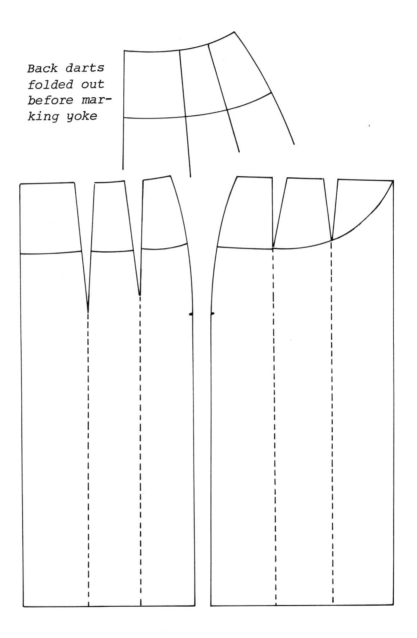

Back darts folded out before marking yoke

Figure 5

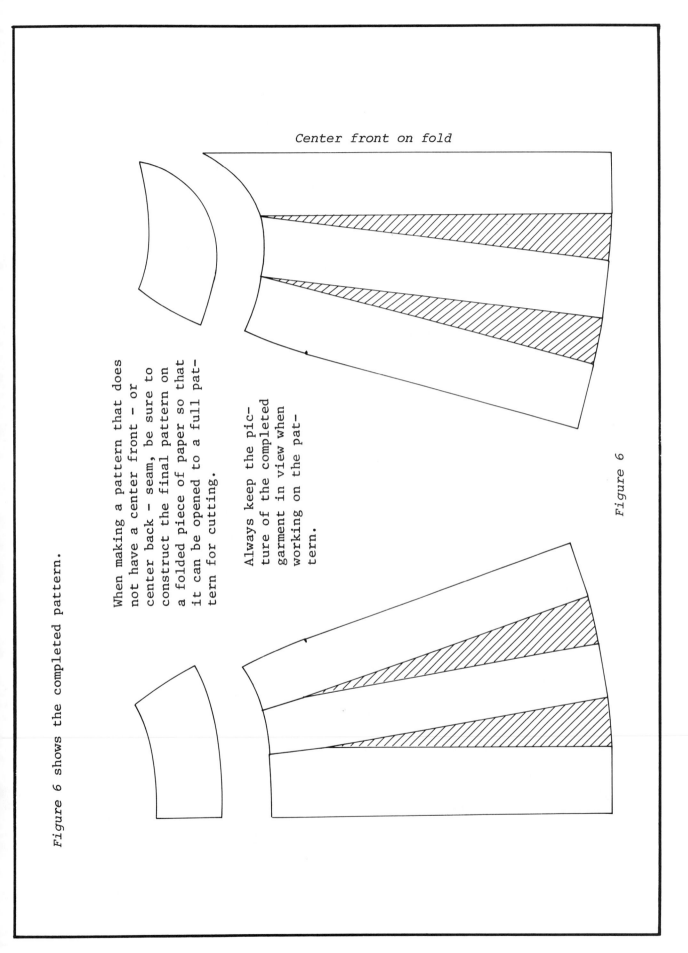

Figure 6 shows the completed pattern.

When making a pattern that does not have a center front – or center back – seam, be sure to construct the final pattern on a folded piece of paper so that it can be opened to a full pattern for cutting.

Always keep the picture of the completed garment in view when working on the pattern.

Center front on fold

Figure 6

205

6. Pleated Skirts

Skirts that are to be all-over pleated must be done by a professional
pleating company. It is not necessary to make a pattern for a skirt that
is to be pleated all around as the pleating company will furnish a pattern
of the type and size desired.

For garments with only a few pleats, the patterns are made in the factory
and the pleating is done by the regular pressers.

A. Center Front Box Pleat

Figure 1 shows the completed skirt with the upper edge
of the box pleat top stitched to hold it in place.

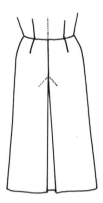

Figure 1

Figure 2 shows the pattern
preparation. A slight flare
has been added from the hip-
line to the hemline.

When adding flare to a skirt, square
the hemline from the new side seam
to a distance of about one third of
the length of the new hemline. Check
the front skirt length against the
back skirt at the side seam, adjust-
ing the back skirt at the hemline.

If flare is added to a front skirt
the same amount of flare must be
added to the back skirt.

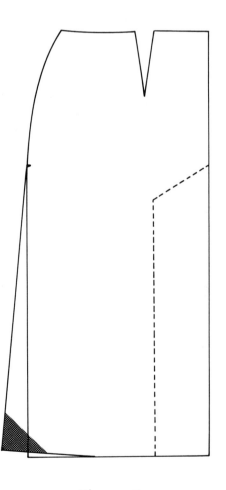

Figure 2

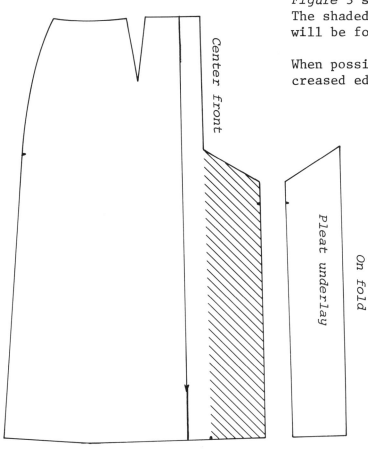

Figure 3 shows the completed patterns.
The shaded area shows the part that
will be folded under

When possible it is better to have the
creased edge of the pleat on the
straight grain of the fabric.

The small separate piece
forms the back of the pleat
and is called the *pleat un-
derlay*.

Figure 3

B. One-way Pleat With Center Box Pleat

Figure 4 shows the completed skirt.

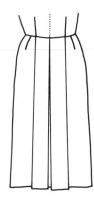

Figure 4

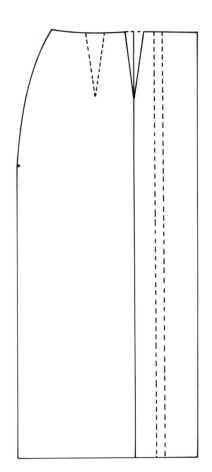

Figure 5 shows the pattern preparation.

The single dart skirt was used and the dart moved closer to the side seam to be out of the way of the pleat.

The broken lines represent the depth of the underlay, which will be cut in one piece except for the center front box pleat.

Figure 5

Figure 6 shows the completed patterns.

The shaded areas will be hidden by the pleats.

Be sure to make the pleat underlay on the fold of the paper so it can be opened flat for cutting.

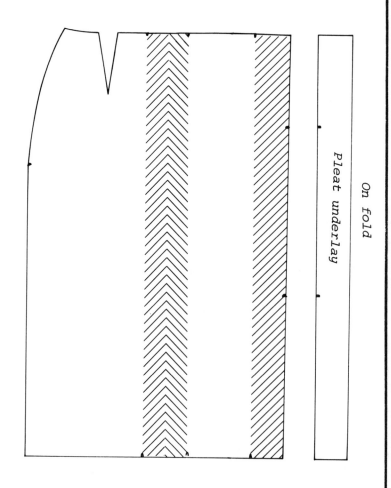

Figure 6

C. In-Set Pleats

Figure 7 shows the completed skirt.

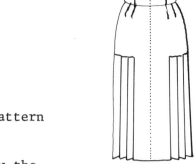

Figure 8 shows the pattern preparation.

The broken lines show the depth of the underlay of the pleats.

Figure 7

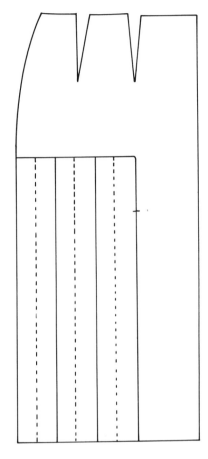

Figure 8

Figure 9 shows the completed patterns. The shaded areas will be hidden by the pleats.

Be sure to notch the top and bottom of the pleated section for pressing guides.

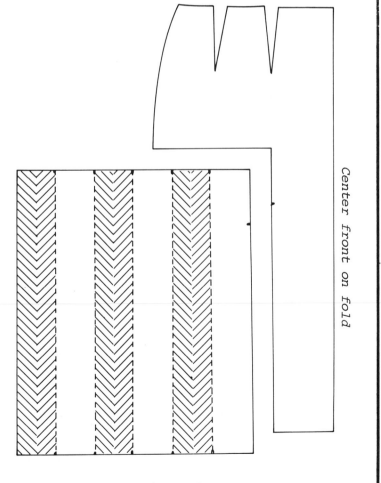

Center front on fold

Figure 9

SEPARATE SKIRTS

Because the weight of a separate skirt (or pants) does not hang from the shoulders as a dress does, it is necessary to make the waistline about 1/2" (1.3 cm) smaller than the waistline on a skirt block that is used with a bodice.

On better skirts and pants, the basic blocks are not changed at the waistline but the waistband is made slightly smaller and the skirt (or pants) is eased into the waistband when sewing.

The seam allowance for waistbands is generally 1/4" (0.6 cm) with a 1" (2.5 cm) extension for the fastening. An exception would be for fabric that will ravel badly or is very thick. The seam allowance at the waistline of the skirt or pants must match the amount allowed for the waistband.

1. Waistbands

 A. Separate Band

 Skirts generally open at the center back, side seam or center front. The adjustments for all openings are the same. Waistbands up to 2" (5.0 cm) wide are made as follows:

 1/8" (0.3 cm) is subtracted from each quarter of the skirt pattern for a total difference of 1/2" (1.3 cm). The waistband is made by drawing a line of the necessary length. Beginning at the skirt opening, notch center front, center back and the side seams on the waistband. Put the 1" (2.5 cm) extension on the end of the waistband that will be *under* the fastening - the button end if buttons and buttonholes are being used; the loop end if a hook and loop are used.

 Determine the width of the band and square the ends. Add seam allowance. The waistband may be cut in two pieces or in one piece with a fold at the top of the band as illustrated in the center back opening waistband in *Figure 1*. The interfacing is cut half the width of the band and is a separate pattern as shown by the shaded area in *Figure 1*.

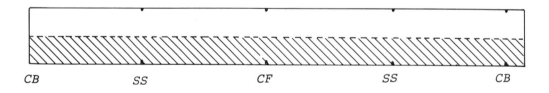

CB SS CF SS CB

Figure 1

To make a waistband over 2" (5.0 cm) wide, make a straight waistband of the desired width, following the instructions given above.

After the wide straight waistband is made, slash and spread the top edge of the band 1/8" (0.3 cm) as shown in *Figure 2*.

This type of waistband must be slightly contoured in order to fit the lower edge of the rib cage, which is larger than the waistline. A facing and an interfacing will be required and are cut from the same pattern as the waistband.

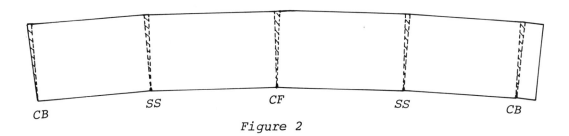

CB SS CF SS CB

Figure 2

B. Faced Waistline

A self or lining fabric facing may be used in place of a separate waistband. The facing is made by drawing around the waistbline of the skirt pieces, pivoting out the darts and closing all seams except the side seams and the seam where the opening will be.

The facings are cut about 3" (7.6 cm) wide and finish about 2 1/2" (6.3 cm) wide. 1/4" (0.6 cm) is turned under at the lower edge and the same amount used to join the facing to the waistline of the skirt. See *Figure 3*.

The pattern for the interfacing is traced from the pattern used for the facing but 3/4" (1.9 cm) is removed from the lower edge so that it will not show below the facing on the inside of the garment.

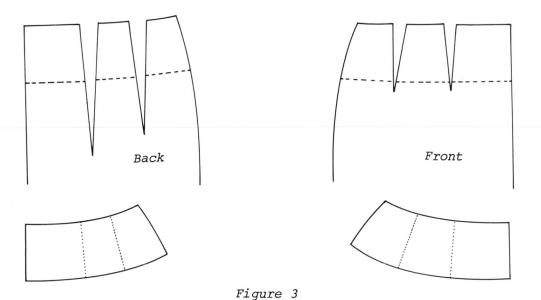

Back *Front*

Figure 3

2. Gored Skirt With Pleats

Figure 1

Figure 1 shows the completed skirt with a box pleat in center front and one-way pleats on the sides.

The front skirt will be cut in three pieces: Two side panels, which are cut from the same pattern, and one center panel made on the fold.

The back skirt should have approximately the same flare as the front skirt.

The waistband is a straight band - refer to Waistbands, 1 - A, *Figure 1*.

Figure 2 shows the pattern preparation. The dart closest to the center front on the two-dart block has been closed to give the skirt flare. The broken lines show the depth of the pleats.

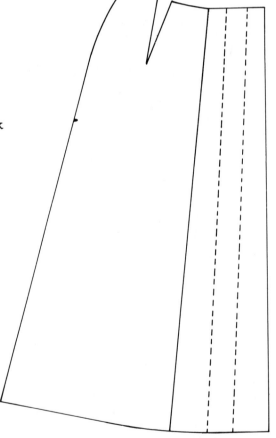

Figure 2

Figure 3 shows the completed patterns.

The shaded areas will be hidden under the pleats.

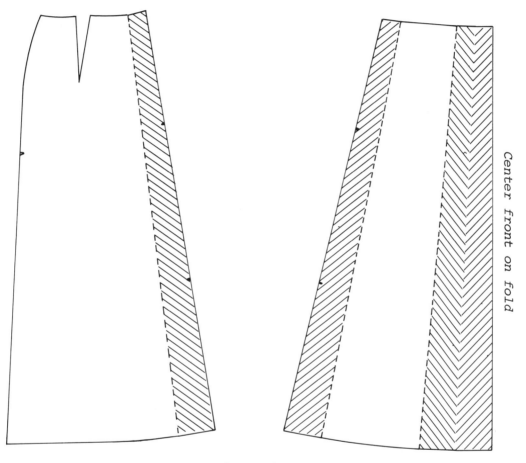

Center front on fold

Figure 3

3. Low Flared Gored Skirt

Figure 1 shows the completed skirt.

The wider waistband is contoured. Refer to
Waistbands, 1 - A, *Figure 2*.

Figure 1

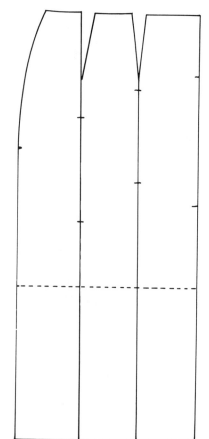

Figure 2 shows the pattern preparation.

Note the identifying crossmarks on the sections
of the skirt.

The back of the skirt would be done the same
way except with double crossmarks.

Figure 2

The flare may be added from
the same depth all around,
or it could vary by origi-
nating from a higher line
in the front to a lower
line in the back - or vice
versa.

Figure 3 shows the completed
patterns for the front skirt.

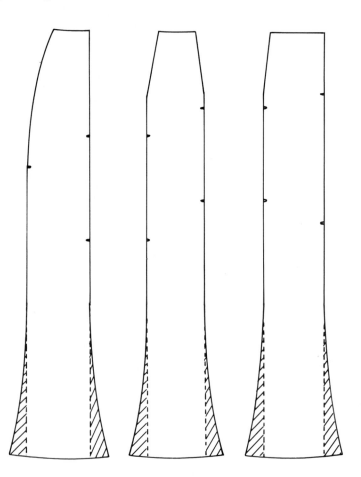

Figure 3

4. Low Torso Skirt With Circular Flare

Figure 1 shows the front skirt.

The flounce would continue on the back skirt but generally in a straight line where it is joined to the body of the skirt.

Figure 2 shows the pattern preparation.

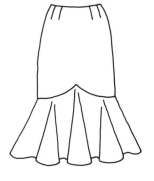

Figure 1

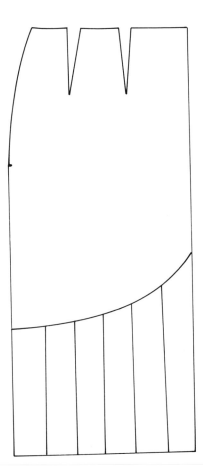

Figure 2

Figure 3 shows the completed front skirt pattern.

For the faced waistline, refer to Waistbands, 1 - B, *Figure 3*.

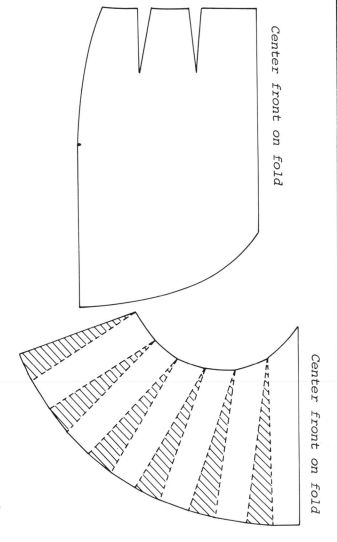

Center front on fold

Center front on fold

Figure 3

215

Chapter 11

Blouses

Notes

The separate blouse, worn with a skirt, pants or jumper, has become a staple of the American wardrobe.

The No-Dart Bodice/Blouse Block from Chapter 6 may be used for many of the styles which follow, even though the instructions and illustrations are based on the basic Torso Block. The criteria for deciding which block should be used will depend on whether a snug fit (Torso Block) or a loose fit (No-Dart Block) is desired.

Although most of the examples given fasten either in the front or the back, the slip-over blouse is quite popular - provided that sufficient ease is allowed in either the cut or the fabric, and the neckline allows the blouse to be put on and taken off without problems.

Darts and Tucks

If only one dart is to be used in the waistline area it is generally the one closest to the center. It should be moved 1/2" (1.3 cm) toward the side seam and enlarged one half the width of the second dart, on both the back and the front. See *Figure 1*.

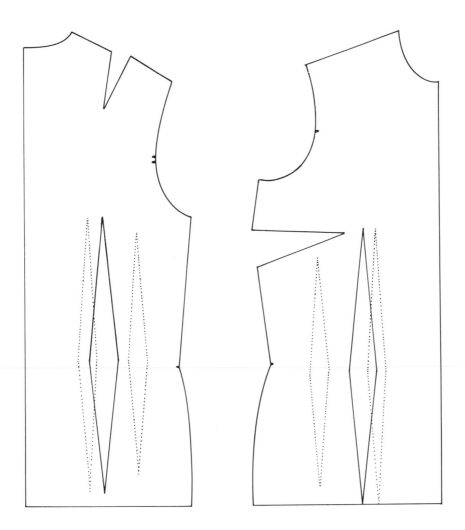

Figure 1

The same type of dart used in the front of the blouse should be used in
the back. The most widely used body darts and tucks are:

A. Shaped Dart

This gives a smooth fit and is
used for either a tuck-in or an
over-blouse.

Figure 2 shows the completed
dart and *Figure 3* shows the
dart as it would look on the
pattern.

The double punch marks
indicate the center of
the dart. The broken
lines indicate the
stitching lines.

Figure 2

Figure 4

Figure 3

B. Top Half-Dart

To keep the visible part of a tuck-in blouse smooth and
still provide extra room at the hipline - one of the many
reasons women prefer separates - only the top half of the
dart is stitched.

See *Figure 4* and *Figure 5*.

Figure 5

C. Lower Half-Dart

This provides a smooth hipline for a tuck-in blouse while giving the bodice a looser fit and more casual look. *Figure 6* shows the completed dart. *Figure 7* shows how the dart would be marked on the pattern.

The center of the dart is indicated by the double punch marks and the broken lines show where the stitching will be. The dotted lines show the section of the dart that will not be used.

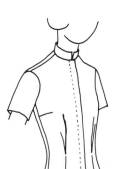

Figure 6

Figure 7

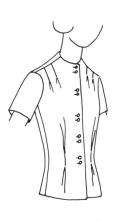

Figure 8

D. Soft Tuck

Provides room above and below the waistline while controlling the fullness and keeping it evenly distributed around the body. It is not generally used on over-blouses.

See *Figure 8* for the look of the finished dart and *Figure 9* for the way the dart would appear on the pattern.

Figure 9

2. Front and Back Openings

Buttoned front and back openings must have the proper extensions added for the buttons and buttonholes. The facings for the buttons and buttonholes may be either cut in one with the body of the garment or may be cut separately.

A. Basic Front Opening Blouse

Figure 1 shows the completed blouse.

By varying the collar, sleeves, trim and fabric endless variations can be made from a simple body such as this.

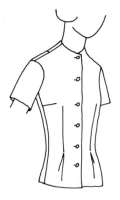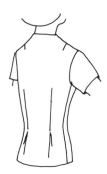

Figure 1

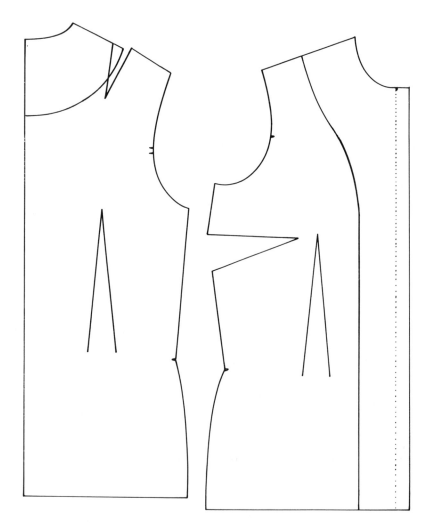

Figure 2 shows the pattern preparation.

Note that the darts of the basic Torso Block have been moved and enlarged as shown in Darts and Tucks – Figure 1.

This pattern could also be made on the No-Dart Blouse Block, eliminating the side bust dart and the shoulder dart.

Figure 2

Figure 3 shows the completed patterns.

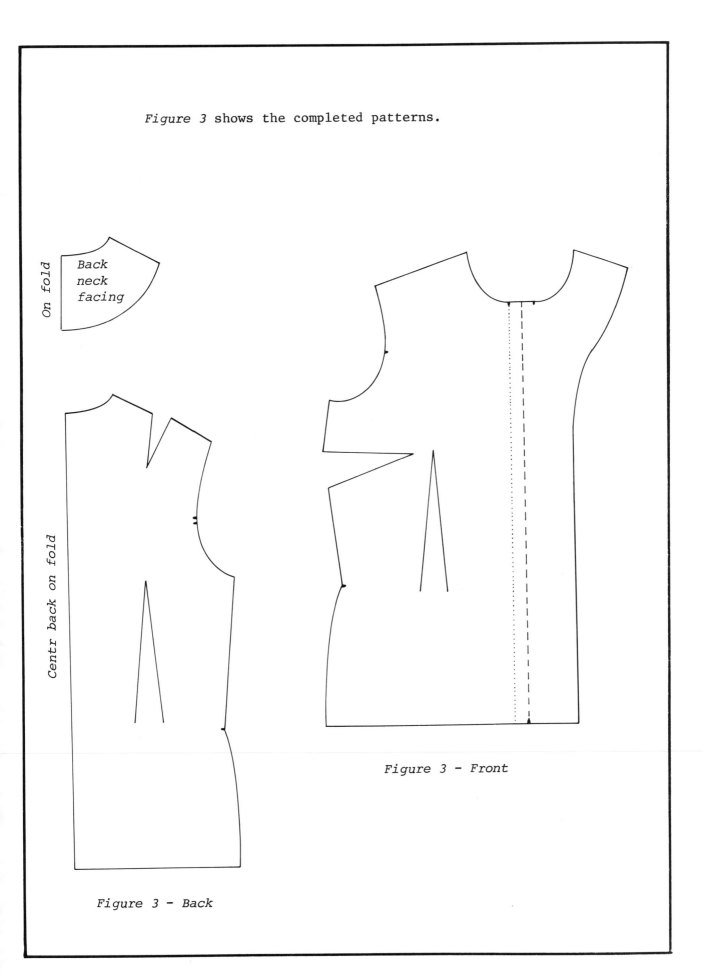

On fold

Back
neck
facing

Centr back on fold

Figure 3 - Front

Figure 3 - Back

B. Basic Back Opening Blouse

Figure 4 shows the completed blouse.

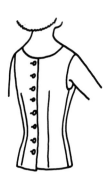

Figure 4

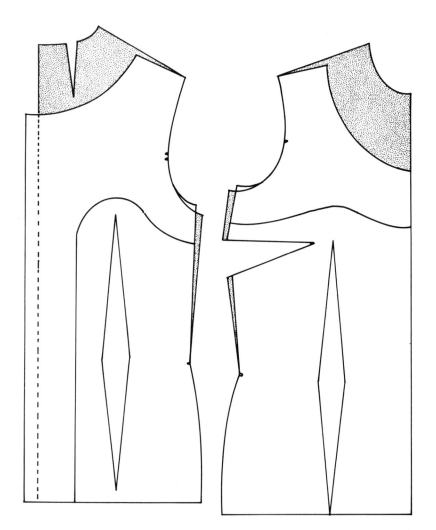

Figure 5 shows the pattern preparation.

The adjustments for the open neckline and sleeveless blouse are the same as for an open neckline and sleeveless bodice.

The shaded areas show the sections to be cut away.

Figure 5

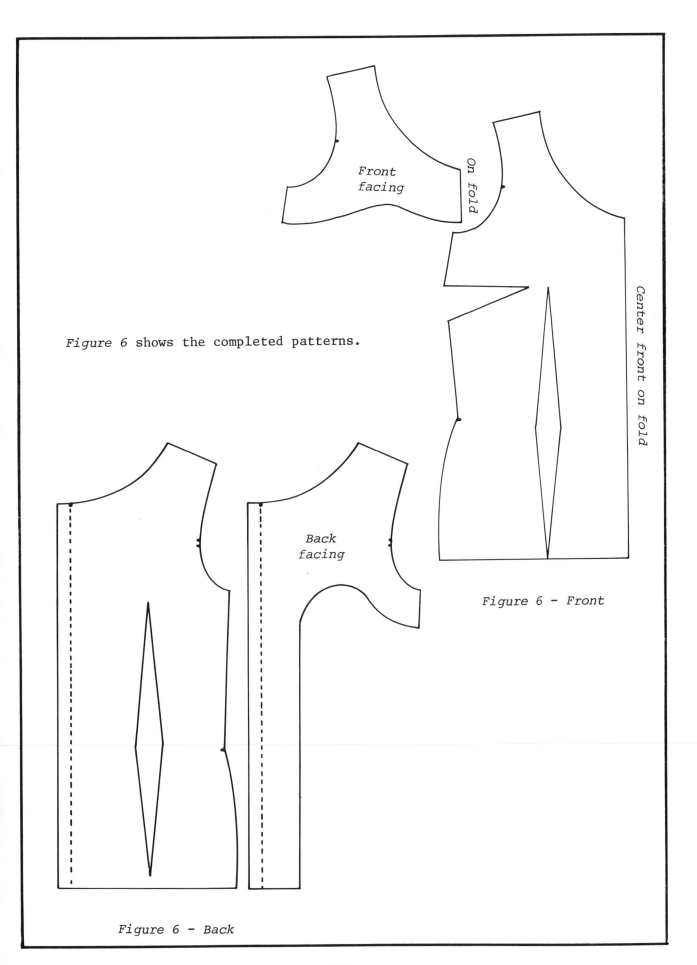

Front facing

On fold

Center front on fold

Figure 6 shows the completed patterns.

Figure 6 - Front

Back facing

Figure 6 - Back

225

C. Basic Shirt

Figure 7 shows the completed shirt.

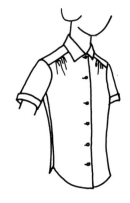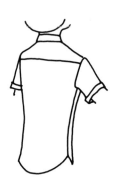

Figure 7

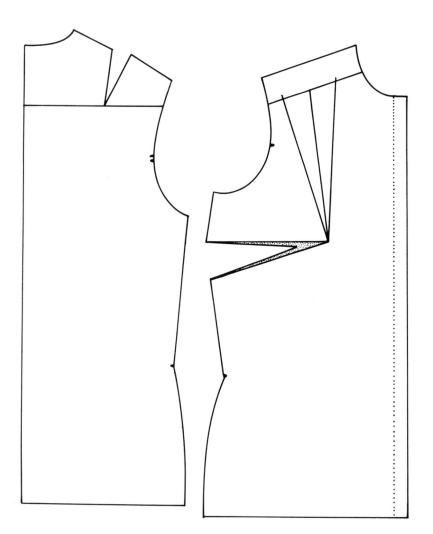

Figure 8

Figure 8 shows the first step of the pattern preparation.

The body darts are omitted from a shirt for a looser fit and a more casual look, however the shaping at the sides is re-retained.

Figure 9 shows the second step in the pattern preparation.

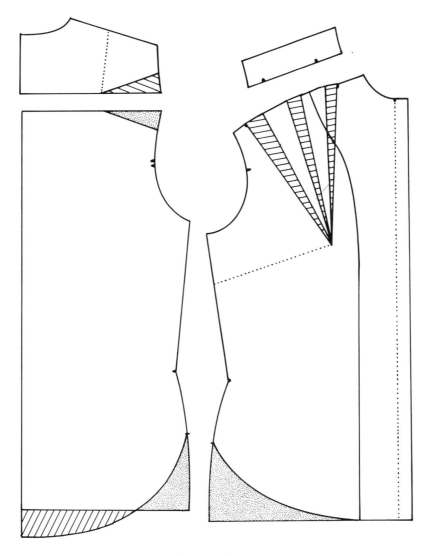

Figure 9

The grey areas show the sections to be removed. The diagonal lines indicate sections to be added to the pattern.

Figure 10 shows the completed patterns.

The front facing can be cut in one with the front blouse or cut separately. No back facing is required as the yoke is cut double.

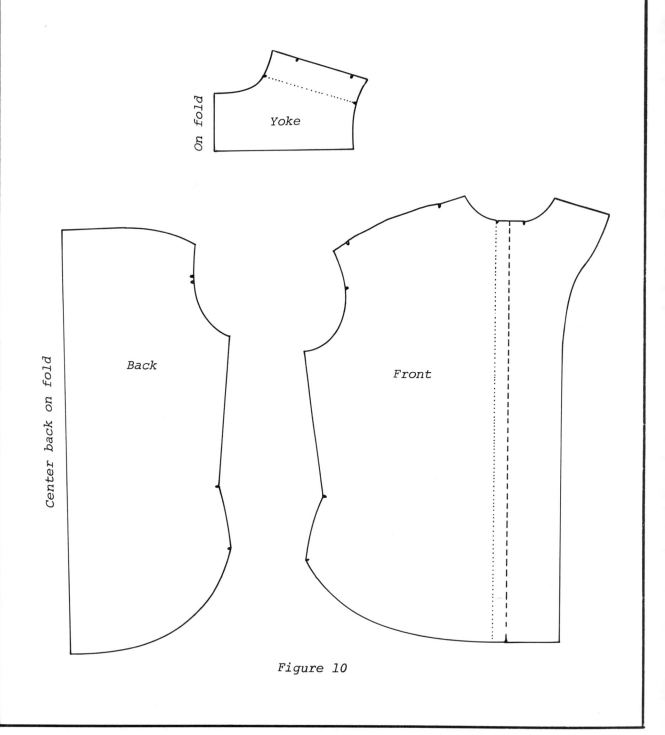

Figure 10

3. No Dart Blouses

Darts may be incorporated into seams or fullness controlled by pleats or gathering.

Blouses cut without darts or fitting seams must be made from knitted or elasticized fabric if they are to have any semblance of fit. In using a stretch fabric of any kind it is best to drape the actual fabric on the dress form to get the pattern.

Figure 1

A. Seamed Blouse

Figure 1 shows the completed blouse.

Figure 2 shows the pattern preparation.

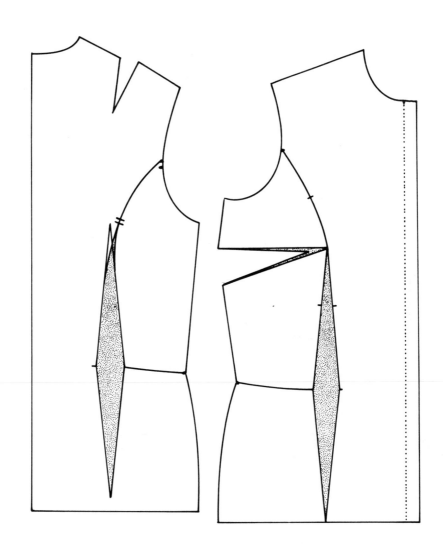

Figure 2

229

Figure 3 shows the completed pattern. The facings would be
made separately.

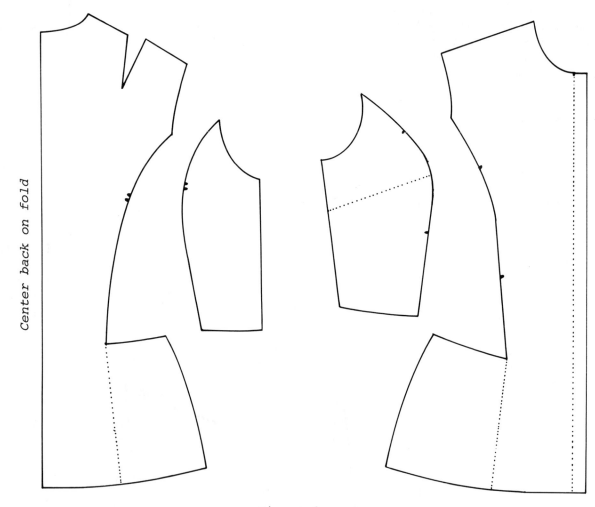

Center back on fold

Figure 3

B. No Dart Shirt

Figure 4 shows the completed pattern with the shoulder seam brought forward to simulate a yoke in the front.

Although this pattern is illustrated on the Torso Block it would be much simpler to make on the No-Dart Blouse Block. The only preparation necessary would be to move the shoulder seam forward; add the extension for the buttons and buttonholes; alter the hemline.

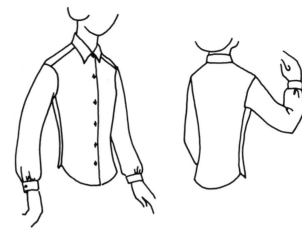

Figure 4

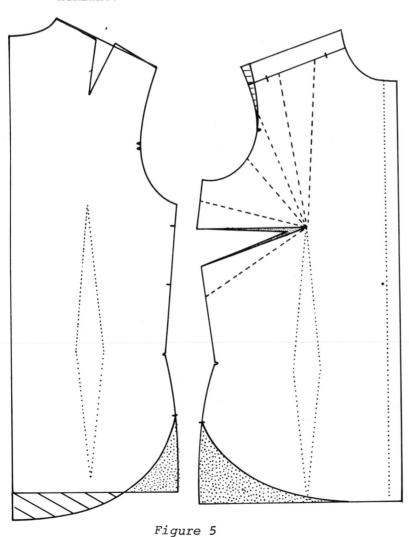

Figure 5 shows the first step of the pattern preparation.

Note that the shoulder length is made longer by drawing a straight line through the back shoulder, eliminating the dart.

The width of the back shoulder dart is added to the front shoulder length.

Broken lines in the front pattern show where it will be slashed and spread.

Figure 5

Figure 6 shows the pattern after it has been cut and spread. The front section of the shoulder has been added to the back shoulder.

It will be necessary to ease the front shoulder seam into the back shoulder seam and to ease the side seam at the side bust dart area into the back side seam. Be sure to notch as indicated on *Figure 6*.

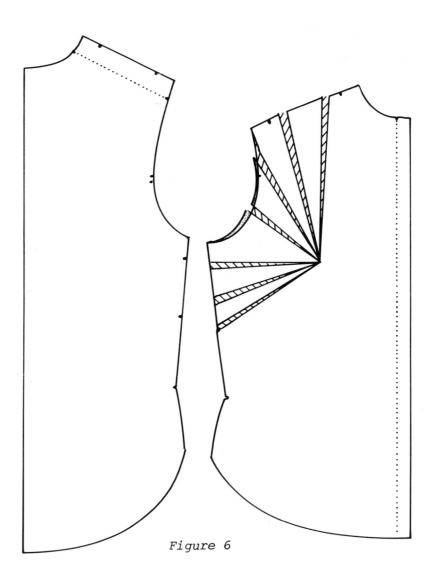

Figure 6

Figure 7 shows the completed patterns. The cap of the front sleeve must be adjusted for the increased length of the new armscye.

The front facing may be cut in one with the blouse front or it may be cut as a separate piece.

The patterns for this style made on the No-Dart Blouse Block would appear exactly the same. The difference would be that there would be no need for easing at the shoulder or side seams.

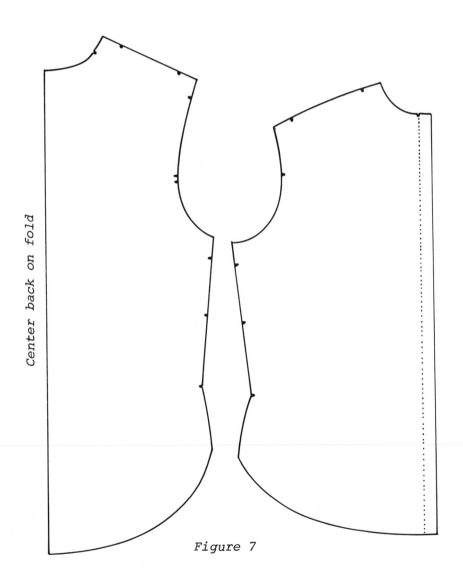

Center back on fold

Figure 7

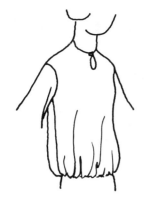 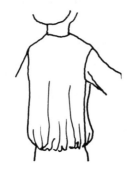

C. Blouson

Figure 8 shows the completed garment.

Because of the looser fit, this style, with an appropriate sleeve, is often zipped or buttoned up the front and made as a casual outer garment or jacket.

Figure 8

Figure 9 shows the pattern preparation on the No-Dart Blouse Block.

Be sure to lengthen the pattern below the waist enough to give the desired amount of blousing when the garment is resting on the hipline.

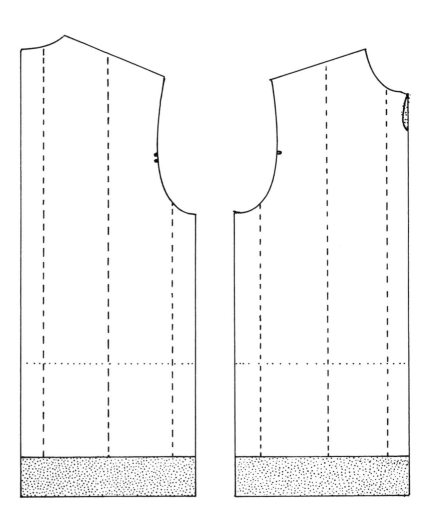

Figure 9

Figure 10 shows the completed patterns.

The amount added when slashing and
spreading will be determined by the
weight of the fabric - the softer
the fabric the more the pattern
can be spread.

The blouson may be finished
at the hemline with either
elastic or a drawstring
run through a casing.

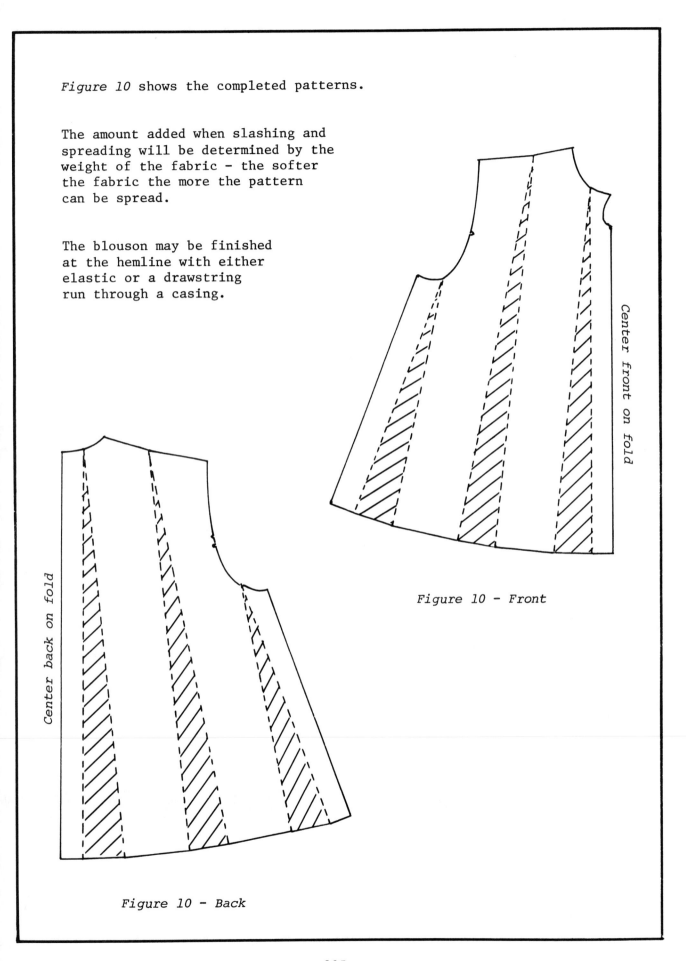

Figure 10 - Front

Figure 10 - Back

Chapter 12

No Waistline Dresses

Notes

The vogue for dresses without waistlines comes and goes but some variation of this style is always current. Sometimes the effect is achieved by moving the natural waistline either higher or lower.

1. Sheath dress

 Although not currently popular for outerwear, this garment is widely used as a lining under loose garments of sheer fabric.

 The snug fit can be eased by leaving out the second dart - the one closest to the side seam - on the front and back patterns.

 Figure 1 shows the completed dress.

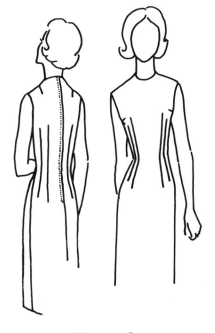

Figure 1

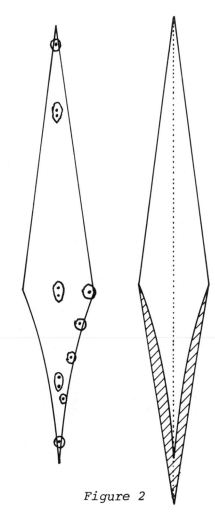

Figure 2

Better fit will be achieved in this style by curving the front body darts from the waistline down to give more room over the abdominal extension and hip area.

Figure 2 shows how the dart would be curved and how it would be marked by punches on the pattern.

Figure 3 shows the pattern preparation after the darts in front have been curved.

The skirt length – waistline to hemline – may be simply added to the Torso Block or the Skirt block may be used to determine the length.

Be sure to make the front pattern first and then check it against the back at the side seams and at the shoulder.

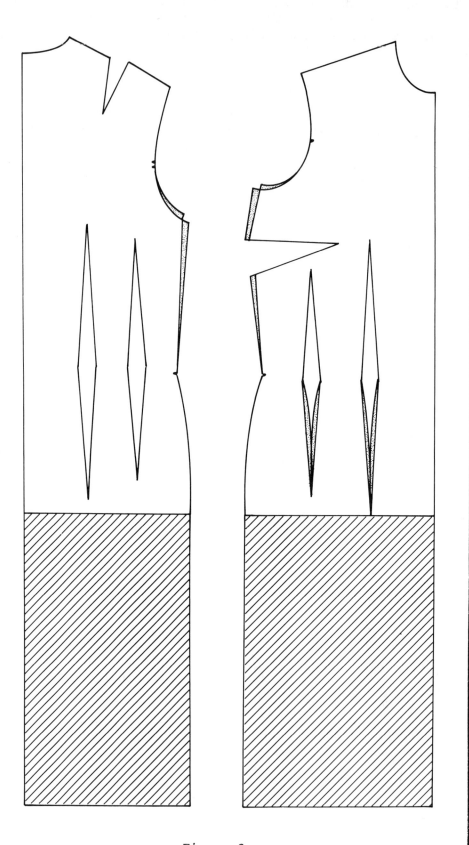

Figure 3

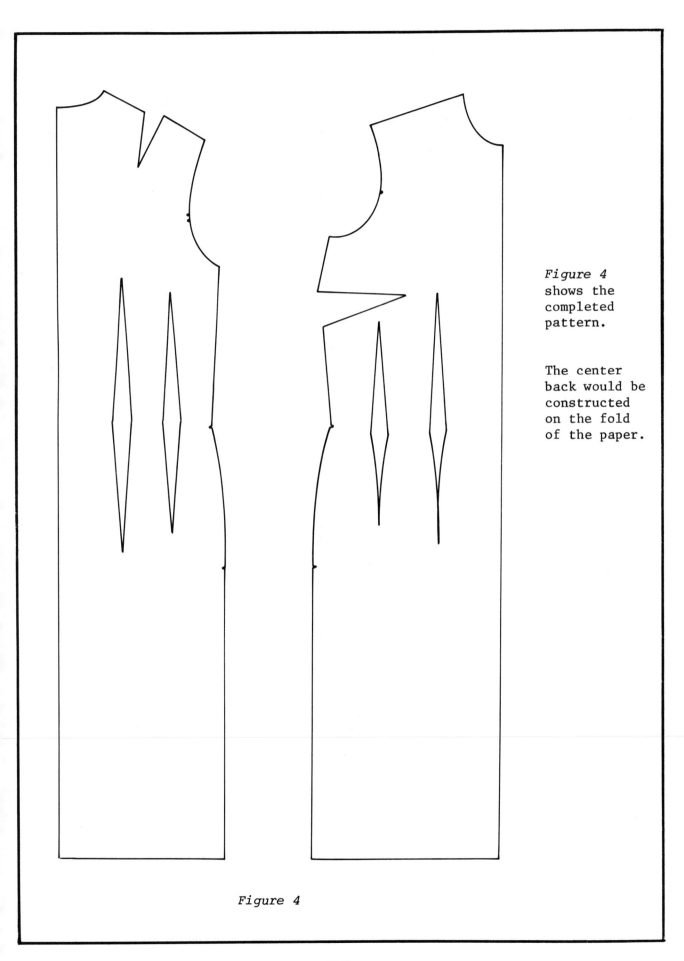

Figure 4
shows the
completed
pattern.

The center
back would be
constructed
on the fold
of the paper.

Figure 4

241

2. Shift Dress

 Sometimes referred to as a *chemise* or *sacque*, the shift dress is made by
 eliminating the body darts or seaming that would make the garment fit
 closer to the body. The side bust dart may be transferred to another
 location for style line.

 The following examples are made from the altered Torso Block because they
 are sleeveless. If using a sleeve they could all be made from a lengthened
 No-Dart Blouse Block.

 Figure 5 shows the completed dress.

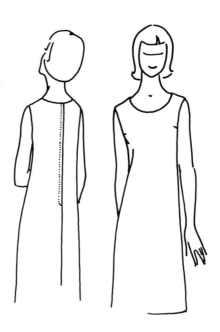

Figure 5

Figure 6
shows the
pattern
preparation.

Be sure to
fold out the
side bust
dart before
drawing the
new side
seam for
the front.

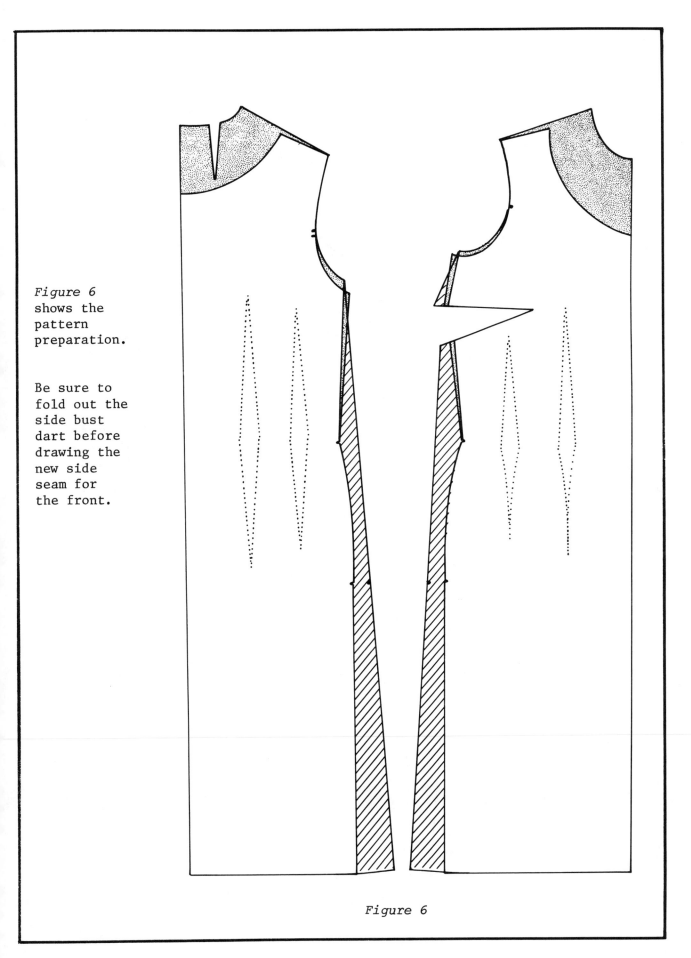

Figure 6

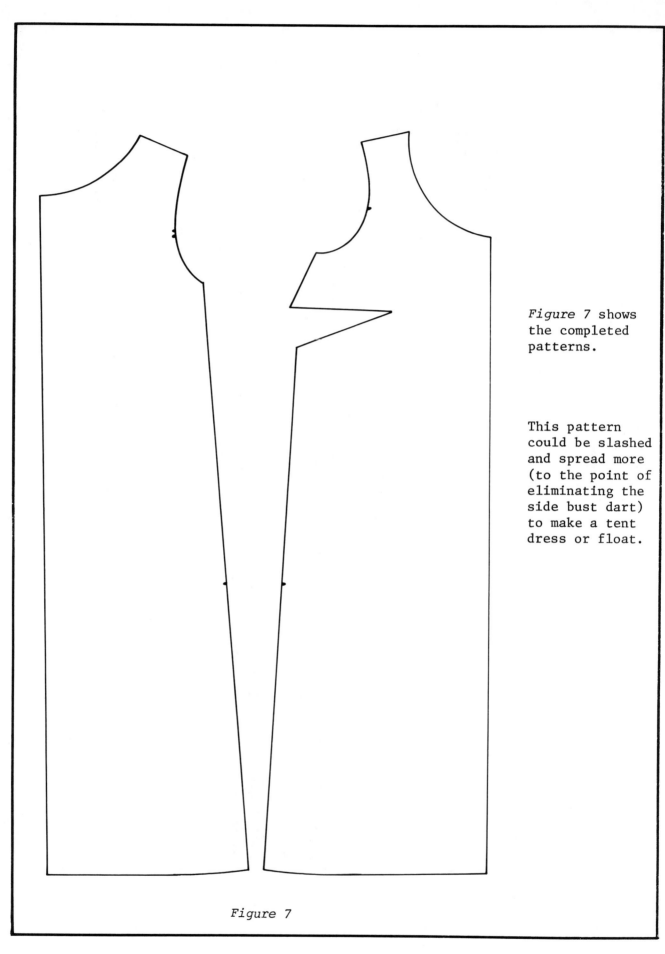

Figure 7 shows
the completed
patterns.

This pattern
could be slashed
and spread more
(to the point of
eliminating the
side bust dart)
to make a tent
dress or float.

Figure 7

244

By marking
the waist-
line of the
Shift Dress
patterns as
shown in
Figure 8, a
casing for
either a
drawstring
or elastic
could be
sewn into
the waistline
and the gar-
ment would
appear as
in the small
insets, *Fig-
ure 9*.

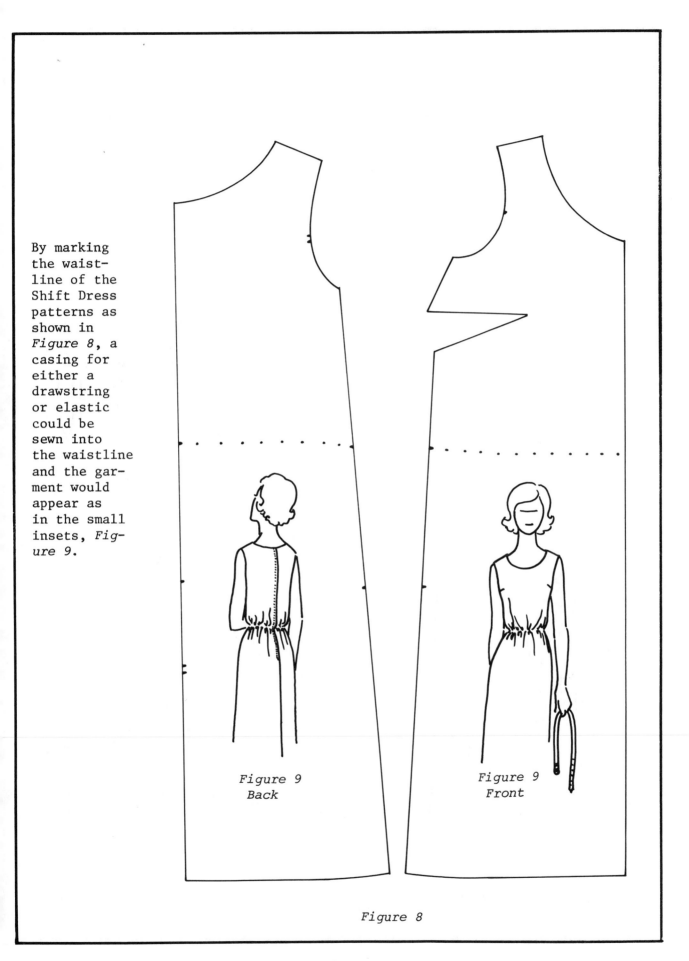

Figure 9
Back

Figure 9
Front

Figure 8

3. Princess Dress

Originally called the *Princess Gabrielle* by its originator Charles Worth. The dress was named in gratitude to the Princess Gabrielle Metterninck for recommending the designer to Empress Eugenia, thus assuring his success.

A. Classic Princess

Figure 10 shows the completed garment.

Figure 10

Without the flare added to the skirt this pattern is sometimes referred to as a *French Fitting Block*.

See *Figure 11*.

Figure 11

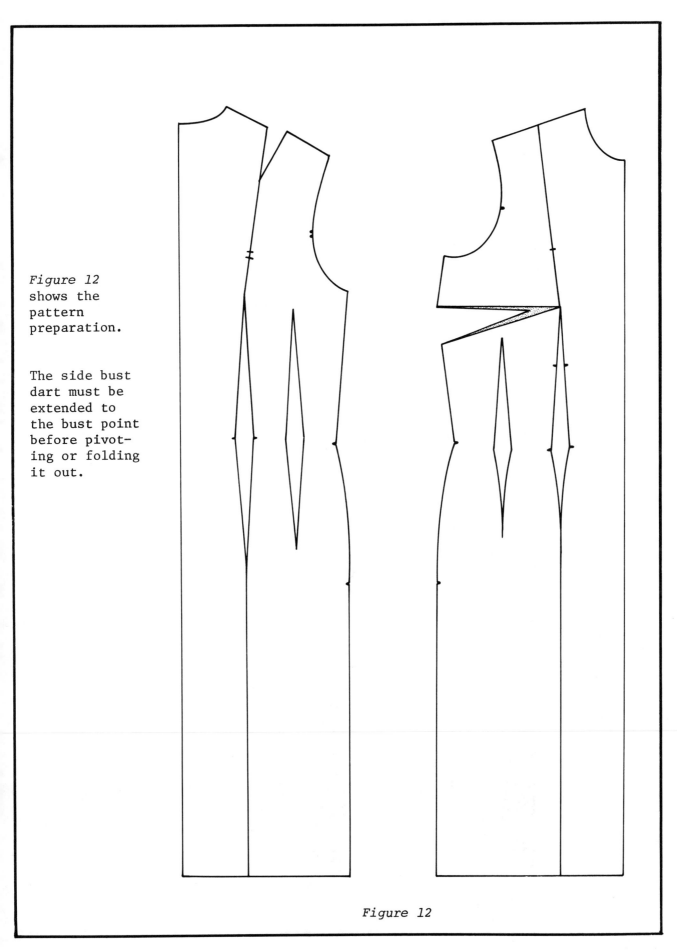

Figure 12
shows the
pattern
preparation.

The side bust
dart must be
extended to
the bust point
before pivot-
ing or folding
it out.

Figure 12

247

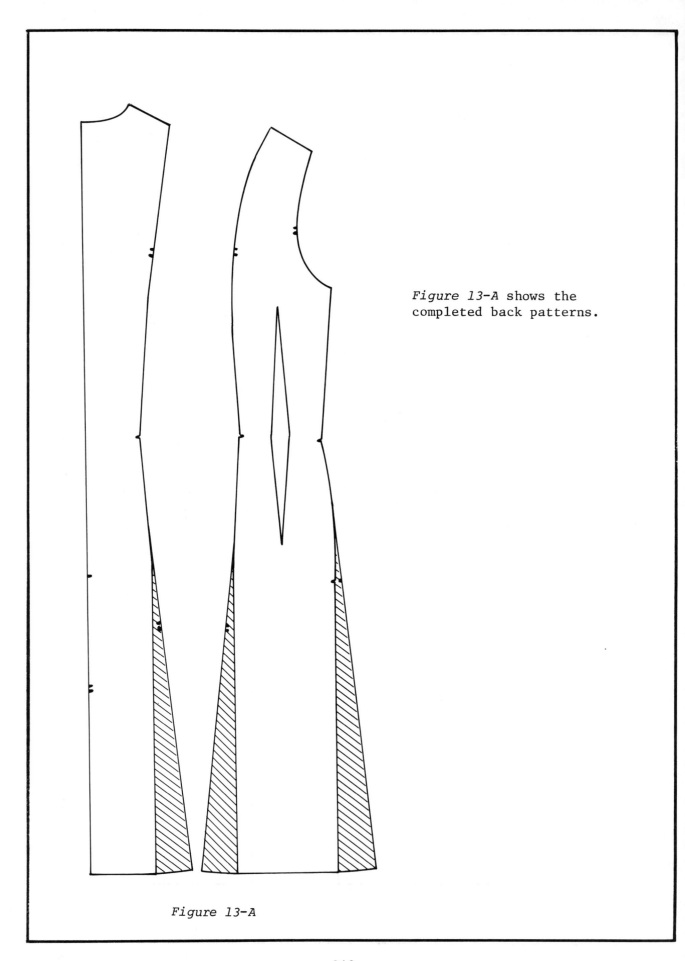

Figure 13-A shows the completed back patterns.

Figure 13-A

248

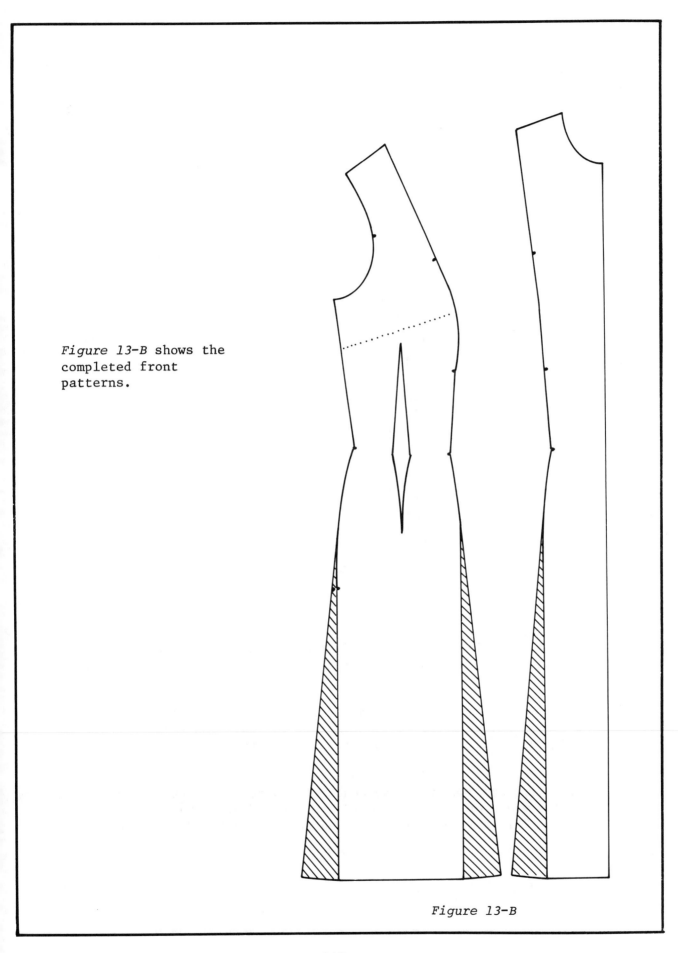

Figure 13-B shows the completed front patterns.

Figure 13-B

B. Armscye Princess

Figure 14 shows the completed garment.

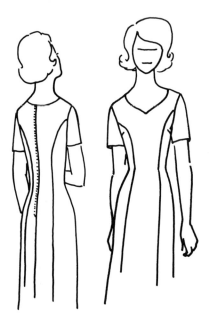

Figure 14

In this example the side bust dart has been left in the original position as on the Torso Block. In the Classic Princess the side bust dart was incorporated into the seaming.

If the difference between the waistline and the bustline is 8" (20.3 cm) or more, it is advisable to leave the dart in its original location rather than moving it into a seam.

The first dart - the one closest to the center - has been moved 1/2" (1.3 cm) away from the center for better proportion. Half of the width of the second dart has been removed from the side seam. This same procedure is used on the front and back patterns.

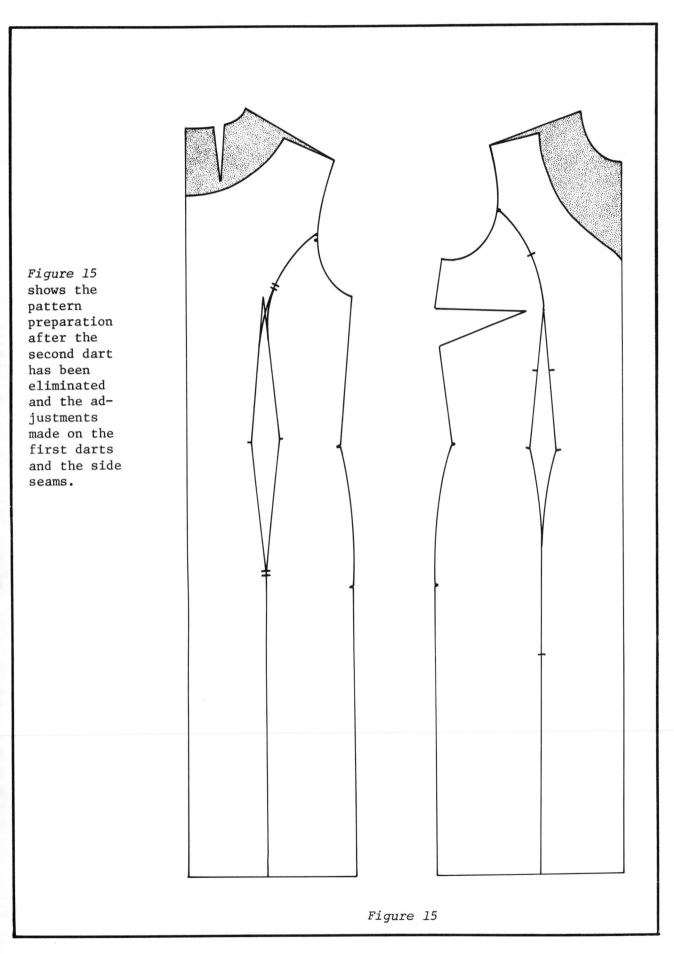

Figure 15 shows the pattern preparation after the second dart has been eliminated and the adjustments made on the first darts and the side seams.

Figure 15

251

Figure 16 shows the completed patterns.

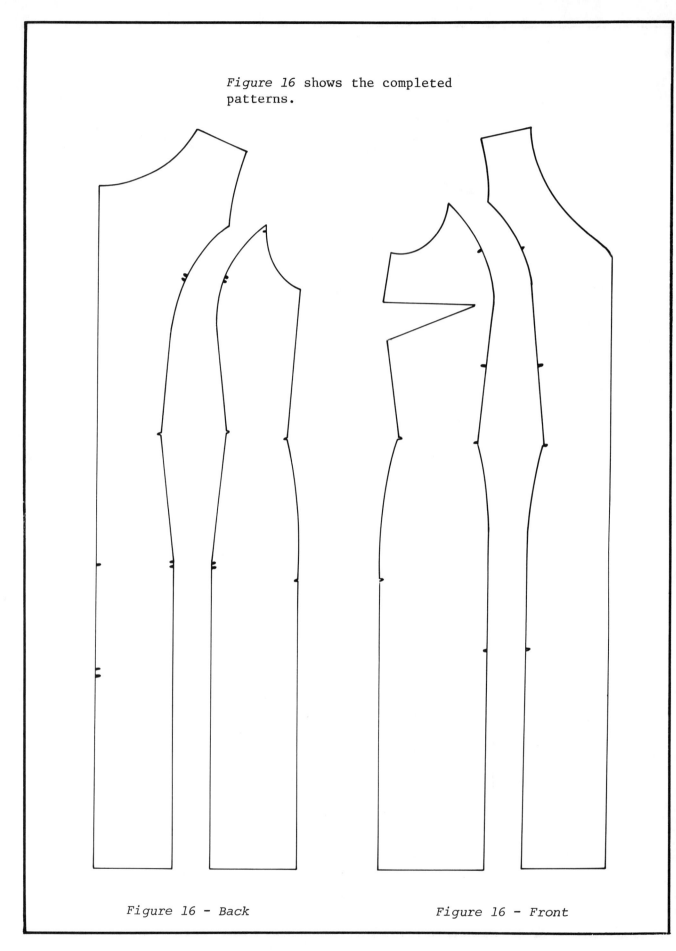

Figure 16 - Back Figure 16 - Front

4. Empire Line

Popularized by the Empress Josephine, first wife of Napoleon I, this high
waisted style is always youthful and flattering.

If the seam is to fit snugly around the body under the bustline, the body
darts should be reshaped as shown by the solid lines in *Figure 17*.

After the darts have been widened under the bustline, fold out the darts
before drawing the new seam line.

Figure 18 shows the completed garment.

Figure 18

Figure 17

Figure 19 shows the pattern preparation.

The second dart has been eliminated in both back and front and the first dart moved 1/2" (1.3 cm) farther from the center.

The side bust dart has been extended to its original point so that it can be transferred into the seam either by pivoting or cutting.

Figure 19

254

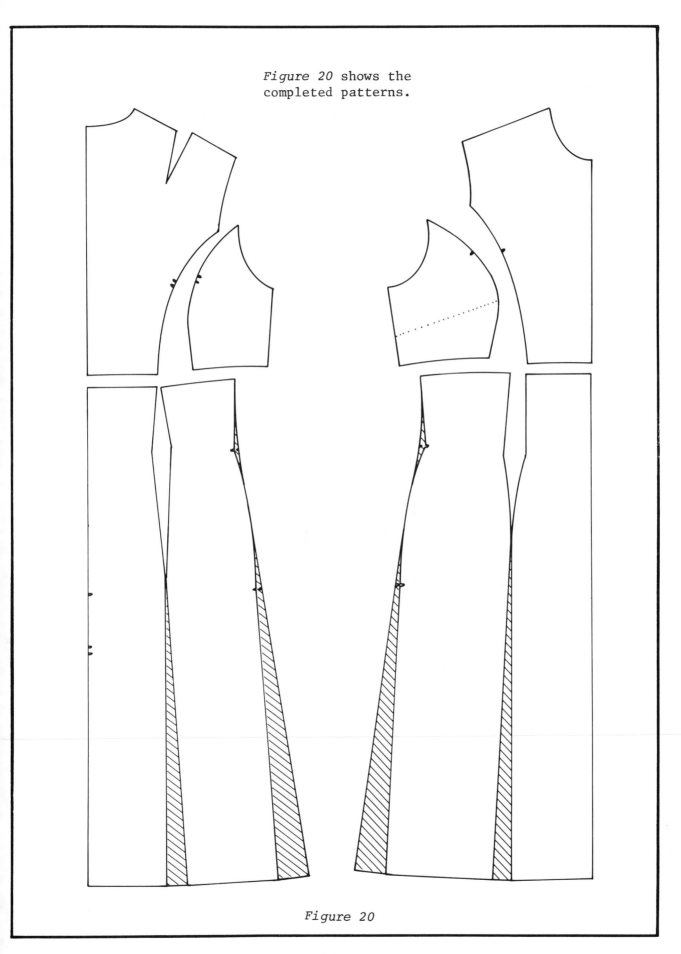

Figure 20 shows the completed patterns.

Figure 20

255

5. Low Torso Line

 When the style emphasis is on the hipline, the low torso line enjoys re-
 newed popularity. That part of the garment below the hipline is often
 in a contrasting color or fabric, whether the dress is short or long.

 Figure 21 shows the completed garment.

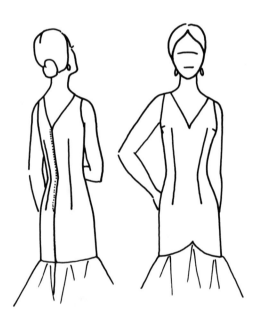

Figure 21

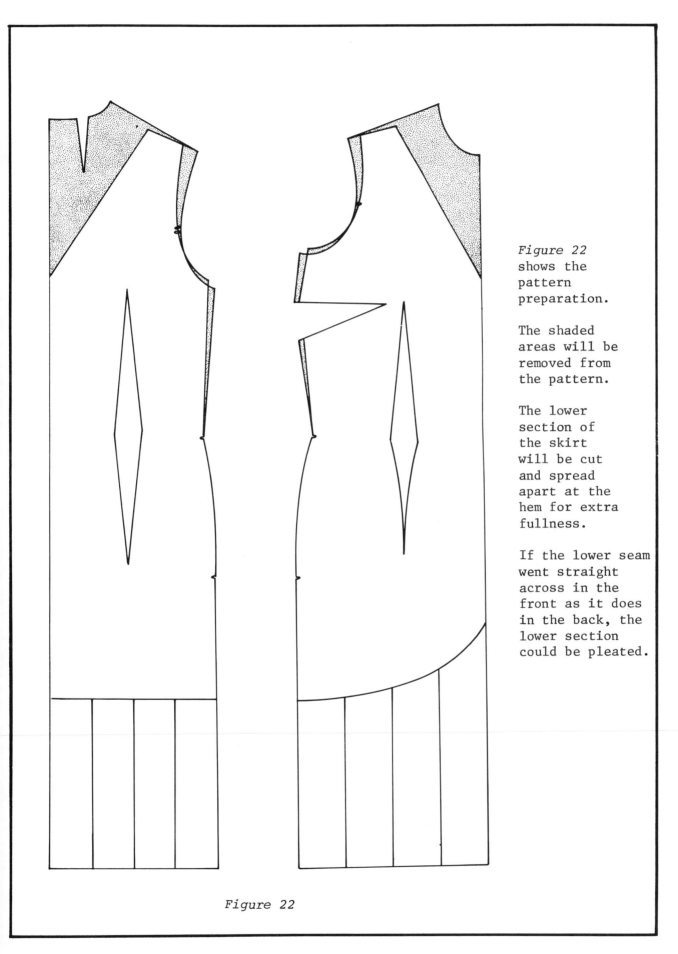

Figure 22
shows the
pattern
preparation.

The shaded
areas will be
removed from
the pattern.

The lower
section of
the skirt
will be cut
and spread
apart at the
hem for extra
fullness.

If the lower seam
went straight
across in the
front as it does
in the back, the
lower section
could be pleated.

Figure 22

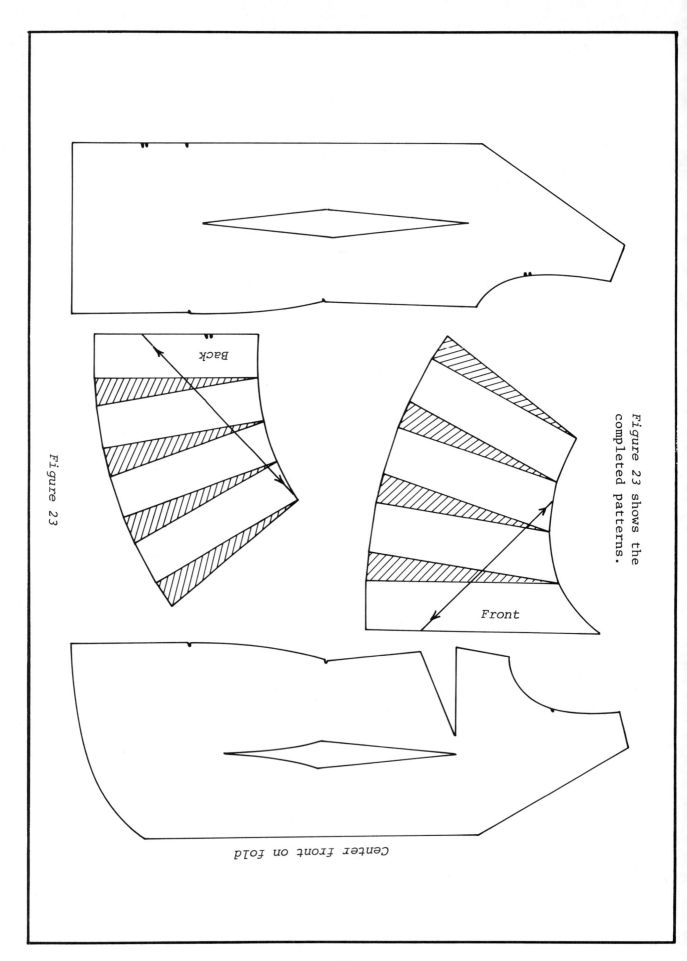

Figure 23 shows the
completed patterns.

Figure 23

Back

Front

Center front on fold

258

Notes

Chapter 13

Pockets

Notes

The fashions for pockets change in the same way other elements of design are changed - hemlines, shoulder widths, positions of waistlines, etc. Sometimes the fad is for large pockets - sometimes for small. Since the size is often the style change it is necessary to learn to judge the best size and placement by eye rather than by any set rules of space relationship or proportion. This applies particularly to the patch pocket.

1. Patch Pockets

 Although they can be made in almost any shape, the most usual shapes for the patch pocket are rectangular, chevron or square. Sometimes these basic shapes will have rounded corners, like the square pocket shown in *Figure 1*.

 Before adding seam allowance to a patch pocket pattern, determine whether the top stitching to hold the pocket in place will be very close to the folded edge or away from the edge.

 In *Figure 1* the chevron pocket with the stitching near the edge would need only 1/4" (0.6 cm) seam allowance. When stitching is further from the fold, the pocket would need 1/2" (1.3 cm) to 3/4" (1.9 cm) seam allowance, depending on the style and the thickness of the fabric.

 The top edge of the pocket needs a minimum of 1" (2.5 cm), whether it is only folded down and pressed into place or folded and stitched. This is known as the *hem* of the pocket.

 For a patch pocket it is only necessary to cut one piece of fabric, unless the pocket is an odd shape in which case a lining piece will also be needed as a facing for the pocket. The facing of the pocket would be applied, then stitched, turned and pressed, before sewing the pocket to the garment.

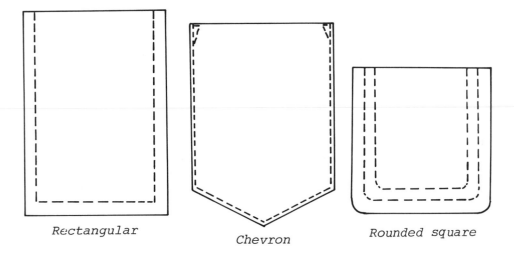

Rectangular Chevron Rounded square

Figure 1

Figure 2 shows a skirt with a patch pocket.

After being hemmed at the top edge, the pocket is top stitched to the front skirt. The side of the pocket is sewn with the side seam when the front skirt is joined to the back skirt.

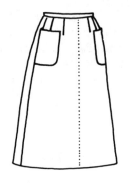

Figure 2

Figure 3 shows the pattern preparation.

For the best results, make up the skirt and then pin or baste the pocket in place to see that it is the right size and in the best position before making the punch marks in the finished pattern.

The punch marks are to guide the sewing machine operator in setting the pocket to the garment. Punch marks are on the skirt only.

Figure 3

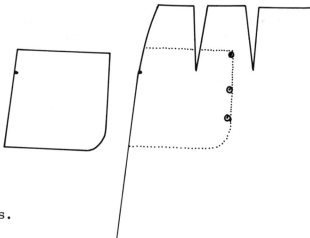

Figure 4 shows the completed patterns.

Note that the pocket is slightly wider at the top than the skirt. This will leave room for the hand to go into the pocket easily and avoid wrinkling.

Figure 4

264

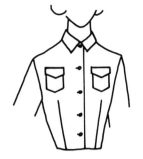

Figure 5 shows a bodice with patch pockets and flaps.

Figure 6 shows the pattern preparation.

Figure 6

Figure 7 shows the completed patterns.

It would be necessary to cut two pieces of fabric for each flap – one of which would be the lining or facing.

Figure 7

2. Seam Line Pockets

Sometimes referred to as trouser pockets when used on pants or skirts, the seam line pocket is most practical if the garment is not too fitted in the hip area. This pocket tends to gap when used on a tight garment.

Figure 8 shows seam line pockets in the panel of a skirt.

Figure 8

The width and depth of this type of pocket is determined by whether it is for a style feature or for utility - as in a work garment. The opening must be large enough to get the hand through comfortably, approximately 7" (17.8 cm). The pocket should be a minimum of 3" (7.6 cm) deeper than the lower opening and about 5" (12.7 cm) wide.

Figure 9 shows the pattern preparation.

Figure 9

Figure 10 shows the completed patterns.

Two pieces of fabric must be cut for each pocket, either in the same fabric as the skirt or in a lighter weight lining fabric for less bulk.

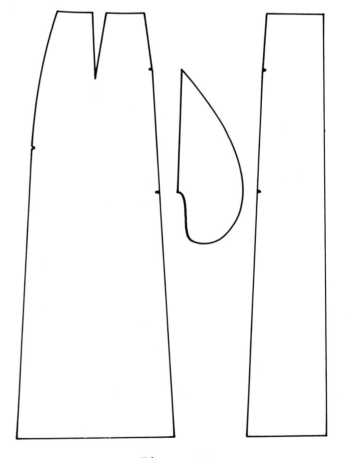

Figure 10

266

Figure 11 shows a variation of the seam line pocket known as the quarter pocket. It is widely used on skirts and trousers.

Figure 11

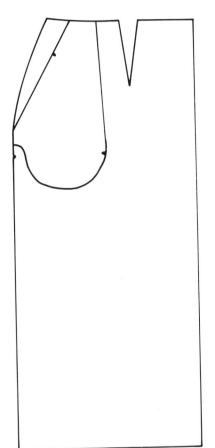

Figure 12 shows the pattern preparation.

Figure 12

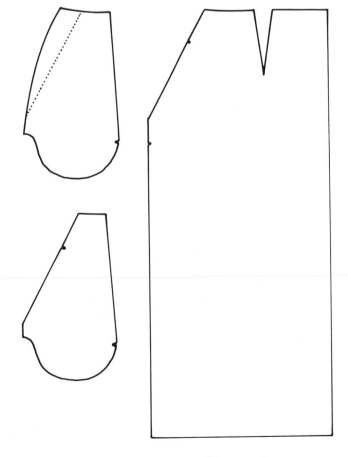

Figure 13 shows the completed patterns. Note that the pocket is cut in two separate pieces. The under pocket – the larger of the two – must be cut in the skirt fabric as part of it is visible.

Figure 13

267

3. Cut-In Pockets

The pocket becomes part of a style line on the garment, the back section of the pocket being a part of the garment.

Figure 14 shows the cut-in pocket on a bodice.

Figure 14

Figure 15 shows the preparation of the pattern.

The size of the pocket is determined by the area the pocket is in and for what purpose the pocket is intended - decorative or utilitarian.

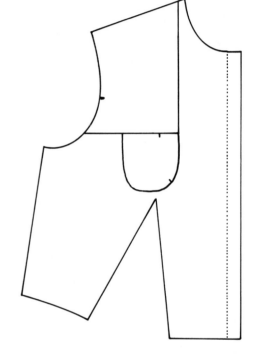

Figure 15

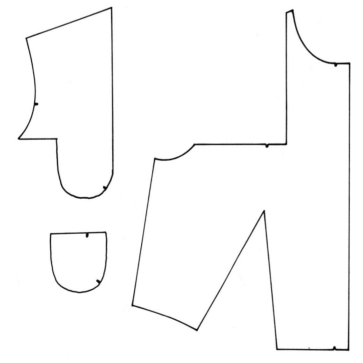

Figure 16 shows the completed patterns.

Figure 16

When used in trousers or skirts, cut-in pockets are referred to by tailors as *top pockets* or *beson pockets*. If the pocket is in the hip area, be sure that the top edge of the opening of the pocket is slightly larger than the under piece. This will keep the under piece from wrinkling when the garment is worn and there will be room for the hand to be inserted into the pocket.

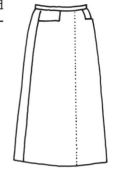

Figure 17 shows the cut-in pocket on a skirt.

Figure 17

Figure 18 shows the pocket preparation on the pattern.

Note how the top edge of the pocket opening has been extended.

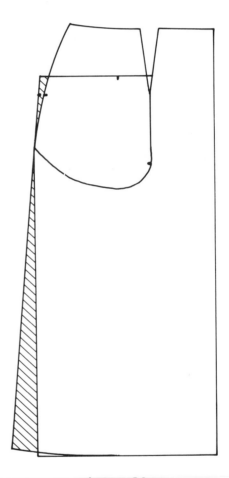

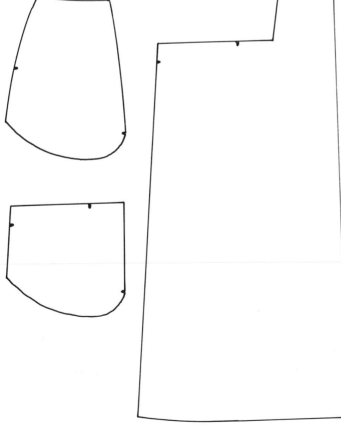

Figure 18

Figure 19 shows the completed patterns.

The under piece of the pocket must be cut of the same fabric as the skirt as part of it will be visible when the garment is finished.

Figure 19

269

4. Welt Pocket

Sometimes referred to as a slot pocket, the welt pocket is simply a pocket inserted into a garment with the opening finished as for a bound buttonhole. Since the opening is finished with small strips of bias, either corded or flat, it is not necessary to make a pattern for the bias strips.

Figure 20 shows a welt pocket with the bias strips folded flat around the opening.

Figure 20

Figure 21 shows the pattern preparation. The under piece of the pocket is slightly longer as it must come to the top line of stitching.

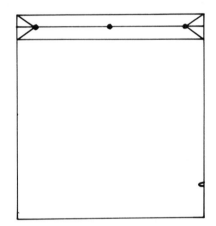

Figure 21

Figure 22 shows the completed patterns.

The illustration at the top shows the three punch marks on the garment to mark the location of the opening of the pocket. The solid lines show where it will be cut. The dotted lines are the stitching lines.

Figure 22

Sometimes the lower edge of the pocket is made with a stand-up piece as shown in *Figure 23*. It would be necessary to make a pattern for the stand-up piece - twice as wide as the height and the same length as the pocket, plus seam allowance.

Figure 23

Figure 24 shows a welt pocket with a flap sewn into the opening. It would be necessary to make a pattern for the flap.

This pocket is widely used on men's suit jackets. It is also used for back trouser pockets with a buttonhole through the flap.

Figure 24

Welt pockets can also be made in a curve - often with contrast piping for western wear. The ends are usually finished with embroidered arrowheads for reinforcement, as shown in *Figure 25*.

Figure 25

Chapter 14

Sleeves - Set-In

Notes

A properly fitted sleeve is generally achieved only after cutting and fitting it in the fabric from which it will finally be made. The amount of ease over the cap will vary according to the fabric it is made from - more ease for soft fabrics and knits - less for firmly woven, bulky or stiff fabrics.

The ultimate use of the garment should be taken into consideration when adjusting the sleeve for movement. A more formal type of garment does not require the same freedom of movement necessary for work or sports clothing. Some of the trim look must often be sacrificed in gaining more movement in a long sleeve.

1. Changing Cap Height

 Increased freedom of movement will be obtained by lengthening the underarm seam of the sleeve, which automatically decreases the cap height.

 Never shorten the cap by cutting it off at the top. This will shorten the over-all length of the sleeve and even if additional length is added to the lower edge of the sleeve it will be out of balance. The more the cap is shortened, the more the sleeve will take on the look of a man's shirt sleeve.

 Figure 1 shows the basic sleeve block with a regular cap.

 Figure 2 shows a sleeve with a shortened cap. As the cap gets shorter the sleeve gets wider at the underarm line.

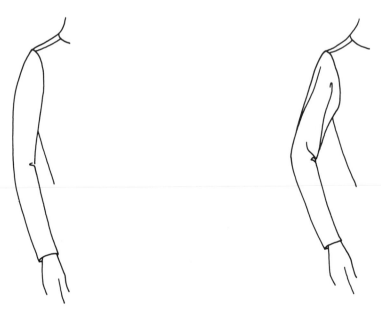

Figure 1 Figure 2

Figure 3 shows how the underarm seam is lengthened and the cap is short-
ened. The over-all length of the sleeve does not change. If an addition-
al underarm length of 2" (5.1 cm) is required, draw a line that distance
above the underarm line on the block, keeping it parallel with the origi-
nal underarm line. Holding the sleeve block at a point midway between
the center notch and the front notch, pivot the sleeve until the under-
arm seam corner touches the new line. Repeat the same process on the back
of the cap. Smooth out any dimples created by the new lines of the cap.
Connect the new front and back points of the sleeve cap at the underarm
line to the elbow. The shorter the cap, the less ease is needed between
the center notch and the front and back cap notches.

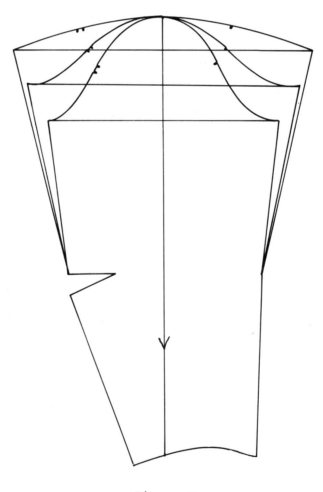

Figure 3

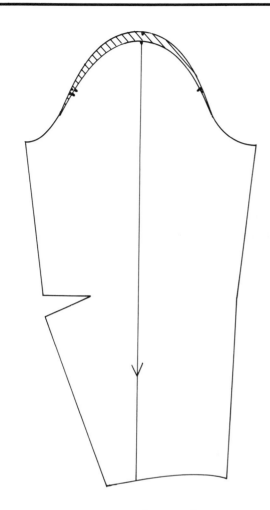

If using a shoulder pad the cap height will need adjustment to fit the new armscye in the altered bodice. See page 123.

This is done by raising the center of the cap the same amount as the shoulder seam has been raised, blending the new lines of the cap into the original lines just below the notches.

The new sleeve should be checked against the corrected bodices at the cap to make sure the notches still allow for 1/2" (1.3 cm) ease between the center notch and the notches on the front and back of the sleeve. There should be 1/4" (0.6 cm) ease between the notches on the sleeve and the end of the underarm seam.

See *Figure 4*.

Figure 4

2. Elbow Darts and Ease

The difference in length between the front edge of the sleeve below the elbow governs the width of the dart. A single dart may be changed by dividing the width of the single dart into the number desired.

Figure 5 shows a two dart sleeve.

The dotted lines indicate the original dart from the basic sleeve block. The shaded areas are the new darts, each half the width of the original dart, and about 1"(2.5 cm) apart. Note that the darts remain the same length as the original dart.

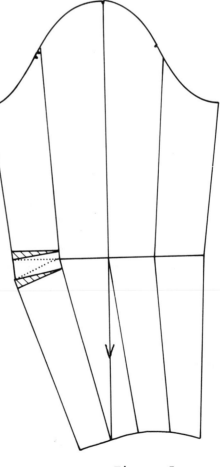

Figure 5

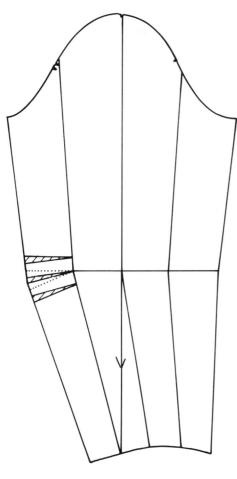

The single dart may be changed to three darts by dividing the width of the dart into three parts.

See *Figure 6.*

If pleats are desired instead of darts, the method would be the same but the darts would not be sewn.

Figure 6

Elbow ease may also be obtained by notching the front edge of the sleeve approximately 1 1/2" (3.8 cm) above and below the front elbow line as a shirring guide or control. The back would be notched the same distance above and below the outer edges of the single dart. The back edge of the sleeve is shirred between the notches and sewn to the matching notches at the front edge of the sleeve.

See *Figure 7.*

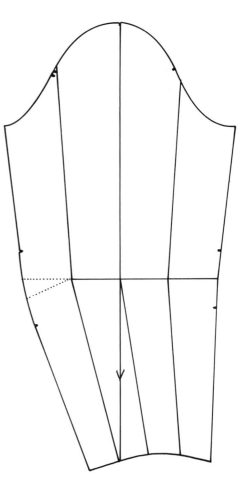

Figure 7

278

3. Shirt Sleeves

The shirt sleeve has a shorter cap than the basic sleeve block and is fuller at the elbow and wrist.

A. Shirt Sleeve With Barrel Cuff

The classic shirt sleeve is shown in *Figure 8*.

The extra fullness at the lower edge of the sleeve may be shirred or pleated to fit the cuff.

Figure 8

Figure 9

The cuff is made by drawing a rectangle the finished width of the cuff, generally about 3" (7.6 cm), by the length of the cuff. The length of the cuff is the wrist measurement of the basic sleeve plus 1" (2.5 cm) for ease and 1" (2.5 cm) for the buttoning - a total of 9" (22.8 cm) for the Size 10. The lower corners of the cuff may be rounded if the cuff is cut in two pieces. See *Figure 9*.

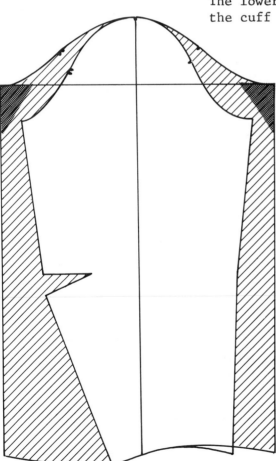

Raise the underarm line about 2" (5.1 cm) and draw in the new cap.

The new front and back underarm seams are made by squaring down from the new underarm line the length of the front sleeve on the block plus the armount the underarm line was raised. Be sure front and back lengths are the same.

For the lower edge of the sleeve, draw a curved line by following the wrist line of the sleeve block.

See *Figure 10*.

Figure 10

The placket opening is located by
dividing the lower edge of the
sleeve into thirds and marking
the opening on the back third.

The opening is about 3" (7.6 cm)
long and parallel with the grain
line. This type of placket is
finished with a small facing or
with binding.

To compensate for the addition of
a cuff the sleeve will need to be
made shorter by the width of the
cuff plus whatever is needed for
a slight blousing of the sleeve
at the lower edge. The amount of
blousing is governed by the style,
the amount of fullness shirred
into the cuff and the type of
fabric used.

See *Figure 11*.

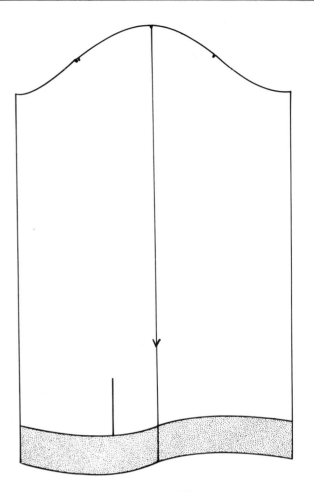

Figure 11

B. Shirt Sleeve With French Cuff

The French cuffed shirt sleeve, fastened with cuff
links, is shown in *Figure 12*.

The French cuff must be twice the width of the finished
cuff in order to fold back and be fastened with links.
The edge that is to be folded back may be rounded at
the corners. The width of
the half that folds back is
1/4" (0.6 cm) wider to cover
the joining of the cuff to
the sleeve. See *Figure 13*.

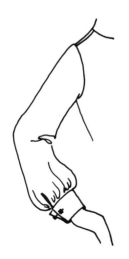

Figure 12

Figure 13

280

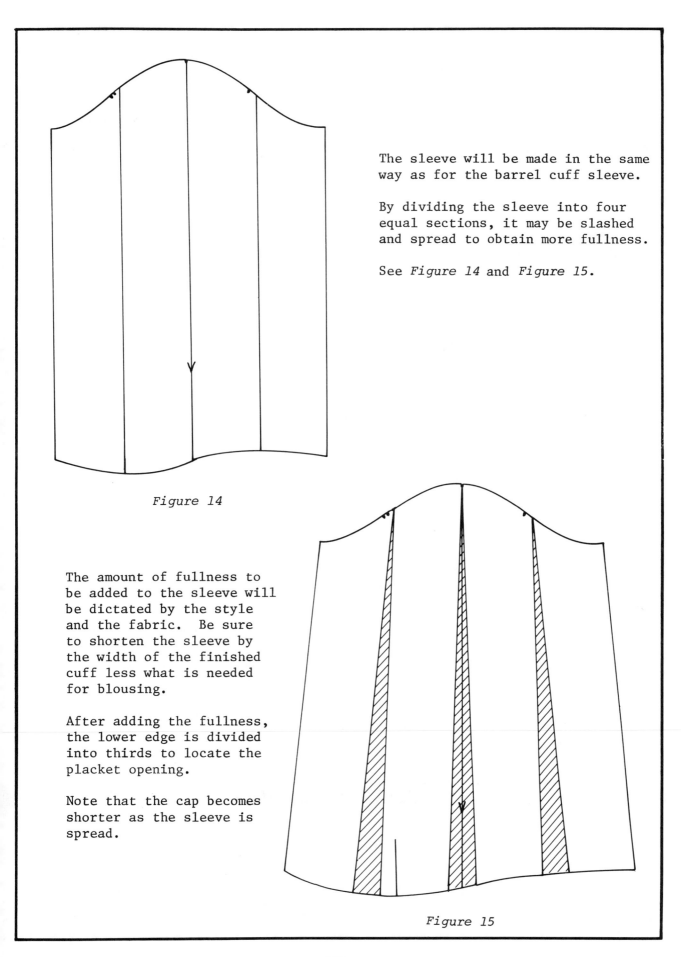

The sleeve will be made in the same way as for the barrel cuff sleeve.

By dividing the sleeve into four equal sections, it may be slashed and spread to obtain more fullness.

See *Figure 14* and *Figure 15*.

Figure 14

The amount of fullness to be added to the sleeve will be dictated by the style and the fabric. Be sure to shorten the sleeve by the width of the finished cuff less what is needed for blousing.

After adding the fullness, the lower edge is divided into thirds to locate the placket opening.

Note that the cap becomes shorter as the sleeve is spread.

Figure 15

281

4. Sleeves With Extra Fullness

Trace the basic sleeve block. Extend the division lines on the sleeve, from the cap to the elbow, to the original squared line at the wrist.

Study the shaded areas on the sleeve in *Figure 1*. The grey areas will be eliminated and the areas with the diagonal lines will be included in the new sleeve pattern.

This basic straight sleeve cannot be used as a long sleeve in woven fabric but it is useful for slashing and spreading to make sleeves with extra fullness.

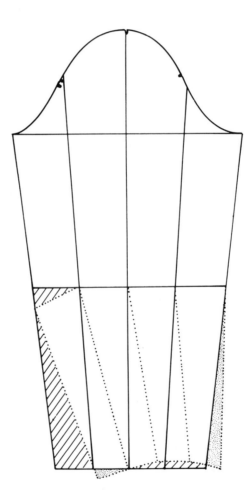

Figure 1

A. Fullness At Lower Edge

 The bell sleeve, *Figure 2,* is made by slashing the
 straight basic sleeve and adding fullness as shown
 in *Figure 3.*

 The lower edge of the sleeve may be plain as shown
 in the illustration or it could be cut in scallops,
 points, or finished with a trim, such as lace.

Figure 2

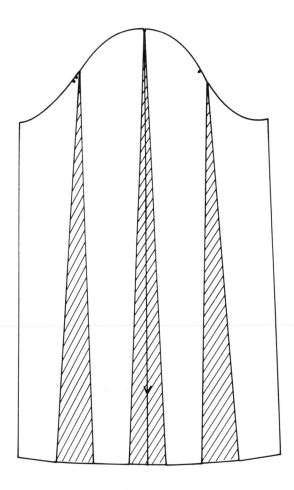

The bell sleeve is finished at the
bottom with a turned up hem or a
separate facing. If a facing is
used it would be traced from the
completed sleeve pattern.

Figure 3

The bishop sleeve, *Figure 4*, is made by slashing and spreading the basic straight sleeve.

Extra length is added for blousing and the lower edge is curved to give extra length for bending the elbow.

See *Figure 5*.

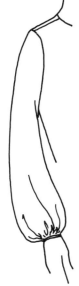

Figure 4

The bishop sleeve may be finished with a band at the wrist, or a casing for elastic or drawstring.

This sleeve can also be made three-quarter length.

Figure 5

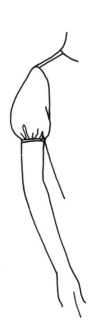

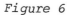

Figure 6

A short puffed sleeve, as in *Figure 6*, is made by cutting the straight basic sleeve to the desired length.

The sleeve is then slashed and spread as in *Figure 7*.

Note the additional length at
the center of the lower edge
of the sleeve to give a more
puffed effect when the bottom
of the sleeve is finished with
a band or elastic.

If the lower edge was not
finished with a band or
elastic but simply left
loose and hemmed or faced
it would be a cape sleeve.

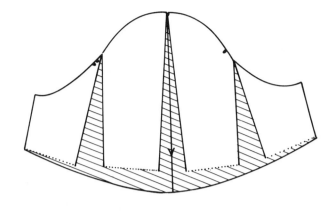

Figure 7

B. Fullness At Cap

For a sleeve puffed at the cap, as in *Figure 8*, trace
around the short sleeve. Divide the cap height into
thirds, squared from the grain line. See *Figure 9*.

Keep the cap notches in the same place so that the sleeve
will fit into the armscye after shirring from the front to
the back notches.

Figure 10 shows how the sleeve is spread. Be sure that
the back and front pieces are evenly spread to maintain
the balance of the sleeve.

The extra cap height causes the sleeve to puff at the top.

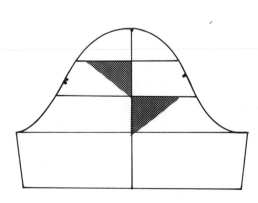

Figure 8

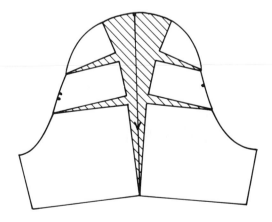

Figure 9

Figure 10

C. Fullness At Lower Edge And Cap

Figure 11 shows the style of the sleeve. It can be finished with a cuff, a band or a casing with elastic at the wrist.

Figure 12 shows the straight basic sleeve prepared to slash and spread. The straight line at the elbow will help to keep the pattern even when spreading.

After spreading the sleeve, extra length is added at both top and bottom to achieve a puffed effect.

See *Figure 13*.

Figure 11

Figure 12

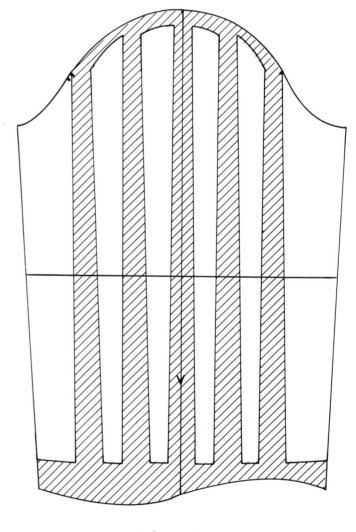

Figure 13

Figure 14 shows a short sleeve with fullness at both the cap and the lower edge.

Figure 15 shows how the sleeve is spread. A more puffed effect can be created by adding extra height to the cap of the sleeve.

Be sure the notches are kept the same distance from the underarm edges on the cap of the new sleeve as on the sleeve block so that when the top is shirred it will fit into the armscye.

The bottom of the sleeve is finished with a band or with elastic.

Figure 14

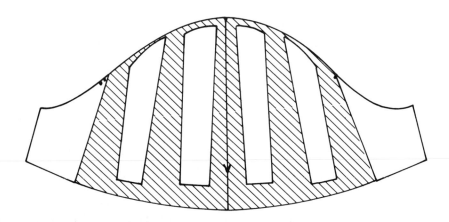

Figure 15

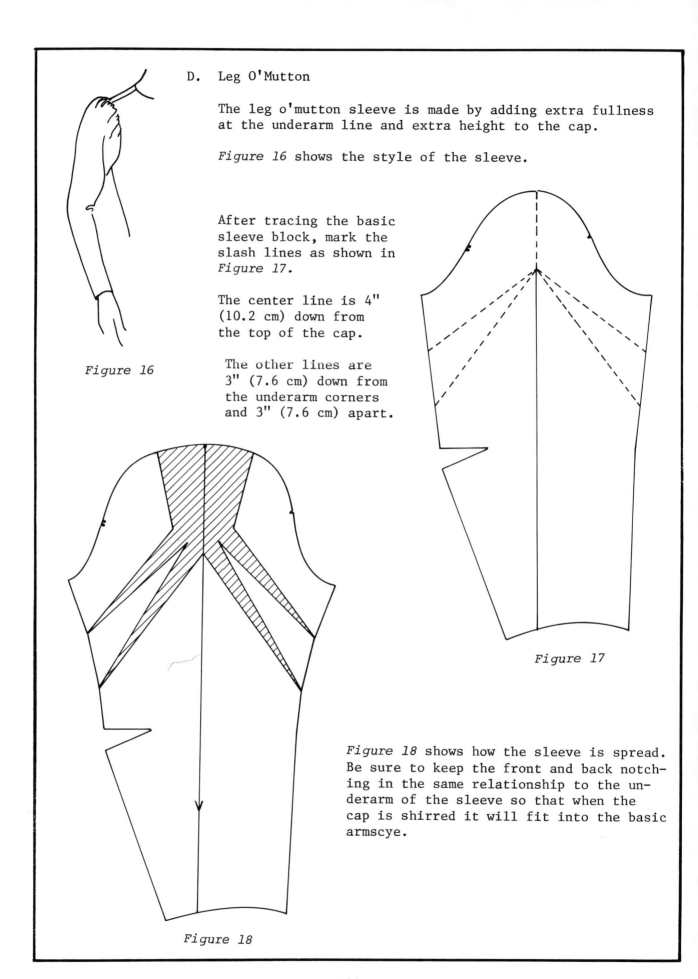

D. Leg O'Mutton

The leg o'mutton sleeve is made by adding extra fullness at the underarm line and extra height to the cap.

Figure 16 shows the style of the sleeve.

After tracing the basic sleeve block, mark the slash lines as shown in *Figure 17*.

The center line is 4" (10.2 cm) down from the top of the cap.

The other lines are 3" (7.6 cm) down from the underarm corners and 3" (7.6 cm) apart.

Figure 16

Figure 17

Figure 18 shows how the sleeve is spread. Be sure to keep the front and back notching in the same relationship to the underarm of the sleeve so that when the cap is shirred it will fit into the basic armscye.

Figure 18

5. Darted Cap

The darted cap sleeve gives width to the shoulder line.
Keep in mind that extra height will be needed in the cap
for the additional length of the darts.

For the 3 dart sleeve, shown in *Figure 1,* trace the basic
sleeve block. Mark the slash lines about 2 1/2" (3.8 cm)
on each side of the center as shown in *Figure 2.*

From the underarm line, raise the center points 1/2"
(1.3 cm) more than the finished length of the darts
will be. If the finished darts are to be 1" (2.5 cm)
long, raise the center 1 1/2" (3.8 cm) from the original
underarm line.

Figure 3 shows how the pattern is completed. The darts
are 1" (2.5 cm) wide at the top and 1" (2.5 cm) long.

Figure 1

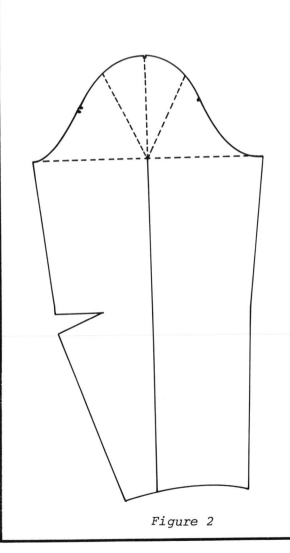

Figure 2

Figure 3

289

For a 5 dart sleeve, *Figure 4*, mark the slash lines 1 1/2" (3.8 cm) apart on the cap and 2" (5.1 cm) below the underarm line.

See *Figure 5*.

Figure 4

If the darts are sewn, some reinforcement is necessary to keep the darts extended. The shape of the reinforcement is obtained by folding out the darts in the paper pattern as a guide.

Figure 5

The darts will be 1" (2.5 cm) wide at the top and 1" (2.5 cm) long.

Complete the darts after spreading the sleeve as shown in *Figure 6*.

The darts may be left unstitched and sewn into the armscye as pleats for a softer, less tailored look.

Figure 6

290

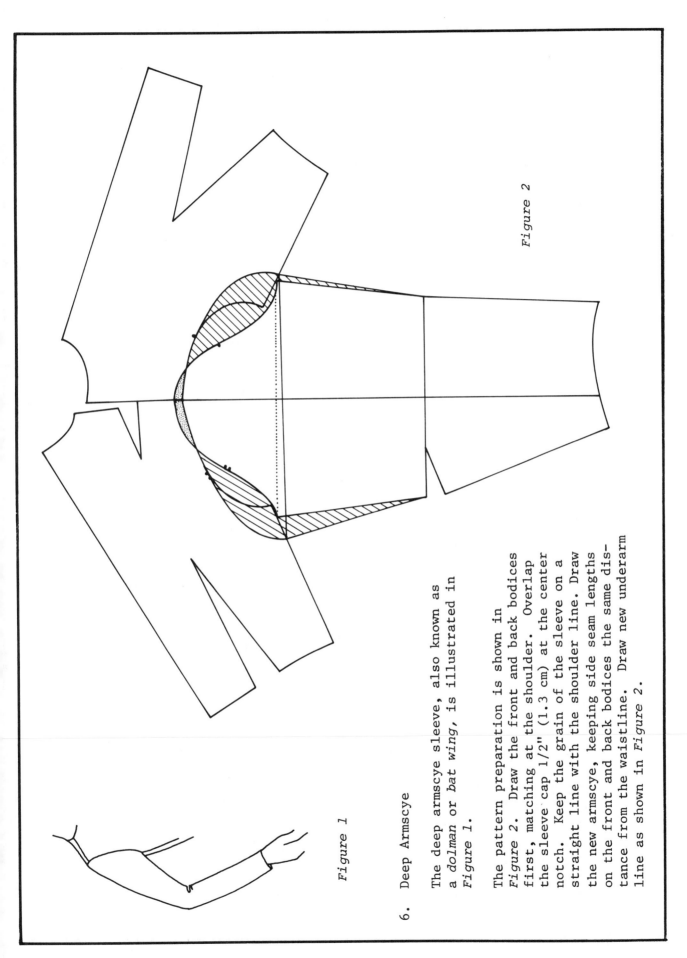

Figure 1

Figure 2

6. Deep Armscye

The deep armscye sleeve, also known as a *dolman* or *bat wing*, is illustrated in *Figure 1*.

The pattern preparation is shown in *Figure 2*. Draw the front and back bodices first, matching at the shoulder. Overlap the sleeve cap 1/2" (1.3 cm) at the center notch. Keep the grain of the sleeve on a straight line with the shoulder line. Draw the new armscye, keeping side seam lengths on the front and back bodices the same distance from the waistline. Draw new underarm line as shown in *Figure 2*.

Cut out the sleeve. Divide the new front and back cap into thirds from the underarm corners to the center.

Draw a rounded line in the lower third of the front and back cap, about 1" (2.5 cm) deep.

See *Figure 3.*

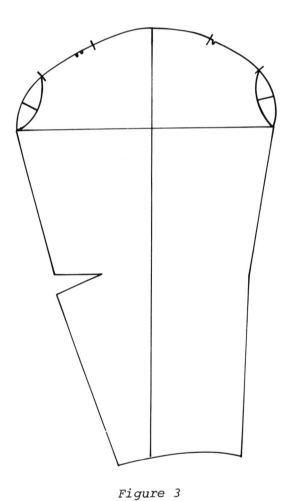

Figure 3

Cut on the rounded lines drawn on the lower third of the front and back sleeve cap. Raise the underarm of the sleeve the same amount that the armscye on the bodice was lowered, keeping the new underarm line parallel to the underarm line drawn in *Figure 2*. Smooth out the cap as shown in *Figure 4*.

Be sure to check the new sleeve cap against the new armscye.

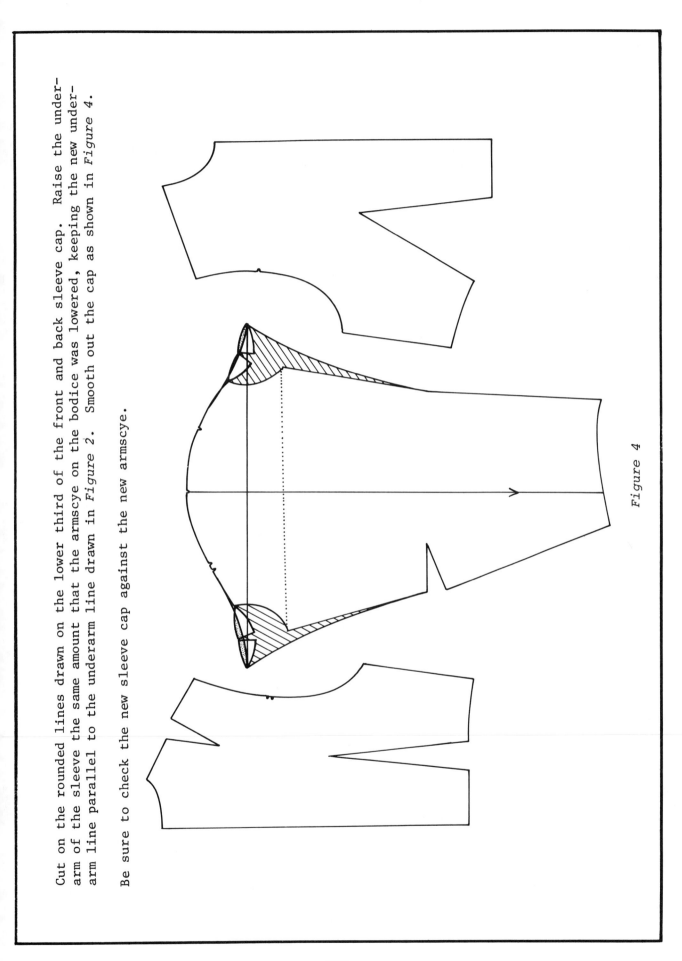

Figure 4

293

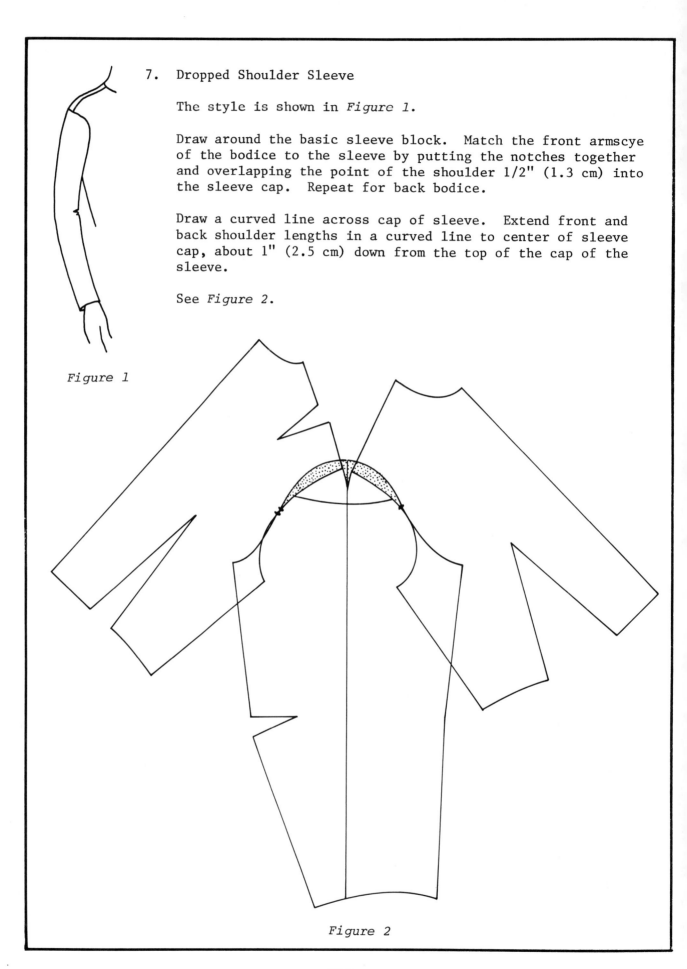

7. Dropped Shoulder Sleeve

The style is shown in *Figure 1*.

Draw around the basic sleeve block. Match the front armscye of the bodice to the sleeve by putting the notches together and overlapping the point of the shoulder 1/2" (1.3 cm) into the sleeve cap. Repeat for back bodice.

Draw a curved line across cap of sleeve. Extend front and back shoulder lengths in a curved line to center of sleeve cap, about 1" (2.5 cm) down from the top of the cap of the sleeve.

See *Figure 2*.

Figure 1

Figure 2

Trace the new bodice pieces with the extended shoulder. The finished patterns are shown in *Figure 3*.

This type of sleeve has a tendency to restrict the raising of the arm and should be tried out in the fabric to check ease of movement. Additional reach can be obtained by increasing underarm length, or by drawing a more shallow curve across the cap in *Figure 2*.

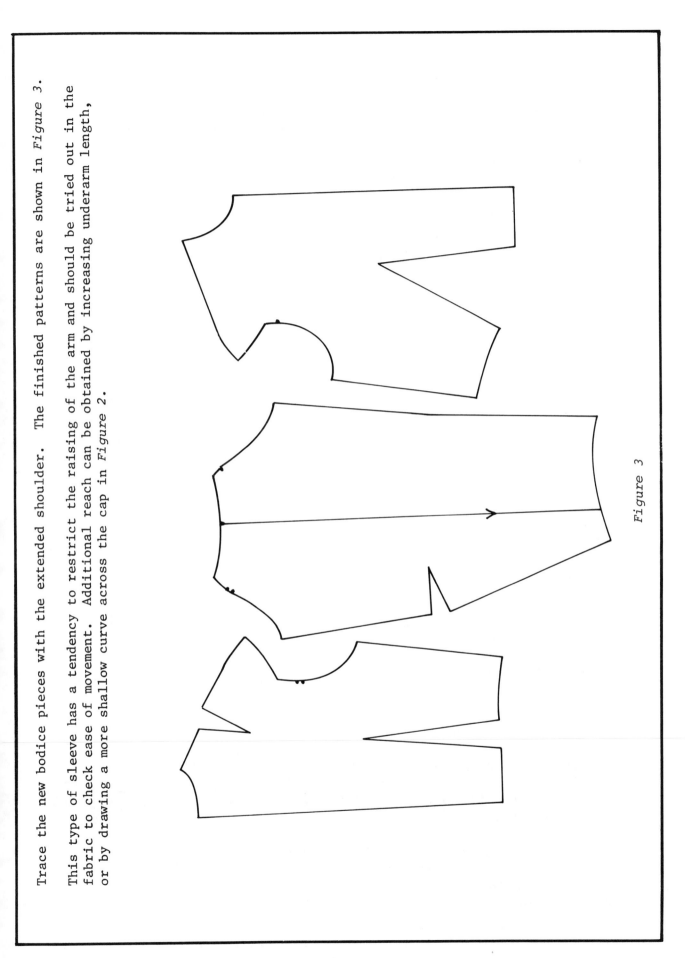

Figure 3

295

Figure 1

8. Two piece Tailored Sleeve

Copied from a man's suit sleeve, this style is generally used on tailored suits and coats but it can be used for dresses and sportswear.

The buttons may either be used as trim or, by making buttonholes in the upper sleeve, the buttons can be functional.

Be sure to use the suit or coat sleeve block when making the pattern for a suit or coat.

Figure 1 shows the completed sleeve.

Fold the front and back edges of the sleeve block to the grain line, from the elbow up, and trace the front and back edges of the sleeve cap onto the center section of the sleeve block in the cap area.

If there is a variance where the front and back edges meet at the grain line, smooth out the curved line which will be on the under sleeve.

Trace around the center section of the sleeve block, including the notches and the curves within the cap area. Mark the bicep line and the elbow line. See *Figure 2.*

On the front bicep line, measure in 1" (2.5 cm); 3/4" (1.9 cm) on the front elbow line; and 1/2" (1.3 cm) on the front wrist. Connect the lines as shown in *Figure 3.*

On the back bicep line, measure in 1" (2.5 cm) and 1/2" (1.3 cm) at the back elbow line. Connect these lines from the back edge of the wrist. Crossmark the line just drawn at 1 1/2" (3.8 cm) above and below the elbow line. See *Figure 3.*

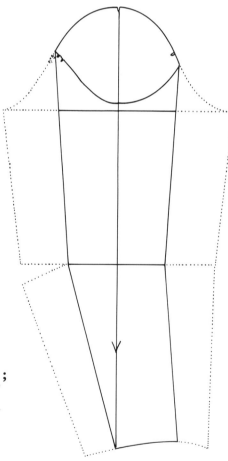

Figure 2

Add a section about 4" (10.2 cm) long and 1" (2.5 cm) wide to the back edge of the sleeve, from the wrist up, for the button section. See *Figure 3*.

Trace the lines just drawn, including the curve at the underarm, for the under sleeve. The grain line will remain the same. The completed under sleeve is shown in *Figure 4*.

To make the upper sleeve, fold the front half of the sleeve on the original line (the broken lines on *Figure 5*), tracing the new line from the elbow to the cap (shown as the dotted line on *Figure 5*).

Fold the lower front half of the sleeve from the elbow to the wrist and trace the new line from elbow to wrist.

Repeat for the back of the sleeve, folding it in sections and tracing the new lines, including the cross-marks near the back elbow line. The back elbow of the upper sleeve will be eased into the elbow of the under sleeve between these crossmarks.

The grain line remains the same as on the original sleeve.

Figure 5 shows the completed upper sleeve.

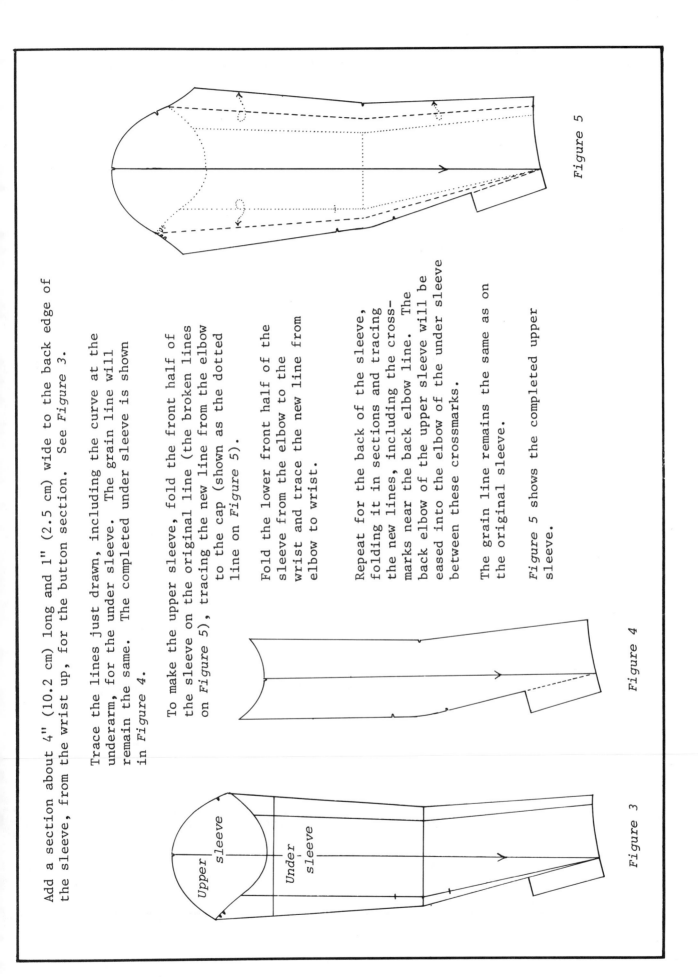

Figure 5

Figure 4

Figure 3

297

Notes

Notes

Chapter 15

Sleeve And Bodice

Cut In One

Notes

Most primitive costumes were developed from the simple T shape. As the sewing and fitting became more sophisticated the sleeve was cut separately. The following patterns are concerned with rejoining the bodice and sleeve in various combinations and styles.

1. Raglan Sleeves

This sleeve was originally used in a loose overcoat made for British Field Marshal Lord Raglan after an injury to his arm made a regular set-in sleeve impractical.

Figure 1 shows the raglan sleeve for a dress or sportswear garment.

After drawing around the front and back bodices, armscyes are divided into thirds - both back and front.

The front neckline is marked at a point 1" (2.5 cm) from the shoulder. The back neckline is marked at 1/2" (1.3 cm) from the shoulder.

A straight line is drawn from the crossmark on the neckline to the top third crossmark on the armscye, on both the front and back bodices.

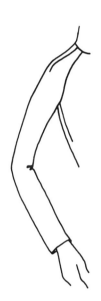

Figure 1

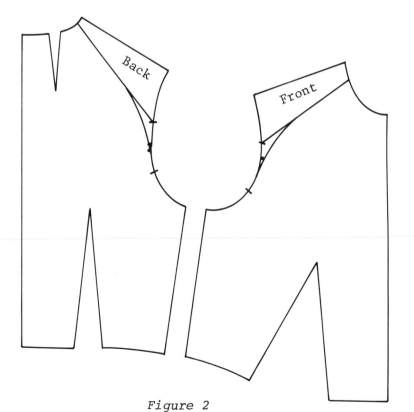

Figure 2

The line from the neckline to the armscye is smoothed into a curve at the second third of the armscye.

See *Figure 2*.

After drawing around the sleeve block, the shoulder sections
from the front and back bodices are joined to the sleeve by
matching the armscye notches to the sleeve notches and over-
lapping the point of the shoulders about 1/2" (1.3 cm) onto
the sleeve cap. See *Figure 3*.

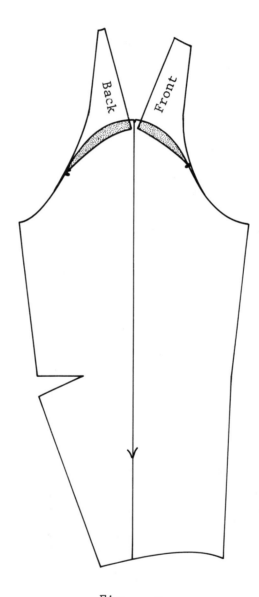

Figure 3

The raglan sleeve may be completed as a one-piece sleeve with a dart at the shoulder or as a two-piece sleeve.

To complete the one-piece sleeve, curve the shoulder dart about 1/2" (1.3 cm) into the sleeve cap as shown in *Figure 4*.

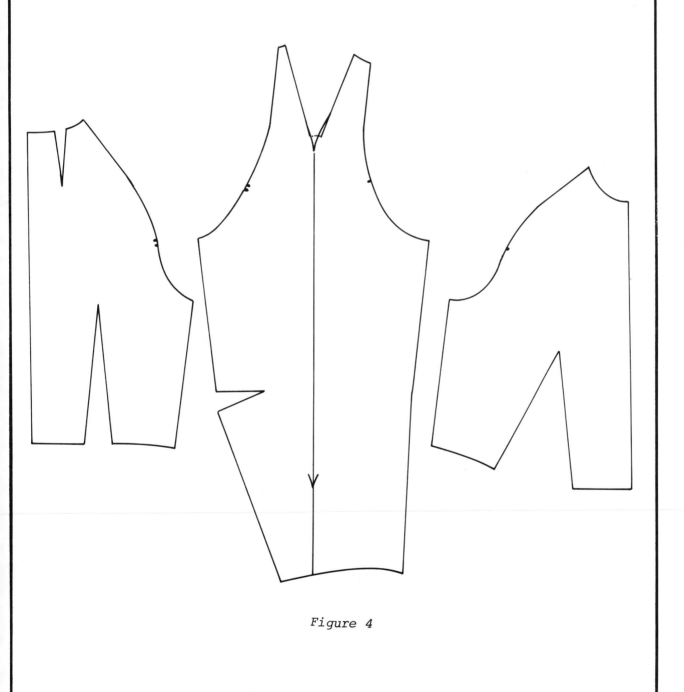

Figure 4

The two-piece raglan sleeve is
made by drawing a line from the
point of the shoulder dart to
the center of the elbow line,
continuing to the center of
the wrist. Smooth out the
angle at the elbow.

See *Figure 5*.

The bodice patterns remain the
same whether the sleeve is made
in one or two sections.

Figure 5

The raglan sleeve can also be made in one piece without
a shoulder dart, as shown in *Figure 6*.

Although this sleeve does not fit as well when made from
firmly woven fabric as the raglan sleeve with the shoulder
dart, it is often preferable in knitted fabrics.

Figure 6

The front and back bodices – be sure to transfer the shoulder dart to the back neck – are placed so that the neck edges and the shoulder lines are touching. Since there is a slight ease in the shoulder, any difference between the front and back should extend at the shoulder point.

The sleeve is placed so that it is overlapping the shoulder points of the bodices about 1/2" (1.3 cm) and is exactly the same distance at the front and back underarm lines without regard to trying to match the center notch of the sleeve to the shoulder point.

On the front section of the bodice, draw an S curve from 1" (2.5 cm) on the neckline to a crossmark 2" (5.1 cm) below the armscye at the side seam. The curved line on the back bodice is from 1/2" (1.3 cm) on the neckline to the same measurement below the armscye as used on the front, 2" (5.1 cm).

See *Figure 7*.

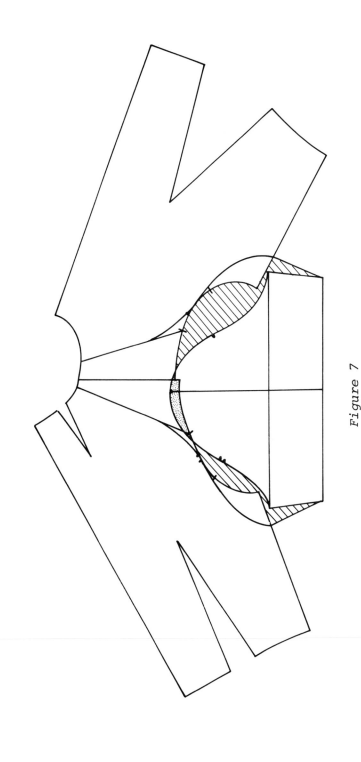

Figure 7

Cut out the sleeve section.
Extend the shoulder line for
the length of the sleeve as
the grain line. Draw in a
new underarm line.

At a point about 4" (10.2 cm)
from the underarm corner of
the front and back sleeve,
draw a rounded line about
1" (2.5 cm) deep.

See *Figure 8*.

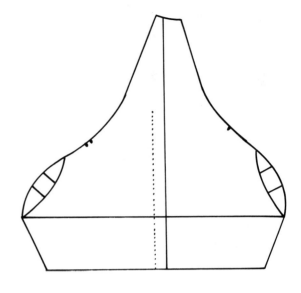

Figure 8

Cut out the rounded lines at the underarm. Raise the underarm corners
of the sleeve the same amount that the armscye on the bodice was lowered,
2" (5.1 cm). Smooth out the lines where the sleeve will be sewn to the
front and back bodices. See *Figure 9*.

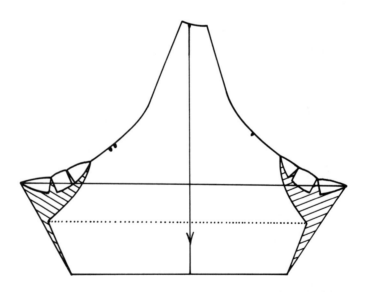

Figure 9

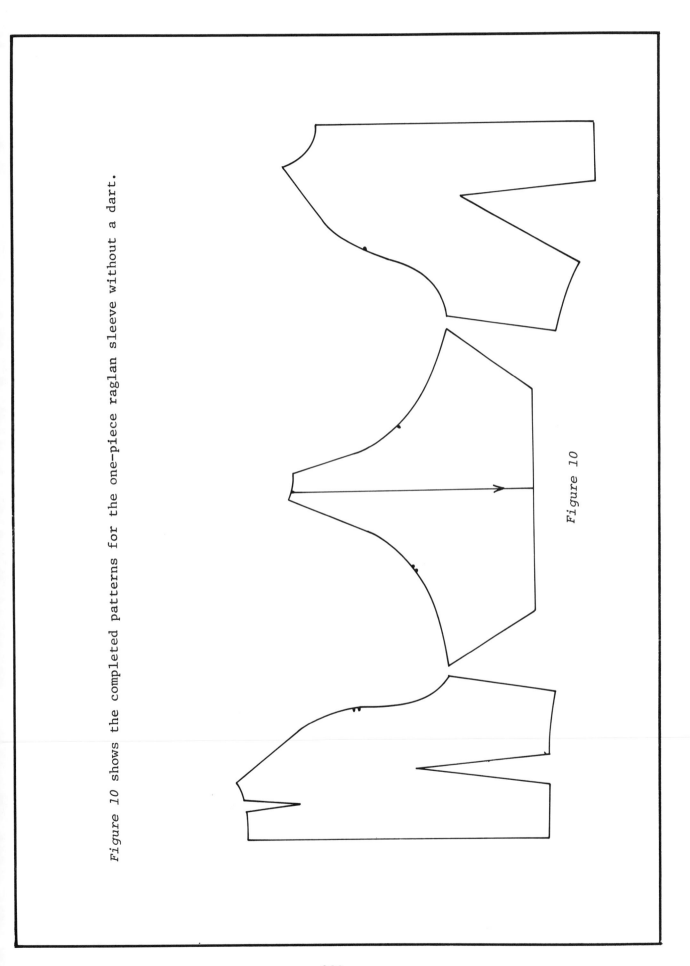

Figure 10 shows the completed patterns for the one-piece raglan sleeve without a dart.

Figure 10

309

2. Sleeve And Yoke Cut In One

Because of the sharp corner in this yoke and sleeve
construction - always a weak point - care must be
taken to not get the yoke line too low on the bodice.

The style shown in *Figure 1* is about the maximum
depth, about 1/2" (1.3 cm) above the front and
back armscye notches.

To construct the pattern, draw around the basic sleeve
block. Match the bodices to the sleeve at the notches
on the sleeve and armscye and drop the shoulder points
of the bodices about 1/2" (1.3 cm) into the sleeve cap.

Draw the yoke lines on the front and back bodices. In
the illustration the lines have been squared with the
center front and center back but they do not necessarily
have to be straight lines.

Figure 1

Curve the front and back shoulders into the sleeve cap
as shown in *Figure 2*.

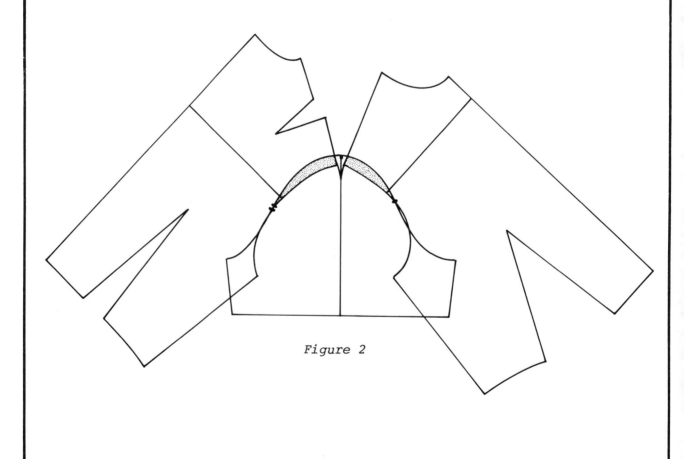

Figure 2

Figure 3 shows the completed patterns.

The yoke line may be curved or pointed as a style variation and does not have to go straight across the body.

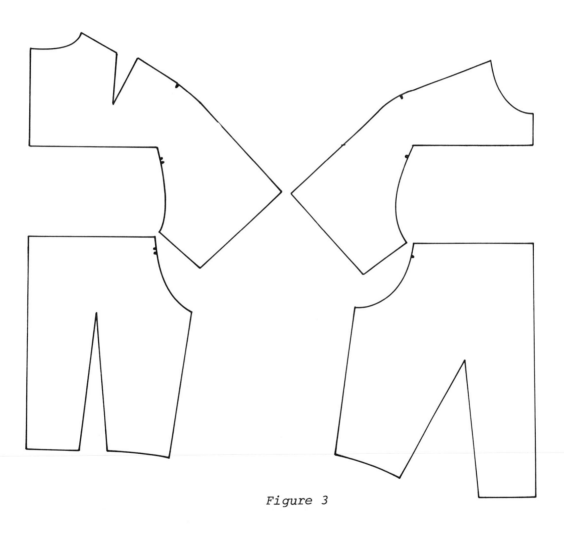

Figure 3

3. Armscye Princess And Sleeve Cut In One

This is essentially a variation on the same principle as the sleeve and yoke cut in one.

The style is shown in *Figure 1*.

After drawing around the sleeve, match the bodices to the sleeve at the armscye and sleeve notches. Drop the bodice 1/2" (1.3 cm) into the sleeve cap at the shoulder points.

Draw the princess lines on the bodices, front and back.

Curve the shoulders into the sleeve cap as shown in *Figure 2*.

Figure 1

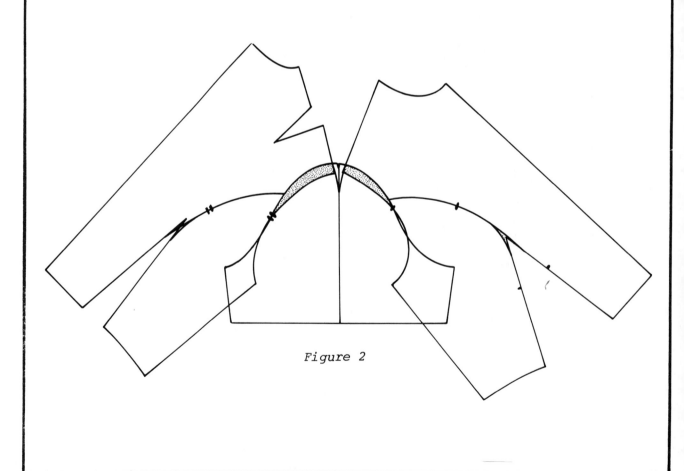

Figure 2

Figure 3 shows the completed patterns.

This same style may also be made with long or three-quarter length sleeves.

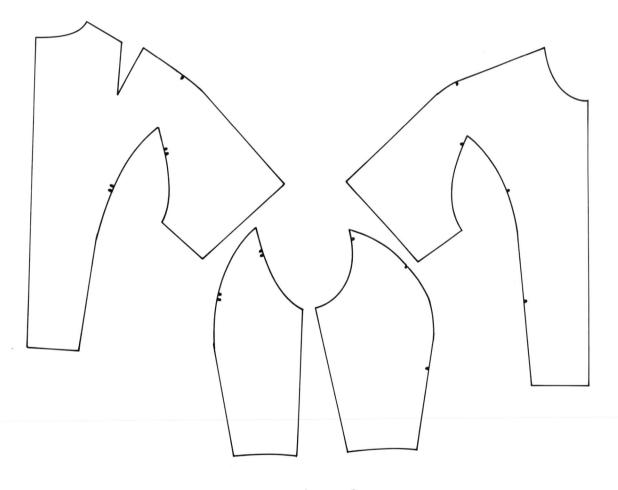

Figure 3

4. Gusset Sleeve

Various views of the gusset sleeve are shown in *Figure 1*.

The gusset should be as inconspicuous as possible when the arm is not raised. Although a one piece gusset may be used, the two piece gusset shown is much easier and faster to make and is the type preferred in most factories.

Figure 1

After drawing around the basic sleeve block, match the front armscye notches of the bodice to the front notches on the cap of the sleeve. Overlap the point of the shoulder on the bodice 1/2" (1.3 cm) onto the sleeve cap.

Holding the point of the shoulder with a push pin, pivot the bodice pattern until the corner of the armscye at the side seam of the bodice is touching the corner of the sleeve at the underarm line.

Repeat the same procedure for the back bodice. Smooth out the shoulder lines.

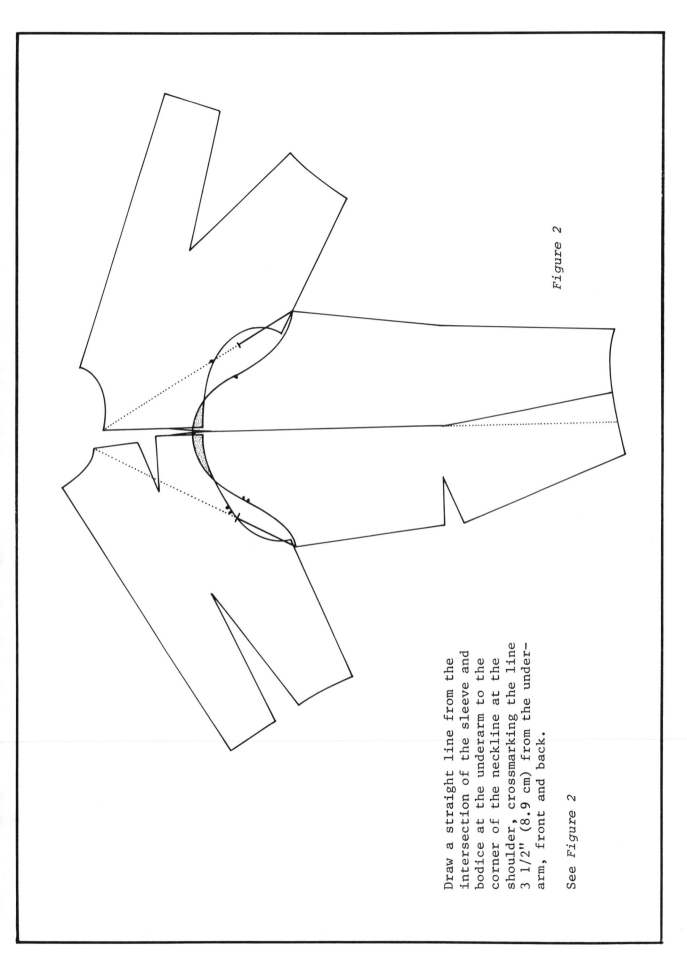

Draw a straight line from the
intersection of the sleeve and
bodice at the underarm to the
corner of the neckline at the
shoulder, crossmarking the line
3 1/2" (8.9 cm) from the under-
arm, front and back.

See *Figure 2*

Figure 2

On the front line drawn from the underarm to the neckline, make a triangle by drawing from a point 1/2" (1.3 cm) on either side of the line at the underarm to the 3 1/2" (8.9 cm) crossmark.

The back triangle is made by matching the side seam length on the front bodice to the side seam length on the back bodice and the underarm lengths of the front and back sleeves.

The front triangle is notched on the line toward the body. The back triangle is marked with double notches, also on the line toward the body.

Figure 3 shows the completed bodice-sleeve patterns without the gussets.

Part of the shaded areas of the front and back triangles will be used for seam allowance to sew in the gussets.

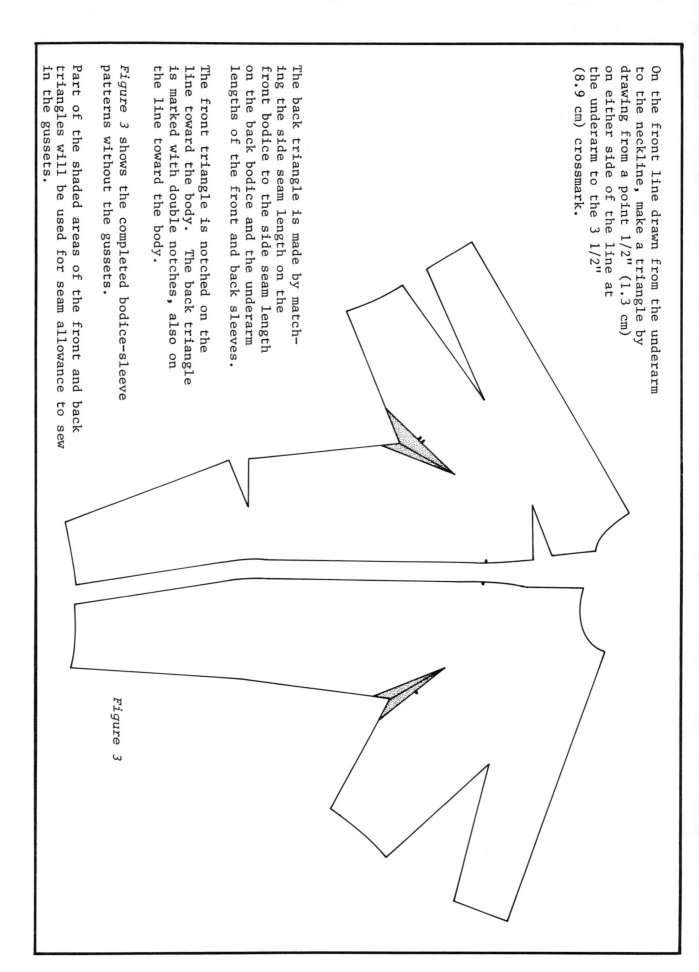

Figure 3

316

The front gusset is made by spreading the cutout front triangle the desired amount to enable the wearer to raise her arm comfortably - usually about 4" (10.2 cm) - and drawing the triangle as shown. The triangle is curved slightly at the underarm seam edge to avoid bulk. See *Figure 4 - Front*.

The back gusset is made by spreading the cutout back triangle the same amount at the base as the front gusset and drawing in the triangle, marking the notches.

The two gusset patterns must measure exactly the same at the underarm or base. The curve for the back is traced from the front curve.

Figure 4 - Front

Figure 4 - Back

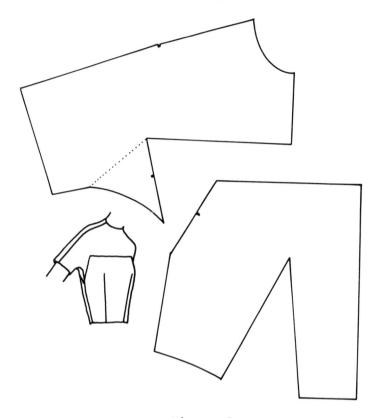

Figure 5

In addition to the plain gusset sleeve, many variations can be
made by separating the sleeve and bodice sections and adding the
gusset to either section.

Some variations are shown in *Figure 5, Figure 6* and *Figure 7.*

Figure 5 shows the gusset added to the sleeve section. The back
sleeve and bodice should follow the same style lines.

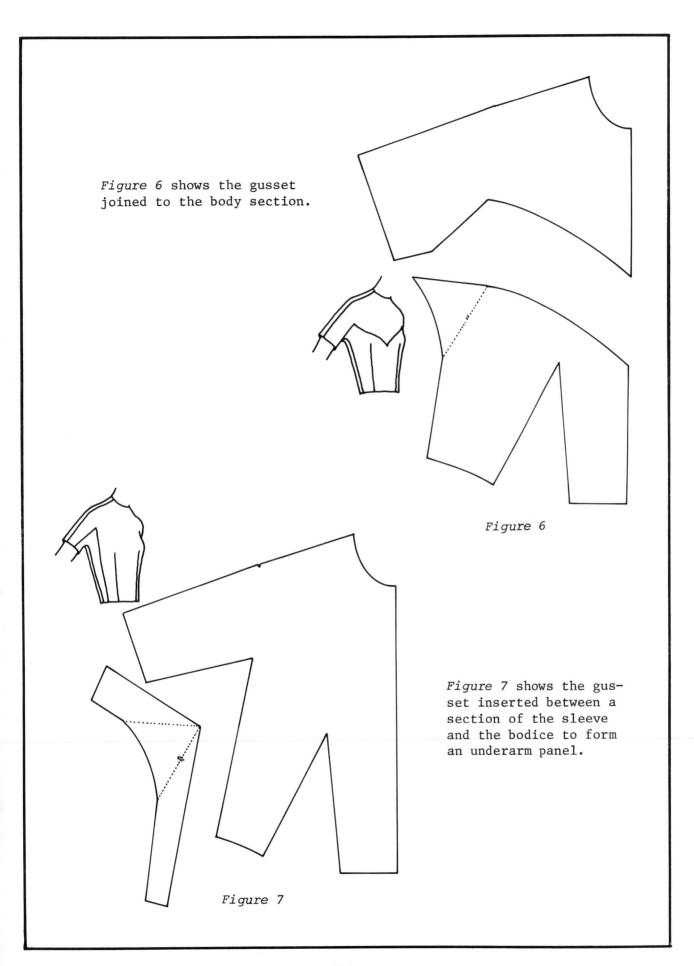

Figure 6 shows the gusset joined to the body section.

Figure 6

Figure 7 shows the gusset inserted between a section of the sleeve and the bodice to form an underarm panel.

Figure 7

5. Cap Sleeve

The cap sleeve, shown in *Figure 1*, must be cut very short or the arm cannot be raised comfortably.

Figure 1

Draw around the bodice patterns, keeping a space of about 1"(2.5 cm) between the front and back shoulders at the armscye and about 2" (5.1 cm) between the shoulders at the neck edge. Let any difference between the front and back shoulder lengths extend at the neck edge.

Measure down 1" (2.5 cm) from the armscye edge of the side seams and make a cross-mark, front and back. The side seams will be sewn together from the waistline up to this mark. Extend the front and back side seams 1" (2.5 cm) into the armscye. From this line, square a line to a point midway between the front and back shoulder corners. Shorten the sleeve with a slightly curved line.

Connect these points, front and back, with a straight line.

Round out the shoulders as in *Figure 2*.

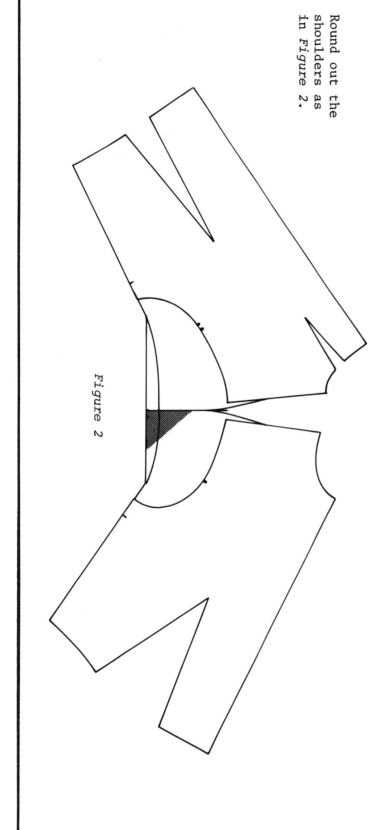

Figure 2

The completed patterns for the cap sleeve are shown in *Figure 3.*

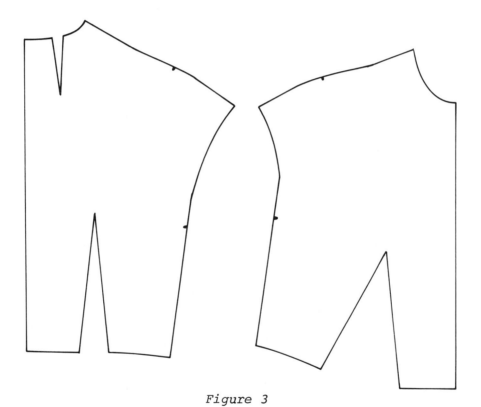

Figure 3

6. Kimono Sleeve

The kimono sleeve may be cut with a very deep underarm as in *Figure 1,*
or with a more shallow curve as shown in *Figure 2.* It will always be
a deeper armscye than the regular set-in basic sleeve.

Figure 1 Figure 2

Draw around the bodice patterns, leaving a space of 1/2" (1.3 cm) be-
tween the shoulder corners at the armscye. Any difference between the
front and back shoulder lengths should extend at the neck edge.

Place the sleeve pattern to overlap the shoulder points 1/2" (1.3 cm)
and so that the front and back corners of the sleeve at the underarm
line are exactly the same distance from the front and back corners of
the armscye and side seams on the bodice. It is not necessary to match
the center notch of the sleeve to the shoulder points of the bodice.

Draw a curved line at the front and back underarms. The curve on the
back should start at the same distance from the waistline on the side
seam as the front, and should end the same distance from the underarm
line on the sleeve as the front. The front and back curves do not have
to be the same shape but they must be the same length so that the dis-
tance from the waistline to the wrist is the same, back and front.

Make a crossmark about 1 1/2" (3.8 cm) from the shoulder point into the
sleeve - on a new line drawn from the center of the shoulder points to
the center of the elbow line. Continue the line from the elbow to the
center of the sleeve at the wrist.

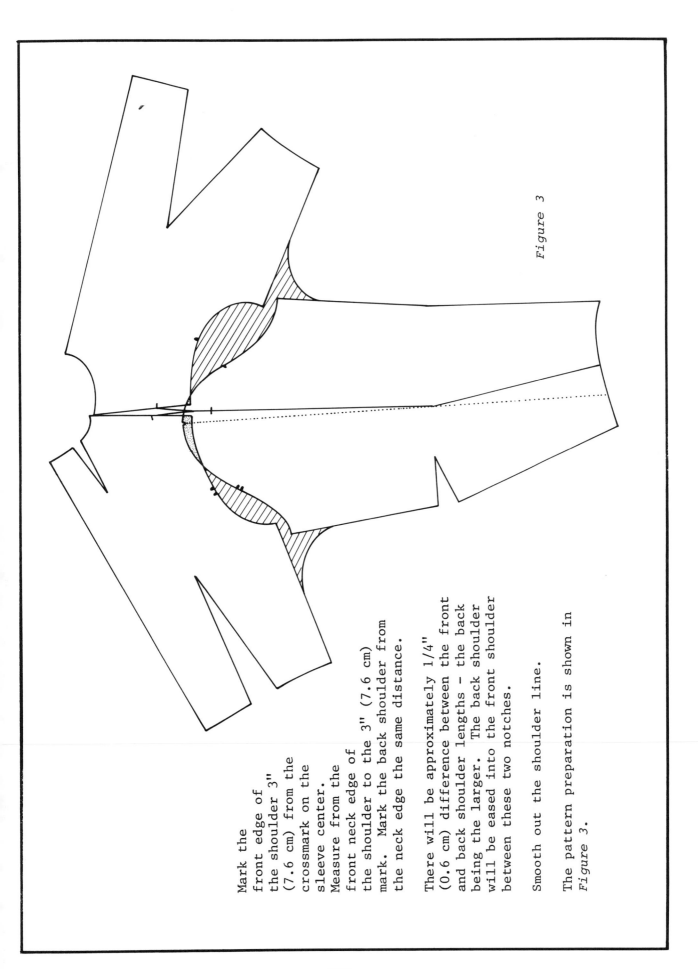

Mark the
front edge of
the shoulder 3"
(7.6 cm) from the
crossmark on the
sleeve center.
Measure from the
front neck edge of
the shoulder to the 3" (7.6 cm)
mark. Mark the back shoulder from
the neck edge the same distance.

There will be approximately 1/4"
(0.6 cm) difference between the front
and back shoulder lengths – the back
being the larger. The back shoulder
will be eased into the front shoulder
between these two notches.

Smooth out the shoulder line.

The pattern preparation is shown in
Figure 3.

Figure 3

After the patterns have been cut out, slash from the underarm to the shoulder, back and front.

The front pattern is shown in *Figure 4*.

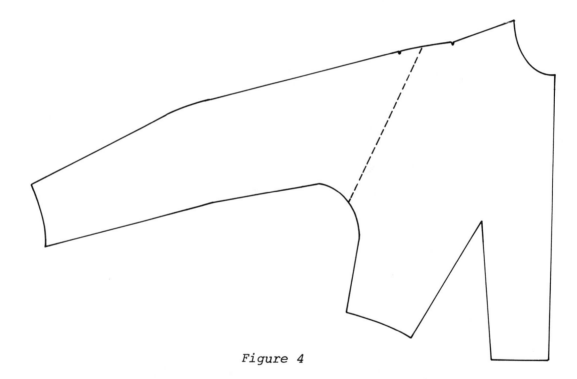

Figure 4

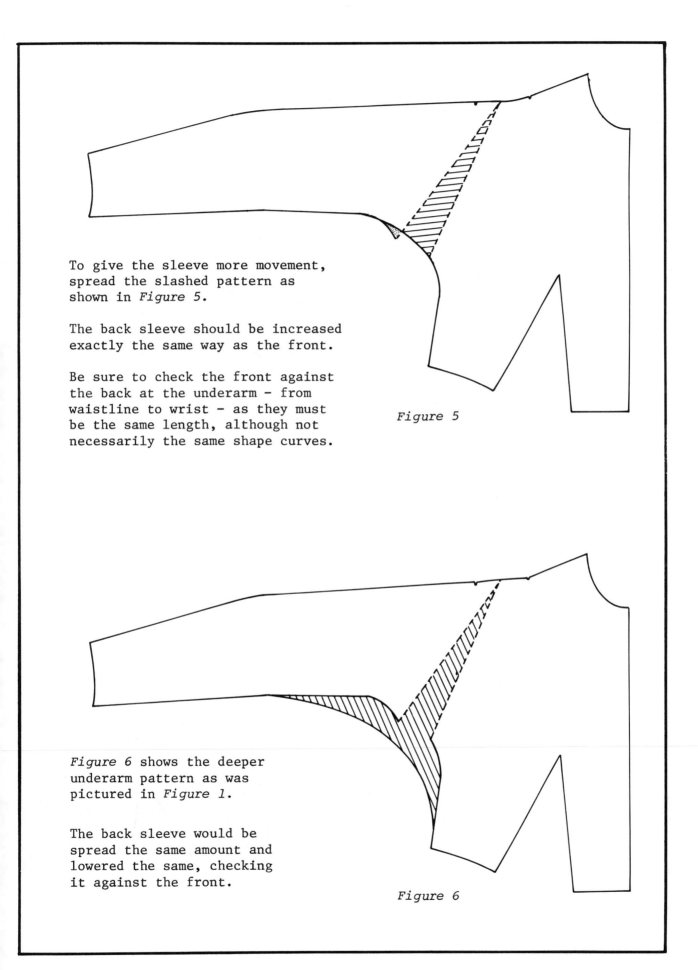

To give the sleeve more movement, spread the slashed pattern as shown in *Figure 5*.

The back sleeve should be increased exactly the same way as the front.

Be sure to check the front against the back at the underarm - from waistline to wrist - as they must be the same length, although not necessarily the same shape curves.

Figure 5

Figure 6 shows the deeper underarm pattern as was pictured in *Figure 1*.

The back sleeve would be spread the same amount and lowered the same, checking it against the front.

Figure 6

Many designers find it useful to make a block of a well-fitted kimono sleeve as it can easily be adapted to make a variety of styles.

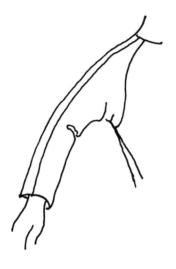

Figure 7 shows how a raglan effect can be obtained with a kimono sleeve. The dotted line is the more conventional raglan sleeve with an S curve, as illustrated in Figure 8.

The broken line is another variation on the raglan sleeve.

Figure 8

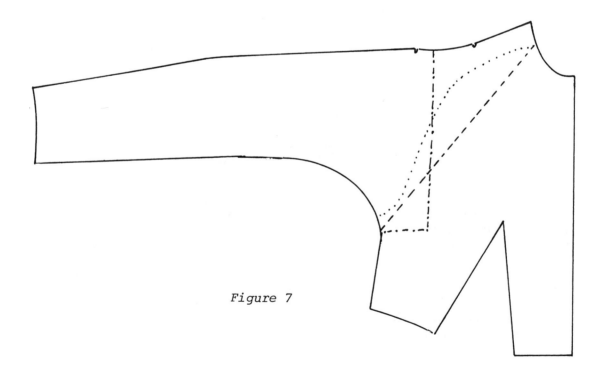

Figure 7

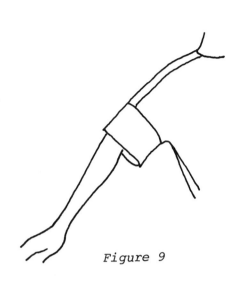

Figure 9

Figure 9 shows the dropped shoulder
sleeve with a loose armscye.

The sleeve section would be made in
one piece by combining the back and
front pieces below the dropped shoulder
line.

See *Figure 10*.

Figure 10

Chapter 16

Necklines

Notes

1. Lowered Necklines

 Necklines that are lowered, or opened, from the original basic blocks re-
 quire minor adjustments to prevent gapping. As a general rule, when neck-
 lines are opened to where they are at the halfway distance on the shoulder
 seam, 1/4" (0.6 cm) should be removed from both the back and front of the
 neckline edge of the shoulder to nothing at the armscye edge of the shoul-
 der.

 When necklines are lower in the back than the basic block, or when the
 neckline is to be opened more than halfway on the shoulder, it is easier
 to work with the basic block with the shoulder dart transferred to the
 back neck. See page 163 for transferring the shoulder dart to the neck.

 A. Round Neckline

 Figure 1 shows a round or scooped neckline.

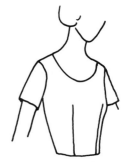

Figure 1

Figure 2 shows the adjustment necessary
at the shoulder after the neckline has
been determined. It is not necessary to
make this adjustment on the shoulder seams
if the new neckline is not more than 2"
(5.1 cm) from the original neckline on the
basic block.

Be sure that the new neckline flows in a
smooth line from front to back.

Figure 2

Figure 3

B. Vee Neckline

The modified vee neckline, as shown in *Figure 3*, needs only the shoulder adjustment pictured in *Figure 4*.

The wider vee, *Figure 5*, requires slightly more adjustment and should be tried out in muslin – particularly if the garment is for a full busted figure.

Figure 4

Figure 5

Figure 6 shows the adjustment necessary to keep the garment from gapping at the neckline.

In addition to adjusting the shoulder, about 1/2" (1.3 cm) is removed in a dart from the neck edge as shown by the shaded area. When pivoted from the bust point, to close the new dart removed from the neckline, the original bust dart will be enlarged.

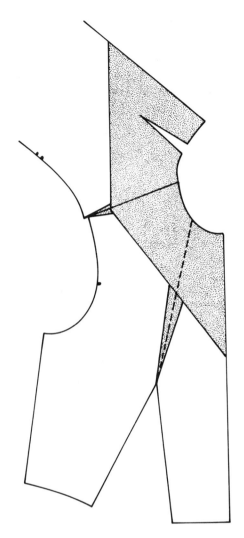

Figure 6

If possible, this type of neckline should be cut with a center front seam so that the neckline will be on the straight grain as in *Figure 7*.

If the style does not call for a center front seam, some of the danger of stretching the neckline can be avoided by cutting the facing on the straight grain.

Because the two legs of the dart removed from the neckline are not the same length, the neckline is blended into a slight curve.

If the dart from the waistline is too large after transferring the dart from the neckline, part of the waistline dart could be put into a side bust dart.

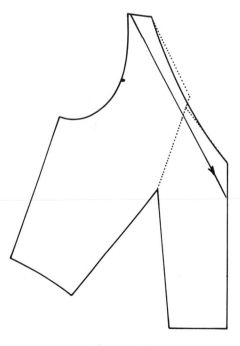

Figure 7

C. Square Neckline

Although the objective is for the neckline to appear square on the body, it is not necessary to cut it on a true square. Because of the natural curves and contours of the body, perfectly straight lines have a tendency to appear curved on the body and curved lines can give the illusion of being straight lines.

Figure 8 shows a square neckline.

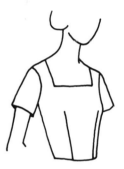

Figure 8

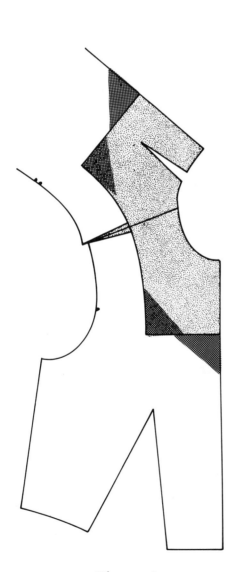

In the pattern preparation, shown in *Figure 9,* the front and back necklines are squared with the center front and center back. The lines are then curved to the shoulder seams, in order to make a smooth transition from front to back.

Figure 9

2. Built-Up Neckline

This type of neckline is practical only when done in a fabric with some body to it and not cut too high on the neck. If a really high neckline is desired then it is better to cut a separate collar.

A. Close-Fitting Built-Up Neckline

Figure 1 shows the style, *Figure 2* shows how the pattern is made.

After transferring the back shoulder dart to the back neckline, extend the center back, dart lines and shoulder at the neck edge 1" (2.5 cm)

Pivot half of the front bust dart to the neck edge. Extend the center front, dart lines and shoulder at the neck edge the same amount as the back, 1" (2.5 cm).

Figure 1

Working from the center front, make the extended sections the same length at the top edge as the original neckline by drawing around the original neckline. Follow the same procedure in the back, starting from the center back.

The top edge of the built-up neckline must equal the original neckline. The shaded areas show the new built-up neckline.

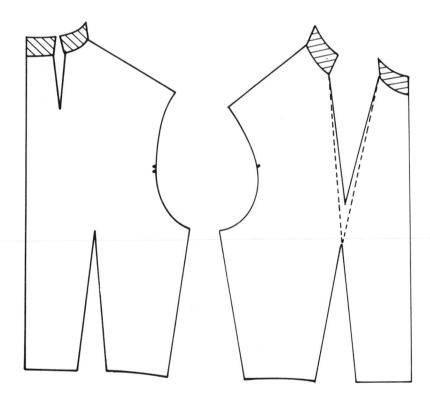

Figure 2

Figure 3 shows the open built-up neckline. In this
example the darts have been incorporated into seams.
This is easier to sew than when only darts are used
to build up the neckline

Figure 3

Figure 4 shows the first step in making the patterns. The base
of the neckline from which the extension will originate must be
established at the same depth all around, as shown by the shaded
areas.

The new body seams are marked and, after crossmarking for identi-
fication, are cut apart. The shaded area is eliminated.

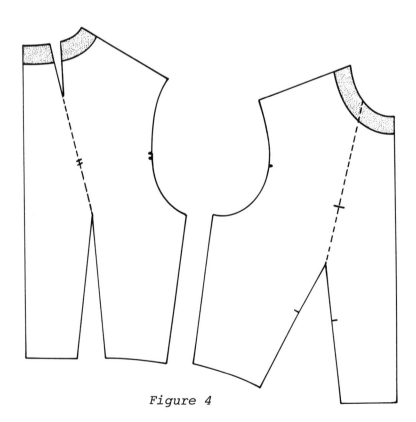

Figure 4

At the cut neckline edge, each section of the pattern is extended 1" (2.5 cm) - the width of the built-up neckline.

The top edge of each section must measure the same as the original cut edge.

Figure 5 shows the patterns with the built-up neckline indicated by the shaded areas.

The patterns for the facings and interfacings are traced from the completed pattern sections.

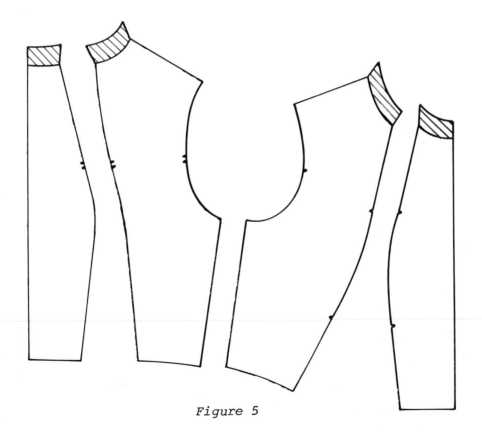

Figure 5

C. Bateau Neckline

The bateau neckline, also called a *boat neck* or *Sabrina neckline*, gives the appearance of a straight line but some curve is necessary for comfort.

Figure 6

Figure 6 shows the style and Figure 7 shows the pattern adjustments.

The grey areas will be removed and the area with the diagonal lines in the center front will become part of the pattern.

If the remaining back neck dart is small enough it may be eased into the neckline.

Figure 7

3. Cowl Neckline

Cowl or draped necklines (the word comes from the hood worn by monks)
are most effective when cut in a very soft fabric such as crepe or chif-
fon. Because cowl necklines drape better when cut on the true bias at
center front, the bust darts can be made smaller or eliminated.

The facing at the neckline should be cut in one with the bodice and folded
to the inside of the garment - but *not creased or pressed* on the folded
edge. A cloth covered weight may be attached to the center edge of the
facing to help control the drape.

A. Single Drape Cowl Neckline

The single drape cowl is shown in *Figure 1*.

Figure 1

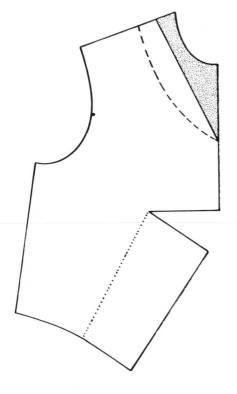

Figure 2 shows the pattern preparation
with the bust dart transferred to the
center front.

After removing a minimum of 1" (2.5 cm)
from the shoulder at the neck edge, draw
a straight line from the new shoulder to
the center front for the depth desired
for the finished neckline - about 4"
(10.2 cm).

From the lower point of the new center
front neckline, draw a slightly curved
line to a mark 1" (2.5 cm) from the neck
edge on the shoulder. This is where the
fullness of the drape will be when the
pattern is completed.

Cut out the front bodice, including the
curved line from center front to shoulder.

Be sure to adjust the back bodice at the
neck edge of the shoulder to fit the ad-
justment made on the front neck edge.

Figure 2

339

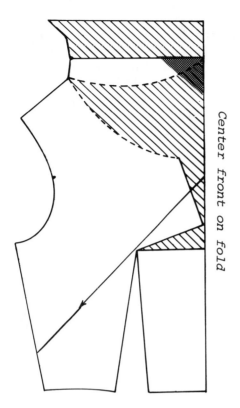

Figure 3

On a line squared with the center front fold of the pattern paper, place the slashed bodice pattern as shown in *Figure 3.*

Note that the bust dart is somewhat smaller than the basic block dart as part of it is left in the center front for the drape.

Add at least 2" (5.1 cm) for the facing at the top edge. The shape of the facing can be determined by folding the paper and tracing the shoulder line.

Mark the bias grain line.

B. Triple Drape Cowl Neckline

By making either two or three slashes and spreading them, double and triple drape cowl necklines can be made.

The triple drape cowl neckline is shown in *Figure 4.*

Figure 4

Figure 5 shows the pattern preparation for the triple drape cowl neckline.

The depth of the center front is 4" (10.2 cm), although it can be any depth desired. The curved lines are 1" (2.5 cm) apart at the center front and at any distance on the shoulder or armscye from which the drape is to originate.

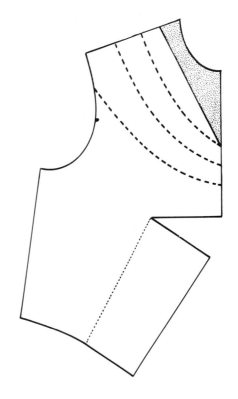

Figure 5

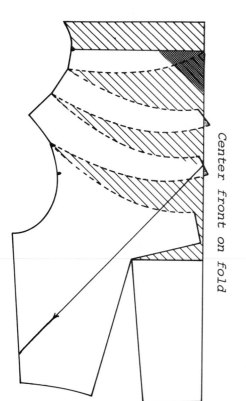

Center front on fold

Figure 6 shows the way the pattern is slashed and spread on the line squared with the center front fold of the pattern paper.

Note that the center edges of the drape patterns extend over the folded line at about midway on each piece. The edges that extend beyond the fold will automatically be eliminated from the pattern.

Make the facing section and draw the bias grain line.

Figure 6

C. Set-In Cowl Neckline

Sometimes it is not practical nor desirable to cut the entire bodice on the bias and a set-in cowl can be made like a yoke.

Figure 7 shows a set-in cowl neckline.

Figure 8 shows the pattern preparation.

The pattern is slashed and spread on the squared center front fold of the pattern paper as shown in *Figure 9*.

The facing may be made parallel with the crease line or deeper in the center. This applies to all facings for cowl drape necklines.

Note the grain lines on the two patterns.

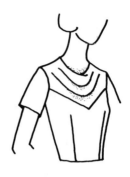

Figure 7

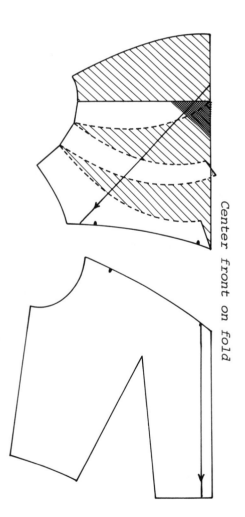

Figure 9

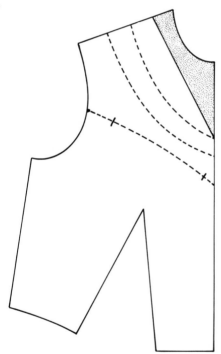

Figure 8

If deeper drapes are required, as in *Figure 10*, the pattern would be spread on the center fold of the pattern paper as shown in *Figure 11*.

The deeper drapes can be made into pleats at the shoulder, partially stitched dart-tucks, or the shoulder could be shirred.

This same method would be applicable whether the front bodice is all in one piece or when the cowl neckline yoke is made as a separate section.

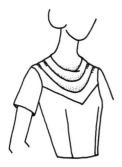

Figure 10

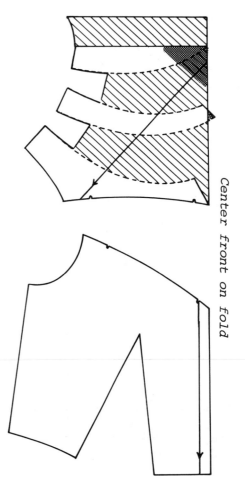

Center front on fold

Figure 11

D. Back Cowl Neckline

Back cowl necklines, see *Figure 12*, are made on the same principle as the front cowl necklines.

It is not practical to have cowl drapes in both the back and front necklines as there would be no control at the shoulder seams and the garment would fall off the shoulders.

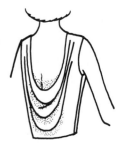

Figure 12

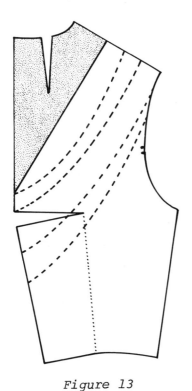

Figure 13 shows the pattern preparation with the dart transferred to the center back.

The front neckline must be widened at the shoulder to match the back neckline. The neckline should not be as low in the center front as in the center back.

Figure 13

Figure 14 shows the pattern slashed and spread on the center back fold of the pattern paper. The back darts have been entirely eliminated.

Complete the facing as for the front and mark the bias grain line.

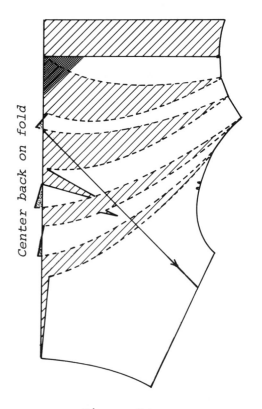

Figure 14

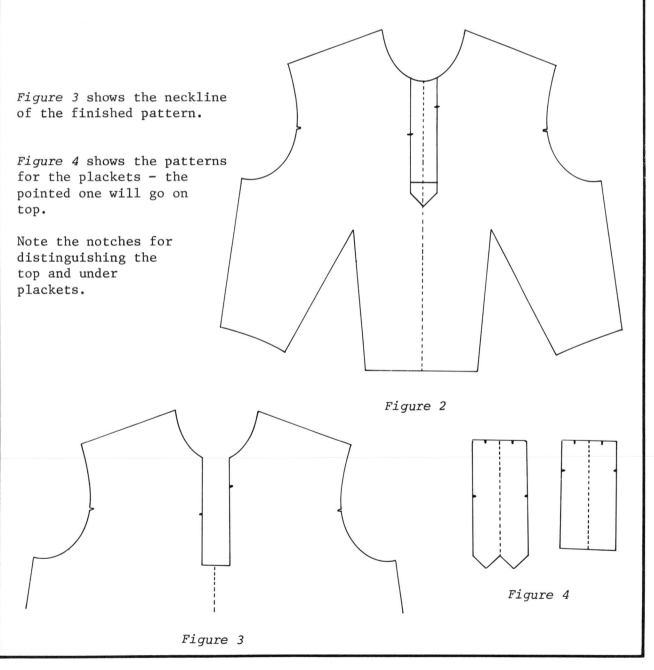

4. Tab or Placket Neckline

This is the same principle used in making a placket for a shirt sleeve. The neckline may be finished plain, as shown in *Figure 1*, or with a collar

Figure 2 shows the pattern preparation.

After drawing around the full pattern, design the width and depth of the placket, keeping in mind that the opening must be large enough to slip over the head.

Figure 1

Figure 3 shows the neckline of the finished pattern.

Figure 4 shows the patterns for the plackets - the pointed one will go on top.

Note the notches for distinguishing the top and under plackets.

Figure 2

Figure 3

Figure 4

Chapter 17

Collars

Notes

Attractive, flattering collars are very important as they are often the focal point of the garment and the first thing a customer looks at when trying on a garment.

All collars, whether cut separately or all in one with the bodice, can be classified in one of three ways:

1. Stand-Up 2. Lie-Down 3. Roll-Over

The most important thing to remember when making a separate or set-in collar is to make the neckline of the bodice, front and back, before attempting the collar.

The methods used to make the following collars can be adapted to either the neckline on the basic blocks or to lower and/or wider necklines.

1. Stand-Up Collars

 A. Mandarin, Chinese or Military Collar

 Keep in mind that the circumference at the base of the neck is somewhat larger than it is further up on the neck. In order for the stand-up collar to fit closely to the neck, the upper edge of the collar must be slightly smaller than the edge that is sewn to the garment.

 Figure 1 shows the style of the collar.

Figure 1

 To make the collar pattern, draw the front neckline. Divide the length of the front neckline in half and draw a straight line from the halfway mark past the center front. From the same mark on the neck, draw a straight line to the shoulder corner of the neck and extend it the distance of half of the total back neck measurement.

 From the front shoulder corner, round out the angle formed by the straight lines until the new curved line equals the front neckline measurement. From the straight lines, square up 1 1/2" (3.8 cm) at the center front and center back for the height of the collar. See *Figure 2*.

Figure 2

 Place the center back of the collar on a fold of paper and trace the neck edge of the collar, marking the notch at the shoulder seam. Make the collar the same width all around as it is at center front and center back, measuring up from the curved neck edge. The collar may be either rounded or squared at center front.
 See *Figure 3*.

On fold

Figure 3

After adding seam allowances, the same pattern is used for the top collar, the lining collar and the interfacing.

B. Mock Turtle or Stove-Pipe Collar

The collar shown in *Figure 4* is open in the back
and may either be closed by extending the zipper
through the collar or by adding an extension to
the collar for buttons and buttonholes or loops.
See *Figure 5*.

Figure 4

After determining the depth of the
neckline, *Figure 6*, draw the new
front neckline and divide in half.
Draw a line from the halfway cross-
mark past the center front. Draw a
line from the same crossmark on the
neck through the shoulder corner of
the neck and extend it the distance
of the back neckline.

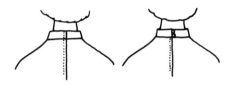

Figure 5

From the shoulder corner, smooth out
the angle and extend the line at the
front until the shoulder to center
front distances are equal on the neck-
line of the bodice and the collar.
Square up from the straight lines at
center front and center back for the
desired width of the collar. See
Figure 7.

Place the center front of the collar
on a fold of paper and trace the neck
edge, marking the shoulder notch.
Measuring up from the neck edge, make
the collar the same width all around.
See *Figure 8*.

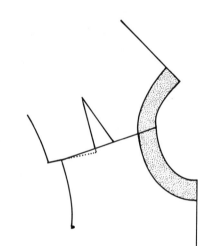

Figure 6

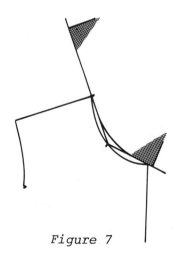

The same pattern is used for the collar, collar
lining and the interfacing.

Figure 7

Figure 8

350

C. Tie Collar

The tie collar shown in *Figure 9* can be cut on the straight or on
the bias. Since it is used on a front fastening garment, notch the
bodice pattern about 1" (2.5 cm) from the center front neck to give
room for the knot of the tie. See *Figure 10*.

Figure 9

Figure 10

Measure the length of the front neckline from the new notch to
the shoulder seam. Measure the back neckline from the shoulder
to the center back. On a folded piece of paper, square a line
for the length of the back and front necklines, plus the amount
required for the tie.

On the squared line, measure from the center back fold the length
of the back neck and make a notch to fit to the shoulder of the
garment. From that notch, measure the length of the front neck
edge to the notch on the bodice and make a corresponding notch on
the tie. After determining the width of the tie, fold the paper
at the upper edge and add seam allowance before cutting.

See *Figure 11*.

Figure 11

This tie collar does not have interfacing and the top and lining
are cut in one piece.

2. Lie-Down or Flat Collars

A. Peter Pan Collar

The style shown in *Figure 1* is made by drawing around the back neck edge of the bodice to the shoulder, pivoting out the neck or shoulder dart. Place the front neck edge of the bodice to the back neck edge at the shoulder, overlapping the shoulder edge at the armscye about 1/2" (1.3 cm). See *Figure 2*.

Figure 1

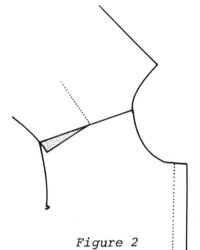

Figure 2

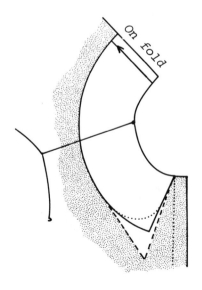

Figure 3

Draw the style or outer edge of the collar the width desired. An average width is 3" (7.6 cm). The front edge of the collar may be pointed or rounded as shown in *Figure 3*.

Trace the collar with the center back on the fold of paper and add seam allowances for the top collar and interfacing pattern.

Draw around the top collar and remove a minimum of 1/8" (0.3 cm) - more for bulkier fabrics - from the outer edge of the collar.

This will be the under collar pattern. It will be the same size at the neck edge and have the same notches as the top collar.

B. Sailor Collar

To make the collar shown in *Figure 4*, draw around the back neck and a portion of the back bodice — with the center back on the fold — and pivot out the neck or shoulder dart.

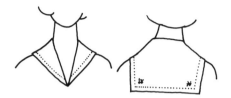

Figure 4

Determine how deep the center front neckline will be — 4" (10.2 cm) is a minimum for this style as it has to slip over the head — and make the front bodice pattern.

Keeping the neck edges together, overlap the back and front shoulder seams at the armscye 1/2" (1.3 cm). Make the center back collar the desired depth, about 10" (25.4 cm), squaring from the center back fold.

The width of the collar at the back will be determined by squaring a line from the lower edge of the back collar, across the shoulder to the center front.

See *Figure 5*.

After adding seam allowance to the pattern, trace around it for the under collar which will be 1/8" (0.3 cm) smaller at the outer edges.

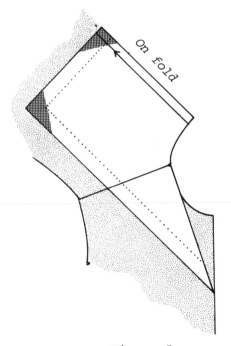

Figure 5

C. Flat Collar For Open Neckline

The style is shown in *Figure 6*.

Figure 6

After making the bodice patterns with the lower neckline, place the center back bodice on the fold of the paper and draw around the neckline and shoulder, pivoting out any darts in the neck or shoulder. Keeping the neck edges together, draw around the front neckline with the shoulders overlapped 1/2" (1.3 cm) at the armscye edge.

Draw the style edge of the collar in the desired width and shape.

Make the undercollar pattern by removing 1/8" (0.3 cm) from the outer edges of the top collar pattern.

The completed collar is shown in *Figure 7*.

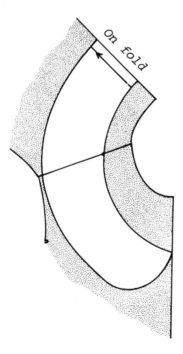

Figure 7

3. Roll-Over Collars

A. Convertible Collar

The convertible collar may be worn either open or closed, as shown in *Figure 1*, and is the type most generally used on casual sportswear.

Figure 1

Draw the front neckline from the bodice and crossmark the halfway distance on the neckline. From the crossmark, draw a line through the shoulder edge at the neck and extend it for half the length of the total back neck. Draw a line from the crossmark on the front neck through the center front, dropping the center front 1/2" (1.3 cm). Curve the line from the shoulder to the front to equal the length of the front neckline on the bodice.

Square a line up from the center back for the desired height of the *stand* of the collar, about 1 1/2" (3.8 cm). The stand is how high the collar extends onto the neck before rolling over. With a straight line connect the top edge of the center back stand to the center front. This will be the *roll line* or fold of the collar. Draw the style line – outer edge – of the collar, making it about 3/8"(1.0cm) wider at the center back and the shoulder seam than the stand. See *Figure 2*.

Figure 2

Roll line

Figure 3

Fold the paper at the roll line and trace the stand, indicated by the shaded area in *Figure 3*.

Unfold the stand. After extending the stand at the center back and checking to make sure there is a definite angle where the stand ends at center front, cut out the collar. See *Figure 4*.

Figure 4

Place the center back of the collar on a fold of paper and slash and spread as shown in *Figure 5*. The slashes are spread 1/8" (0.3 cm). Check the neck edge and the outer edge of collar at center back to be sure they are both squared with the fold for at least 1 1/2" (3.8 cm). After adding seam allowance this will be the top collar and interfacing pattern.

If using a fusible interfacing, make a separate pattern for it by removing 1/8" (0.3 cm) from all edges of the pattern.

To make the under collar, remove 1/8" (0.3 cm) from the outer edges of the top collar pattern.

Figure 5

A simpler method of making a convertible collar is shown in *Figure 6*. The drawback on this method is that it is difficult to determine where the style edges of the collar will fall in relation to the bodice. It is also hard to gauge how wide the spread - the distance between the collar points at the front - will be without cutting the collar in muslin and trying it on the dress form. The collar does have merit however: It eliminates top and under collar fabric matching problems and it is inexpensive to produce.

On a folded piece of paper, square a line equal to half the total neck measurement. From the fold, mark the distance from the center back to the shoulder and make a notch on the squared line. At the center front measure up 3/4" (1.9 cm) and draw a slightly curved line from the shoulder notch to the raised center front.

Determine the desired width of the collar by doubling the height of the stand and adding 3/8" (1.0 cm). For a 1 1/2" (3.8 cm) stand the total width would be 3 3/8" (8.6 cm).

Measuring up from the original squared line at the fold, square a line from the fold for the total width of the collar. Shape the point of the collar. This collar may be cut in one piece by folding on the outer edge of the collar. The completed collar, unfolded, would appear as in *Figure 7*.

On fold

On fold

Figure 6

Figure 7

B. Turtle-Neck Collar

The turtle-neck collar, shown in *Figure 8,* works best when cut on the bias if made in a woven fabric. The entire collar is cut in one piece.

Square a line down from the folded edge of the paper for the width of the stand and the fall combined. If a 2" (5.1 cm) stand is to be used, the squared line would be 4" (10.2 cm) long. This line will be the center back of the collar.

Figure 8

Since the collar is to be cut on the bias, square a line from the center back 1/8" (0.3 cm) less than half of the back neck measurement and make a notch for the shoulder. Extend the squared line from the shoulder notch 1/8" (0.3 cm) less than the measurement of the front neck and mark a center front notch.

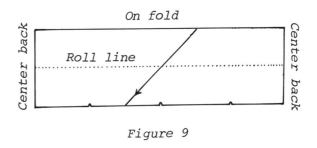

Figure 9

Repeat the measurement from center front to shoulder and from shoulder to center back. Square a line up to the folded edge of the paper. Draw the bias grain line and add seam allowances. The collar is cut on the fold. See *Figure 9*.

C. Tailored Shirt Collar

The tailored shirt collar is made with a separate stand like a man's dress shirt collar. See *Figure 10*.

To make the stand, draw a straight line from the shoulder edge of the neckline through the center front neck for the length of the front neck measurement including the extension. At the center front square a line up 1" (2.5 cm) for the height of the stand at center front. From the center front stand height square a line parallel to the first straight line for the length of the combined front and back necklines.

Figure 10

Square down the center back 1 1/2" (3.8 cm) for the height of the stand at the center back. From the bottom edge of the center back stand, square a line to the shoulder corner at the neck edge.

From the shoulder, draw a slight curve to meet the base of the stand at center front.

The center front will be extended the same amount as the extension. The stand comes to the edge of the overlap and does not stop at the center front as in most other styles.

Round out the top edge of the extension on the stand.

See *Figure 11*.

Figure 11

The collar is made by tracing the stand and then making the lower edge of the center back of the collar, to the shoulder, 3/8" (1.0 cm) deeper than the stand. From the shoulder to the front the collar may be shaped as desired. See *Figure 12*.

Figure 12

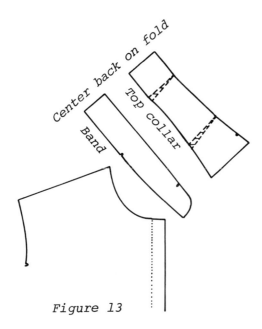

Figure 13

The outer collar should be cut out and then slashed and spread at the outer edge. Spread about 1/8" (0.3 cm) in two places as shown in *Figure 13*. This will give room for a necktie between the collar and the band.

The pieces for the band, interfacing and band lining will be cut from the same patterns.

For the over collar it will be necessary to remove 1/8" (0.3 cm) from the outer edges of the top collar to make the under collar

D. Choir-Boy, Dutch or Eton Collar

The rolled collar shown in *Figure 14* is made by drawing around the back bodice neckline and shoulder, pivoting out any darts at the neck or shoulder. After determining the height of the stand and crossmarking it on a line extended up from the center back neck, continue the line up at the center back until it is double the height of the stand. From the top of the line at center back, square a line for the length of the back neckline to which the collar will be attached.

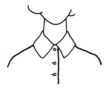

Figure 14

From the crossmark at center back indicating the height of the stand or roll line, measure down and draw the lower edge of the collar from the center back to the point where it will cross the shoulder.

Connect this shoulder point to the end of the squared line at the top of the collar as shown in *Figure 15*. Cut out back collar section.

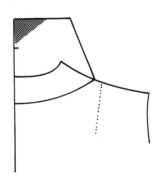

Figure 15

Draw around the neckline and upper part of the front bodice. Measure the distance on the back collar section from the original neck edge to the shoulder. Crossmark the same distance on the front shoulder from the neck edge.

Place the edge of the back collar section at the crossmark on the front shoulder and pivot the back collar section from the shoulder crossmark until the distance from the center front to the neck edge of the back collar section equals the front neckline measurement.

See *Figure 16*.

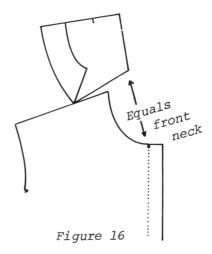

Figure 16

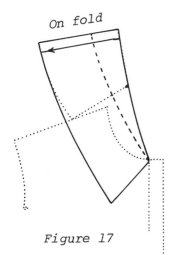

Figure 17

Smooth out the neck edge of the collar from the back collar section to the center front, marking the shoulder notch. Draw in the style - outer - edge of collar from shoulder to front, smoothing out any angles at the shoulder between front and back as shown in *Figure 17*.

Retrace the collar with the center back on the fold of the paper and add seam allowances. Make the under collar by removing 1/8" (0.3 cm) from the outer edge of the top collar.

E. Portrait Collar

The portrait collar, shown in *Figure 18*, is made by following the same principles used in making the choir-boy collar.

As in all collars, be sure to make the neckline first.

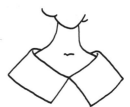

Figure 18

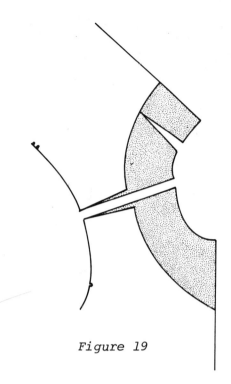

Figure 19

After lowering the necklines on the front and back bodices the desired amount and adjusting the neck edge of the shoulders for an open neckline, *Figure 19*, draw around the upper section of the back bodice. Extend the center back for a distance of twice the height of the stand or roll line.

Crossmark the height of the stand on the center back line. Square the top line for the measurement of the lowered back neck on the bodice.

Draw in the lower edge of the collar from center back to the shoulder and connect the shoulder to the squared line at the top.

See *Figure 20*.

Figure 20

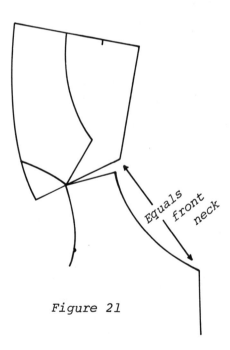

Figure 21

Equals front neck

Cut out the back collar section. Measure the distance from the original back neck to the shoulder on the back collar section. crossmark an equal distance on the front shoulder from the neck edge.

Pivot the back collar section from the crossmark on the shoulder until the distance from the center front of the bodice to the edge of the back neck equals the front neckline.

See *Figure 21*.

360

Smooth out the neck edge of the collar, marking the shoulder notch.

Draw in the style edge of the collar as shown in *Figure 22*.

Retrace the collar with the center back on the fold of the pattern paper and add seam allowances.

Make the under collar by removing 1/8" (0.3 cm) from the outer edge of the top collar.

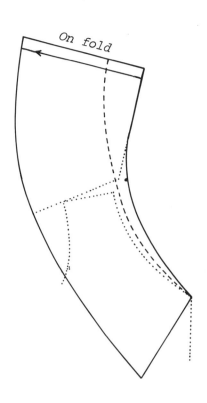

Figure 22

F. Tailored Notched Collar

While used primarily on suits and coats, the tailored notched collar, shown in *Figure 23,* can be used on tailored dresses and sportswear.

Figure 23

Draw around the front bodice pattern and add the extension for the buttons and buttonholes, about 3/4" (1.9 cm), depending on the size of the button.

After deciding at what depth on the center front line the garment will open, extend the shoulder line at the neck edge 1" (2.5 cm). This will be the height of the stand of the collar at the shoulder. Connect the stand, through the center front depth, to the front edge of the buttonhole extension.

This will be the roll line for the lapel and collar. See *Figure 24*.

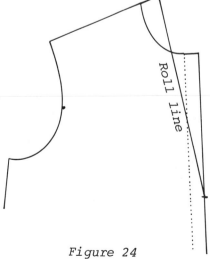

Figure 24

Fold the pattern on the roll line and
using a tracing wheel, trace the origi-
nal neckline and collar stand. When
the paper is unfolded it should look
like *Figure 25*.

The dotted line shows the traced section.

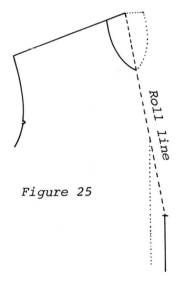

Figure 25

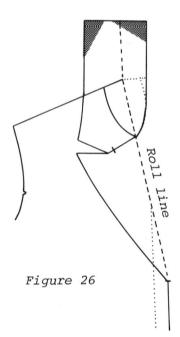

From the traced shoulder point, extend a line 1/4"
(0.6 cm) for ease. At a midway point on the traced
neckline between the center front and shoulder,
draw a straight line, through the 1/4" (0.6 cm) ease
mark, for the length of the back neck.

At the center back neck, square a line twice the
height of the back collar stand plus 3/8" (1.0 cm),
about 3 3/8" (8.6 cm).

Square from the center back to the shoulder line
and draw in the style lines of the collar and the
lapel. See *Figure 26*.

Figure 26

Refold the pattern on the roll line
and trace the lapel - sometimes re-
ferred to as *revers* - marking the
joining of the collar and lapel.

The unfolded pattern is shown in
Figure 27.

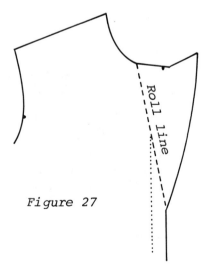

Figure 27

Trace and cut out the collar section. Slash and spread the collar
1/8" (0.3 cm) in two places at the outer edge. If desired, the
under collar may be cut in two pieces with a seam at the center
back. When cut in two pieces the grain line is a true bias at the
center back. The under collar pattern is shown in *Figure 28*.

Figure 28

The top collar and facing will be made by adding 1/8" (0.3 cm)
to the outer edges of the lapel and under collar as shown in
Figure 29.

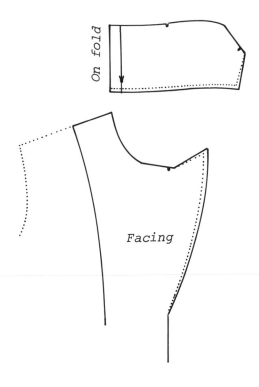

Figure 29

4. Collar and Bodice Cut In One

A. Shawl Collar

The shawl collar, shown in *Figure 1*, is made by drawing around the bodice front, including the extension for the buttons and buttonholes. From the point on the edge of the extension opposite the top button, draw a line through the shoulder at the neck edge for the length of the back neck from shoulder to center back. Square the line at the center back neck for 3" (7.6 cm).

Figure 1

Extend the shoulder line at the front neck edge 3/4" (1.9 cm) and draw the roll line, which will be a straight line from center front to center back through the extended line at the shoulder. Draw in the outer edge or style line as shown in *Figure 2*.

If a collar with less stand and a lower roll line is required, slash and spread the outer edges of the back neck as shown in *Figure 3*.

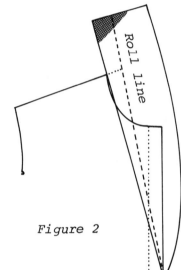

Figure 2

Variations in the styles of shawl collars are pictured in *Figure 4*.

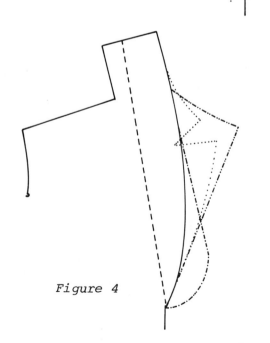

Figure 3

Figure 4

Figure 5

B. Cape Collar

Sometimes referred to as a *flat shawl collar*, the cape collar shown in *Figure 5* has little or no stand.

To make the pattern, trace the front bodice with the button extension included and indicate the top button. Draw the roll line from the neck edge of the shoulder to a point opposite the top button on the extension.

Draw the outer edge or style line of the collar. See *Figure 6*.

Figure 6

Fold the pattern on the roll line and trace the outer edge of the collar. When unfolded it will look like *Figure 7*.

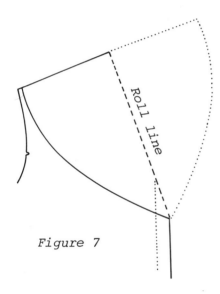

Figure 7

With the shoulder dart pivoted out, match the back bodice to the front pattern at the neck edge and the traced shoulder line. Draw the back neck and the center back of the bodice pattern.

Draw the outer edges of the collar in the back, blending the lines with the style line from the front collar.

See *Figure 8*.

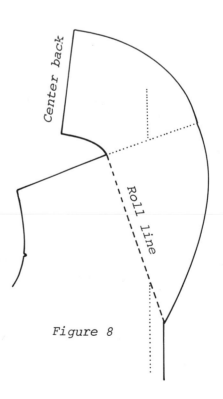

Figure 8

If more roll to the collar is desired, slash the back section of the collar and overlap the outer edges as shown in *Figure 9*.

Figure 9

Be sure to add 1/8" (0.3 cm) at the outer edge of the collar on the facing. The facing becomes the top collar in this style.

See *Figure 10*.

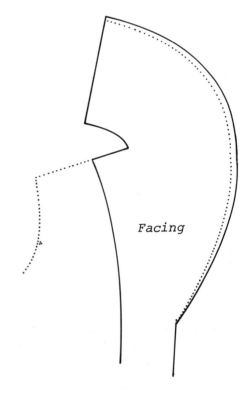

Facing

Figure 10

Notes

Chapter 18

Pants

Notes

If the basic pants blocks are carefully made and fitted, many variations can be made from them with only minor adjustments. When working with the pants blocks be sure to remove or add the same amount on *both* sides of the grain line at mid thigh, knee and hemline. This rule applies to both the back and the front. The exact same amount does not have to be removed or added to the back as is removed or added to the front.

1. Fitted or Jeans-Type Pants

 A popular style with girls and young women who are slim and flat-hipped, the fitted pants shown in *Figure 1* are most successfully constructed in either a firmly woven fabric or in a heavy knitted fabric.

 Fold out the front darts and make the front waistband by drawing a line parallel with the waistline, about 1 3/4" (4.4 cm) wide.

 See *Figure 2.*

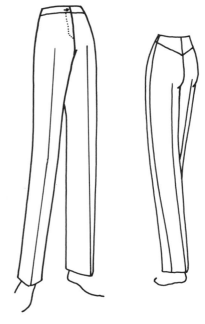

Figure 1

Figure 2

Fold out the back darts and draw a straight line from the 1 3/4" (4.4 cm) width of the front waistband at the side seam to a point on the center back 2" (5.1 cm) shorter than the longest dart.

With the darts eliminated this will become the back yoke and waistband.

See *Figure 3.*

Figure 3

371

Narrow the pants, front and back, just below the hip line as much as de-
sired. After the thigh and knee areas have been tightened, the bottom
width will be only slightly smaller than the knee. Keep the width the
same on both sides of the grain line. Adjustments are shown in *Figure 4*.

Knee line

Knee line

Figure 4

From the front crotch, remove about 3/4" (1.9 cm) down to the mid thigh. Add the section removed from the front to the back crotch. Check the length from knee to crotch at the back inseam to make sure it is the same length as the front inseam from knee to crotch. If necessary, remove any difference from the back crotch. See *Figure 5*.

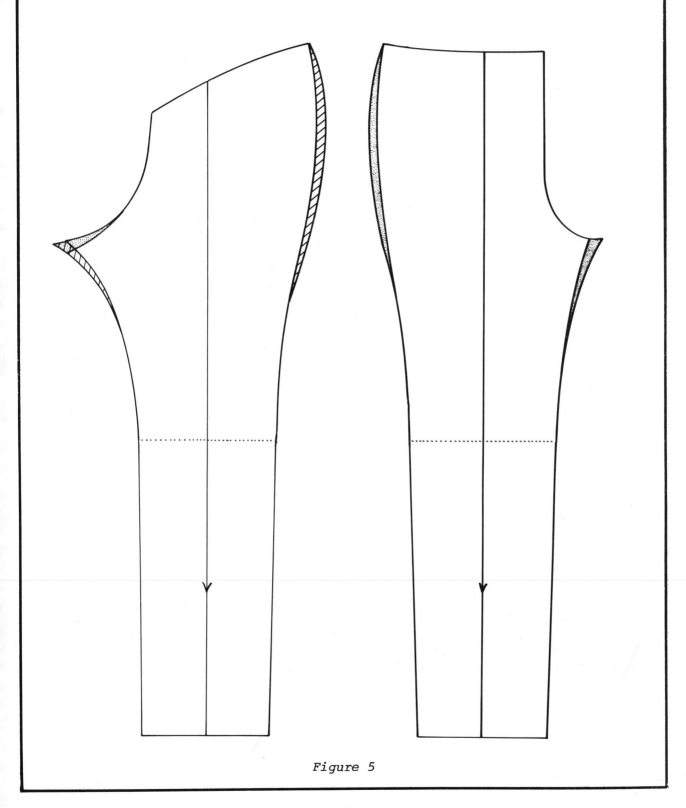

Figure 5

Relocate the side seams by straightening the front side seam from the waist to mid thigh. This amount is then added to the back at the side seam.

In *Figure 5* the grey area indicates the parts of the pattern that are to be removed and the diagonal lines show what has been added to the pattern.

In a knit or stretch fabric, the front and back dart widths that remain in the pattern can be eased into the waistband without any problems. If there is too much dart to ease into the waistband, remove the excess at the front and back side seams for a depth no lower than the dart is long.

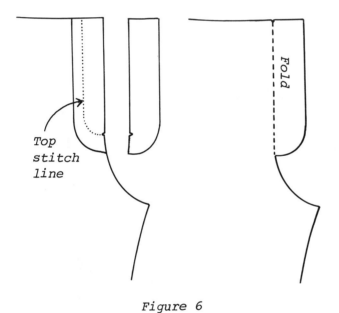

Top stitch line

The fly can be cut separately or in one with the front pants.

The fly is 1 3/4" (4.4 cm) wide finished and 1" (2.5 cm) longer than the finished length of the zipper.

See *Figure 6*.

Figure 6

The completed front and back patterns, with waistbands and separate fly, are shown in *Figure 7*.

If pockets are desired, see Chapter 13 - Pockets.

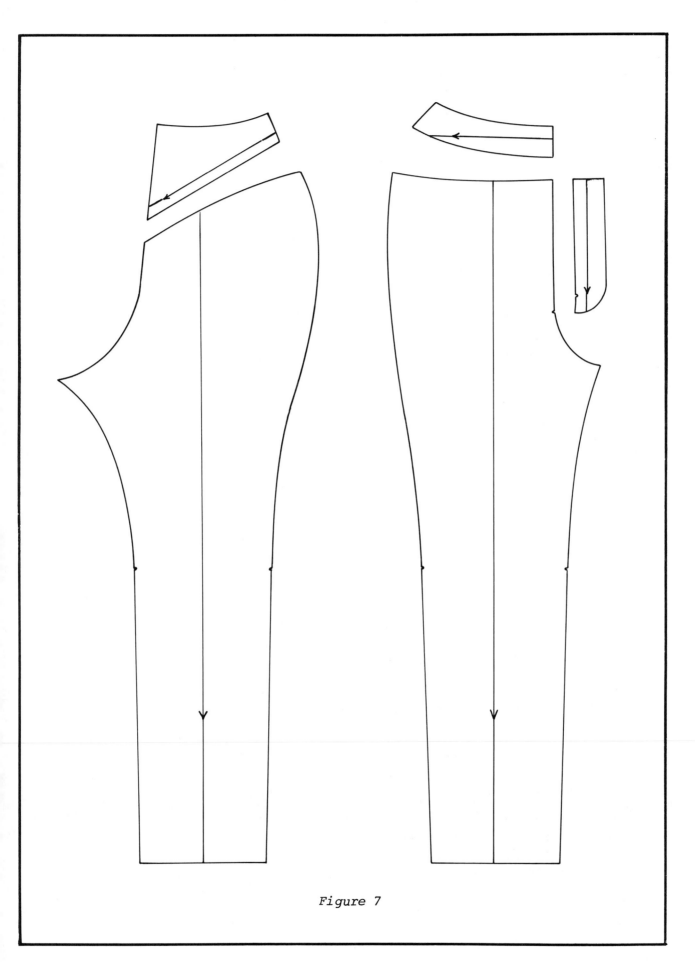

Figure 7

2. Flared Pants

The pants shown in *Figure 1* have flare added only from the knee down to the hemline.

Figure 1

Be sure to keep the width the same on both sides of the grain line.

The flare will appear more exaggerated if the pants are tightened from mid thigh to the knee before adding the flare from knee to hemline.

The front pattern is shown in *Figure 2* and the back pattern would be done the same way.

The back does not necessarily have to have exactly the same amount of flare as the front but it should not have less flare.

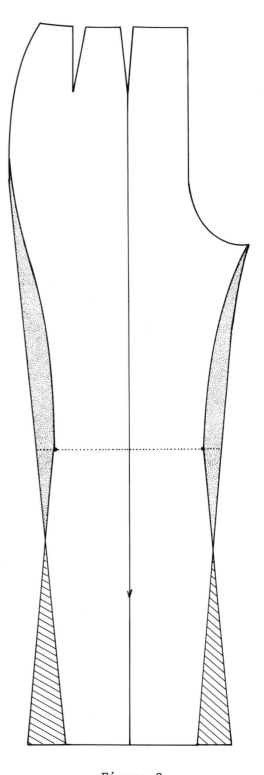

Figure 2

When the flare originates higher on the leg, as shown in *Figure 3*, the additional width is added from about 5" (12.7 cm) below the crotch line, in a straight line, to the desired hemline width.

Figure 3

Figure 4 shows the front pattern adjustment. The back is adjusted in the same manner.

A zipper may be set in with a fly front, in the side seam on the left hip or at center back. A conventional waistband may be used or the waistline may be faced.

If a knitted or stretch fabric is used, the darts and zipper may be eliminated and the waistline finished with elastic. Be sure that the front and back waistlines are enlarged - see the dotted lines on *Figure 4* - so that the pants can be pulled on over the hips.

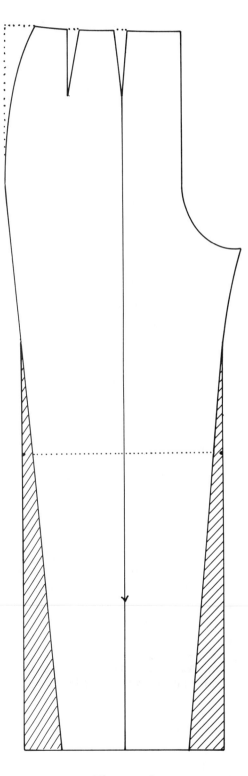

Figure 4

3. Pleated Front Pants

The pleats are really tucks or dart-tucks that are pressed into pleats.

The style is shown in *Figure 1*.

Figure 1

To add the pleats, slash and spread
the front pants only, as shown in
Figure 2.

The slash is spread from 1 1/2"(3.8 cm)
at the waistline to nothing at the hem-
line. The grain line - crease line -
remains on the front edge of the slash.
Both darts are incorporated into the
second small pleat.

If desired, flare may be added (be sure
to add flare also to the back pattern)
and the waistline finished with a band.

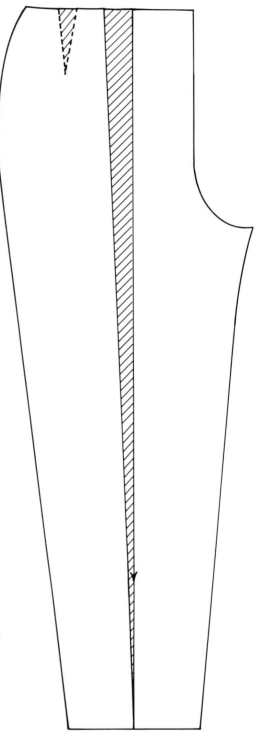

Figure 2

378

4. Mid-Calf Pants And Shorts

Mid-calf pants, known by various names such as *pedal pushers*, *clam diggers*, *capris*, *toreadors*, *etc.*, and knee length shorts, sometimes called *Bermudas*, *Jaimacas*, *cabin boys*, *walk shorts*, *etc.*,
are shown in *Figure 1* and *Figure 2*.

Any of the above are made by shortening the basic pants blocks the desired amount and slightly narrowing the hemline - about 1/2" (2.5 cm) - on each side of the grain line, front and back.

Figure 1

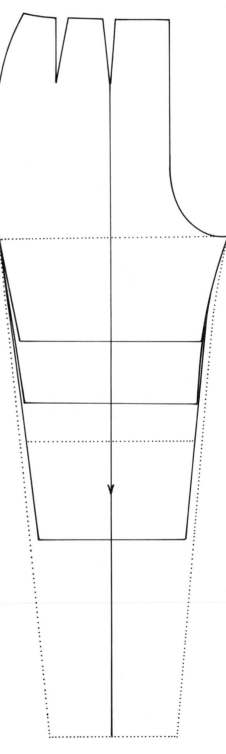

The basic front patterns are shown in *Figure 3*.

After shortening the pants to the desired length, other styles may be developed by adding pleats, cuffs, pockets, etc.

Figure 2

Figure 3

Brief fitted shorts, *Figure 4*, are prepared as pictured in *Figure 5*. At the center front crotch inseam, draw a curved line from 2" (5.1 cm) below the crotch to the crotch line at the side seam. Remove 3/8" (1.0 cm) from the new hemline at the inseam and at the side seam. About 3" (7.6 cm) from the inseam edge of the hemline, slash the pattern to the center.

The back pattern is prepared the same way.

Figure 4

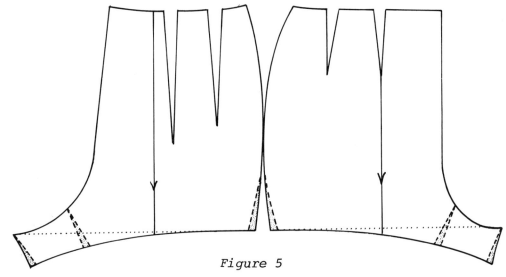

Figure 5

Overlap the slash from hemline to center 3/8" (1.0 cm) at the lower edge of the hemline to nothing at the center. This will give a snugger fit around the leg. The back and front are done the same way.

The completed front and back patterns are shown in *Figure 6*.

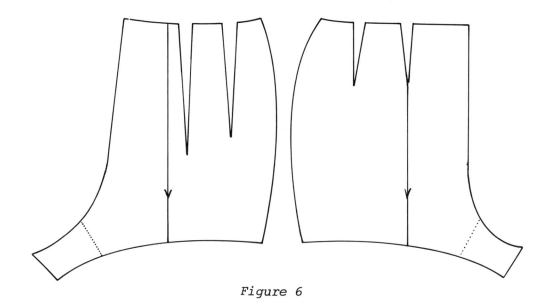

Figure 6

5. Culottes

The culottes shown in *Figure 1* are developed from the skirt block. The two-dart block may also be used.

Mark around the front and back skirt blocks with the side seams together. The crotch depth, measured down from the waistline at the side seam, is 1" (2.5 cm) longer than the crotch depth on the basic pants block.

From the side seam at the crotch depth, square a line past the center front for a distance equal to one half of the front hip measurement less 1" (2.5 cm). Add the same amount at the center front hemline and connect the hemline to the crotch line.

The back crotch length, squared from the crotch line at the side seam, is equal to one half the back hip plus 1" (2.5 cm). Add the same amount at the hemline and connect the crotch to the hemline. Draw in the curves for the front and back crotch as shown in *Figure 2*.

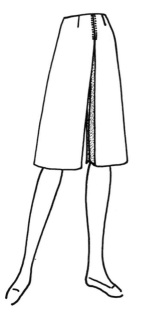

Figure 1

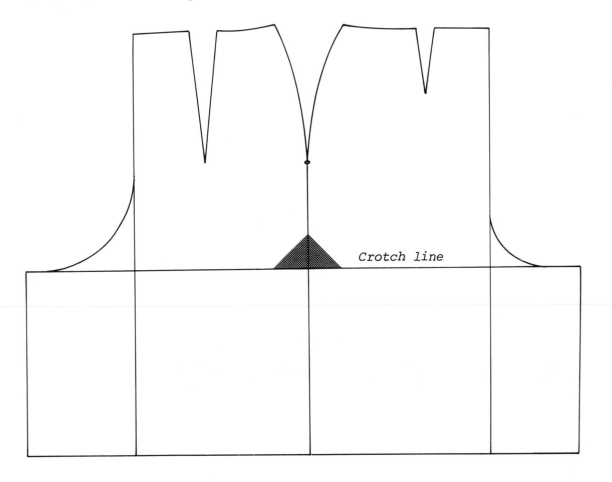

Crotch line

Figure 2

To make the pattern with inverted pleats in the center front and center back, slash the patterns on the center front and center back lines and spread a minimum of 4" (10.2 cm). The grain line remains on the original center line.

In addition to the extra width for the pleat, the back has 2" (5.1 cm) more added at the hemline. This helps the culottes hang straighter in the back and conceal the division.

See *Figure 3* and *Figure 4*.

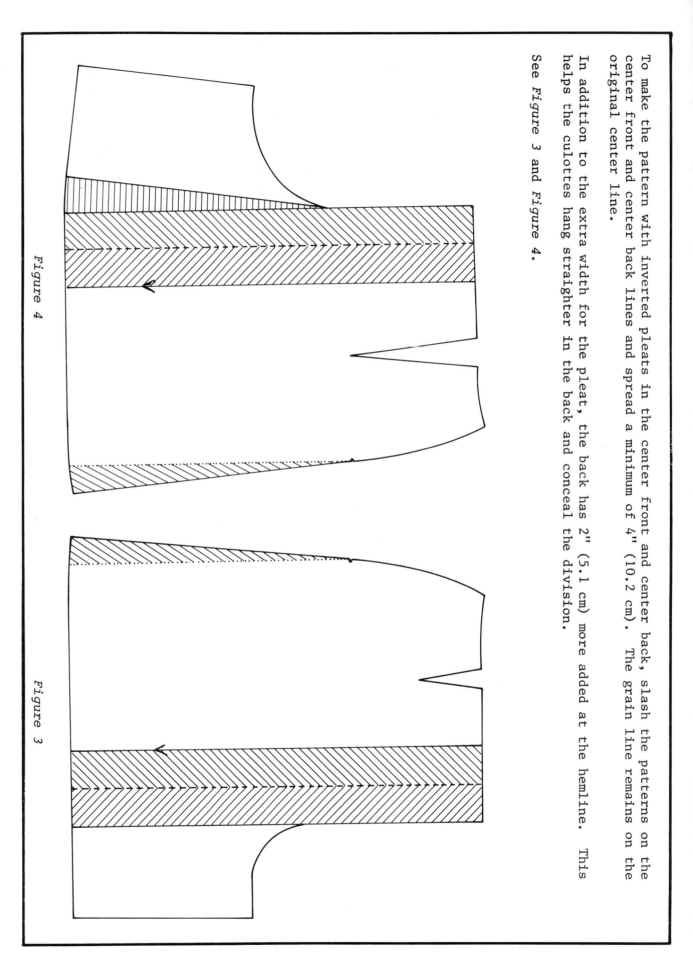

Figure 4

Figure 3

382

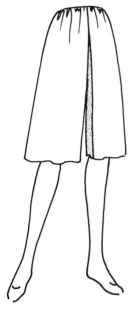

Figure 8

Long or short culottes may be made, *Figure 8*, by slashing and spreading the pattern as shown in *Figure 9*.

The same procedure would be followed to make the back pattern.

The waistline would be shirred or pleated to fit a waistband or bodice.

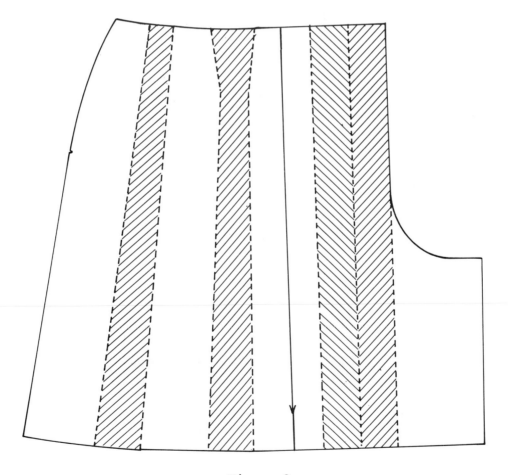

Figure 9

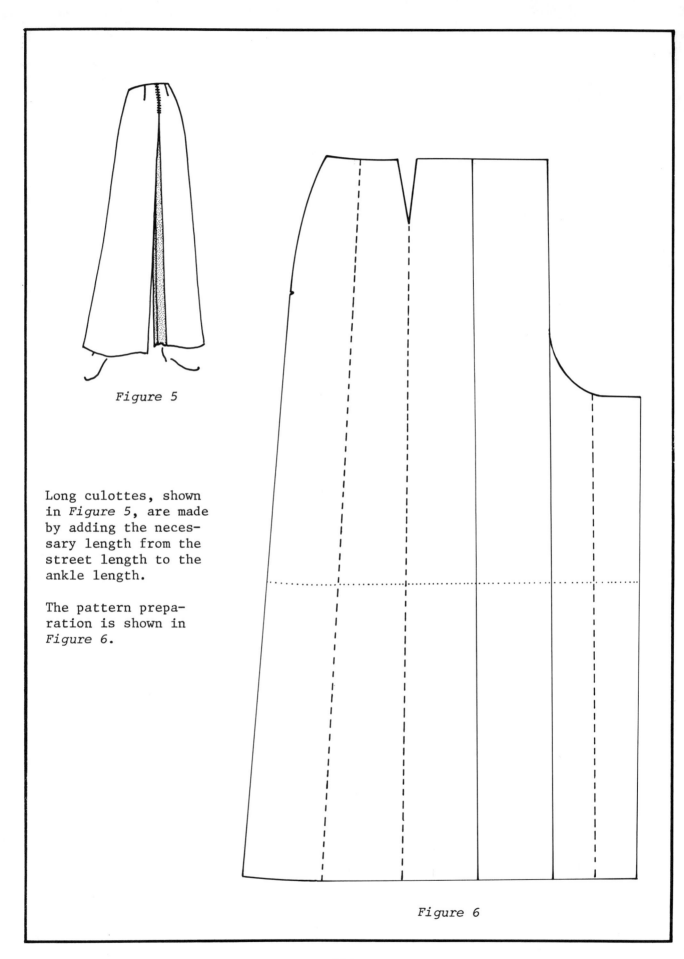

Figure 5

Long culottes, shown
in *Figure 5*, are made
by adding the neces-
sary length from the
street length to the
ankle length.

The pattern prepa-
ration is shown in
Figure 6.

Figure 6

The slashed and spread pattern is shown in *Figure 7*.

The back would follow the same procedure as the front except additional fullness would be added at the hemline of the back pleat.

Refer to *Figure 4*.

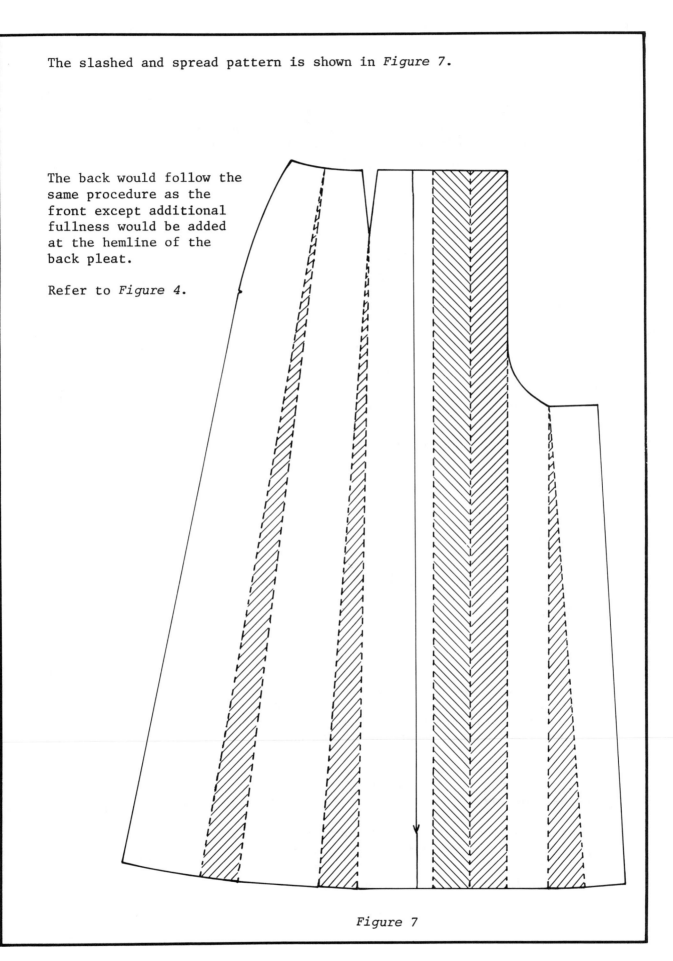

Figure 7

6. Jumpsuits

Pants attached to the bodice, *Figure 1*, work most satisfactorily in knits or stretch fabrics. It is best to make a basic jumpsuit block and test it for fit in the fabric of which it will ultimately be made. Style lines – seams, collars, pockets, etc. – can be added later.

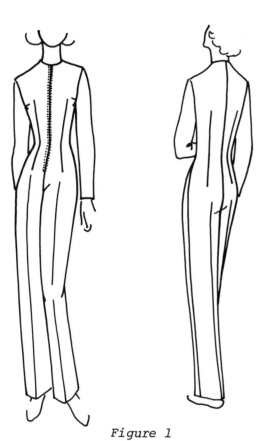

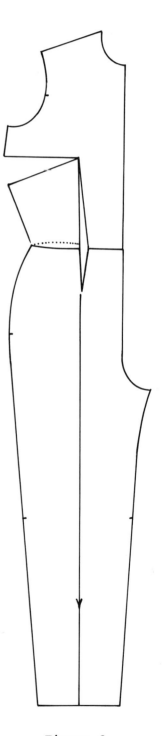

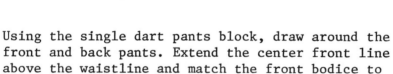

Figure 1

Using the single dart pants block, draw around the front and back pants. Extend the center front line above the waistline and match the front bodice to the new line and the waistline of the pants.

Beginning at the front leg of the bodice dart, draw around the front, top and side of the bodice to the bustline.

Pivot the bodice pattern at the bust point, opening up a side bust dart, until the side seam at the waistline of the bodice touches the side seam at the waistline of the pants. See *Figure 2*.

Figure 2

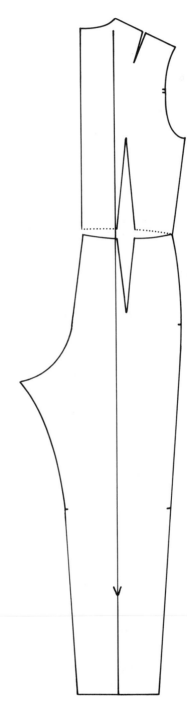

To make the back jumpsuit pattern, extend the grain line of the pants above the waistline.

Keeping the center back of the back bodice parallel with the extended grain line, match the side seams of the bodice and pants at the waistline.

There will be a gap between the pants and the bodice at the center back waistline. This gives the needed ease for comfort in sitting and bending.

See *Figure 3*.

Figure 3

387

Shorten the side bust dart 1 1/2" (3.8 cm) from the bust point. Relocate the point of the dart under the bust by keeping the center of the dart parallel with the center front. Smooth out the angle on the side seam at the waistline.

Connect the center back at the waistline. Connect the back bodice and the pants dart, adjusting the dart if necessary so that the center of the dart runs parallel with the center back.

Smooth out the side seam at the back waistline.

Check the front side seam against the back side seam, beginning at the armscye and working down. Any adjustment necessary should be made on the hemline of the back pattern.

The completed patterns are shown in *Figure 4*.

If more crotch depth is needed, lower the front and back the same amount so that the front and back inseams remain equal in length.

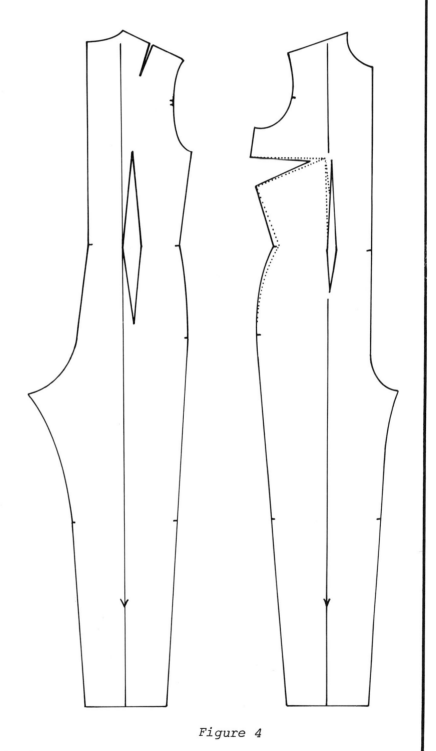

Figure 4

Notes

Chapter 19

Miscellaneous

Notes

1. Hoods

Hoods may be attached to coats, capes or sportswear. Be sure to work from the *necklines* of the patterns to which the hood will be sewn.

Measurements are given for a size 10. Slight adjustments may be necessary according to fabric and style requirements.

A. Loose Hood

The loose hood is shown in *Figure 1*.

Figure 1

Figure 2

Draw the back neckline, including 3" (7.6 cm) on the shoulder. Crossmark the shoulder. Draw the center back to a distance of 16" (40.6 cm) from the center back neckline. This will be the depth of the hood.

From the depth of the hood square a line 12" (30.4 cm) long. From the end of the line just drawn, square a line up 10" (25.4 cm), parallel with the center back.

Label the lines as shown in *Figure 2*.

393

Make a crossmark on the front shoulder 3" (7.6 cm) from the neck edge. Place the front bodice pattern on the paper to match the back neck and shoulder. From the crossmark on the shoulder, pivot the front bodice pattern until there is a 3/4" (1.9 cm) space between the neck edges of the front and back. By drawing from the neck edges to the crossmark on the shoulder a dart will be made. This dart may either be sewn out or folded into a pleat. Draw the front neckline.

With a curved line, connect the lower front edge of the hood at the center front neckline to the *face edge* line already drawn from the back.

The hood may be left square at the top and cut in one piece with a seam at the center back and the top edge on the fold. Or, the hood may be rounded at the center back top.

See *Figure 3*.

Figure 3

Figure 4

B. Fitted Hood

This style fits better and is more comfortable if made in stretch or knitted fabric.

The hood, made in four sections, is shown in *Figure 4*.

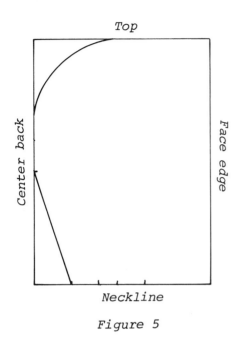

Figure 5

To make the pattern for the fitted hood first make a rectangle 13" (32.0 cm) long and 9 1/2" (24.1 cm) wide. Be sure that the corners are perfectly square.

Label the rectangle as shown in *Figure 5*.

From the back of the rectangle, measure in 2" (5.1 cm) on the *neckline* and make a cross-mark. Make another crossmark on the *neckline* equal to half of the measurement of the back neck. Make another crossmark 1" (2.5 cm) from the second one for a dart. Measure the other half of the back neck and crossmark for a notch to match the shoulder seam.

From the new center back neckline, draw a line to a point 7" (17.8 cm) down from the *top* on the *center back*. Round out the *top* of the *center back* as shown in *Figure 5*.

Extend the *face edge* of the rectangle 1 1/2" (3.8 cm) below the *neckline*. From the shoulder notch on the *neckline*, draw a slightly curved line through the extension of the *face edge* for a distance equal to the front neckline on the bodice to which the hood will be sewn.

From the crossmark for the dart closest to the *back* on the *neckline*, draw a line parallel with the *center back*, around the curve to the *face edge*. From the *neckline*, complete the dart – making it about 4" (10.2 cm) long.

To make the two legs of the dart equal, measure the longer leg and extend the other the same distance. One leg will be below the original *neckline*. Square a line from the new dart leg and connect the new *center back* to the squared line.

The dart at the *face edge* is 1" (2.5 cm) wide and 2 1/2" (6.4 cm) long. Make the two legs of the dart equal. Round a line on the *face edge* from the lower leg of the front dart to the center front neckline.

Crossmark the sections for identification before cutting apart and adding seam allowances. Two pieces will be cut from each section.

See *Figure 6*.

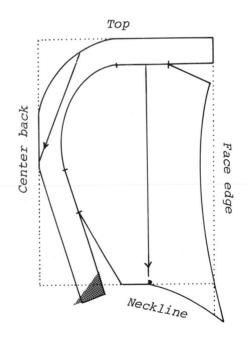

Figure 6

2. Capes

Capes may be any length from the waistline to the floor.

Street length capes should be 1" (2.5 cm) longer than the dress length.

A. Slim Cape

The style is shown in
Figure 1.

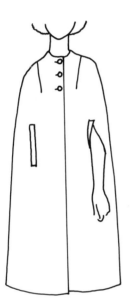

Figure 1

After pivoting the side bust dart to the shoulder, draw around the front torso block, extending the length at the hemline 1" (2.5 cm) longer than the dress length

From the center front, square a line through the bottom of the armscye for a distance equal to one fourth of the bicept measurement on the sleeve. On the size 10, one fourth of the bicep measurement is 3 1/8" (7.9 cm).

Square a line from the extended underarm to the hemline as shown in *Figure 2.*

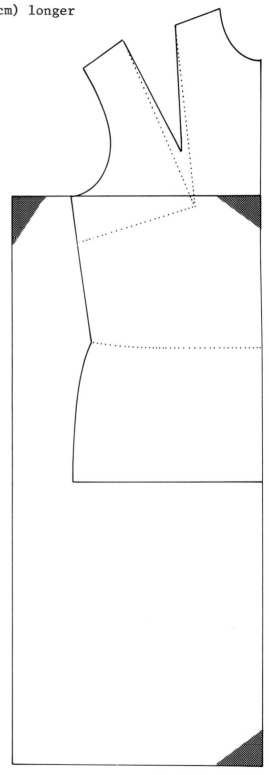

Figure 2

Add 3" (7.6 cm) flare at the hem-
line and draw a straight line
through the extended underarm
line to the shoulder height.
Extend the shoulder length
through the new side seam.
Round out the angle at the
intersection of the side
seam and the shoulder.

To locate the correct position
for the arm opening, measure
3" (7.6 cm) past the front
shoulder dart on the under-
arm line. Square down to a
point 6" (15.2 cm) below the
waistline. The opening will
be 8" (20.3 cm) long - 6"
(15.2 cm) below the waist-
line and 2" (5.1 cm) above
the waistline.

Shorten the shoulder dart
2" (5.1 cm) from the bust
point. Add the necessary
extension for the buttons
and buttonholes at the
center front.

The completed front pattern
is shown in *Figure 3*.

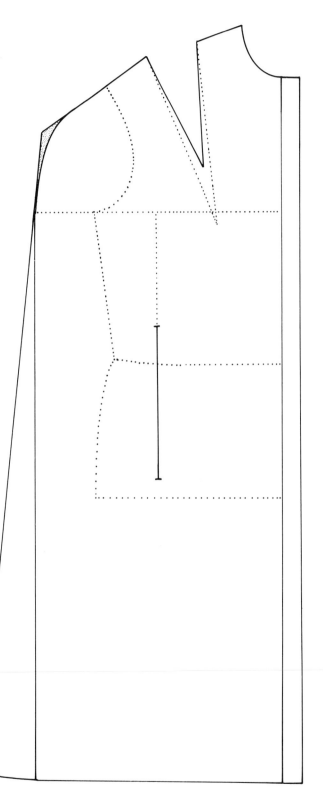

Figure 3

397

To make the back cape pattern, draw around the back torso block, extending the length at the hemline 1" (2.5 cm) longer than the dress length.

From the center back, square a line through the bottom of the armscye for the same measurement used for the front - 3 1/8" (7.9 cm), which is equal to one fourth of the bicep measurement on the sleeve for a size 10.

Square a line down from the extended underarm line to the hemline as shown in *Figure 4*.

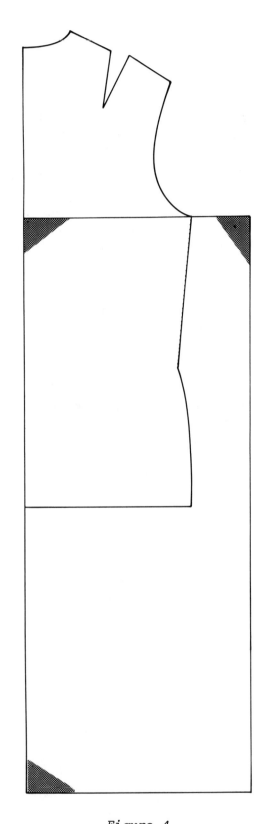

Figure 4

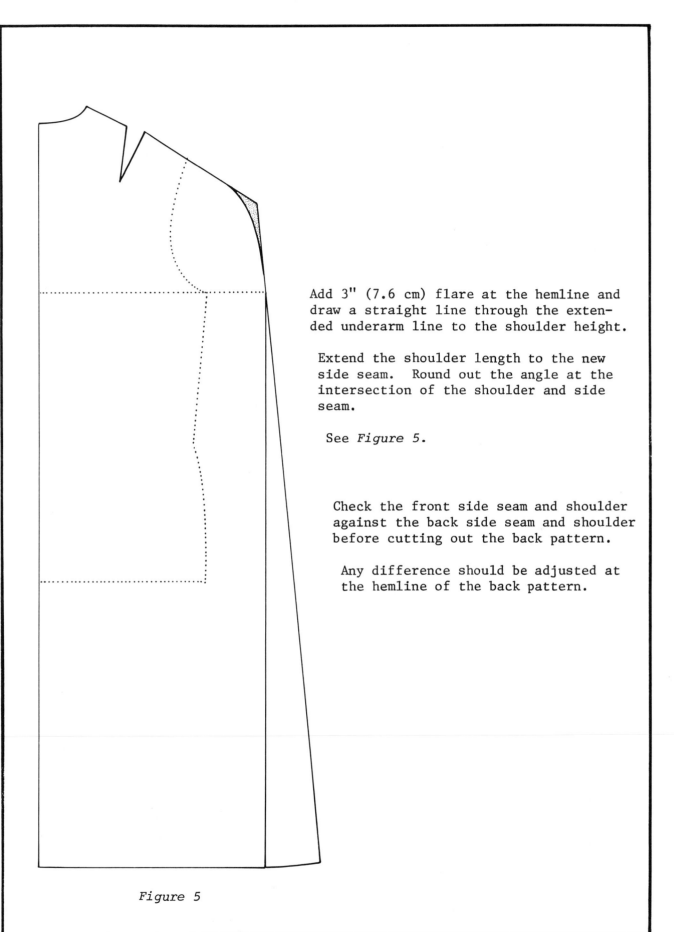

Add 3" (7.6 cm) flare at the hemline and draw a straight line through the extended underarm line to the shoulder height.

Extend the shoulder length to the new side seam. Round out the angle at the intersection of the shoulder and side seam.

See *Figure 5*.

Check the front side seam and shoulder against the back side seam and shoulder before cutting out the back pattern.

Any difference should be adjusted at the hemline of the back pattern.

Figure 5

B. Flare Cape

The flared cape, shown in
Figure 6, is made by slash-
ing the slim cape patterns
and spreading the hemlines
the desired amount.

Figure 6

The pattern prepara-
tion is shown in
Figure 7.

Figure 7

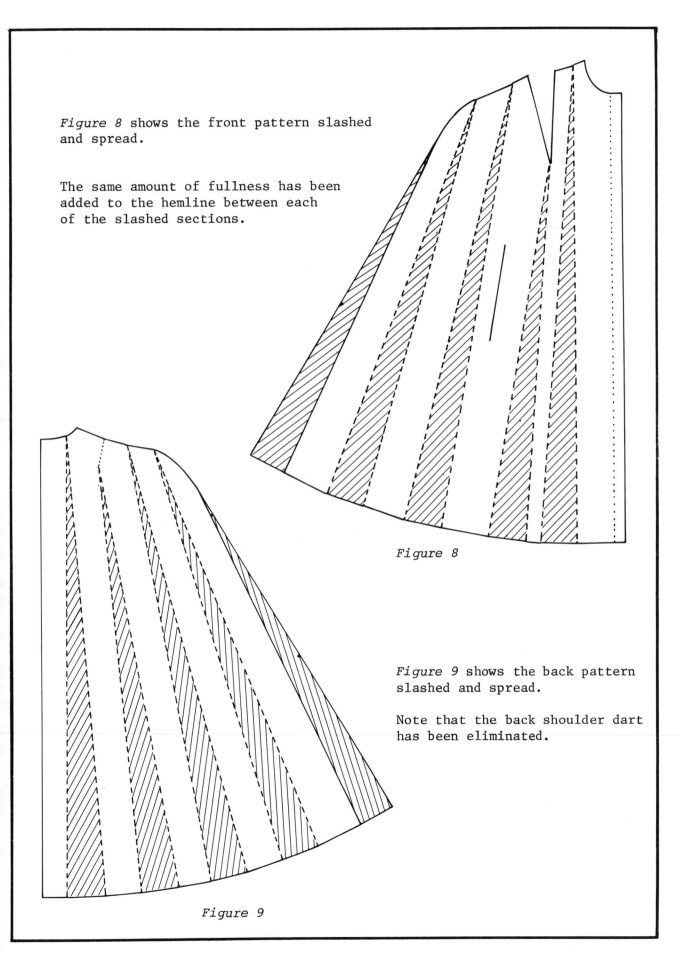

Figure 8 shows the front pattern slashed and spread.

The same amount of fullness has been added to the hemline between each of the slashed sections.

Figure 8

Figure 9 shows the back pattern slashed and spread.

Note that the back shoulder dart has been eliminated.

Figure 9

C. Circular Cape

Short capes are generally cut with more flare than long capes.

The short half-circle cape is shown in *Figure 10*.

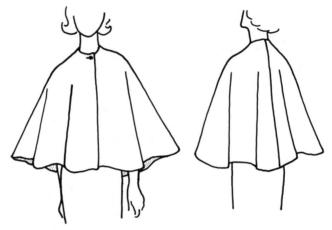

Figure 10

Since no darts are required, the back shoulder dart is closed by pivoting from the point of the dart so that the dart at the waistline is enlarged. From a straight line for the center front, square a line for the center back. Place the front and back bodice blocks so that the shoulder points at the armscye are touching and the center front and center back are on the squared lines. Draw around the blocks.

Square a line from the center front to the bottom of the armscye. Square a line from the center back to the bottom of the back armscye. Connect the two underarm lines with a curved line. Draw the hemline the desired length, keeping it parallel with the underarm lines.

This cape may be cut with only a center back seam and a dart formed by the front and back shoulders. If a side seam is required, it will be located by drawing a straight line from the intersection of the shoulder points through the center of the curved underarm line to the hemline. Round out the angle at the front and back shoulder points.

The pattern for the short circular cape is shown in *Figure 11*.

Center back

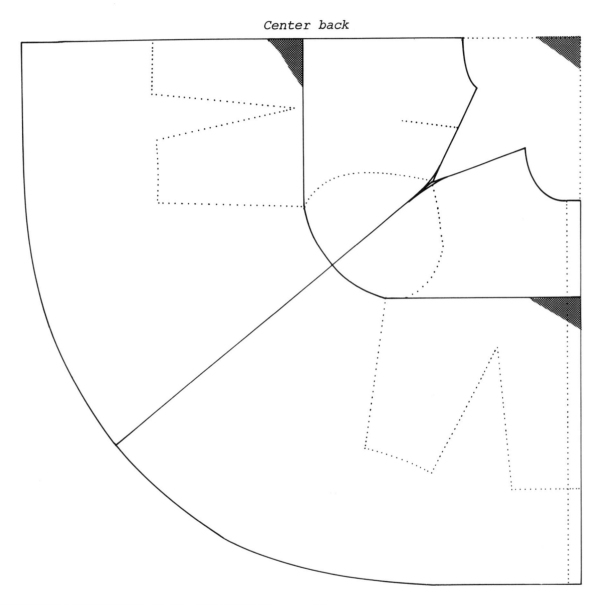

Figure 11

The same principles would be followed in making this cape street length or floor length.

3. Caftans

This loose fitting native dress is generally worn today as loungewear, although it can be shortened and worn as an overblouse with a skirt or pants. The sleeves may be set-in or cut all in one with the garment.

A. Caftan With Set-In Sleeves

The style shown in *figure 1* is cut with a one piece back and a one piece front. The front is slashed so that the garment will go over the head. The front can be cut in two pieces by adding seam allowances at the center front for either a zipper or buttons.

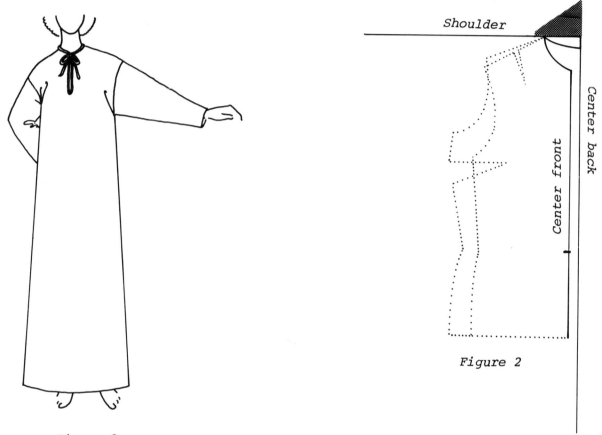

Figure 2

Figure 1

On a long center back line, square a line at the top which will be the shoulder line. Place the back torso block on the center back line so that the corner of the neck touches the squared shoulder line. Draw around the back neckline.

Matching the corner of the front neck with the back neckline already drawn, mark around the front neckline and center front of the front torso block. Crossmark the center front waistline.

See *Figure 2*.

Shoulder

Center back

Center front

Measuring from the waistline down on the center line, square off a line at the desired length.

Divide the circumference of the bust by 4 and add 2" (5.1 cm) for ease.

Size 10 bust circumference - 36" (91.4 cm)

36" ÷ 4 = 9" + 2" = 11"

(91.4 cm ÷ 4 = 22.8 cm + 5.1 cm = 27.9 cm)

Crossmark this measurement on the shoulder line and hemline, measuring from the center back. Connect the shoulder and hemline. From the center back, square a line across the waistline to the line that connects the shoulder and hemline.

Measure the shoulder from the side of the neck over the arm to the wrist. For a size 10, long sleeve, the measurement would be 28 3/4" (73.0 cm) - the shoulder length plus the overarm sleeve length. On the shoulder line, measure this distance from the corner of the neck. At the end of the line, square down about 5" (12.7 cm) for the sleeve opening.

Divide the distance from the shoulder to the waistline at the side by 2. From this point on the side, connect a line to the bottom of the wrist to form the sleeve.

For an ankle length garment, add a minimum of 8" (20.3 cm) flare at the hemline to nothing at the intersection of the sleeve at the underarm.

See *Figure 3.*

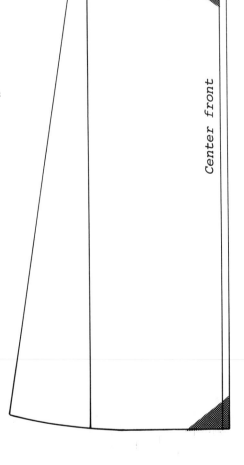

Figure 3

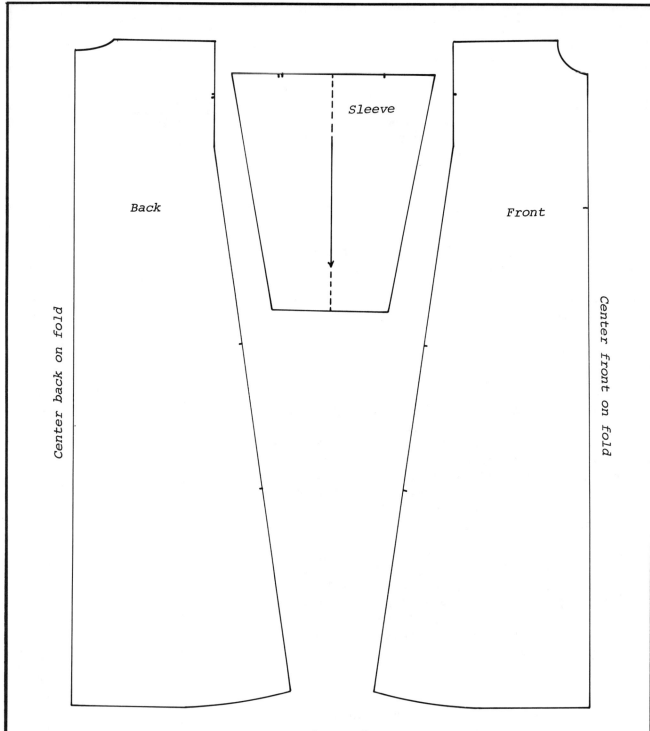

Figure 4

The pattern for the back is traced with the center back on the fold and seam
allowances added. The front is traced on the fold, adding seam allowance and
marking the center front slash about 10" (25.4 cm) from the center front neck-
line down. The sleeve is traced on the fold, the fold becoming the grain line,
and seam allowances added. The neckline and slash may be faced or bound.

The completed patterns are shown in *Figure 4*.

B. Caftan With Cut-In Sleeve

The caftan shown
in *Figure 5* has
only shoulder
and side seams.
It could be made
with zipper or
button closure
at center front
instead of the
slashed neckline.

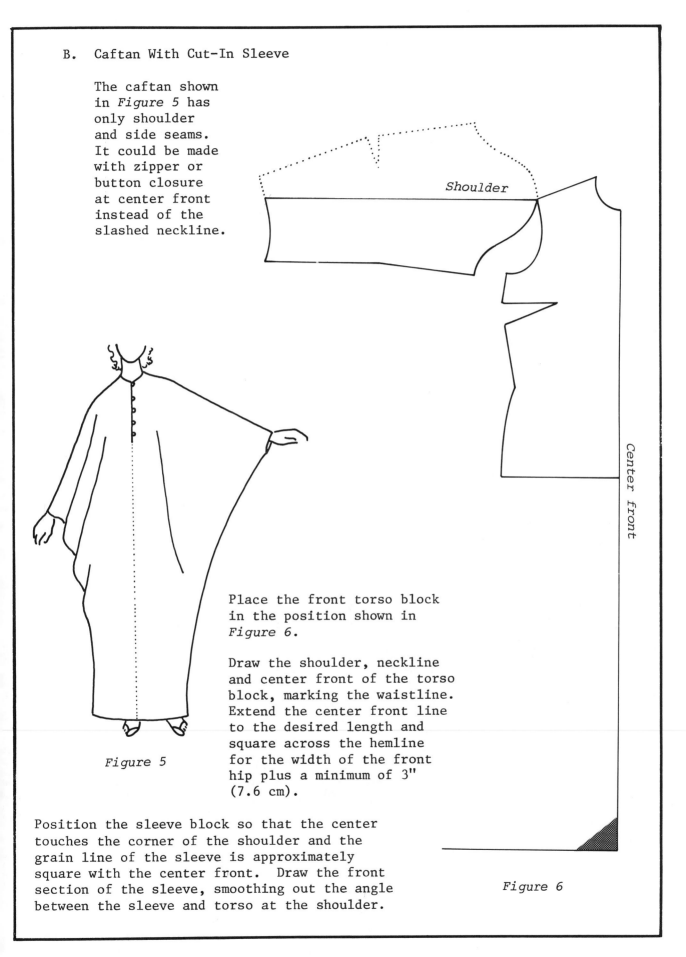

Shoulder

Center front

Figure 5

Place the front torso block
in the position shown in
Figure 6.

Draw the shoulder, neckline
and center front of the torso
block, marking the waistline.
Extend the center front line
to the desired length and
square across the hemline
for the width of the front
hip plus a minimum of 3"
(7.6 cm).

Position the sleeve block so that the center
touches the corner of the shoulder and the
grain line of the sleeve is approximately
square with the center front. Draw the front
section of the sleeve, smoothing out the angle
between the sleeve and torso at the shoulder.

Figure 6

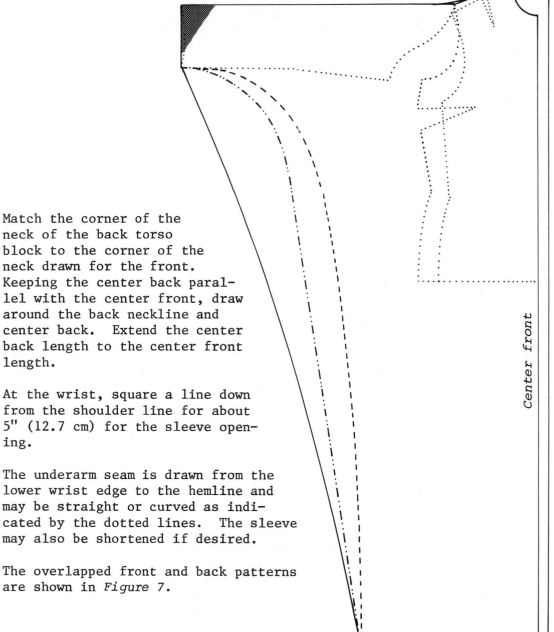

Match the corner of the
neck of the back torso
block to the corner of the
neck drawn for the front.
Keeping the center back paral-
lel with the center front, draw
around the back neckline and
center back. Extend the center
back length to the center front
length.

At the wrist, square a line down
from the shoulder line for about
5" (12.7 cm) for the sleeve open-
ing.

The underarm seam is drawn from the
lower wrist edge to the hemline and
may be straight or curved as indi-
cated by the dotted lines. The sleeve
may also be shortened if desired.

The overlapped front and back patterns
are shown in *Figure 7*.

Figure 7

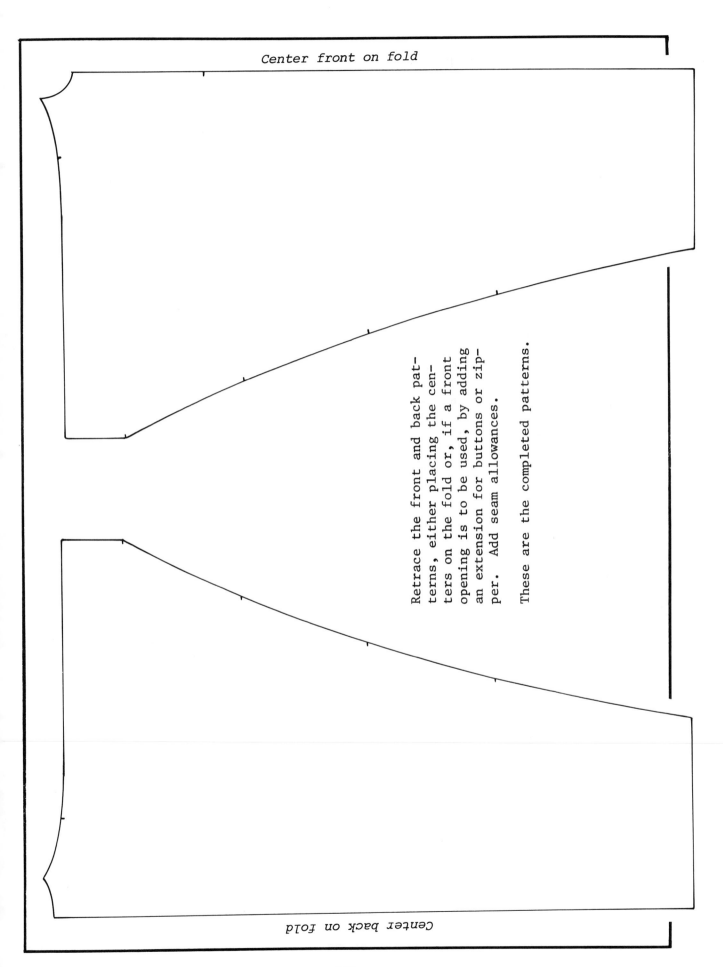

Retrace the front and back patterns, either placing the centers on the fold or, if a front opening is to be used, by adding an extension for buttons or zipper. Add seam allowances.

These are the completed patterns.

4. Basic Suit and Coat Blocks

The torso blocks are used to develop the suit and coat blocks. The adjustments given are for general use but may vary according to the thickness of the fabric, the weight of the lining and interlining and the dictates of fashion.

Once the blocks are perfected, the principles given in other chapters will apply to suits and coats as well as to dresses and sportswear - the collars, pockets, sleeves, etc.

A. Suit block

Pivot the side bust dart of the front torso block to the middle of the shoulder and draw around the pattern, including the darts.

Draw around the back torso block, including the darts.

The front and back torso blocks are altered as follows:

(1) Neckline - Lower 1/8" (0.3 cm) all around.

(2) Shoulder - Raise 1/8" (0.3 cm) at shoulder point and extend 1/8" (0.3 cm). If shoulder pads are to be used, see page 123.

(3) Armscye - Lower 3/8" (1.0 cm), blending from the new shoulder length so that it is 1/8" (0.3 cm) wider at the chest line.

(4) Side seams - Add 1/4" (0.6 cm) from the lowered armscye, past the waist, to the hip.

(5) Body darts - The darts closest to the side seams are not generally used. The darts closest to the center - front and back - are moved 1/4" (0.6 cm) farther from the center for better balance. The points of the shoulder darts should be moved the same amount.

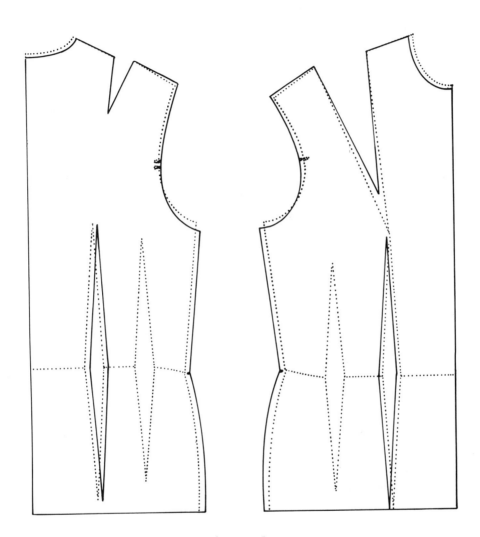

Figure 1

The dotted lines in *Figure 1* show the basic torso blocks and
the solid lines show the adjustments for the suit block.

The sleeve for the suit block should be altered as follows:

(1) Cap - Raise 1/8" (0.3 cm) at center and widen 1/16" (0.1 cm) on each side. If a shoulder pad is to be used, see page 277 for further adjustments.

(2) Bicep line - Lower 3/8" (1.0 cm) and widen 1/4" (0.6 cm) on the front and back of the sleeve.

(3) Underarm - Add 1/4" (0.6 cm) from the bicep line down to the elbow. Reduce the dart at the elbow to 1" (2.5 cm) by pivoting the pattern from the center of the elow line. This will increase the width at the wrist.

(4) Wrist - Add 1/8" (0.3 cm) at each side of the wrist and blend to the 1/4" (0.3 cm) added at the elbow. Add 1/8" (0.3 cm) to the length of the sleeve at the wrist.

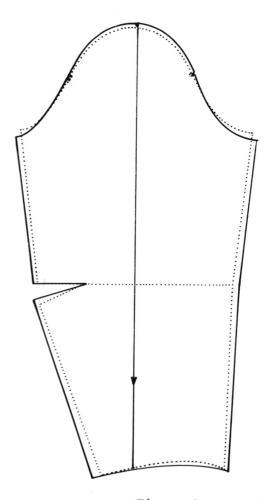

In *Figure 2* the dotted lines show the basic sleeve block and the solid lines show the adjustments for the suit sleeve.

Be sure to check the armscyes of the front and back suit blocks against the sleeve cap before cutting out the suit sleeve block.

Figure 2

Notes

B. Coat Block

Pivot the side bust dart of the front basic torso block to the center
of the shoulder. Draw around the front and back torso blocks, in-
cluding the darts. Add the dress length to the torso blocks.

The front and back basic torso blocks will be altered as follows:

- (1) Neckline – Lower 1/4" (0.6 cm) all around.

- (2) Shoulder – Raise 1/4" (0.6 cm) at shoulder point and
extend 1/4" (0.6 cm). If shoulder pads are to
be used, further adjustments will be necessary
as explained on page 123.

- (3) Armscye – Lower 1" (2.5 cm), blending from the new
shoulder length so that it is 1/4" (0.6 cm)
wider at the chest line.

- (4) Side seams – Add 3/4" (1.9 cm) from the lowered armscye,
1 1/2" (3.8 cm) at the hip and 3" (7.6 cm) wider
at the hemline. These are minimum measurements.

- (5) Body darts – The darts closest to the side seams are
not generally used. The darts closest to the
center – front and back – are moved 1/2" (1.3 cm)
farther from the center for better balance. The
points of the shoulder darts should be moved the
same amount.

- (6) Hemline – Lengthen 1" (2.5 cm) more than the dress
length.

The dotted lines in *Figure 3* show the basic torso blocks and the
solid lines show the adjustments for the coat block.

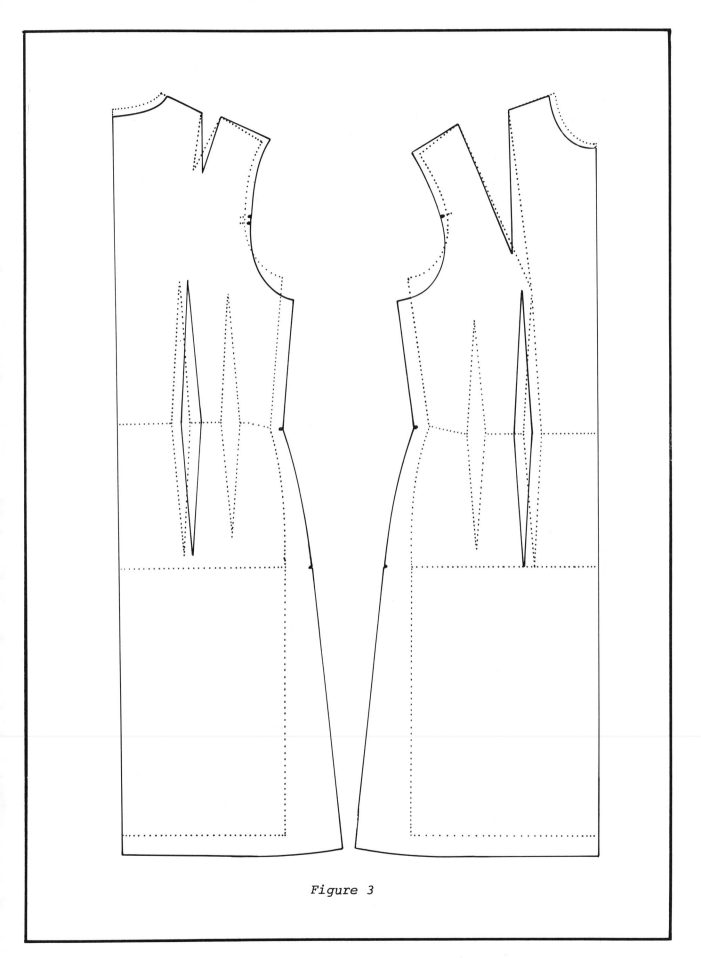

Figure 3

The sleeve for the coat block is adjusted as follows:

(1) Cap - Raise 1/4" (0.6 cm) at center and widen 1/8"
 (0.3 cm) on each side. If a shoulder pad
 is to be used, see page 277 for further
 adjustments.

(2) Bicep line - Lower 1" (2.5 cm) and widen the front
 and back sleeve at the bicep line by 3/4"
 (1.9 cm).

(3) Underarm - From the 3/4" (1.9 cm) added to the back
 and front of the sleeve at the bicep line,
 reduce the amount to 1/2" (1.3 cm) on each
 side of the elbow. By pivoting the pattern
 at the center of the elbow line, reduce the
 elbow dart to 3/4" (1.9 cm). This will in-
 crease the width at the wrist.

(4) Wrist - Add 1/4" (0.6 cm) at each side of the new
 wrist width and connect to the 1/2" (1.3 cm)
 added at the elbow. Add 1/4" (0.6 cm) to
 the length of the sleeve at the wrist.

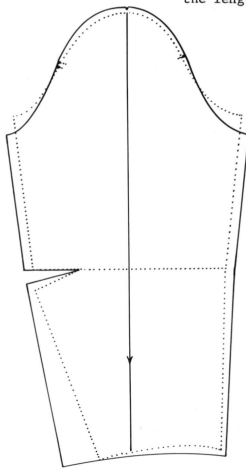

The dotted lines in *Figure 4* show
the basic sleeve block and the
solid lines show the adjustments
for the coat sleeve.

Be sure to check the armscyes of
the front and back coat blocks
against the sleeve cap before
cutting out the coat sleeve block.

Figure 4

Notes

Chapter 20

Men's Casual Wear

Notes

MEN'S CASUAL WEAR

Many of the principles of patternmaking are the same for men's casual wear as
for women's wear. If the sections on women's patternmaking have been mastered,
patternmaking for men's casual wear should present no problems. Many of to-
day's well known names in men's wear started as designers of women's apparel:
Bill Blass, Geoffrey Beene, Pierre Cardin, Yves St. Laurent, etc.

The patterns for men's wear are shown complete, i.e., a shirt is shown with the
back and front views and the patterns will include the sleeves, collar and
pockets as well as the front and back body.

1. Shirts

 A. How To Measure

 The following numbers relate to the numbers shown on the bodies in
 Figure 1 and *Figure 2*. The numbers for measuring are in the same or-
 der as they will be used to construct the patterns.

 (1) Center Back Length - Neck to Waist

 The measurement is taken from the seventh
 cervicale at the nape of the neck to the
 waistline.

 (2) Chest Circumference

 Measure around the body at the fullest part
 of the chest over the nipples, keeping the
 tape parallel to the floor.

 (3) Underarm Length from Waist

 Although this measurement can be taken from
 the waistline to the lower armscye, it is
 usually calculated by dividing the Center
 Back Length, Number 1, by 2 and then sub-
 tracting 1 1/4" (3.2 cm) from the half.

 (4) Neck Circumference

 This corresponds to the collar size and is
 taken at the base of the neck.

 (5) Front Chest Width

 Taken from armscye to armscye across the
 front of the body about midway between the
 base of the throat and the fullest part of
 the chest.

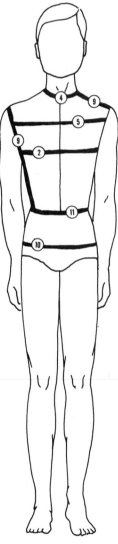

Figure 1

421

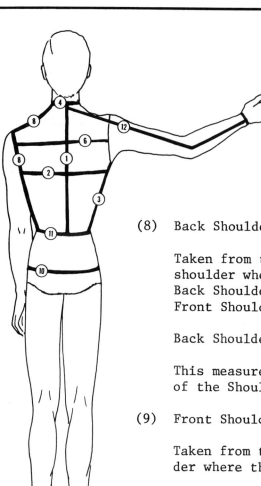

Figure 2

(6) Back Blade Width

Taken from armscye to armscye across the back of the body, over the fullness of the shoulder blades.

(7) Rise of Back Neck at Shoulder

The depth of the shoulder seam from the center back neck.

(8) Back Shoulder Length

Taken from the side of the neck to the point on the shoulder where a set in sleeve would be sewn. The Back Shoulder Length is 1/4" (0.6 cm) longer than the Front Shoulder Length.

Back Shoulder Height from Waist

This measurement is taken from the waistline to the end of the Shoulder Length.

(9) Front Shoulder Length

Taken from the side of the neck to the end of the shoulder where the sleeve joins the body of the shirt.

Front Shoulder Height from Waist

This measurement is taken from the waistline to the end of the Shoulder Length in front and is generally 1" (2.5 cm) less than the Back Shoulder Height from Waist.

(10) Seat Circumference

For shirts the same measurement is used as for the Chest Circumference, Number 2, including ease. The seat is normally 6" (15.2 cm) below the waistline.

(11) Waist Circumference

Measurement is taken at the natural waistline.

(12) Overall Sleeve Length

The measurement is taken from the middle of the back neck, over the shoulder and along the back of the arm with a slightly bent elbow, to the wrist. If the hand is flexed back, the exact point of the wrist will be indicated by the wrinkle between the forearm and the hand.

MEASUREMENT CHART

MAN'S SHIRT

Measurement	Size 40		Personal
	Inches	Centimeters	

1. Center Back Length - Neck to Waist.....19 48.3 _____

2. Chest Circumference....................40 101.6 _____

 Including 4" (10.2 cm) ease......44 111.8 _____

 Half of Chest Circumference
 including ease...................22 55.9 _____

3. Underarm Length from Waist............ 8 1/4 20.6 _____

 Center Back Length, Number 1,
 divided by 2 less 1 1/4" (3.2 cm)

4. Neck Circumference....................15 38.1 _____

 Circumference divided by Pi equals
 Diameter. Diameter divided by 2
 equals Radius..................... 2 3/8 6.0 _____

 15 ÷ 3 1/7 = 4 3/4 ÷ 2 = 2 3/8

 38.1 ÷ 3.1416 = 12.1 ÷ 2 = 6.0

5. Front Chest Width....................15 38.1 _____

 Divided by 2..................... 7 1/2 19.1 _____

6. Back Blade Width.....................16 1/2 41.9 _____

 Divided by 2..................... 8 1/4 21.0 _____

7. Rise of Back Neck at Shoulder.......... 1 2.5 _____

8. Back Shoulder Length.................. 6 1/2 16.5 _____

 1/4" (0.6 cm) longer than Front Shoulder Length

 Back Shoulder Height from Waist.......17 1/2 44.4 _____

 1" (2.5 cm) longer than Front Shoulder Height

9. Front Shoulder Length................. 6 1/4 15.9 _____

 Front Shoulder Height from Waist.......16 1/2 41.9 _____

Measurement	Size 40		Personal
	Inches	Centimeters	
10. Seat Circumference....................44		111.8	_____
Same as Number 1, including ease			
Divided by 2.....................22		55.9	_____
11. Waist Circumference...................32		81.3	_____
Including 4" (10.2 cm) ease.......36		91.5	_____
Divided by 2.....................18		45.7	_____
Divided by 4..................... 9		22.9	_____
12. Overall Sleeve Length.................33		83.8	_____

B. Man's Shirt Block

The numbers in the directions for drafting the block correspond to the numbers in the Measurement Chart. The measurements used for this draft are for a size 40 chest, which is the generally accepted model size.

The pattern produced is for the left side of the body.

1. Center Back Length - Neck to Waist - 19" (48.3 cm)

 At the right hand side of the paper, about 2" (5.1 cm) from the edge, draw a vertical line for the Center Back Length, leaving approximately 2" (5.1 cm) above the line and 8" (20.3 cm) below. Square the line at the top and bottom for a short distance.

2. Chest Circumference, Including Ease (half) - 22" (55.9 cm)

 Extend the squared lines for the distance of the Chest Circumference. Connect the top and bottom lines for the Center Front. Divide the area between the Center Back and Center Front in half for the Side Seam, making sure the line is squared from the top and bottom. See *Figure 1*.

3. Underarm Length from Waist - 8 1/4" (20.6 cm)

 On the Side Seam, measure from the bottom up for the Underarm Length and square to the Center Back and Center Front.

Figure 1

4. Neck Circumference (Radius) - 2 3/8" (6.0 cm)

 From Center Front, on the top line, mark the radius of the Neck Circumference and the same measurement down on Center Front. Square the two measurements, from the top line and from Center Front, to form a square. See *Figure 1.*

5. Front Chest Width (half) - 7 1/2" (19.1 cm)

 From Center Front measure the Chest Width and square a line from top to waist.

6. Back Blade Width (half) - 8 1/4" (21.0 cm)

 From Center Back measure the Back Blade Width and square a line from top to waist. See *Figure 1.*

7. Rise of Back Neck at Shoulder - 1" (2.5 cm)

 From Center Back, on the top line, crossmark the radius of the Neck Circumference, Number 4. From the crossmark, square a line up from the top line for the measurement of the Rise of the Back Neck at Shoulder.

8. Back Shoulder Height from Waist - 17 1/2" (44.4 cm)

 Back Shoulder Length - 6 1/2" (16.5 cm)

 Square a line from Center Back to the Side Seam for the measurement of Back Shoulder Height from Waist. Draw a line the length of the Back Shoulder from the side of the neck to where it touches on the Back Shoulder Height.

9. Front Shoulder Height from Waist - 16 1/2" (41.9 cm)

 Front Shoulder Length - 6 1/4" (15.9 cm)

 From Center Front square a line to the Side Seam for the Front Shoulder Height. Draw a line the length of the Front Shoulder from the side of the front neck to where it touches on the Front Shoulder Height. The Back Shoulder Length, which is 1/4" (0.6 cm) longer than the front, will be eased into the Front Shoulder Length. See *Figure 1.*

10. Extend the Center Back, Side Seam and Center Front lines below the waist. Measure down 6" (15.2 cm) and draw the seat line from Center Back to Center Front.

 30" (76.2 cm) from neckline to finished hem at Center Back is an acceptable length for sport shirts. Dress shirts will be from 2" (5.1 cm) to 4" (10.2 cm) longer at Center Back, depending on the manufacturer and if the shirt has the traditionally curved hemline. Measure down the desired length and square from Center Back to Center Front. See *Figure 2.*

11. Waist Circumference (half) - 18" (45.7 cm)

For a fitted shirt, with or without darts, subtract the desired waist measurement from the actual waist measurement on the draft. Divide the difference by 6, using 2 parts for each dart and 2 parts at the side seam. The center of the darts will be half the distance between the side seam and Center Back or Center Front. The darts will extend from the seat line to the armscye level.

Draft waist measurement, minus desired waist, divided by 6:

22" - 18" = 4" ÷ 6 = 2/3"

55.9 cm - 45.7 = 10.2 cm ÷ 6 = 1.7 cm

Draw in the curves for the neck and armscye, Number 12.

Front and back armscye curves should be very close to the same length - the front being slightly more curved to make up for the difference between the front and back shoulder height.

See *Figure 2*.

Figure 2

427

Figure 3

Figure 3 shows the completed shirt blocks, front and back, without button and buttonhole extensions and without seam allowances.

Some shirt manufacturers use 3/8" (1.0 cm) for every seam in the shirt, including the neck and collar. Other makers use 1/2" (1.3 cm) for all seams except the neck, collar and cuffs, for which they use 1/4" (0.6 cm) seams. An accepted standard for button and buttonhole extension is 3/4" (1.9 cm).

Knit garments that will be overlocked will need 3/8" (1.0 cm) for all seam allowances.

C. Man's Sleeve Block

The measurements used for this block are from the size 40 shirt block and will be for the left sleeve.

1. Overall Sleeve Length - 33" (83.8 cm) - 22 1/2" (57.2 cm)

 Since the sleeve length was measured from the center back of the body to the wrist - see *Figure 2* on page 422, Number 12 - it will be necessary to subtract the length from center back to shoulder and the width of the cuff. About 1" (2.5 cm) is needed for a slight blousing of the sleeve.

 33" - 8 1/2" (center back to shoulder) = 24 1/2"

 83.8 cm - 21.6 cm (center back to shoulder) = 62.2 cm

 24 1/2" - 3" (width of cuff) = 21 1/2" + 1" = 22 1/2"

 62.2 cm - 7.6 cm (width of cuff) = 54.6 cm + 2.5 cm = 57.2 cm

On fold

Figure 1

Fold a piece of pattern paper approximately 22" (55.9 cm) wide by 26" (66.0 cm) long lengthwise down the middle. On the folded edge mark the sleeve length including the blousing but less the amount from center back to shoulder and the width of the cuff. Square lines at the top and bottom of the measurement. See *Figure 1*.

2. Cap Height - 3" (7.6 cm)

 Cap height will vary from 3" (7.6 cm) for a shirt sleeve to as much as 10" (25.4 cm) for a tailored suit sleeve. Sometimes referred to by tailors as the *sleevehead* or the *head of the sleeve*, the degree of freedom of movement is determined by the cap height: The more shallow the cap the longer the underarm seam - which allows the room to raise the arm.

 From the top, measure down for the cap height and square a line from the fold. This will be the underarm length.

3. Total of Front and Back Armscye - Divided in half, minus 1/4" (0.6 cm)

 21" ÷ 2 = 10 1/2" - 1/4" = 10 1/4"
 53.3 cm ÷ 2 = 26.7 cm - 0.6 cm = 26.0 cm

 From the top at the fold, draw a diagonal line to the underarm line for the length of half the total armscye, minus 1/4" (0.6 cm).

Draw a shallow curve from the folded edge to the underarm line.
See *Figure 1*.

4. Bottom Width of Sleeve - Including pleats - 14" (35.6 cm) - Divided
 in half - 7" (17.8 cm)

 Mark the width of the sleeve on the bottom line. Connect the cap
 height line to the bottom for the underarm seam. This may be a
 straight line or a slightly curved line depending on the style
 desired. See *Figure 1*.

 The shirt sleeve block is completed by tracing through to the other
 side of the paper and cutting out the pattern.

The following sleeve block also fits into the armscye of the shirt block
but is used for casual jackets rather than shirts as it has a higher
cap.

1. Overall Sleeve Length - 24 1/2" (62.2 cm)

 On a folded piece of paper, measure the
 overall sleeve length, squaring the lines
 at the top and bottom.

2. Cap Height - 6" (15.2 cm)

 From the top, on the fold, measure down
 the cap height and square a line. This
 will be the underarm length.

3. Half of Total Measurement of Back and
 Front Armscyes, Minus 1/4" (0.6 cm) -
 10 1/4" (26.0 cm)

 From the top line, draw a straight line
 on the diagonal to the underarm line.
 Divide the line just drawn into thirds,
 extending the top third 5/8" (1.6 cm).
 Draw in the curve for the back of the
 sleeve cap. Draw a dotted line, cross-
 ing at the lower third for the front of
 the sleeve cap. See *Figure 2*.

4. The Elbow Line will be 1" (2.5 cm)
 above half of the distance between the
 underarm line and the wrist. Square a
 line from the fold of the paper.

5. Wrist Measurement - 12" (30.5 cm) Divided
 in Half - 6" (15.2 cm)

 Half of the wrist measurement will be
 crossmarked on the bottom line and con-
 nected with a straight line to the end
 of the underarm line.

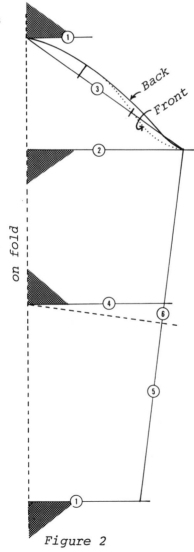

Figure 2

430

6. For the elbow dart, measure down from the elbow line 1" (2.5 cm) and draw a dotted line to the folded edge of the elbow line. Make the second fold in the paper to close the dart.

 See *Figure 2.*

7. Refold the original crease from the top to the elbow and, keeping the elbow dart folded, make a new fold from the elbow down to the wrist. The paper will be flat when folded correctly. See *Figure 3.*

8. From the third fold - the one from the elbow to the wrist - square a new line for half the wrist, 6" (15.2 cm). Keep the paper folded and connect this new wrist line to the elbow line.

Figure 3

9. With the paper still folded, trace the front curve of the cap and the underarm seam to the other side of the paper.

 Unfold the paper. Shorten the elbow dart to one fourth of the total elbow. Be sure that the dart and the fuller part of the cap are on the back edge of the sleeve. Curve the wrist.

 The original fold line will be the grain line and should be marked with an arrow.

 See *Figure 4.*

Figure 4

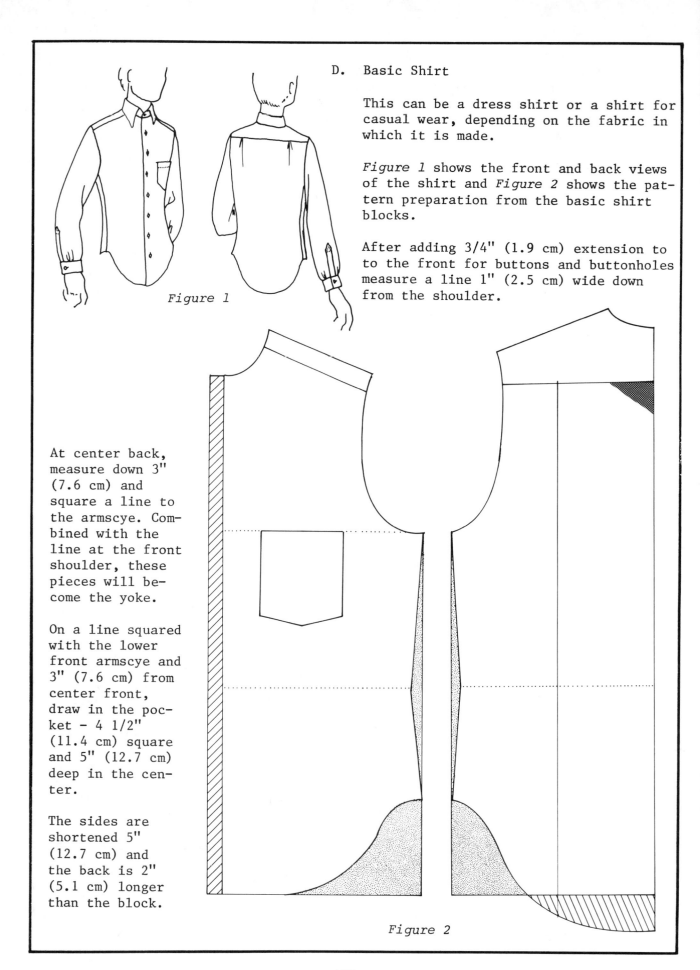

D. Basic Shirt

This can be a dress shirt or a shirt for casual wear, depending on the fabric in which it is made.

Figure 1 shows the front and back views of the shirt and *Figure 2* shows the pattern preparation from the basic shirt blocks.

After adding 3/4" (1.9 cm) extension to to the front for buttons and buttonholes measure a line 1" (2.5 cm) wide down from the shoulder.

Figure 1

At center back, measure down 3" (7.6 cm) and square a line to the armscye. Combined with the line at the front shoulder, these pieces will become the yoke.

On a line squared with the lower front armscye and 3" (7.6 cm) from center front, draw in the pocket - 4 1/2" (11.4 cm) square and 5" (12.7 cm) deep in the center.

The sides are shortened 5" (12.7 cm) and the back is 2" (5.1 cm) longer than the block.

Figure 2

Add a minimum of 1 1/2" (3.8 cm) to the front
extension for a self cut-on facing.

On the center of the back body dart on the
basic shirt block, extend a line up to the
yoke and down to the hem. See *Figure 2.*

Center back on fold

Figure 3

Figure 3 shows the completed body patterns, including the yoke.

The back has been opened 1 1/2" (3.8 cm) at the top to nothing at the hem
for a pleat in the back. Be sure that the center back of the shirt is
made on a fold of paper so that it can be opened out to a single piece
when unfolded. The fold will be the grain line.

If there is any discrepancy in the front and back shoulder lengths, match
the necklines and smooth out the armscye edge of the shoulder.

Draw around the shirt sleeve block, marking the grain line.

At the wrist, curve the line up about 1/2" (1.3 cm) in the front and down the same distance in the back. See *Figure 4*.

In the back section of the sleeve, about 4" (10.2 cm) from the grain line, draw the center of the sleeve placket 5" (12.7 cm) long, parallel with the grain line.

The placket will be 1" (2.5 cm) wide and 1" (2.5 cm) longer than the opening.

Starting at 1" (2.5 cm) from the grain line, crossmark for a 2" (5.1 cm) pleat on the back and front sections of the sleeve at the lower edge.

The cuff will be 3" (7.6 cm) wide and 9" (22.9 cm) long, including the extensions for the buttons and buttonholes.

See *Figure 3*.

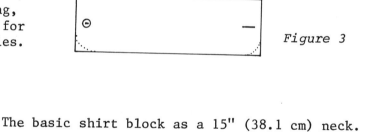

Figure 3

Figure 4

Figure 5

The basic shirt block as a 15" (38.1 cm) neck.

The two piece collar is made by folding a piece of paper and squaring a line from the fold for half the total neck measurement, crossmarking the line for the half of the back neck measurement. At the end of the line, measure up 1/2" (1.3 cm) and draw a slightly curved line from the cross-mark for the back of the neck to the raised line in the front. Draw a line parallel to the original line, making it 1 1/2" (3.8 cm) deep at center back and 1" (2.5 cm) deep at center front. Extend the collar band 3/4" (1.9 cm) for the front extension. See *Figure 4*.

The top collar, *Figure 5*, starts 1/2" (1.3 cm) from center front and is 3/8" (1.0 cm) wider from center back past the shoulder than the band. The ends may be squared, pointed or rounded.

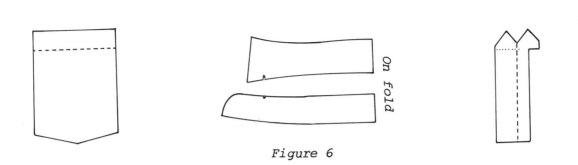

Figure 6

Figure 6 shows the completed patterns for the pocket, band and over collar and the sleeve placket. The pocket has a 1" (2.5 cm) hem. Be sure to make the collars on the fold and to make an under collar pattern for the over collar by removing 1/8" (0.3 cm) at the outer edge. A strip 1" (2.5 cm) wide and 5" (12.7 cm) long will be needed for the under side of the placket.

E. Sport Shirt

The sport shirt pictured in *Figure 1* is made without a yoke at the shoulders and has a convertible collar.

Note that the buttonholes on this type of shirt are horizontal as opposed to the vertical buttonholes on a dress shirt.

Figure 2 shows the preparation of the front basic shirt block. The slash at the side seam will be 5" (12.7 cm) finished. The extension for the buttons and buttonholes is 3/4" (1.9 cm).

Convertible collar shirts are more comfortable if 1/8" (0.3 cm) from the front and back necklines.

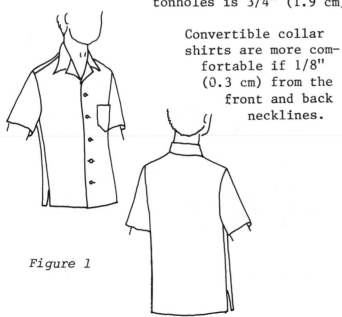

Figure 1

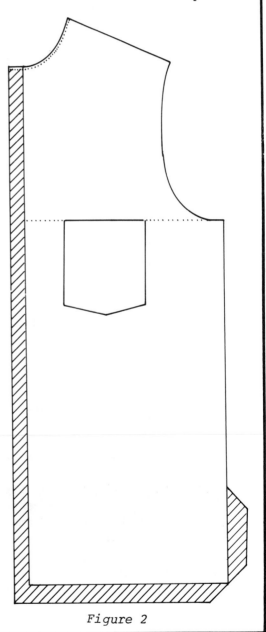

Figure 2

435

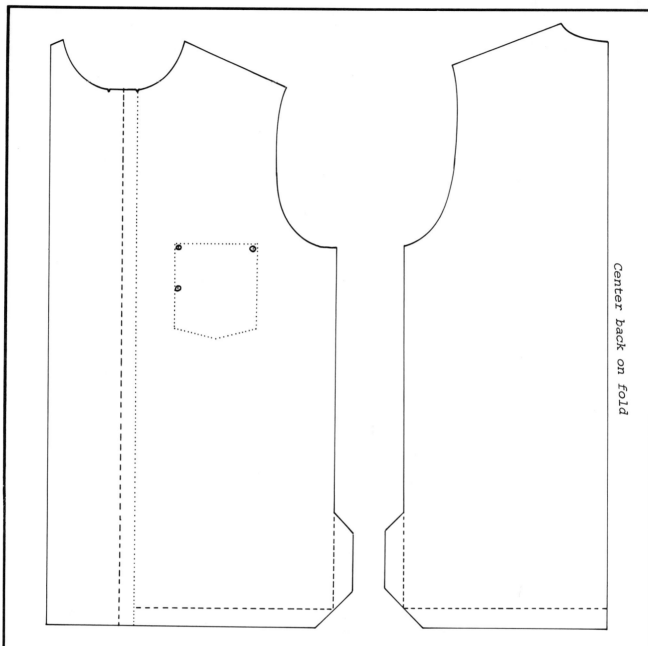

Center back on fold

Figure 3

Figure 3 shows the completed front and back body patterns of the sport shirt. Note that the front has a self facing which measures 4" (10.2 cm) from the edge of the button/buttonhole extension. This allows the collar to be worn open without exposing the wrong side of the fabric.

After making the front pattern, use it to match the side seams with the back so that the adjustments for the back and front will be the same. The back pattern will be made on a fold of the paper so that it can be opened as a one piece flat pattern.

The pocket on this shirt is the same size and positioned the same way as on the Basic Shirt, page 432.

Figure 4

To make the short sleeve, draw around the basic shirt sleeve with the center of the sleeve on the fold of paper.

Draw a diagonal line from the center of the cap to the corner of the underarm. From the line just drawn, square a line down from the corner for 5" (12.7 cm) for the length of the underarm seam. Square a line from the fold to meet the underarm seam. This will be the finished length of the sleeve. See *Figure 5*.

Figure 6 shows the short sleeve after it has been cut out and 1" (2.5 cm) folded back for a hem.

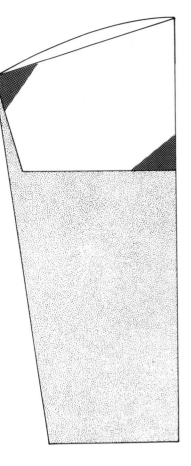

Figure 5

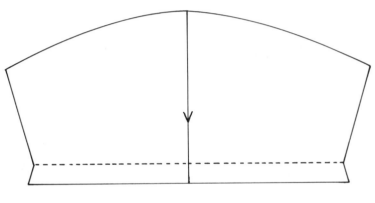

Figure 6

The convertible collar, *Figure 7*, starts by squaring a line from a fold of paper for the length of the adjusted front and back necks, divided in half. The fold will be the center back. Make a crossmark where the back of the collar will meet the shoulder seam. At the end of the measurement from the shoulder to the center front, square a line up for 3/4" (1.9 cm). Draw a slightly curved line from the shoulder to the raised line.

3" (7.6 cm) up on the fold from the first squared line, square another line for the outer edge of the collar. After the second squared line passes the area opposite the crossmark for the shoulder on the neck edge of the collar, the size and shape of the points and the spread of the collar will be at the discrimination of the designer. The dotted lines in *Figure 7* show some of the choices.

After seam allowances have been added, make the undercollar by removing 1/8" (0.3 cm) from the outer edges.

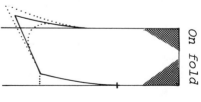

Figure 7

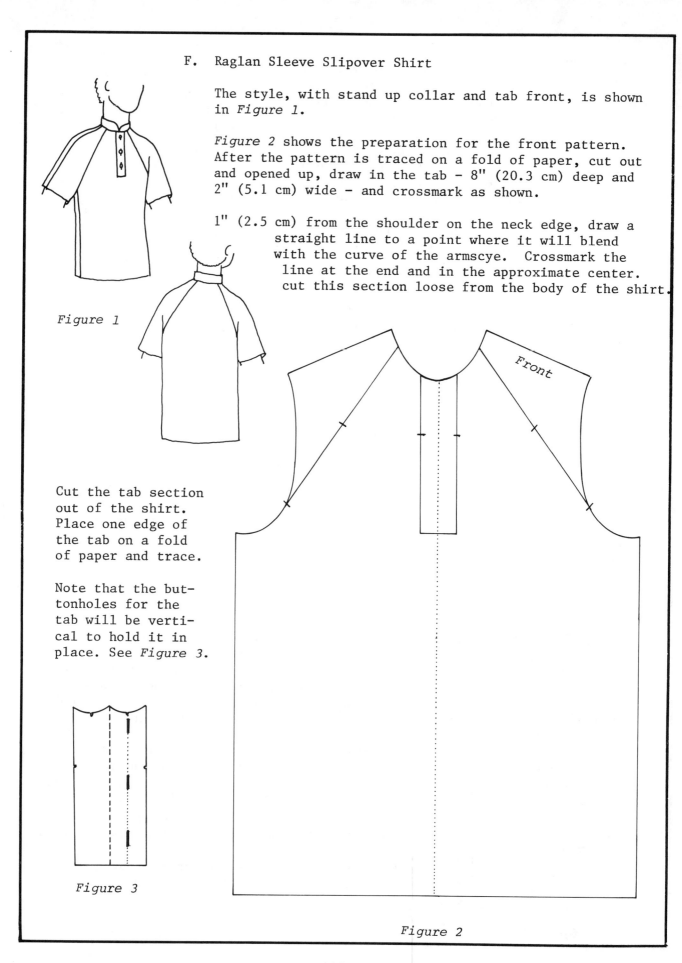

F. Raglan Sleeve Slipover Shirt

The style, with stand up collar and tab front, is shown
in *Figure 1*.

Figure 2 shows the preparation for the front pattern.
After the pattern is traced on a fold of paper, cut out
and opened up, draw in the tab – 8" (20.3 cm) deep and
2" (5.1 cm) wide – and crossmark as shown.

1" (2.5 cm) from the shoulder on the neck edge, draw a
straight line to a point where it will blend
with the curve of the armscye. Crossmark the
line at the end and in the approximate center.
cut this section loose from the body of the shirt.

Figure 1

Cut the tab section
out of the shirt.
Place one edge of
the tab on a fold
of paper and trace.

Note that the but-
tonholes for the
tab will be verti-
cal to hold it in
place. See *Figure 3*.

Figure 3

Front

Figure 2

On the back neck edge, measure in 1" (2.5 cm)
from the shoulder and draw a straight line
to where it blends with the curve of the
armscye.

Crossmark the line where it touches the arm-
scye and make double crossmarks - to indicate
the back - approximately in the middle of the
line. See *Figure 4*.

Cut the shoulder section loose from the body.

Confusion can be avoided by labeling the
pieces that have been cut from the back
and front bodies.

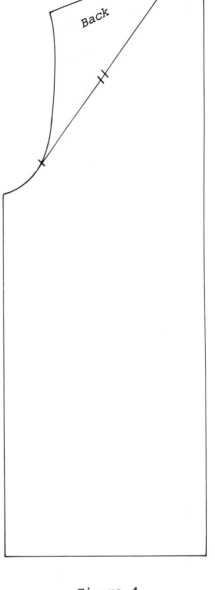

Figure 4

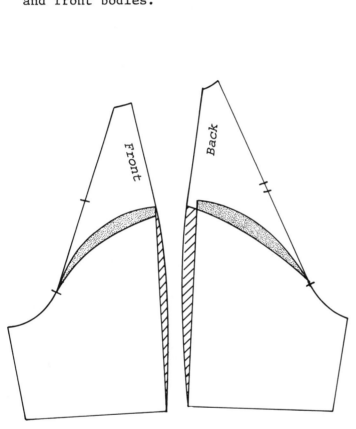

Figure 5

Draw around the front and back halves of the sleeve separately. Measure
the crossmarks made on the front and back bodies from the side seam at the
armscye. Mark the front and back sleeves to correspond with those cross-
marks. Using those crossmarks as a guide, overlap the shoulder pieces
cut from the bodies 1/2" (1.3 cm) at the shoulder and cap of the sleeve.
If there is any discrepancy in the joining of the shoulder piece and sleeve,
adjust the sleeve to the shoulder piece by enlarging or decreasing the
sleeve section. Be sure to notch the crossmarks to distinguish between the
back and front sections of the sleeve. From the tip of the shoulder to the
hem, both front and back may be slightly rounded for freedom of movement.

The stand up or band collar is made by squaring a line from the fold of paper for the length of the neck on the shirt pattern from center back to center front, crossmarking the shoulder seam.

At center front, square a line up 3/4" (1.9 cm).

Draw a curved line from the crossmark at the shoulder to the raised center front. The collar will be 1 1/2" (3.8 cm) high. The top edge is drawn parallel with the neck edge. The center front may be squared or rounded.

See *Figure 7*.

Figure 7

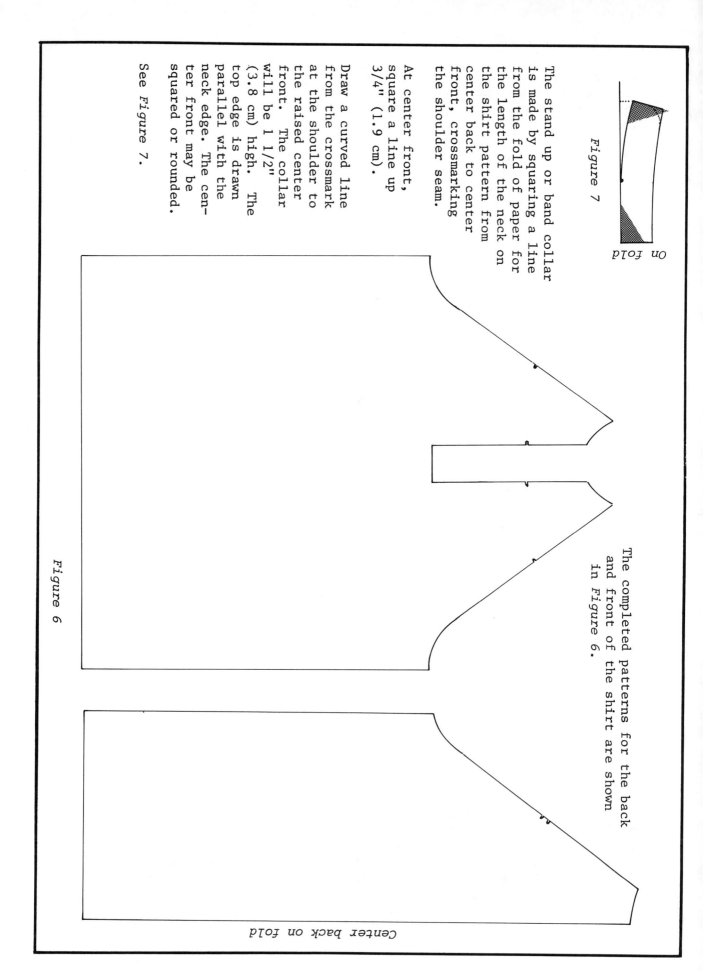

On fold

The completed patterns for the back and front of the shirt are shown in *Figure 6*.

Figure 6

Center back on fold

440

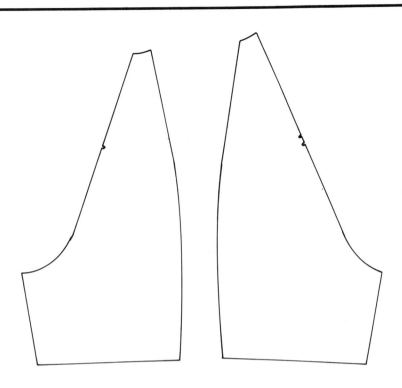

Figure 8

The completed patterns for the two piece raglan sleeve is shown in *Figure 8*.

If a one piece raglan sleeve is needed, follow the diagram in *Figure 9*.
After drawing around the two parts of the sleeve, with the neck and shoul-
seams closed, draw a straight line from the front underarm corner to the
back underarm corner. From this line, measure down to the desired length
for the underarm seam of the sleeve. Correct the measurement at the fin-
ished hemline..

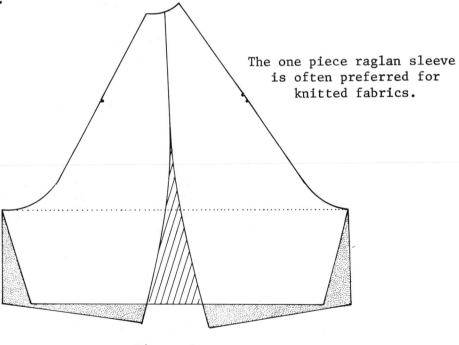

The one piece raglan sleeve
is often preferred for
knitted fabrics.

Figure 9

441

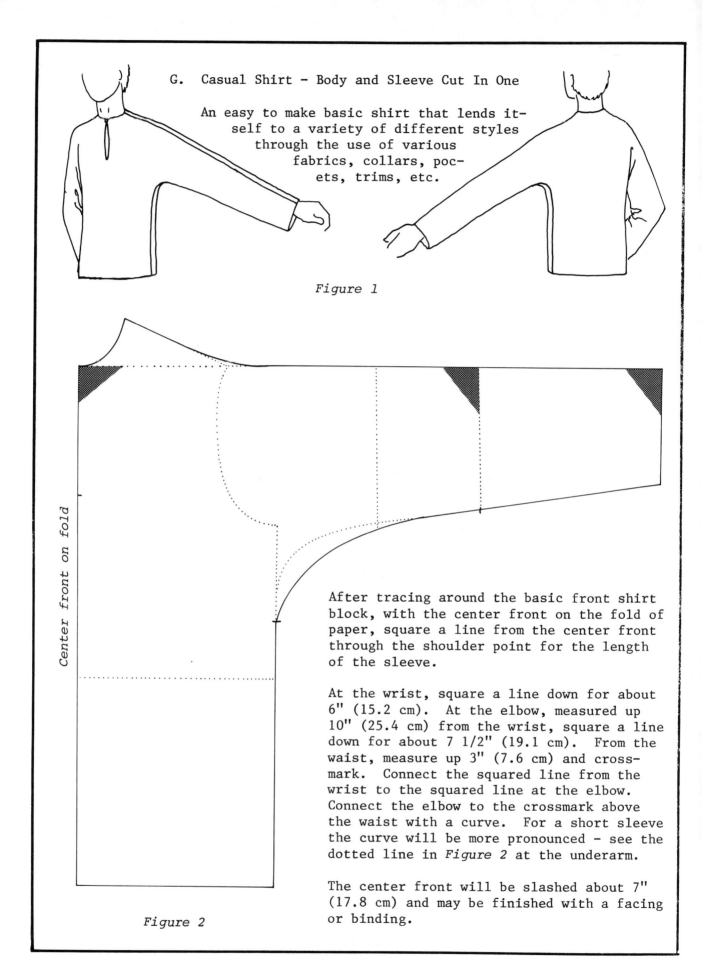

G. Casual Shirt – Body and Sleeve Cut In One

An easy to make basic shirt that lends it-self to a variety of different styles through the use of various fabrics, collars, poc-ets, trims, etc.

Figure 1

Center front on fold

After tracing around the basic front shirt block, with the center front on the fold of paper, square a line from the center front through the shoulder point for the length of the sleeve.

At the wrist, square a line down for about 6" (15.2 cm). At the elbow, measured up 10" (25.4 cm) from the wrist, square a line down for about 7 1/2" (19.1 cm). From the waist, measure up 3" (7.6 cm) and cross-mark. Connect the squared line from the wrist to the squared line at the elbow. Connect the elbow to the crossmark above the waist with a curve. For a short sleeve the curve will be more pronounced – see the dotted line in *Figure 2* at the underarm.

The center front will be slashed about 7" (17.8 cm) and may be finished with a facing or binding.

Figure 2

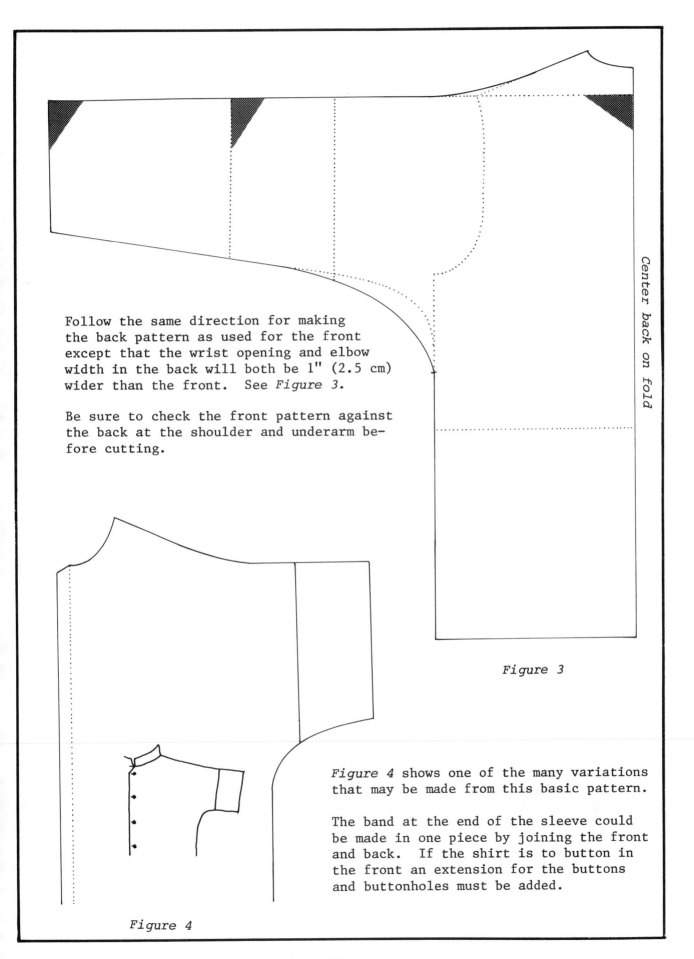

Follow the same direction for making
the back pattern as used for the front
except that the wrist opening and elbow
width in the back will both be 1" (2.5 cm)
wider than the front. See *Figure 3*.

Be sure to check the front pattern against
the back at the shoulder and underarm be-
fore cutting.

Center back on fold

Figure 3

Figure 4 shows one of the many variations
that may be made from this basic pattern.

The band at the end of the sleeve could
be made in one piece by joining the front
and back. If the shirt is to button in
the front an extension for the buttons
and buttonholes must be added.

Figure 4

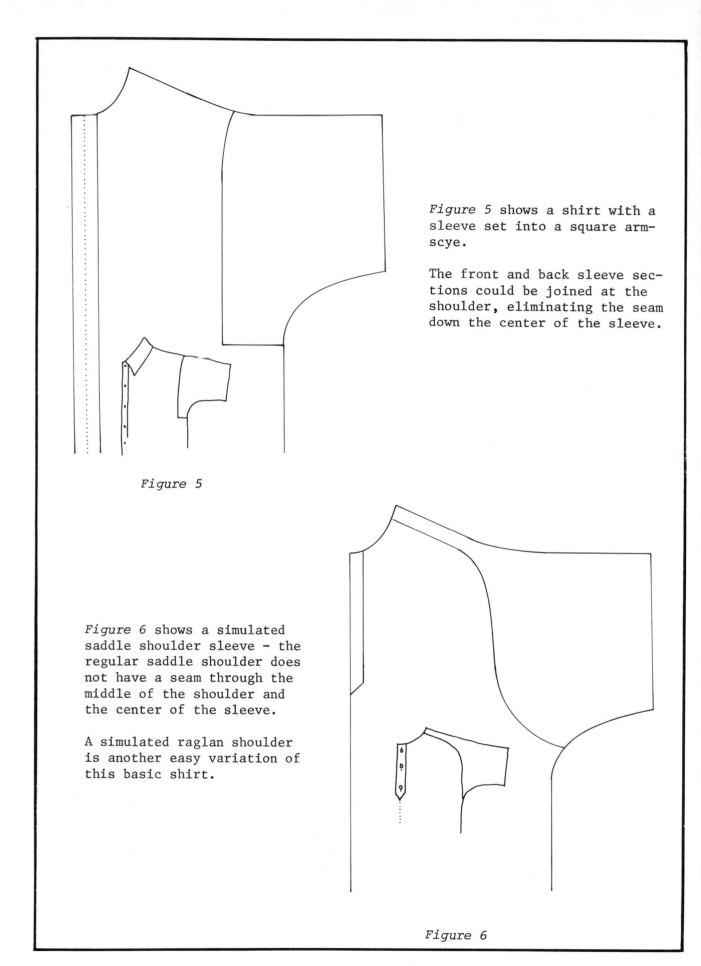

Figure 5 shows a shirt with a sleeve set into a square armscye.

The front and back sleeve sections could be joined at the shoulder, eliminating the seam down the center of the sleeve.

Figure 5

Figure 6 shows a simulated saddle shoulder sleeve - the regular saddle shoulder does not have a seam through the middle of the shoulder and the center of the sleeve.

A simulated raglan shoulder is another easy variation of this basic shirt.

Figure 6

H. Casual Jacket

The basic shirt patterns will need some slight adjustments to make them larger, whether the jacket is to be unlined or have a thin lining:

Lower the neckline 1/4" (0.6 cm). Raise and extend the shoulder 1/2" (1.3 cm) and the same amount through the chest at the armscye. The armscye will be dropped 1" (2.5 cm) at the side seam. The side seam will be extended 3/4" (1.9 cm) from the armscye to the hem.

If a shoulder pad is to be used, the point of the shoulder will have to be raised and extended the depth of the shoulder pad as shown by the diagonal lines in *Figure 1*.

After the above adjustments are made on the front pattern, make the same adjustments on the back pattern.

Figure 1

445

Adjustments for the sleeve are shown on
Figure 2.

Raise the sleeve cap 1/2" (1.3 cm).
Lower the underarm line 1" (2.5 cm)
and extend it 1/2" (1.3 cm) on
each side – all the way to the
wrist. Lower the hem at the
wrist 1/4" (0.6 cm).

The diagonal lines indicate
the additional adjustments
needed when shoulder pads are
used. The cap will be further
raised the same amount the
shoulders of the body of the
jacket were raised – which is
the depth of the thick end of
the shoulder pad.

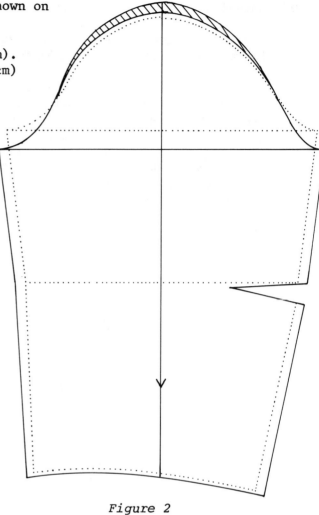

Figure 2

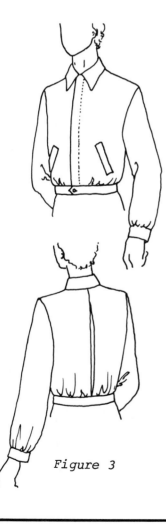

Figure 3 shows a waist length jacket, sometimes
called a *windbreaker* or *golf jacket*, and is made
in a variety of fabrics – from poplin to leather
and tweed.

The style shown is a fly button or snap front with
convertible collar, slanted bound pockets and self
fabric bands at the wrist and waist. There is a
box pleat in the center back.

A zippered front jacket, with knitted bands at the
neck, wrist and waist, could be easily adapted from
this pattern.

Figure 3

446

Draw around the front jacket block. This style will be 1 1/2" (3.8 cm) below the waistline of the jacket block to allow for ease and some blousing.

At center front, add 1" (2.5 cm) for the extension and 2 1/2" (6.4 cm) for the facing. The stitching to hold the buttonhole fly on the left front will be 2" (5.1 cm) from the fold.

The pocket opening will be 6" (15.2 cm) and will be placed on an angle about 3" (7.6 cm) above the waistband. The pocket flap is 1" (2.5 cm) wide finished.

See *Figure 4* for the front jacket pattern.

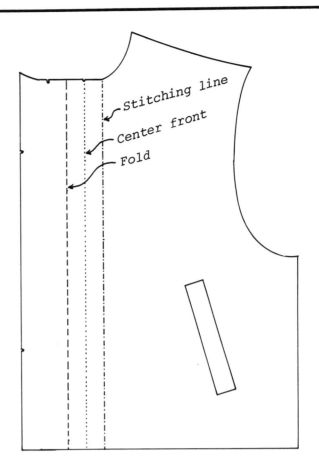

Figure 4

Figure 5

Figure 5 shows the pattern for the buttonhole fly, used on the left side of the garment only. The fly, when folded, must be at least 1/4" (0.6 cm) more narrow than the facing so that it will not extend beyond the fold of the extension. The fly is first stitched to the facing and then held in place by the top stitching on the front of the garment.

The pocket, shown in *Figure 6*, must be wide enough and deep enough to serve whatever purpose it is intended for. Don't make them too small - skimpy pockets are the sign of a poorly designed garment.

Figure 6

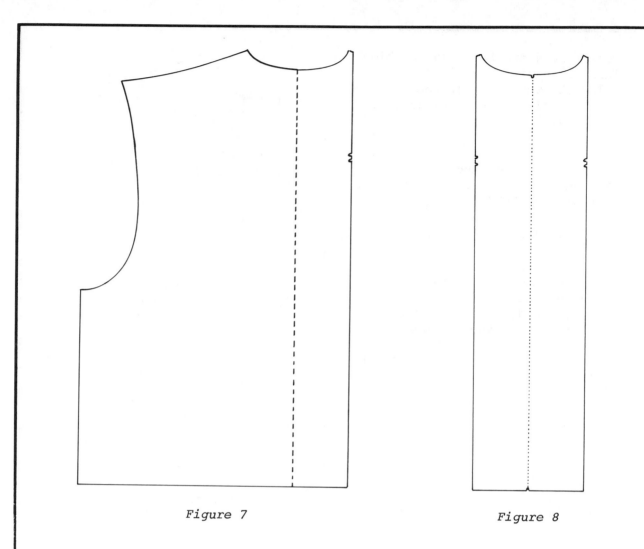

Figure 7

Figure 8

After drawing around the back jacket block and adjusting the length to 1 1/2" (3.8 cm) below the waistline, same as the front, extend the center back 3" (7.6 cm) for the center back box pleat, double notching as shown in *Figure 7*.

The pleat underlay, *Figure 8*, is traced from the extension added to the center back of the jacket.

The waistband, which will finish 2" (5.1 cm) wide, is shown in *Figure 9*.

Since this is a non-elasticized waistband and must go over other clothing, about 4" (10.2 cm) of ease will be needed. For a 32" (81.3 cm) waist, the measurement of each quarter of the band will be 9" (22.9 cm) - plus the extensions at each end for the button and buttonhole.

Figure 9

The dart in the elbow of the sleeve
has been eliminated by measuring 3"
(7.6 cm) above and below the elbow
line on the front of the sleeve.
The same distance, 3" (7.6 cm)
is measured from the outer legs
of the dart in the back of the
sleeve. The dart line is
smoothed out and the back
edge of the sleeve will be
eased into the front edge.

The cuff will be 3" (7.6 cm)
wide and 10" (25.4 cm) long,
finished.

The width of the cuff, less
1" (2.5 cm) for blousing,
must be removed from the lower
edge of the sleeve.

See *Figure 10*, which shows the
completed sleeve and cuff.

The lower edge of the sleeve
will be shirred to fit the
cuff, just as the waist of the
jacket is shirred to fit the
waistband.

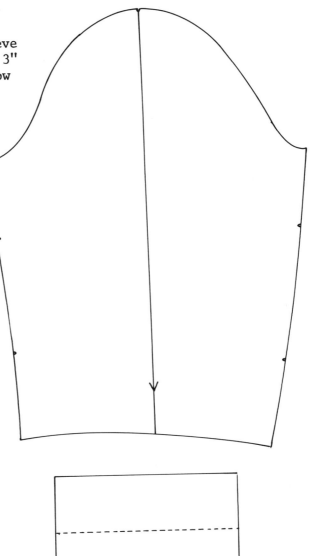

Figure 10

To make the convertible collar, square a line from a fold of paper for the
distance from the center back neck to the center front neck on the jacket
pattern. Crossmark the shoulder.

At the center front, measure up 3/4" (1.9 cm) and draw a slightly curved
line to that point from the crossmark at the shoulder. The collar will
be 4" (10.2 cm) deep at the center back, narrow-
ing slightly at the shoulder area. The shape of
the point and the spread of the collar are at the
discretion of the designer.

After drafting the top collar, make the under col-
lar by removing 1/8" (0.3 cm) from the outer edge.
See *Figure 11*.

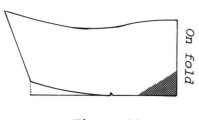

On fold

Figure 11

449

Notes

2. Pants

 A. How To Measure

 Some of the measurements needed to draft men's pants are taken directly on the body and others are calculated.

 The following numbers relate to the numbers shown on the body in *Figure 1* and are in the same order as they will be used to construct the patterns.

 (1) Outseam – Waist to Finished Length

 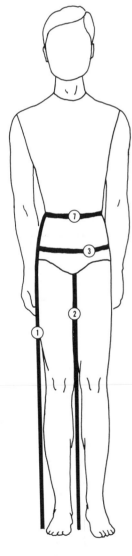

 The measurement is taken at the side of the body, about midway between the center front and center back. The person being measured should tie small cord or piece of tailor's tape around his waist, determining his own waistline and how snug he wishes the pants to be at that point. It is suggested that the measurement be taken from the waist to the floor, 3" (7.6 cm) added for hem and the final length determined after the pants have been completed except for the finished length.

 (2) Inseam – Crotch to Finished Length

 Tailors generally use a special tape-measure for determining this measurement, stiffened at one end. The end of the tape should be held comfortably into the crotch, measuring from crotch to floor. If 3" (7.6 cm) has been added to Number 1 – Outseam, the same measurement must be added to the inseam measurement. The difference between the outseam and the inseam is known as the *rise*.

 (3) Seat Circumference

 Taken approximately 6" (15.2 cm) below the waistline, this measurement must be taken over the fullest part of the seat.

 (4), (5), (6) – Calculated measurements

 (7) Waist Circumference

 Taken at the normal waistline.

 (8), (9), (10) – Calculated measurements

 Figure 1

MEASUREMENT CHART

MAN'S PANTS

Measurement		Size 32	Personal
	Inches	Centimeters	
1. Outseam - Waist to Finished Length.....41		104.1	_____
2. Inseam - Crotch to Finished Length.....32		81.3	_____
3. Seat Circumference....................37		94.0	_____
Including 2" (5.1 cm) ease........39		99.1	_____
Divided by 2.....................19 1/2		49.5	_____
Divided by 4..................... 9 3/4		24.8	_____
4. Knee Line............................18		45.7	_____
2" (5.1 cm) above half of Number 2			
5. Front Crotch Extension................ 2 3/4		7.0	_____
1/12 of Number 3, minus 1/2" (1.3 cm)			
6. Back Crotch Extension................. 3 3/4		9.5	_____
1/12 of Number 3, plus 1/2" (1.3 cm)			
7. Waist Circumference...................32		81.3	_____
Divided by 4..................... 8		20.3	_____
8. Back Rise - Normal Seat............... 1 1/4		3.2	_____
Flat Seat........................ 7/8		2.2	_____
Full Seat........................ 1 3/4		4.4	_____
9. Grain Line - No measurement			
10. Knee Circumference....................21		53.3	_____
Divided by 4..................... 5 1/4		13.3	_____
Bottom Circumference...................19		48.3	_____
Divided by 4..................... 4 3/4		12.1	_____

Notes

B. Man's Pants Block

The measurements used for this draft are for a size 32" (81.3 cm) waist and 32" (81.3 cm) inseam, which is the usual model size. The pattern will be drafted for the left side of the body.

The numbers in the directions for drafting the block correspond to the numbers in the Measurement Chart.

1. Outseam - Waist to Finished Length - 41" (104.1 cm)

Draw the full outseam length about 5" (12.7 cm) from the left hand edge of the paper. Square the outseam length at the top and bottom.

2. Inseam - Crotch to Finished Length - 32" (81.3 cm)

On the first line drawn, the outseam length, measure up from the bottom of the line for the length of the inseam. Square a line for the crotch line. See *Figure 1*.

3. Seat Circumference, Including Ease - 37" (94.0 cm)

From the top of the outseam length, measure down 6" (15.2 cm) to the seat. Square a line from the outseam length for the seat line. From center front to side seam on this line will be one fourth of the total seat including ease, minus 1/2" (1.3 cm) - 9 1/4" (23/5cm). The back seat will be one fourth of the total plus 1/2" (1.3 cm) - 10 1/4" (26.0 cm). After these measurements have been marked on the seat line, square lines down to the crotch line and up to the top squared line.

4. Knee Line, from Bottom - 18" (45.7 cm)

The knee line is 2" (5.1 cm) above the midway point between the bottom line and the crotch. The knee line is squared from the outseam length.

5. Front Crotch Extension - 2 3/4" (7.0 cm)

The front crotch extension is equal to one twelfth of the seat circumference, including ease, minus 1/2" (1.3 cm). Extend the crotch line to the left of the first line drawn - the outseam length - for the correct distance and then draw in a curve as shown on *Figure 1*.

6. Back Crotch Extension - 3 3/4" (9.5 cm)

The back crotch extension is equal to one twelfth of the seat circumference, including ease, plus 1/2" (1.3 cm). Draw in the curve for the back crotch. Note that the curve for the back is not as sharp as the front crotch curve. See *Figure 1*.

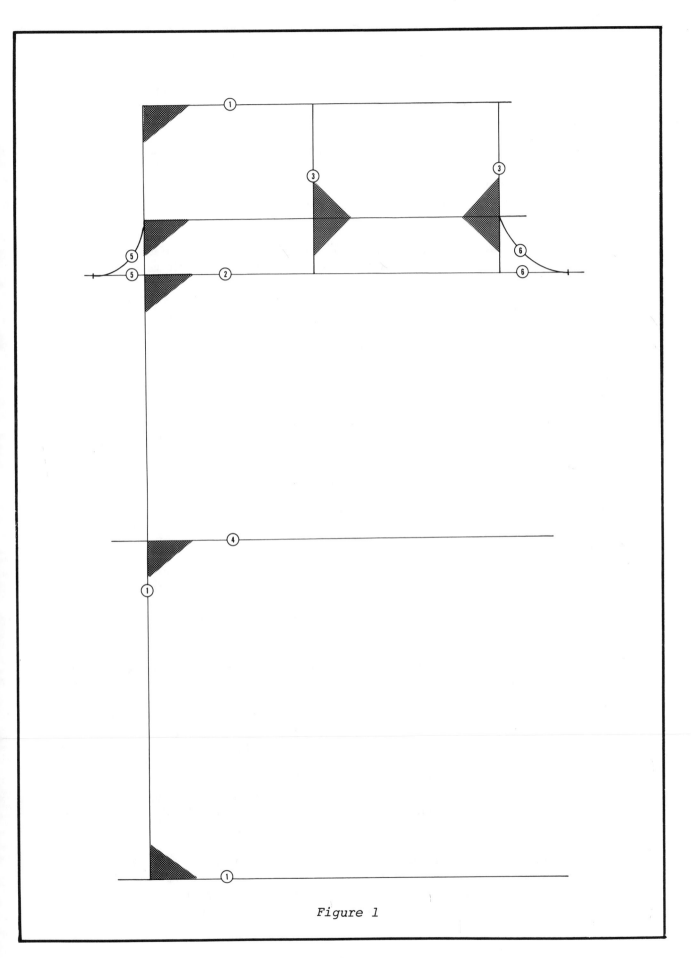

Figure 1

7. Waist Circumference, Divided by 4 – 8" (20.3 cm)

At the top of the outseam length, measure one fourth of the total waist circumference on the squared line. Curve the side seam down to the seat line.

8. Back Rise, Normal Seat – 1 1/4" (3.2 cm)

From center back, measure in 1 1/4" (3.2 cm) on the top line and up the same amount. Connect with a straight line to the back seat line.

If the seat is flat, use 7/8" (2.2 cm) for both measurements. If the seat is full, use 1 3/4" (4.4 cm) for both measurements.

The back waist will be one fourth of the waist circumference, plus 1" (2.5 cm) for the dart width – 9" (22.9 cm). Draw a straight line from the top of the back rise to where it falls on the waist line. Connect to seat line at the side seam with a slight curve. The front and back side seams from the seat to the waist must be the same length. Make any necessary adjustments on the back side seam.

The *center* of the back dart will be 3 1/2" (8.9 cm) from the side seam at the waist and 1" (2.5 cm) wide. Square the center of the dart down from the waist for 3" (7.6 cm) and draw in the dart. See *Figure 2*.

9. The front grain line, which will also be the grain line, is half way between the point of the front crotch and the side seam. Square lines from the crotch line to the top and bottom of the pattern.

10. Knee Circumference, Divided by 4 – 5 1/4" (13.3 cm)
Bottom Circumference, Divided by 4 – 4 3/4" (12.1 cm)

Both of these measurements are determined by current styling and subject to change.

To complete the front pattern, mark one fourth of the knee circumference, minus 1/2" (1.3 cm) – 4 3/4" (12.1 cm) – on each side of the grain line at the knee. Mark one fourth of bottom circumference, minus 1/2" (1.3 cm) – 4 1/4" (10.8 cm) – on each side of grain line at bottom of draft. At the side seam, connect the bottom line to the knee line and the knee line to the seat line. On the front inseam, draw a straight line from the bottom, through the measurement at the knee, to the crotch. On the line just drawn, measure down approximately one third of the distance between the crotch and the knee. From the top third, draw a slightly curved line to the point of the crotch. See *Figure 2*.

11. The back grain line, at the crotch line, will be the same distance from the side seam as the front grain line is from the side seam at the crotch line, plus 1/2" (1.3 cm). From the crotch line, square lines to the top and bottom of the pattern.

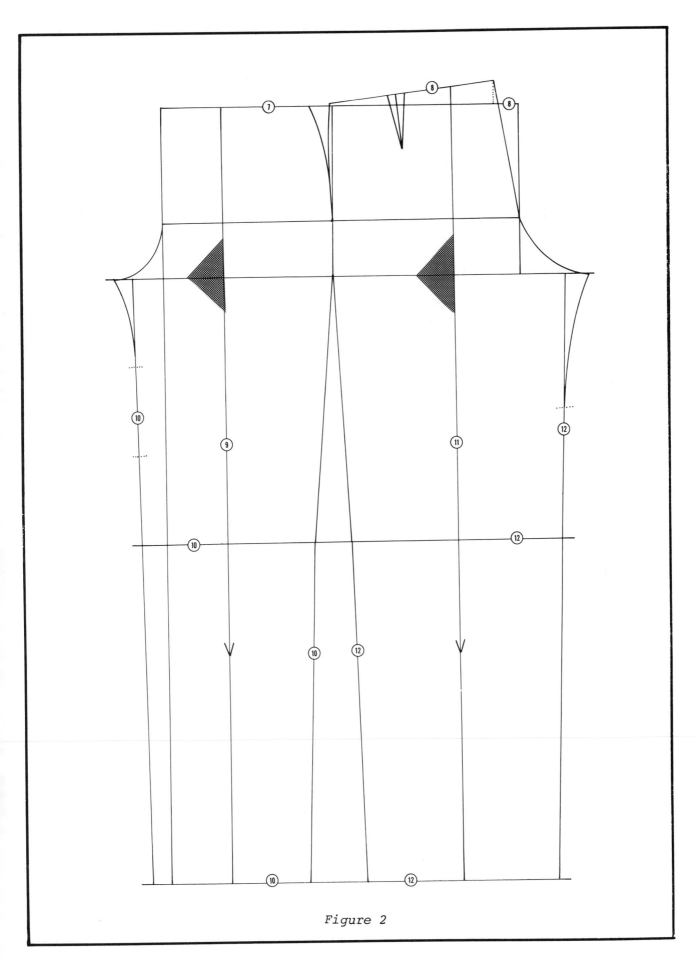

Figure 2

12. Mark one fourth of knee circumference, plus 1/2" (1.3 cm) – 5 3/4" (14,6 cm) on each side of the grain line at the back knee.

Mark one fourth of bottom circumference, plus 1/2" (1.3 cm) – 5 1/4" (13.3 cm) – on each side of the grain line on the bottom line.

At the side seam, connect the bottom line to the knee line and the knee line to the seat line. On the back inseam, draw a straight line from the bottom, through the crossmark at the knee, to the crotch line. On the line just drawn, measure down approximately midway between the crotch and the knee. From the midway point, draw a slightly curve line to the point of the crotch.

The distance must be the same from the knee to the crotch point on the back inseam as from the knee to the crotch point on the front inseam. If any adjustment is necessary, lower or raise the back crotch point.

See *Figure 2*.

The completed front and back pants patterns are shown in *Figure 3*.

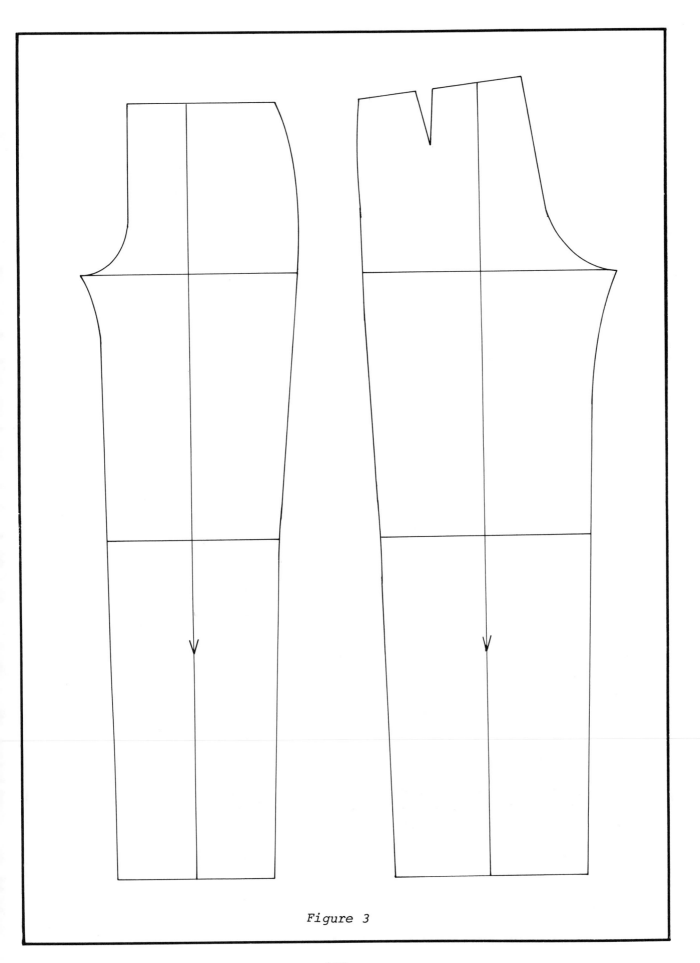

Figure 3

C. Pants With Top Pockets and Extended Waistband

Figure 1 shows the front and back view of the pants.

Many men prefer this type of pocket as it does not gap, especially when seated.

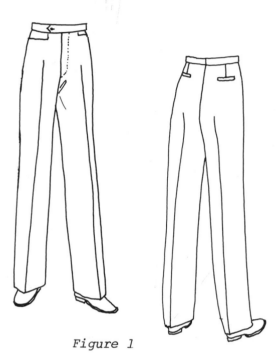

Figure 1

After drawing around the basic block of the front pants pattern, draw the shape and size of the pocket desired. Starting about 3" (7.6 cm) from center front at the waist, measure down 1" (2.5 cm) for the front edge of the pocket. The pocket opening should be about 6" (15.2 cm) and slants downward to the side seam. The lower edge of the pocket, shown by the dotted lines, should be a minimum of 7" (17.8 cm) below the opening.

The fly will be 1/4" (0.6 cm) wider than the line of stitching from the front edge and deep enough to accomodate a 7" (17.8 cm) zipper.

The legs of the trousers may be narrowed or flared as shown by the dotted lines in Figure 2.

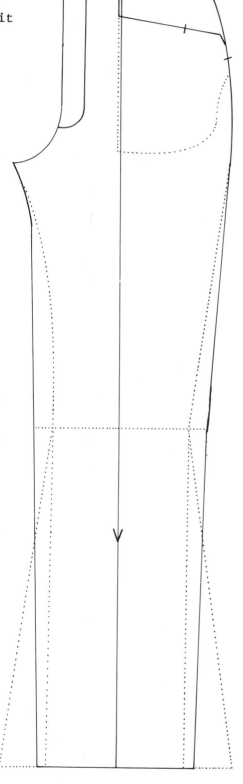

Figure 2

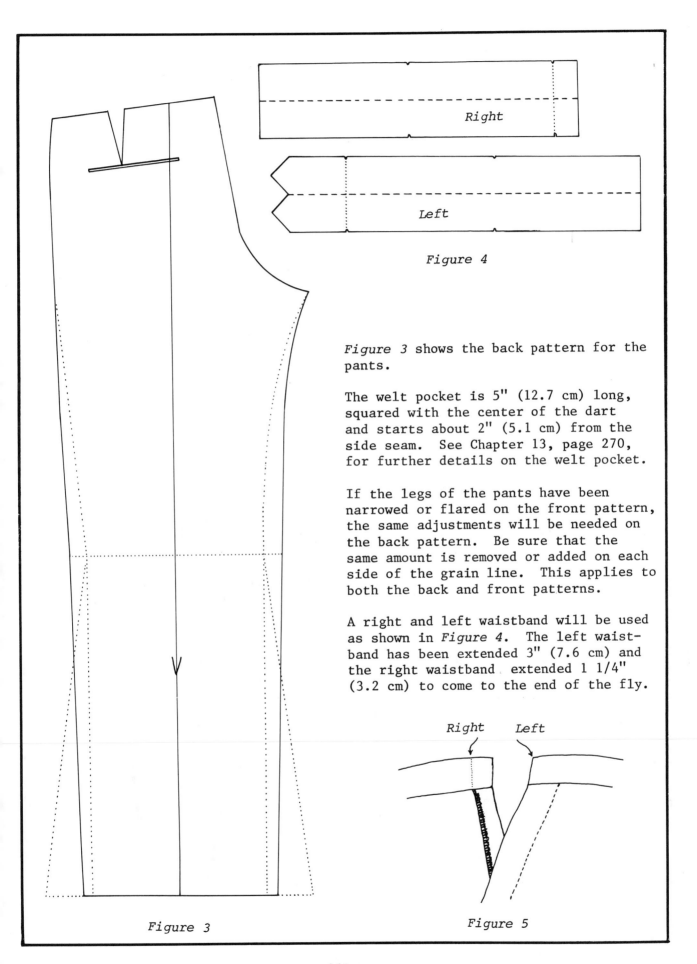

Figure 4

Figure 3

Figure 3 shows the back pattern for the pants.

The welt pocket is 5" (12.7 cm) long, squared with the center of the dart and starts about 2" (5.1 cm) from the side seam. See Chapter 13, page 270, for further details on the welt pocket.

If the legs of the pants have been narrowed or flared on the front pattern, the same adjustments will be needed on the back pattern. Be sure that the same amount is removed or added on each side of the grain line. This applies to both the back and front patterns.

A right and left waistband will be used as shown in *Figure 4*. The left waistband has been extended 3" (7.6 cm) and the right waistband extended 1 1/4" (3.2 cm) to come to the end of the fly.

Right Left

Figure 5

461

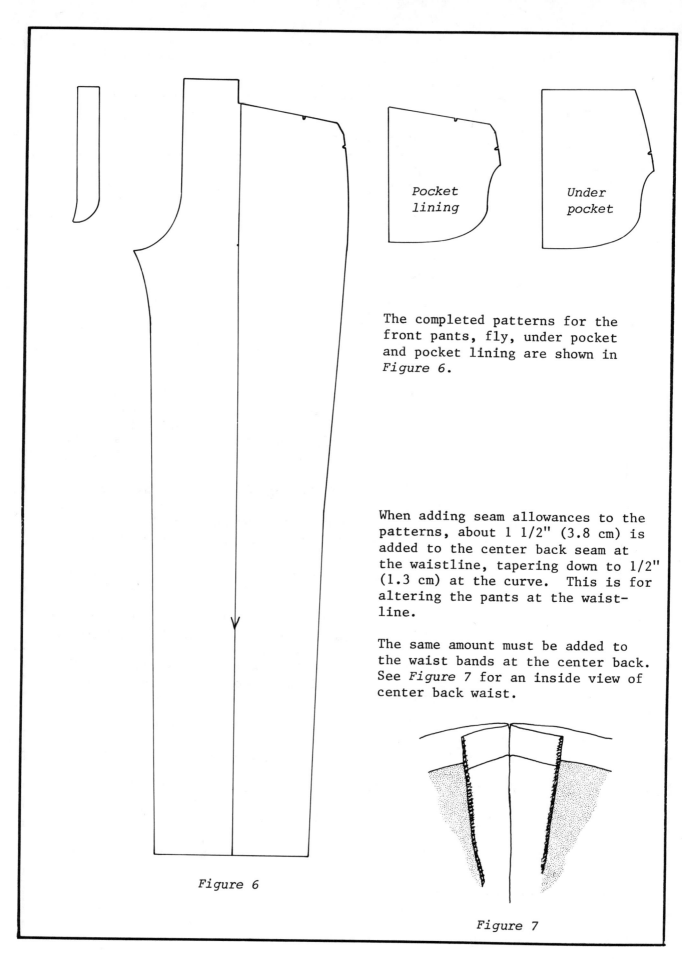

Pocket lining

Under pocket

The completed patterns for the front pants, fly, under pocket and pocket lining are shown in *Figure 6*.

When adding seam allowances to the patterns, about 1 1/2" (3.8 cm) is added to the center back seam at the waistline, tapering down to 1/2" (1.3 cm) at the curve. This is for altering the pants at the waist-line.

The same amount must be added to the waist bands at the center back. See *Figure 7* for an inside view of center back waist.

Figure 6

Figure 7

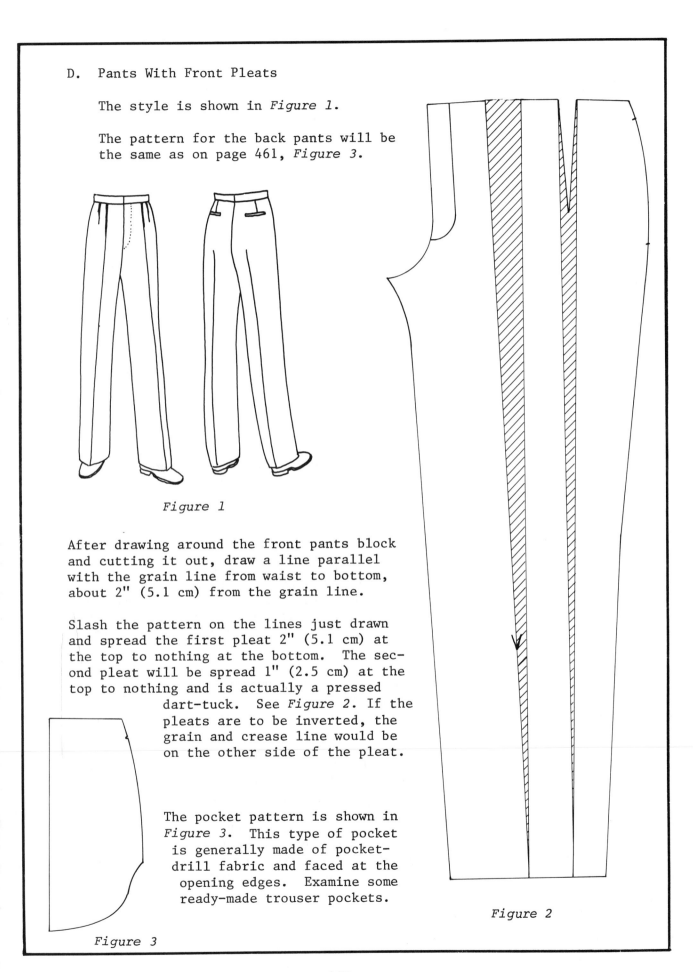

D. Pants With Front Pleats

The style is shown in *Figure 1*.

The pattern for the back pants will be the same as on page 461, *Figure 3*.

Figure 1

After drawing around the front pants block and cutting it out, draw a line parallel with the grain line from waist to bottom, about 2" (5.1 cm) from the grain line.

Slash the pattern on the lines just drawn and spread the first pleat 2" (5.1 cm) at the top to nothing at the bottom. The second pleat will be spread 1" (2.5 cm) at the top to nothing and is actually a pressed dart-tuck. See *Figure 2*. If the pleats are to be inverted, the grain and crease line would be on the other side of the pleat.

The pocket pattern is shown in *Figure 3*. This type of pocket is generally made of pocket-drill fabric and faced at the opening edges. Examine some ready-made trouser pockets.

Figure 3

Figure 2

E. Pants With Elasticized Waist

Figure 1 shows the front and back view of casual pull-on pants with elastic in the waistband.

Figure 1

After drawing around the basic front pants, measure from center front to the widest part of the hip area. This measurement, plus 1/2" (1.3 cm) for additional ease, will determine the size of the front waist line. See *Figure 2*.

The front *quarter pockets* start 2" (5.1 cm) from the side seam at the waist and the opening is 6" (15.2 cm). Draw in the pocket, crossmarking as shown.

The pattern for the fly depends on the length of the zipper to be used and the distance that the stitching will be from center front.

This type of casual pants can also be made with buttons or snaps at the fly. Since the waist is elasticized, this type of pants is often made without a fly opening.

Figure 2

The pattern for the back pants must be
enlarged at the waistline by follow-
ing the same procedure as used to
increase the front waistline. See
Figure 3.

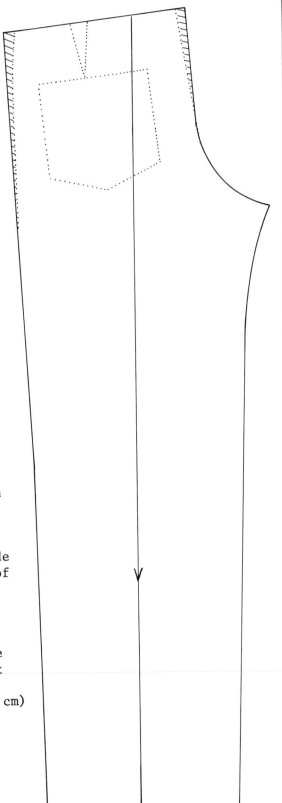

The top of the back patch pocket is
parallel with the back waistline and
is 6" (15.2 cm) wide. The edge of
the pocket will be 2" (5.1 cm) from
the side seam. The
pocket is shown by the
dotted lines in *Figure
3*.

The completed pattern
for the pocket, without
hem or seam allowance,
is shown in *Figure 4*.

Figure 4

The waistline for this type
of casual pants may be fin-
ished in several ways: With
ready-made novelty elastic
webbing; with elastic in a
casing, the elastic being
about 1/4" (0.6 cm) less wide
than the casing; with rows of
narrow elastic or elastic
thread stitched inside the
casing.

The waistband must equal the
length of the enlarged waist
and may be cut in one piece
or in two pieces. A 2"(5.1 cm)
waistband is shown in *Fig-
ure 5*.

Figure 5

Figure 3

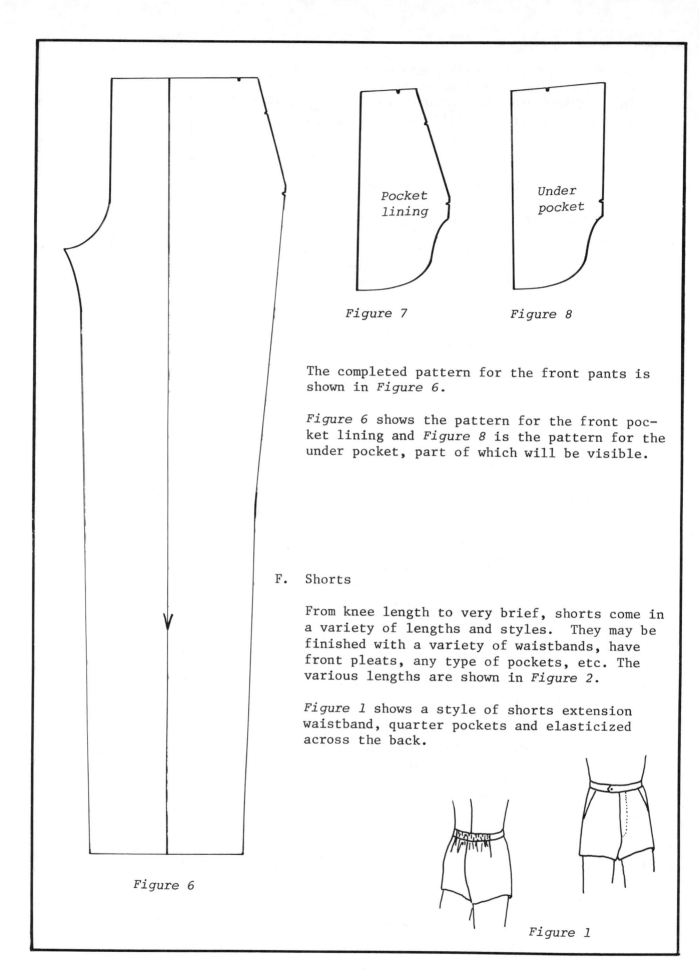

Figure 7

Figure 8

Pocket lining

Under pocket

The completed pattern for the front pants is shown in *Figure 6*.

Figure 6 shows the pattern for the front pocket lining and *Figure 8* is the pattern for the under pocket, part of which will be visible.

F. Shorts

From knee length to very brief, shorts come in a variety of lengths and styles. They may be finished with a variety of waistbands, have front pleats, any type of pockets, etc. The various lengths are shown in *Figure 2*.

Figure 1 shows a style of shorts extension waistband, quarter pockets and elasticized across the back.

Figure 6

Figure 1

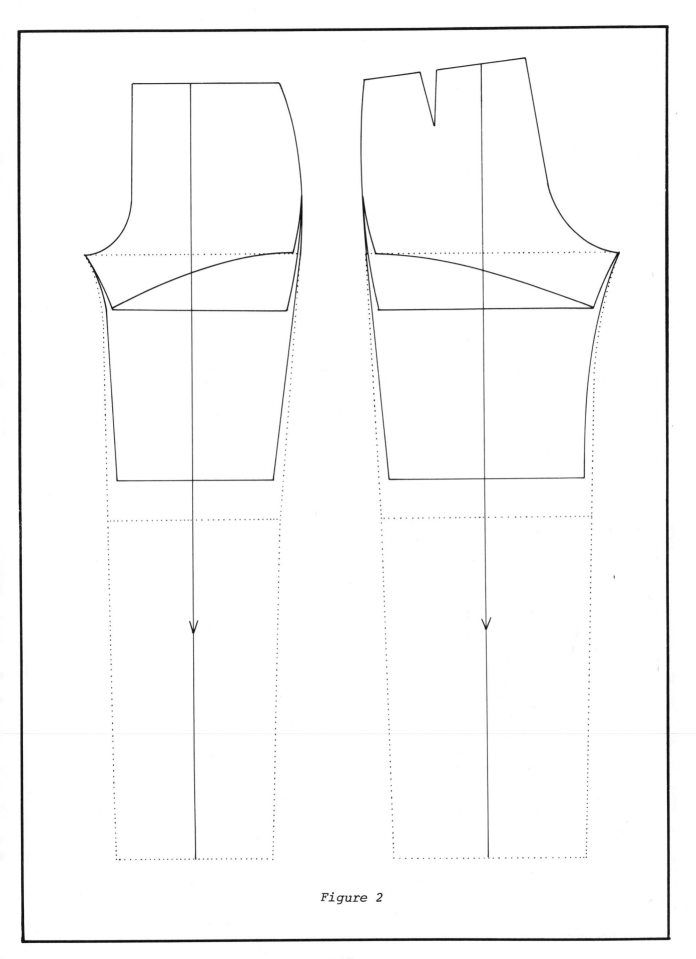

Figure 2

467

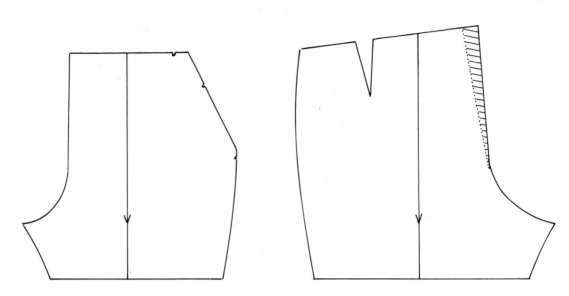

Figure 3

The finished patterns for the front and back shorts are shown in *Figure 3*.
Note that the legs have been narrowed by 1/2" (1.3 cm) on both the inseam
and the outseam as illustrated in *Figure 2*. 1" (2.5 cm) has been added to
the center back waist to accomodate the elastic which goes from dart to
dart in the back.

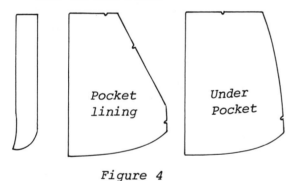

Pocket lining *Under Pocket*

Figure 4

The patterns for the fly, front pocket
lining and under pocket are shown in
Figure 4.

Due to the styling, this waistband
must be cut in three pieces: The
right front, the left front which
has the extension added on, and
the center back section which
will be elasticized. The width
of the waistband is the designer's
choice.

See *Figure 5*.

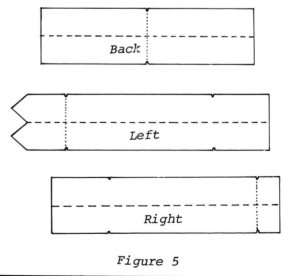

Back

Left

Right

Figure 5